THE AHMANSON FOUNDATION

has endowed this imprint

to honor the memory of

FRANKLIN D. MURPHY

who for half a century

served arts and letters,

beauty and learning, in

equal measure by shaping

with a brilliant devotion

those institutions upon

which they rely.

THE PUBLISHER AND THE UNIVERSITY OF CALIFORNIA PRESS
FOUNDATION GRATEFULLY ACKNOWLEDGE THE GENEROUS
SUPPORT OF THE AHMANSON • MURPHY IMPRINT IN FINE ARTS.

THE PUBLISHER AND THE UNIVERSITY OF CALIFORNIA PRESS
FOUNDATION ALSO GRATEFULLY ACKNOWLEDGE THE GENEROUS
SUPPORT OF FURTHERMORE, A PROGRAM OF THE J.M. KAPLAN
FUND, IN MAKING THIS BOOK POSSIBLE.

Furthermore:
a program of the J.M. Kaplan Fund

©

THIS BOOK WAS ALSO PUBLISHED WITH THE SUPPORT OF THE
ISRAEL SCIENCE FOUNDATION.

IN ADDITION, THE PUBLISHER GRATEFULLY ACKNOWLEDGES THE
GENEROUS SUPPORT OF THE CHAIRMAN'S CIRCLE OF THE
UNIVERSITY OF CALIFORNIA PRESS FOUNDATION, WHOSE
MEMBERS ARE:

ELIZABETH AND DAVID BIRKA-WHITE
SUZANNE HOLLIDAY CALPESTRI
SUSAN MAGEE
MERYL SELIG
THE RICHARD AND LISA KENDALL FUND

MARY CASSATT BETWEEN PARIS AND NEW YORK

MARY CASSATT BETWEEN PARIS AND NEW YORK

The Making of a Transatlantic Legacy

Ruth E. Iskin

UNIVERSITY OF CALIFORNIA PRESS

University of California Press
Oakland, California

© 2025 by Ruth E. Iskin

Library of Congress Cataloging-in-Publication Data

Names: Iskin, Ruth, author.
Title: Mary Cassatt between Paris and New York : the making of a transatlantic legacy / Ruth E. Iskin.
Description: Oakland, California : University of California Press, [2025] | Includes bibliographical
 references and index.
Identifiers: LCCN 2024008394 | ISBN 9780520355453 (cloth) | ISBN 9780520355460 (ebook)
Subjects: LCSH: Cassatt, Mary, 1844–1926—Criticism and interpretation. | Women—Suffrage—United
 States—19th century.
Classification: LCC ND237.C3 I85 2025 | DDC 759.13 [B]—dc23/eng/20240620
LC record available at https://lccn.loc.gov/2024008394

Printed in China

33 32 31 30 29 28 27 26 25 24
10 9 8 7 6 5 4 3 2 1

CONTENTS

PREFACE AND ACKNOWLEDGMENTS

THIS BOOK HAS BEEN A LONG time in the making. My interest in Mary Cassatt goes back to my graduate studies, when my initial research on her work yielded a paper—presented at the 1975 College Art Association meeting in Washington, DC—that introduced a feminist interpretation of Cassatt's mural of *Modern Woman* in the Woman's Building at the 1893 Chicago World's Fair. In later years, I discussed Cassatt in several publications as part of my broader interest in Impressionism and in feminism and nineteenth-century art history; these include my 2007 book *Modern Women and Parisian Consumer Culture in Impressionist Painting*, the essay "Was There a New Woman in Impressionist Painting?," and several articles devoted more specifically to Cassatt, or Degas and Cassatt.

But it was only during the past decade that my longtime interest in writing a monograph on Cassatt materialized with this project. The current book builds on a body of scholarship on Cassatt, including the foundational work of the pioneering Cassatt scholar Nancy Mowll Mathews, among whose works are the 1984 volume of selected correspondence by Cassatt and the 1994 definitive biography of the artist; and the work of Griselda Pollock, who

is known for her vigorous feminist voice in art history and who in 1998 published her study of Cassatt's art interpreted from a feminist perspective. These works, along with the scholarship of numerous other scholars, have enabled me to consider Cassatt within the context of a rich and growing body of work. Likewise, the developments that took place in recent decades in cultural history, feminist and gender studies, visual culture, museum and exhibition studies, friendship studies, and transatlantic studies have all contributed to my ability to ask new questions about Cassatt's art, life, politics, and legacy.

I am deeply grateful for all of this intellectual sustenance, as well as for the personal, professional, and institutional support that has made this book possible. In 2015 the Center for Advanced Study in the Visual Arts, at the National Gallery of Art, Washington, DC, awarded me a semester-long residency as a Paul Mellon and Ailsa Mellon Bruce Visiting Senior Fellow, which facilitated an intensive research period in ideal circumstances. In 2018 the Terra Foundation for American Art's award of a Senior Research Travel Grant enabled my travel to conduct research in several archives, museums, and libraries in the United States. The Israel Science Foundation awarded the book a grant supporting its publication, and the Ben-Gurion University of the Negev, Israel, has supported this project as well as my ongoing academic work through an annual research budget.

I wish to thank the reviewers of the manuscript—Cécile Whiting and Michelle Foa—for their cogent criticism and helpful suggestions that guided my development of the book from the initial proposal all the way through to the final version of the manuscript. I am also grateful to my colleagues Paula J. Birnbaum and Ayelet Carmi, who read the manuscript more than once and whose criticism and ideas stimulated my thinking and supported me throughout the process; I thank Carmi also for her invaluable help in shortening the manuscript.

Several other colleagues provided insightful criticism and suggestions, including two preeminent feminist art historians—Norma Broude and Mary Garrard—who generously read the chapters of the manuscript as they evolved and helped clarify my ideas and their presentation. Cultural historian Vanessa R. Schwartz offered sharp criticism in good spirits, evoking further thinking on the topic at hand. Several colleagues whose areas of expertise differ from my own provided helpful suggestions on particular chapters—film scholar Ori Levin of Tel Aviv University; Tal Dekel, curator and art historian of contemporary art and gender in Israel; Ann Temkin, chief curator of painting and sculpture at the Museum of Modern Art, New York. And historian and descendant of the Cassatt family Mark Meigs shared with me his knowledge about the family. I am grateful to them all.

I thank the staff members of the archives, libraries, and museums who shared their expertise and facilitated my research at their institutions and my access to unpublished letters and an unpublished diary. Melissa Bowling at the archives of the Metropolitan Museum of Art was especially helpful throughout my research at the archives. At the Met, I also benefited from access to the curatorial files, and from discussions

with curators of nineteenth-century art in the museum's American Wing—Elizabeth Kornhauser and Stephanie Hedrich—and from Laura D. Corey's availability to answer questions after my departure. My appreciation is extended to Allison Harig, archivist of the Shelburne Museum Archives, in Burlington, Vermont, and to Melanie Bourbeau, senior curator at the Hill-Stead Museum, in Farmington, Connecticut, both of whom helped me greatly with archival research.

I am grateful to the Archives of American Art, Smithsonian Institution, in Washington, DC, especially to Marisa Bourgoin, head of reference services, and librarian Lindsey G. Bright; and to Alexandra Reigle, reference librarian at the American Art and Portrait Gallery Library in Washington, DC. At the National Gallery of Art, in Washington, DC, I am thankful for the warm welcome from Mary Morton, curator and head of the Department of French Paintings, and Carlotta J. Owens, assistant curator of modern prints and drawings; and for the help of members of the curatorial staff Jennifer Henel and Michelle Bird. My thanks to Erica E. Hirshler, the curator of American paintings at the Museum of Fine Arts, Boston, for making available some materials in the museum. I am grateful to the Pennsylvania Museum of Art's Jennifer Thomson, curator of European painting and sculpture, and Kathleen A. Foster, curator of American art, for generously providing extensive information on and installation shots of the display of Cassatt's artworks in their museum galleries. My thanks also to Madeleine Viljoen, curator of prints and special collections at the New York Public Library, and to Lois White, head of research services at the Research Library of the Getty Research Institute, Los Angeles, for their help with long-distance research in their collections. My thanks to Ivy Albright, collections and curatorial consultant at the Museum of the National Woman's Party, the Belmont-Paul House, Washington, DC, who welcomed me to the collection and helped me access material in it (the collection has since been given to the Library of Congress); at the Manuscript Division of the Library of Congress, I benefited from discussion with historian of women and gender Elizabeth Novara and the assistance of reference librarian Edith A. Sandler.

I am also indebted to institutions and scholars in Paris, and gratefully acknowledge the staff members at the Musée d'Orsay's Documentation, the Archives de Paris, and the INIIA library. My thanks to Sylvie Colomb, cheffe du service des ressources documentaires, and to Claire Martin, in charge of documentary studies at the Petit Palais, Musée des Beaux-Arts de la ville de Paris, for providing materials on Cassatt's artworks in their collection. My gratitude to Sylvie Patry, at the time chief curator at the Musée d'Orsay, for welcoming me to the Berthe Morisot exhibition she curated and for the discussion on the Cassatt project. My thanks to two art historians at Université de Paris 1 Panthéon-Sorbonne: Catherine Meneux, who alerted me to Cassatt's correspondence with Roger Marx and generously provided me with a copy of her transcription of it, and Marie Gispert, for her help in obtaining French scholarly literature.

I thank Warren Adelson and the Adelson Galleries in the United States for access to the online Cassatt catalogue raisonné. Among the many people who helped to obtain

photographs of or permissions for artworks, I want to mention especially Paul Perrin, director of conservation of the Musée d'Orsay, and the museum's photographer, Sophie Crépy; art historian Nicole Georgopulos; and the expert on the art collection of the Whittemore family, Ann Y. Smith. I gratefully acknowledge Liat Shiber for her work in obtaining photographs and permissions for this book. I thank Shira Gottlieb for helping with obtaining occasional research materials in Paris and for sharing her expertise on the topic of women and aging in nineteenth-century Paris. I also thank my current PhD advisee, Mayrav Lanski Shenhar, for her generous help with obtaining materials during her overseas travels and for sharing information from her research on Sarah Choate Sears, the topic of her dissertation. I thank members of the Ben-Gurion University administration—in particular, Rozalin Maman, the administrator of the Department of the Arts—for ongoing administrative support. My gratitude as well to my colleagues at the university—art historians Ronit Milano and Inbal Ben-Asher Gitler, the Humanities and Social Sciences dean, Nirit Ben-Aryeh Debby, and the department chair, Sara Offenberg—some of whom I approached for various kinds of advice along the way, and all of whom have provided a supportive academic environment.

My gratitude goes to Natalie Melzer, the language editor of this manuscript before it was submitted to the press, for her intelligent editing, thanks to which this book is reader-friendly. I wish to express my appreciation to all those who made this project possible at University of California Press: editor LeKeisha Hughes, who adeptly shepherded the project from manuscript to publication; Nadine Little, who originally acquired the book; editorial director Kim Robinson; editorial assistant Nora Becker; copyeditor Erica Olsen; production editor Jessica Moll; and the entire production staff of the press.

Finally, I thank my sister, Michal Iskin, whose fabulous Friday night dinners and whose company on some wonderful European travels sustained me through the long haul of writing this book.

INTRODUCTION

I cannot tell you what I suffer for the want of seeing a good picture,
no amount of bodily suffering occasioned by the want of comforts
would seem to be too great a price for the pleasure of living in a
country where one could have some art advantages.

MARY CASSATT, [1871]

THIS BOOK AIMS to reenvision Cassatt's life, career, and art
in the context of her transatlantic friendships, networks,
collecting activities, and politics. Paying close attention to
the complexity of Cassatt's strong identifications as an American
citizen and cultural nationalist on the one hand, and as a member
of the French Impressionist group on the other, it charts the larger
stakes and lasting impact of her lifelong work promoting French
and European art to American collectors.

During Cassatt's lifetime, the United States was still consid-
ered a cultural periphery, and American artists and critics yearned
to develop a national school of art free from a dependence on
Europe.[1] This book argues that Cassatt played an outsize role in
the transatlantic art world of her time, bridging the Parisian and
New York art worlds both through her own artistic reputation and
in the unique impact she had through advising American collec-
tors on acquiring contemporary French art. It aims to chart a
revised understanding of Cassatt within the transatlantic context
of her life and career and to analyze her posthumous legacy, with

attention to the way in which it remains, even in today's globalizing world, tied to the nationalist affiliations of museums on both sides of the Atlantic.

The book also analyzes Cassatt's feminism in detail, including her strong interest in the American suffrage battle and the impact of the fierce pro- and anti-suffrage discourses of her time, to illuminate some of her artworks in new ways. Here, too, it shows the transatlantic nature of her support of suffrage, which was focused specifically on American suffrage even though she lived in France and in principle wished for women's equality throughout the world.

In 1874, when the thirty-year-old Mary Cassatt decided to settle in Paris in order to develop her career as an artist, she most likely did not anticipate that just a few years later, she would be exhibiting with the most talked-about group of artists in Paris—the Impressionists—and would attract the attention of numerous art critics as well as some French collectors.[2] After the first time she exhibited with the Impressionists, in 1879, her father described this as a feat that would secure her success for the rest of her career: "She is now known to the Art world as well as to the general public in such a way as not to be forgotten again so long as she continues to paint!"[3] Cassatt settled in Paris after several years of travel to various other European locations, including Rome, Madrid, Seville, Amsterdam, and the village of Ecouen, north of Paris. In 1870–71, the Franco-Prussian War forced her to spend some time back in the United States, where she felt desperate about the lack of any opportunity to see art, at a time before American museums had been founded. Although before settling in Paris she had "detested" the city, after studying the old masters as well as the newer Barbizon style of painting in nature, she realized that it was "necessary for her to be there, to look after her own interests."[4] Paris at the time was an art capital like no other, offering not only the riches of the Louvre but also opportunities to exhibit, the potential to find patronage, and the multiple benefits of working in an international art center. It was a metropolis in which art and artists occupied a major position, where Cassatt could meet numerous young contemporary artists, some of whom, as she soon learned, had broken away from the dictates of the academic teachers who were the gatekeepers of the Salon and the official recognition it bestowed.

Cassatt ended up living in France for the rest of her life, but she never cut her ties to home. Letters, therefore, occupied an important place in her life. Cassatt's print *The Letter*, 1890–91 (from the print series that was inspired by her enthusiastic encounter with a large exhibition of Japanese prints in Paris in 1890), shows a young woman preparing to send a letter by licking the envelope—a rare depiction of the preparation for sending a letter, as opposed to the reading of a letter, which was a common theme in the European tradition (fig. I.1).[5] Such was Cassatt's emphasis on the preparations that in her original plan for the print, she did not even include the letter, as seen in its first state (fig. I.2), adding it only later by scraping away an area in the blue ink that covers the desk's surface (fig. I.1).[6] Correspondence was the common means of trans-

atlantic communication in Cassatt's days, while telegrams were reserved for very brief and urgent communications and the telephone (which Cassatt began using in 1906 for communications inside France) was not yet operating across the Atlantic.

After she settled in Paris, Cassatt visited her homeland only three times (in 1875, 1898, and 1908), dreading the passage on the transatlantic ocean liners because she suffered from severe seasickness that would disable her for weeks after arrival. Thus, the letters she sent and received were her lifeline to her homeland. Eagerly anticipating them, she walked daily to the post office, and when sending her own letters, she calculated the date of their arrival by keeping track of the transatlantic ocean liner that would carry them. Throughout the more than five decades that Cassatt lived in France, she maintained a deep connection with her homeland, primarily through prolific correspondence with her American friends and family.

The many letters Cassatt wrote, especially to her closest friend, the New York–based collector and suffrage activist Louisine Havemeyer, are a major source for learning about Cassatt's ideas and feelings about a range of issues, including her homeland, living in France, art, advising American collectors, and women's equality and suffrage. Her letters to Havemeyer, many still unpublished, were a key source in my research for this book.[7] They are especially valuable because they express Cassatt's voice in real time and are candid as only letters to a trusted friend and confidante can be—letters written with intimacy, transparency, and no notion that they might be published. Havemeyer's letters to Cassatt did not survive, but her memoir includes her insights about Cassatt. As with any memoir, Havemeyer formulated many of her insights years after the events described. She began writing the memoir during a lengthy visit with Cassatt in the South of France in 1914, but it was published many years later.[8] The memoir is a unique source on Cassatt because of the perspective it offers of a close friend of over five decades who understood Cassatt extremely well and shared her feminist worldview as well as her commitment to collecting art to enrich American culture. Havemeyer's perspective is also that of someone who shared Cassatt's nationality and class; who knew some of the friends with whom Cassatt interacted, including Degas; and who had been a sympathetic eyewitness to some of these interactions.

This book is the first to study Cassatt based on her multiple identifications: as an artist with French Impressionism, and as a cultural nationalist with her American homeland. It studies her national identity both in terms of her own identifications and in terms of how she is viewed today. With rare exceptions, scholars have not addressed these questions, assuming them to be "a non-issue," as Hollis Clayson observed.[9] But I argue that they are in fact a major issue. Kevin Sharp focused on the shift that occurred during Cassatt's lifetime, from being recognized mainly in France and associated with that country in the earlier parts of her career, to being claimed by American critics as an American artist by the turn of the twentieth century.[10] Building on Sharp's study, my analysis focuses on the period of almost one hundred years from Cassatt's death in 1926 to today, and considers how Cassatt has been represented in museums on both

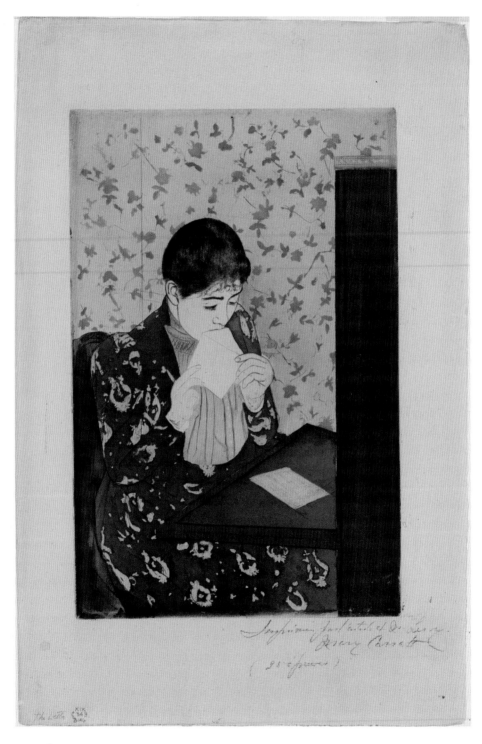

FIGURE I.1

Mary Cassatt, *The Letter,* 1890–91. Color drypoint and aquatint on laid paper (fourth state of four), 18.9 × 12.2 in. (48 × 31 cm). Prints and Photographs Division, Library of Congress, Washington, DC. 2006676026.

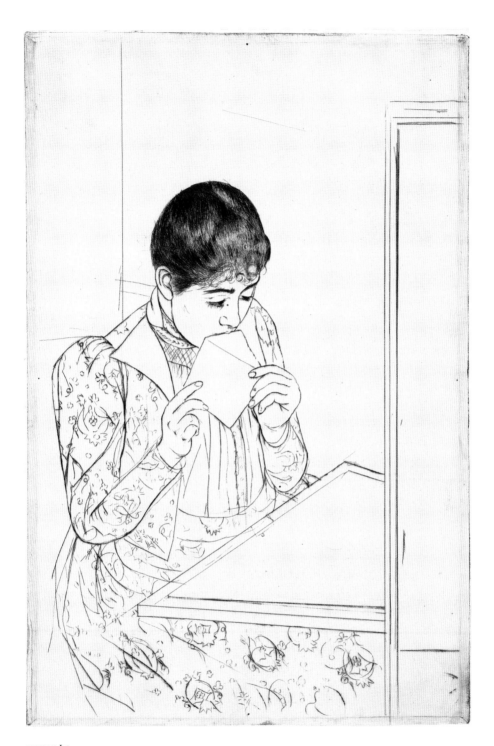

FIGURE I.2

Mary Cassatt, *The Letter*, 1890–91. Drypoint printed in black ink from one plate (first state of four), 13.6 × 9.1 in. (34.6 × 23.2 cm). The Metropolitan Museum of Art, New York. Gift of Arthur Sachs, 1916 (16.3.2). © The Metropolitan Museum of Art. Image source: Art Resource, NY.

sides of the Atlantic in special exhibitions and permanent displays. I analyze the difference between the way in which Cassatt is represented in most American museums today—fundamentally as an American artist—and her representation in French museums, which regard her as one of France's Impressionists and display her alongside the likes of Monet, Pissarro, Morisot, and Degas. In today's globalizing era, we tend to look at art and artists as increasingly "transnational." But in the case of Cassatt, as I argue, not only were nation-based identifications a determining factor in her own worldview, but they also continue to shape the way in which her art is displayed in museums to this day. So this book both alerts us to the historical framework within which Cassatt operated and illuminates the issues that continue to shape her legacy.

The transatlantic world of Cassatt's time was defined by the movement of goods, among them art, and of people, including artists, collectors, and dealers. The growing transatlantic art market of her days included such phenomena as numerous American collectors acquiring art in Europe, especially in Paris, and several Parisian galleries opening branches in New York. Paul Durand-Ruel, who represented Cassatt and was the chief French dealer of the Impressionists and their main promoter on both sides of the Atlantic, opened his gallery in New York City in 1887.[11] Cassatt brought Durand-Ruel some of his most important American collectors, and both she and he had a great impact on the transfer of Impressionist paintings from France to the United States. Other Parisian galleries similarly opened up branches in New York to support their sales in the United States. Paris's art market also benefited from an auction house and a highly developed print culture, with numerous magazines and newspapers featuring art reviews.

Cassatt's effectiveness in advising Americans to acquire avant-garde French art and some European old masters coincided with the period when American collectors became crucial players in an emerging transatlantic art world system. The transatlantic market for French art became important in tandem with the changes in the French art world system: over the course of the nineteenth century, with the disintegration of state patronage and of Paris's central annual Salon, the success of French artists gradually depended less on their nation and more on private collectors and gallery dealers.[12] By the time the Impressionists emerged, their livelihood, careers, and recognition depended on a system of private collectors, critics, galleries, and auctions, not only in France but also in the United States and to some extent in other nations in Europe, especially Germany.[13]

In 1911 Udo J. Keppler, a writer, publisher, political cartoonist, and collector of Native American art, published a caricature, *The Magnet*, about the massive importation of European art and artifacts to the United States (fig. I.3). It appeared as a centerfold in the American satiric journal *Puck*, published by him at the time. It features John Pierpont Morgan, the American financier who amassed European art and artifacts, pointing at Europe a huge dollar-shaped magnet that "pulls" diverse European cultural riches across the vast Atlantic.[14] The caricature expresses a typical critical French view

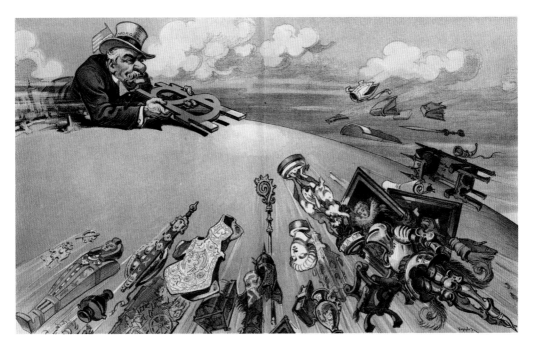

FIGURE I.3

Udo J. Keppler, *The Magnet*. 1911. Illustration from the centerfold of *Puck Illustrated* 69, no. 1790 (June 21, 1911). Photomechanical print. Prints and Photographs Division, Library of Congress, Washington, DC, 2011649038.

of wealthy American collectors as buying up European culture while lacking any taste and refinement of their own. It may also imply Keppler's own critique, as an advocate for Native rights, of the tendency of American collectors to amass European art while ignoring the cultural traditions of their own continent.[15]As European art objects made the journey from Europe to the United States, American art students and artists moved in the opposite direction, going to various European capitals, including Rome, Munich, and London, in addition to Paris. Cassatt was one of many American artists who went to Paris,[16] among them numerous women (about a thousand in 1888), alongside many art students and artists who came to the city from across Europe.[17]

How did these multiple transatlantic affiliations and crossings shape Cassatt's identity, art, and legacy? This book offers an answer that breaks with the typical dichotomous view of Cassatt as either an artist who belonged to the French Impressionists or an American expatriate artist. The labeling of Cassatt as an expatriate is predominant and often automatic, yet this view fails to account for the complexity of her position as an artist and that of her legacy.[18] The term *expatriate* does not fit Cassatt insofar as it implies not only the act of leaving one's country but also the renunciation of one's allegiance to it.[19] Cassatt maintained a strong American identity throughout her life and never gave up her American citizenship long after she knew she would never return home.[20] Even after nearly four decades of living in France, she

insisted to Achille Segard, her first biographer: "I am an American, clearly and frankly American."[21]

Cosmopolitan—another term applied to Cassatt, reflecting the fact that she was well traveled and possessed a broad understanding of culture that was not limited to one nation—is similarly problematic, since she was not a "cosmopolitan" in the sense of seeing herself as a "citizen of the world" or part of a universal community without any meaningful affiliation to state citizenship or national identity.[22] And interpreting her as "striving for a genuine trans-nationality"[23] is, as I noted earlier, likewise at odds with the fact that Cassatt was deeply committed to the American nation. Perhaps Cassatt can be described as a "cosmopolitan patriot," a term coined by Kwame Anthony Appiah to capture the possibility of a cosmopolitan sensibility coexisting with strong feelings for one's homeland (whether defined as the country of birth or the country in which one lives).[24] Appiah describes this as a form of "rooted cosmopolitanism," which he explains with reference to Gertrude Stein's statement that there was no point in roots if you couldn't take them with you.[25] Cassatt took her American roots with her, and clung to them even as she developed artistic roots in the Parisian art world.

Cassatt subscribed to what scholars later referred to as American cultural nationalism. Whereas the revolutionary generation that gained political independence saw itself as a "trans-Atlantic intellectual fraternity,"[26] Americans' cultural nationalism developed in the early nineteenth century with a focus on the ambition of forming an original American culture that would be free from dependence on Europe.[27] In 1837 Ralph Waldo Emerson famously declared this mission accomplished in literature: "Our day of dependence, our long apprenticeship to the learning of other lands, draws to a close."[28] Decades later, a declaration of cultural independence was yet to be proclaimed in the visual arts, and as Wanda M. Corn demonstrated, striving for this independence played an important role in the post–World War I New York avant-garde.[29] Cassatt believed that to develop an original American modern art necessitated a transatlantic dialogue with the culture of the old world, including both its masterpieces and contemporary innovations. Unlike the focus of the wealthiest American collectors of the late nineteenth century on art by old masters,[30] Cassatt's primary emphasis as a collecting advisor was on avant-garde art, although she also facilitated the arrival of some important works by old masters to American museums.

Cassatt lacked the kind of fortune needed to create a major collection herself. She assembled only a small collection of works by Courbet, Manet, Degas, and a few other Impressionist colleagues, as well as Japanese prints, but her main activity in the area of collecting was to advise wealthy Americans on collecting French and European art.[31] For Cassatt, as for Havemeyer, collecting was connected to knowing what art "means in a nation's life."[32] She regarded collecting for the purpose of transferring art to the United States as a patriotic act and saw the Havemeyers' collecting, and by implication her own deep involvement in it, as a national commitment.[33] Cassatt's ultimate interest was not merely to help collectors form their private collections but also to see these

collections eventually reach museums, so that American artists could study and work in their homeland and develop an original American art school equal to the artistic schools of France and other European nations.[34] Although many others shared this goal at the time, Cassatt distinguished herself by tirelessly working over several decades with American collectors to advance it. She was determined, knowledgeable, and passionate. Her choice to advise American collectors coincided with the urgent need of American museums, founded from the 1870s onward, to accumulate their collections, which at the time depended on major bequests of artworks from private collections.

Cassatt's belief that the United States had no artistic tradition of its own and that European art was crucial for the formation of an American art was shared by most Americans (and Europeans). She was typical of her time in not considering such traditions as Native American art as valuable for the development of an American art that was not indebted to Europe. The reigning division between art and craft located Native American art in the latter category, and more generally, Native American culture was seen as "separate from mainstream culture."[35] Later, some Americans saw Native American art as a potentially "rich site for transcultural exchange and national cultural development."[36] But during Cassatt's time, elites viewed European art as the necessary pathway to artistic development in the United States.

As strongly as she was committed to the cultural development of the United States, so was Cassatt passionate about her own artistic "citizenship" with the Impressionists in France. She never considered herself an *American artist*, and throughout her life consistently referred to the Impressionists (sometimes also including Manet) as "our set." For example, in 1903 she informed a friend that "There is to be an exhibition opening April 2nd at the Bernheim[-Jeune] gallery *of all our set*, including Manet, Degas, Sisley, Berthe Morisot, and myself."[37] Her lifelong loyalty to the Impressionists in France was an allegiance less to an artistic style than to the principles of artistic independence. Preferring the name chosen by the artists themselves, the "Independents," she explained that the group's exhibitions were "a protest against official [government-sponsored Salon] exhibitions," juries, and prizes.[38] She stated that "Impressionists" was "a name which might apply to Monet but can have no meaning when attached to Degas' name."[39] Unlike the expatriates John Singer Sargent and James McNeill Whistler, Cassatt put down her artistic roots in a group of mostly French artists. She maximized the possibilities of the transatlantic art world of her time to integrate her two passions—contemporary French art, in which she was partaking as an artist, and the collecting and transferring of European art to the United States. The consistency and force of her views on collecting and of her actions in working with American collectors on transferring art to the United States lead me to argue that these positions and actions should not remain external to her artistic legacy but should be recognized as an important part of it.

My focus on Cassatt, an American artist who lived and worked permanently in France—and my analysis of the significance of her multiple identities in a transatlantic

world—also provides an opportunity to explore various issues that form part of the study of "global" Impressionism. A prominent recent tendency in studies of Impressionism focuses on its international diffusion, exploring local translations of Impressionism around the world and interrogating "impressionism as an artistic language simultaneously operating locally, nationally, and internationally."[40] My study is relevant to these developments in two ways. First, by exploring the history of museums and of collecting, I return to a key hub for the dissemination of Impressionism, with the goal of helping us better understand what has shaped the notions of artistic transfer and cultural movement. Second, my emphasis on her multiple identities internationalizes Cassatt. I ask how the matrix of tensions, challenges, and opportunities posed by Cassatt's complex identifications played out in a single artist within the transatlantic axis of Paris and New York, and I show how her American identity and cultural nationalism coexisted with her committed artistic identity as a French Impressionist.

As an American citizen, Cassatt cared deeply not only about the development of a national artistic culture but also about women's equality, and in particular women's right to vote, in the United States. This book also aims to expand our understanding of Cassatt and her art in the context of the American suffrage movement of her time. During the last several decades, scholarship has focused primarily on Cassatt's gender, offering complex readings of her work through the lens of her position as a woman.[41] As Anne Higonnet recently observed, feminist scholarship of the 1980s and 1990s on Cassatt and Morisot resurrected "their reputations by singling them out and demonstrating their difference."[42] She proposes that "instead of only considering" these artists as "constrained by the limits of their gender, it might also be possible now to recognize how deeply they understood the [Impressionist] movement's most fundamentally modern principle, and painted accordingly."[43]

In keeping with Higonnet's approach, this book looks beyond the influence of conservative constraints on women in order to offer new interpretations of Cassatt's art. For example, instead of assuming that the ideology of "separate spheres" for men and women provides the key to understanding Cassatt's focus on depicting middle-class women and children in interiors,[44] this book highlights the impact on Cassatt of the nineteenth-century new feminist discourses, which included the demand to break the dichotomy of "separate spheres" and free women to engage in pursuits that had previously been the exclusive domain of men. It argues that Cassatt's support of suffrage and its attendant feminist discourses are crucial to our understanding of her person and her art. Cassatt herself was a modern woman who left her home and crossed the Atlantic at a young age to pursue her artistic education and become a professional artist. She herself, in other words, broke out of the limitations of the domestic sphere. Nonetheless, as the book shows, in both her personal life and her work, her own relationship with gender was touched by contradictions. She was an ambitious, independent artist, yet she also never entirely shed her identity as an elite Philadelphia "lady"—

neither simply or completely a bourgeois, nor fully a precursor to the 1890s New Woman, but a mixture of both.[45] She believed in and practiced many of the freedoms claimed by the New Woman—to pursue her education and career, to work for financial independence, and to be an independent artist, departing from academic strictures and forging her own identity among the Impressionist group. Yet she was also anchored in a transatlantic network that included numerous conservative Americans, some of them her family members and closest friends, who belonged to the American financial elite and denounced women's equality and suffrage. Cassatt, who was generally known to be a passionate defender of her beliefs, sometimes lost her temper in their presence, as when several young women who were her guests expressed anti-suffrage opinions. She was also greatly distressed by the fact that Jennie Cassatt, the widow of her beloved brother Gardner, became an active anti-suffragist.

Going beyond earlier discussions that recognized Cassatt's support of suffrage, this book argues that she was deeply impacted by the fierce pro- and anti-suffrage debates and reinterprets some of her art in this light. For example, it makes the case that although Cassatt believed in the importance of women's roles as mothers, like other feminists of her time she objected to limiting women to the home sphere. When considered outside the historical context of the fierce debates about suffrage, her artistic representations of women as mothers with children may appear to shore up a conservative upper-bourgeois ideal. Yet in my analysis of her works that feature mothers and children, I ask if they can instead be read as reflecting the feminist discourse of her time that highlighted the value of women as mothers as a strategic political lever for claiming women's broader roles outside the home.

The book also revisits some rarely considered subjects in Cassatt's oeuvre, including portraits of older women, portrayals of women (not necessarily mothers) mentoring young girls or teenagers, depictions of women's community beyond the nuclear family, and Cassatt's interpretation of elite American fatherhood. I analyze Cassatt's artworks on these subjects in light of the pro- and anti-suffrage discourses, and include a discussion of various visual culture images—such as photographs, caricatures, and propaganda images—because these played an important role in those deeply contested debates.[46] Though Cassatt was probably directly familiar with only some of the images discussed—for example, Honoré Daumier's caricatures and the sunflower as a symbol of the American suffrage movement—such images help to describe and give substance to the fierce historical moment in which she lived and worked, and which significantly influenced her outlook. So, for example, I include several photographs of distinguished American suffrage leaders in their old age, along with these leaders' writings on the topic of women's aging, to show that feminist discourses challenged the negative valuation of women's old age. The existence of this discourse alongside the fact that Cassatt's own letters echo these views led me to recognize Cassatt's portraits of older women as reflective of her own feminist worldview and that of her time.

The book generally pays closer attention to American rather than French feminist discourses, because Cassatt was primarily interested in the battle for suffrage in the United States. She clearly did hope for the emancipation of women throughout the world, and the fact that she was living in France suggests that she was likely aware of major French feminist debates there; but her strongest interest was squarely in the American battle for suffrage, and this for two main reasons. The first was her consistent and deep identification as an American, even after more than five decades in France, and the second was her close friendship with Louisine Havemeyer, who (at Cassatt's suggestion) became a suffrage activist in the United States, and eventually a prominent one. Through this friendship, the artist was close to the American battle for suffrage despite her geographical distance. This distance, however, did not prevent Cassatt from actively participating at least once in American suffrage by exhibiting her art in the 1915 New York exhibition, featuring her work alongside that of Degas and some old masters, that Havemeyer curated in support of suffrage. In France, Cassatt did not have similar close friendships with women involved in the local women's rights movement.

This book critically revisits some of the common narratives about Cassatt. It is the first comprehensive study of her life, work, and legacy through the prism of a transatlantic framework—a perspective that animates each of the book's chapters. Chapter 1 looks specifically at Cassatt's transatlantic network. It demonstrates her rootedness in her American social circles throughout her life in France through her close friendships with American women and men who lived across the Atlantic. It also shifts the focus of discussions about her life from the narrower prism of her ties to her family to an analysis of the social and professional role of her network of American collectors, artists and professional men and women in a variety of cultural fields.

The development of friendship studies provided an initial inspiration for my choice to look more closely at Cassatt's friendships than previous book-length studies on the artist have done. And indeed, engaging in detailed analyses of Cassatt's most important friendships proved to be an important avenue for gaining new insights into her life, work, practices, and legacy. The broader survey in chapter 1 of her transatlantic network of friends and colleagues is followed by in-depth analyses of Cassatt's two most important friendships—with Louisine Havemeyer (chapter 2) and with Edgar Degas (chapter 3). I argue that Cassatt's lifelong friendship with Havemeyer, which has received less scholarly attention than her friendship with Degas, had a significantly greater impact than has previously been understood. Anchored in strong affective bonds, in a shared political commitment to women's equality, in a shared passion for art and collecting, and in particular in a shared commitment to advancing the cultural standing of the American nation, this friendship produced one of the most extensive collections of modern French art in the United States, the core of which is now housed at the Metropolitan Museum of Art.[47] More broadly, in terms of friendship studies and gender studies, the analysis of the Cassatt-Havemeyer friendship shows that contrary to stereotypes that limit the purview of women's friendships to "feminine" concerns,

this friendship encompassed private and affective dimensions along with professional, public, national, and political ones.

As for the Cassatt-Degas friendship (chapter 3), the book charts a revisionist narrative of this professional and personal relationship, analyzing its dynamics and mutual benefits, its comradeship, caring, and kindness, as well as its conflicts and Cassatt's strategies for handling them. I argue that, contrary to a common assumption, the relationship was much less defined by the traditional gender hierarchy that assumed a one-way contribution by a male master to his female protégé. My analysis foregrounds Cassatt's agency in the relationship and offers a new perspective on the narrative about how she joined the Paris Impressionists, arguing that this was the result not of "a chance discovery" by Degas[48] but of Cassatt's explicit networking. Whereas existing studies have tended, with rare exceptions, to look at Degas's contribution to Cassatt but not at her contribution to Degas, I also devote a substantial discussion to the latter, specifically to Cassatt's contribution to Degas's transatlantic reputation and to his extensive representation in American museums.[49]

Previous studies have discussed Cassatt as a feminist, yet this is the first book to devote an entire chapter to her feminism (chapter 4), delving deeply into Cassatt's specific feminist beliefs and aspirations, primarily through a close reading of her correspondence. It charts Cassatt's positions on suffrage and women's equality, marriage versus career, financial independence, and her choice to pursue a life of professional work informed by a strong work ethic over a life of leisure. It also discusses her position on equal citizenship, taxation without representation, women's exhibitions, and the nineteenth-century doctrine of the gendered separation of the private and public spheres. I argue that Cassatt was a transatlantic feminist whose views were primarily connected to the American suffrage movement and its broader struggle for women's equality. Based on this preliminary intellectual biography, chapter 5 engages with questions about the impact of Cassatt's transatlantic feminism on her art. It offers new interpretations of some specific themes in Cassatt's art, including motherhood, fatherhood, and the portrayals of older women.

Chapter 6 then analyzes a unique and important exhibition that marks the only time Cassatt actively participated in supporting the American cause of suffrage. In 1915 her art was featured next to that of Degas and old masters in a New York exhibition initiated and organized by Havemeyer (with Cassatt's input) explicitly to support the cause of American women's suffrage; its proceeds went directly to this campaign. Offering a revised account of the artworks in the exhibition, I analyze its related presentation of Cassatt and Degas, its trajectory for exhibiting modernism in the context of the old masters, and its reception in the New York press.

Finally, this book seeks to shed light on the way in which Cassatt's legacy has evolved from the artist's death in 1926 to today, focusing primarily on the impact of museums on this legacy (chapter 7). I argue that national interests have driven French museums and most American museums to develop different strategies for displaying

Cassatt's art, thereby creating two different narratives about the artist that have in turn shaped two dissimilar Cassatt legacies: one as a French Impressionist, the other as an American artist. I propose that in addition to these competing national agendas, Cassatt's legacy was impacted also by the complex dynamics of her own transatlantic life course. Today, most of Cassatt's work is in the United States, where, with rare exceptions, it is exhibited in the context of American art and not, as Cassatt herself wished, within the context of the French avant-garde to which she saw her art as belonging. As the book and in particular the last chapter shows, Cassatt and her legacy cannot be fully charted within the boundaries of either her homeland or France, but can be understood anew within the framework of the transatlantic art world of her time. She was both an American who held on to her American identity and an artist who identified fiercely with the French Impressionists. Thus, she cannot be reduced to one or the other to accommodate convenient national classifications. In the international aspects of her life and career, in her dual identifications, and specifically in her participation in an art movement of a country other than her homeland, Cassatt may be seen as a fascinating precursor of many later and especially contemporary artists.

This book is neither a straightforward art history monograph on Cassatt's oeuvre nor a biography of the painter. It includes biographical elements—for example, in the discussions of her friendships, her feelings about her national and artistic belongings, and her goals in collecting—but does not chronicle her entire life. My aim is to provide a history of Cassatt's life, work, politics, and legacy that foregrounds and explores the implications of her transatlantic status and political commitments: to investigate what it meant for her as an artist to be between two nations, what it meant for her to be an upper-class American professional woman for whom women's equality and suffrage were important, and more broadly how her politics related to her art. My intention is to understand how these important issues animated Cassatt's life and work but also to offer a case study of what it meant in her time to be a woman who was active in multiple aspects of the public sphere. In these respects, the book shows how Cassatt's life and work offer a window onto the cultural history of her late nineteenth- and early twentieth-century moment.

1

CASSATT'S TRANSATLANTIC NETWORK

THROUGHOUT HER OVER five decades of living in France, from 1875 to her death in 1926, Mary Cassatt called the United States "home," in contexts both mundane and political. So, for example, comparing the price of telephone installation and use in both countries, she mentions that in France it seems cheaper than "at home";[1] and writing about the then president of the United States, Woodrow Wilson, she notes that he is visiting France "instead of being at home to attend to things."[2] She also used "our," "us," and "we" consistently in her letters to refer to Americans, and "they" and "their" to refer to the French. For example, reporting on the mood in France after the end of World War I, she writes: "Here the craze is now to say that *they* [the French] could get on very well without *us*, *they* won the war, *we* had little to do with it, *they* don't go quite so far as to deny the bravery of *our* men but of course *we* could never equal *their* men."[3] Her consistent identification as an American continued to the end of her life.

Cassatt crossed the Atlantic only three times after she settled in France. How, then, did she maintain her deep sense of

belonging to the United States even while living in France for over half a century? Cassatt nurtured her identification with her homeland primarily through her network of American friends, many of whom came for annual visits to France. Except for the Impressionist painter Edgar Degas, her closest friends were Americans. Of course, her connection to her homeland persisted also through her American family. Most of her family members lived in the United States but came frequently for lengthy visits. In addition, after her parents and sister joined her in Paris in 1877, she lived with them in the same household. After her mother's death in 1895, Cassatt lived on her own, supported by several staff members. But Cassatt never limited herself to the domestic environment or family circle. Her social network, in which Americans played a prominent role, was always crucial to her, both personally and professionally. Since socializing with friends often included family members, as was customary in the European and American upper middle class during the nineteenth century, there was a certain fluid overlap between Cassatt's family and her friends.

To understand Cassatt as an artist, a person with a strong national affiliation to her homeland, and an advisor to American collectors, it is essential to study her within her network, because of its major role in her life. The present chapter discusses the makeup, scope, practices, and functions of Cassatt's network, with a particular focus on her mature years, from her forties onward. It examines specific relationships with her closest American friends and shows that from her earliest to her latest years in France, she relied on an American network of friends and colleagues.

Studying Cassatt's transatlantic network is in tune with the sociologist Howard S. Becker's analysis of the art world as "the network of cooperation" that is "central to the analysis of art as a social phenomenon."[4] In the broadest terms, a social network can be defined as "a set of relationships"[5] that "represents one informal way of associating together human agents."[6] A principal characteristic of a social network is its dynamic nature, as an entity that grows, contracts, spawns, or splinters off. Whereas the modernist paradigm represented artists as autonomous creators, usually with a focus on aesthetic aspects of their art, some Cassatt scholarship tended to foreground Cassatt's family, and much of it positioned her as a follower of Degas.[7] Tying Cassatt to the familial identity as primary or subordinating her to a prominent male artist falls in line with gender stereotypes. By contrast, focusing on Cassatt's transatlantic network casts and examines her as an agent within her social context. More broadly, it recognizes her as an agent within the transatlantic framework of the late nineteenth and early twentieth centuries, and moreover as one who played a crucial role in the development of the United States' culture and of its museums.

Cassatt's transatlantic network included diverse American men and women—collectors, leading businessmen and their wives, heiresses, artists, dealers, museum directors, curators, and critics. Prominent among her closest friends were several professional women, including an artist, an architect, and a curator, some of them suffragists. Many of her American friends came to Paris on annual trips, and some lived

there for a few months or years. Cassatt's network was the key social structure that enabled her to carry out her extensive work with Americans on collecting artworks by Manet, Courbet, the Impressionists, and some old masters. Her goal was to help create American collections of some of the best European art, with the idea that it would later be given to American museums. Cassatt had a powerful ability to inspire people through her belief in the ultimate value of art and her own dedication to making it, as well as her passion and aptitude for educating others about it. She worked tirelessly to spread knowledge about modern art among artists, and mentored and advised American collectors. Her ultimate goal for the art she believed in was to make it accessible to the general American public, and to American artists, through museums. This was her mission, and she carried it out through her transatlantic network.

Cassatt's network was also the backbone of her social life as an independent woman who never married, and as an artist. Her social and professional lives were thoroughly intertwined. Cassatt's American upper-class status enabled her to develop her network based on friendships that included men and women of America's wealthy elite, as well as artists.[8] Cassatt usually mixed professional activities, such as going to art galleries and museums with friends who were collectors or artists, with socializing. She entertained her friends in her Paris apartment and at her country residence, and often invited her American friends to stay in her country home overnight or for several days. She toured the French countryside with them, took daylong excursions outside of Paris, and sometimes traveled with them abroad, usually with groups of friends. Cassatt's network of Americans intersected with her French and Paris-based colleagues and friends, including Cassatt's dealers, the Durand-Ruels (the father, Paul, and his sons Joseph and Georges); Ambroise Vollard; and her friend the Armenian Dikran Kelekian, the preeminent dealer of ancient Islamic art and Persian ceramics, who had galleries in Paris, New York, and Cairo. My focus in what follows, however, is on some of Cassatt's most important friendships with Americans—including James J. Stillman, Sarah Choate Sears, Theodate Pope, Sara T. Hallowell, and Forbes Watson—because the personal aspect was more pronounced in these relationships, due at least in part to the shared heritage, and because they underscore the transatlantic scope of Cassatt's network. Cassatt's most important friendship, with Louisine Havemeyer, is the topic of the next chapter.

Cassatt's network changed over different phases of her life, but Americans played a consistently major role within it, from her youth to her old age. During the early years of traveling in Europe to study art, she teamed up with young American female art students.[9] When she settled in Paris as a young professional, Cassatt developed a new network that included French artists, but she continued to associate with young American artists as well. Cassatt used her home as a social gathering place for American men and women artists.[10] In 1876, for example, Cassatt's friend May Alcott Nieriker (sister of Louisa May Alcott, whose novel *Little Women* was first published in 1868–69) reported on a tea party at Cassatt's home, where she noted meeting "various New York

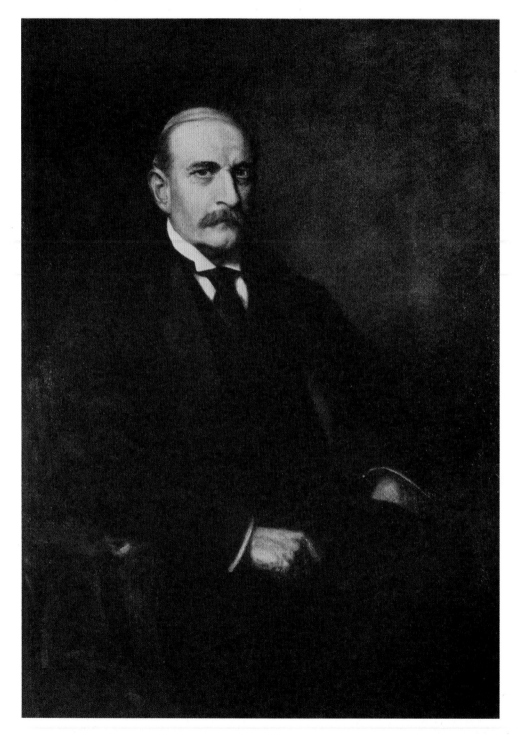

Unknown photographer, *James Stillman,* from Anna Burr, *Portrait of a Banker,* 1927. General Research Division, The New York Public Library.

friends."[11] When Cassatt was a young woman in her early days in Paris, her American women friends, most of whom were themselves art students or artists, also provided her with companionship and helped her overcome nineteenth-century constraints on the freedom of young middle-class women to be alone in public spaces. She went with them to galleries, museums, and the theater and on excursions outside of Paris.[12] No less importantly, Cassatt's social network of American women provided her with encouragement and affirmation for her art. When in 1877 the Salon rejected Cassatt's painting (after previously accepting paintings by her five times), May Alcott Nieriker observed that Cassatt's work "is exceedingly strong and fine, but perhaps it's too original a style for these fogies to appreciate."[13]

THE LATER YEARS

JAMES J. STILLMAN

Cassatt's friendship with the leading American banker James J. Stillman was one of the most important in her life. She was in her early sixties when she met him in Paris in 1906, and their friendship lasted until Stillman returned to the United States in 1917, the year before he died.[14] Stillman was one of the wealthiest financiers in the United States; at the time of his death, he left an estate of about $45 million (the equivalent of nearly $1 billion in 2021) (fig. 1.1).[15] He was one of the "big three" giants of Wall Street, "who had acquired predominant power over banks, transportation systems, producing and trading corporations, huge public utilities, etc."[16] Under his leadership as the president of the National City Bank (today Citigroup) from 1891 to 1909, and thereafter chairman of its board of directors, the bank became the largest in the United States, a leader in foreign exchange, and the first to open foreign branches.[17] In 1909, after several lengthy stays in Paris, Stillman moved there permanently. He did not retire but worked remotely by exchanging weekly letters and coded daily cables, supplemented by occasional visits to the United States and meetings with special envoys who traveled to Paris to relay messages to him.[18] Consumed by business and work throughout most of his life, Stillman insisted on his deathbed that "it was not money, but power" for which he had "played The Game."[19]

As part of Cassatt's and Stillman's close association, they visited museums, gallery exhibitions, and private collections together, and she helped him collect art. Stillman and Cassatt entertained each other in their respective homes, along with others in their social networks. They also enjoyed touring France by car ("motoring," as it was referred to when the automobile was a new invention), and on a few occasions traveled abroad together, with other friends or staff members. Stillman and Cassatt introduced each other to their friends and family members. Cassatt met many wealthy and powerful Americans through Stillman, including the Vanderbilts and the Rockefellers.[20] Stillman had a vast network of American acquaintances, which he cultivated for years, as was typical for businessmen.[21] He had entertained lavishly in his home in New York

City and his rented summer home in Newport, and after 1906 in his Paris mansion (located on the rue Rembrandt, overlooking the Parc Monceau), where his art collection was displayed.[22] Cassatt and Stillman usually included each other when they entertained mutual friends. In October 1910, for example, Cassatt invited Stillman and his two sisters, along with Sarah Choate Sears and her daughter, Helen (discussed below), to her country residence, where she served them an American lemon dessert sent to her from the United States by their mutual friend Louisine Havemeyer.[23] Entertaining friends sometimes included combining an excursion, dinner, and the theater. For example, in April 1910 Cassatt and Narcissa Cox Vanderlip left Stillman and Narcissa's husband, Frank A. Vanderlip (Stillman's successor at the New York bank), in the South of France and traveled to Versailles. Cassatt then invited Mrs. Vanderlip to a dinner in Paris, after which they saw Sarah Bernhardt performing in *La Dame aux Camélias*.[24] Cassatt must have greatly enjoyed the company of the thirty-year-old Mrs. Vanderlip, who had attended the University of Chicago before marrying Frank Vanderlip, a leading financier and close friend of Stillman, and became a leading New York suffrage activist.[25]

Meeting Stillman was also an opportunity for Cassatt to mentor one of the wealthiest Americans in collecting the kind of art she believed in, motivated by her vision that it would later be given to American museums. As Stillman's daughter-in-law, Mildred Whitney Stillman, observed, "Miss Cassatt's enthusiasm for the pictures she understood and created was a great stimulus and laid the foundation for the friendship."[26] Cassatt provided Stillman with an entrée into the Parisian art world. Her tutelage helped Stillman lose "that timidity he had formerly experienced in the art galleries."[27] Several months after she first met Stillman, Cassatt was happy with his progress, writing to Havemeyer: "I do like the way he is learning, and is subordinating his taste for the agreeable to the quality of Art[;] he learnt that in your house."[28] Cassatt was successful in influencing Stillman to abandon sentimental artworks, such as those by Jean-Baptiste Greuze, and instead to buy art by old masters that she considered worthwhile, including Titian, Rembrandt, Murillo, and Moroni.[29] Cassatt introduced Stillman to the art dealers she knew—Durand-Ruel and Wildenstein,[30] René Avogli-Trotti, and Kelekian, among others.

Despite her best efforts, Cassatt did not succeed in turning Stillman into a collector of art by Degas or most other Impressionist artists.[31] She wrote to Havemeyer: "Mr. Stillman has the greatest contempt for Modern Art as represented by the Impressionists, falsely so called, but he does not understand or do them justice."[32] He did purchase a few Courbet paintings at Cassatt's suggestion and also owned one Morisot, as did Cassatt.[33] The one Impressionist painter that Stillman greatly admired and collected in depth was Cassatt herself. He collected her artworks on his own initiative, as Cassatt never pushed her friends or the collectors she advised to acquire her works, possessing a certain modesty when it came to her own art. Over the years, Stillman acquired twenty-four paintings and pastels by Cassatt, and thus became the biggest

collector of her work. By comparison, the much more extensive art collection of Cassatt's closest friend, Havemeyer, included seventeen Cassatt works.[34] Such was Stillman's enthusiasm about Cassatt's art that in 1913 he optimistically predicted, "In ten years her paintings will sell for as much as his [Degas's]."[35] Although Cassatt may have been flattered, she did not share his belief and reportedly responded with "shrieks."[36] Stillman's great support of Cassatt's art also led him to buy numerous copies of Achille Segard's 1913 biography of Cassatt, which was the first book dedicated to her.[37]

For both Cassatt and Stillman, the friendship they shared was unlike any other in their lives. For Cassatt, this was a rare meaningful personal relationship with a powerful American man from her social orbit, someone who moved in similar circles and knew some of her closest friends. Aside from admiring Cassatt's art, Stillman cared about her personally, and this clearly moved her. To Havemeyer, she wrote: "He is very nice to me. I feel really touched by his liking my pictures & me so much";[38] and to Stillman himself: "You brought something to my life I had not before."[39] When Stillman returned from a trip, Cassatt wrote to him, "I have missed you dreadfully, I will be ready for a drive at three, and perhaps we may see the Ingres exhibition."[40] For his part, Stillman did indeed often visit Cassatt as soon as he returned from various trips—writing, for example, that "of course on arriving in Grasse I immediately called on Miss Cassatt and found her in fine feather."[41] When Cassatt was in Constantinople, she wrote to Stillman: "I often think of you with very affectionate regards and hope you will find that happiness you wish for, it must of course exist, but the nearest I can imagine to it is peace in one's inward life."[42]

Cassatt and Stillman had the kind of emotional bond that at times relieved the loneliness that afflicted them both. At the time he met Cassatt, Stillman had been separated from his wife for a dozen years. Cassatt, who repeatedly mentioned Stillman's loneliness in letters to Havemeyer, must have identified with him when she wrote: "How lonely one can be in this world!"[43] She did not see herself as filling this void in his life, however, and had expressed her hope that his two unmarried sisters, Clara and Bessie, would. But the sisters, who came for long visits to France, were "wrapped up in each other . . . there is no room for outsiders."[44] Cassatt liked Stillman's sisters very much, included them in her socializing with their brother, and kept in touch with them through correspondence.[45] This was typical of Cassatt's close friendships, which often expanded to include friendships with family members of her primary friends.

Cassatt and Stillman were protective of one another and showed real concern for each other's health and emotional well-being. Stillman was "kindness itself" when Cassatt suffered greatly after the untimely death of her younger brother, Gardner, in 1911.[46] At the time, she experienced what today would be described as a nervous breakdown.[47] For a lengthy period, she was unable to paint and had to devote herself entirely to her healing. Stillman took it upon himself to help her recover: "He is now engaged in curing me & I only hope he succeeds."[48] One of Stillman's remedies for Cassatt was

silence. Typically a fierce talker, Cassatt reported that keeping silent did indeed help her to conserve her energy: "Mr. Stillman has been impressing upon me the absolute necessity of quiet. No more talking, we sat in his auto for hours at a time without opening our lips, he thinks if only I won't exert myself I will come out all right."[49]

The motoring, a passion Stillman and Cassatt shared, was itself another remedy. Cassatt wrote to Havemeyer in 1912 about its beneficial effects: "Yesterday we made the most wonderful excursion . . . we had the two cars and crossed the mountains in very risky places, I slept well after that."[50] Owning an automobile was still reserved for the wealthy, whose driving in the countryside, chauffeured by their drivers, was a new form of leisure. Cassatt and Stillman, who each had their own automobile and chauffeur, tended to travel together on long trips in their separate vehicles—Cassatt with her housekeeper, Mathilde Valet, and her driver, Armand Delaporte; Stillman with the couple who served as his secretaries in Europe. The two parties met up at various points along the route. Cassatt wrote to Havemeyer:

> I go to Tours[,] Bordeaux[,] Biarritz & then across to Cannes. Mr. Stillman goes with his secretary and the latter[']s wife the same route, we will meet constantly "en route." He seems very pleased with the plans & of course I am, but I won't allow him to have me on his mind, this route is new to him & no doubt we will see many fine things.[51]

The context in which Cassatt makes the comment "I won't allow him to have me on his mind"—in 1911, the year of her breakdown—suggests that she wanted to spare Stillman from worrying about her so that he could enjoy the touring, rather than, as has been intimated, indicating an attempt by Cassatt to squash a romantic interest on his part.[52]

In 1913, after visiting Cassatt in the South of France, where she had been recovering, and after learning about her determination to return to Paris and paint, Stillman was again solicitous of her well-being. He wrote: "If she plunges in her excitable way into her old life, I fear she will be made to realize that she has had a long illness and is not as young as she once was—but no human being can tell her that, not even Mathilde."[53]

Cassatt, in turn, was often concerned about Stillman's gloomy mood and advised him to go down south to the sunshine. She suggested to him that the "realm of art is also consoling and gives one serenity. One must distract one's mind from worrying and place one's interest elsewhere," adding, "I cannot bear to think of you worried and depressed and alone over here."[54] Cassatt feared that Stillman's weighty business responsibilities were affecting his health. In 1909, when he went on a business trip to New York, she wrote: "I was afraid you would allow yourself once more to be drawn into the vortex. The dullness over here is safer."[55] When in 1913 Stillman's sisters wanted him to return to the United States for the funeral of his friend J. P. Morgan, the leading American financier and art collector, Cassatt was exasperated: "[H]is sisters want him to go home! They don't understand and don't want to understand, if he gets

into the whirlpool he won't come out alive. . . . I felt quite sad for him, & urged him not to go."[56] She was right. Stillman, who was suffering from heart ailments, returned to the United States in 1917 to resume the post of president of the bank, and died the following year.

Cassatt and Stillman's friendship spanned her sixties and seventies, and his fifties and sixties (he was five years her junior). In this phase of their lives, they enjoyed each other's companionship, their emotional intimacy, socializing, and seeing and discussing art and politics. They were also set in their ways, which included keeping their separate households and their staffs. Such a friendship between a highly accomplished woman and a powerful man, which was not based on romance and did not lead to marriage, had no available model through which it could be understood at the time. This was likely the reason for the belief, expressed by Cassatt's niece, that Stillman would have liked to marry Cassatt.[57] But Stillman's choices suggest otherwise. Although he never saw his wife again after their separation, Stillman never formally divorced her, which precluded the possibility of his remarriage. Given that he was just as fanatic about having his household run precisely according to his orders as he was about controlling his bank, his not having obtained a divorce suggests that he did not wish to remarry. Nor would Cassatt have been interested in marrying.[58] She had long before decided to dedicate herself to her art, and by the time she met Stillman, late in her life, she was entirely set in her lifestyle of independence.

Cassatt was apparently unaware of Stillman's reputation as something of a despot both at home and at work.[59] She would likely have been shocked had she known how he had treated Sarah Elizabeth Rumrill, his wife of twenty-three years and the mother of their five children. In 1894 Stillman made a unilateral decision to separate from his wife, and carried it out in a most brutal way.[60] He first removed her from being in charge of the household and turned these duties over to the housekeeper, who obeyed his orders, and then forced her into exile outside the United States, forbidding her to have any contact with him or their children.[61] After her departure, Stillman benefited from the entirely false rumors that she was addicted to drugs and mentally unstable.[62] Rumrill had to wait until Stillman's death, twenty-four years later, before she could return to her home country and see her children.[63] Cassatt knew only Stillman's narrative, in which his wife was vilified and he was cast as flawless, and she accepted it as true. Cassatt thus idealized Stillman's role as a father, although in reality his relationship with his children was limited to the point that they felt they never knew him.[64] She wrote to Havemeyer: "Don't you think he deserves much credit for bringing his children up as he did without a Mother's help & making respectable young men and women of them? When I think of my poor brother Aleck's brood, I can't but admire the man who can dominate a situation."[65]

The fact that Cassatt felt especially comfortable with Stillman is confirmed by the fact that she allowed him to photograph her, despite usually refusing adamantly to be photographed. Stillman habitually photographed his friends and family and sent them

the photos. In late 1910, for example, he photographed Cassatt on a trip to Versailles with a few friends. When she received the photograph, she wrote him that she had "spoiled" it by "my absurd stiffness, I am always so afraid of moving I stand like a Ramrod—I wish sometime you would take a photograph of me, when I promise to be more natural."[66] Cassatt also agreed to paint Stillman's portrait even though she rarely portrayed men outside of her family.[67] In early 1911, she wrote to Havemeyer from her trip to Egypt with her brother Gardner and his family that she was "glad Mr. Stillman will pose for me."[68] In the end, she was not able to do the portrait because she was devastated by Gardner's death while on that trip.

Although they had much in common, Cassatt and Stillman also had many differences. Cassatt was "as communicative as her friend was the reverse."[69] Making this observation, Stillman's daughter-in-law was alluding to Cassatt's energetic conversing and Stillman's notoriously long silences. She noted that at times Cassatt found his "tranquility and steadfastness decidedly soothing,"[70] but sometimes she lost patience with him and even refused to see him. Stillman ingratiated himself by sending precious gifts—for example, "pet dog collars and feeding bowls from Tiffany's."[71] Another important difference between them was that Cassatt's greatest passion was Art (she always capitalized the word), whereas Stillman's was business. She wrote to Havemeyer: "I was with the Stillmans at Brussels but Mr. S had an exciting cable about a loan to China & left us early on Friday morning, very much happier. Of course that is life & excitement to them. Men like him I mean. Art isn't but a pastime."[72] Stillman also had a passion for elite feminine fashion, to the point that he dedicated one of the rooms in his mansion to the display of fashions sent over by the best Paris designers along with their models.[73] He selected dresses, gowns, and accessories for his daughters, daughters-in-law, and their girls and sent them across the Atlantic. Although Cassatt had an elegant, fashionable appearance, as seen in the photograph of her taken during the period in which she knew Stillman (fig. 5.3), fashion was not a special passion for her. Stillman, who in 1910 took Cassatt to visit the house of Paul Poiret, the rising designer at the time, was likely disappointed with her unenthusiastic response: "It is anarchy in clothes."[74]

Stillman and Cassatt were also at odds on some issues of politics. In general, Cassatt was happy for the opportunity to discuss political matters with a fellow American who, like her, was interested in politics. For example, following the Roosevelt elections, she wrote to Havemeyer: "One would like to talk it over with someone, I have done so with Mr. S[tillman]."[75] But they did not always see eye to eye. On the issue of suffrage, Cassatt astutely observed that Stillman's ties with some of his best male friends, including Myron Herrick (who was then the US ambassador to France), were strengthened by their shared anti-suffrage sentiments. She noted: "Mr. Stillman and his good friend Mr. Herrick are both such anti-suffragettes, that is one of their bonds."[76] When Cassatt wanted to discuss the topic of suffrage with Stillman, he sometimes skillfully changed the subject. He described such an incident to his sister

Clara in 1913. Visiting Cassatt in her rented villa in Grasse, in the South of France, he found that she was

> naturally more interested than ever in discussing everyone and woman suffrage in particular. I was able to change the subject by telling her, as I had previously written, of how the Wildensteins in taking me into their private apartments, for the first time, to show me a remarkable Italian painting, was the means of my seeing a pastel of Miss Cassatt's on the wall. . . . They kept talking of Miss Cassatt's talent, and repeated several times she is a grand maître.[77]

But at other times, Stillman did make comments to Cassatt that reflected his anti-suffrage viewpoint, claiming, for example, that "husbands force the women to vote in the Los Angeles elections!" This statement led Cassatt to declare: "He isn't a suffragette."[78] Irritated by his comments, Cassatt wrote to Havemeyer, who was a suffragist, "Mr. S[tillman] says women don't vote" (referring to those who could), and she noted: "He has a curious faculty of taking it out of one."[79] Naturally, Cassatt was thrilled when one of Stillman's sisters sent her a suffrage almanac in 1913[80] and added the comment "women must fight in the body against war."[81] She did not miss the opportunity to taunt Stillman, writing to Havemeyer: "I was pleased, I want to show it [the suffrage almanac] to Mr. Stillman, and see what he says to his sisters sending it."[82] Eventually, Stillman changed his view, after being persuaded by the Vanderlips, who belonged to his elite social circle. Frank Vanderlip, his close friend and business associate, was an active supporter of suffrage, a cause to which his wife, Narcissa Cox Vanderlip, was dedicated.[83] Cassatt reported to Havemeyer in 1915 that "Stillman has come around to suffrage."[84]

Stillman believed that a man's friends are his business associates, a view that was reflected in his life. Cassatt was his only female friend and the only person in his social circle who was an unmarried independent woman, a professional, and a suffragist. In many ways, he seems to have treated her like a female version of his male friends, with respect and a deep appreciation of their friendship. This contrasted not only with Stillman's treatment of his wife but also with his usual contempt for women, as evidenced, for instance, in his belief that one should never consult women but rather tell them what to do.[85] Cassatt never conformed herself to feminine norms, including the view that women should hold back from freely expressing strong opinions. Undaunted by Stillman's power, she took a position of authority in the area of collecting and spoke to him with uncompromising conviction. When attempting to influence Stillman to buy a particular artwork, she could be quite tough. The art dealer René Gimpel reported: "Mary Cassatt bullies Stillman, and that's how she made a collector out of him. In front of the Velasquez she told him, 'Buy this picture. It's shameful to be rich like you. Such a purchase will redeem you.'"[86] Stillman reportedly smiled and did not seem to object.[87]

As Americans in Paris, Cassatt and Stillman felt a special connection because of their shared heritage and ongoing connections with their homeland. Although they lived in Paris, the United States was where their families and most of their close friends resided. It was where Stillman's business—his lifelong passion—was based. It was where Cassatt wished to receive her fellow Americans' appreciation for her art, and it was the homeland to whose cultural life she was committed by sending European art across the Atlantic.

SARAH CHOATE SEARS

One of Cassatt's most important American friends during her mature years was the Bostonian Sarah Choate Sears—an artist, a photographer, a collector, a patron, and a philanthropist. Cassatt's and Sears's extensive networks included some common friends who were among the wealthiest elite of the United States, including Havemeyer, Stillman, and the Vanderlips. Cassatt initially met Sears on her 1898 visit to Boston through her artist friend Rose Lamb, who was a member of the Boston elite.[88] But her friendship with Sears began in 1906, after Sears was widowed and spent extensive time in Paris. Like other wealthy Americans, Sears usually made an annual crossing to spend several weeks or more in Paris and to travel in Europe, enabling Cassatt and Sears to see each other fairly regularly.[89] Sears traveled with her daughter, Helen, until 1913, when Helen married. Cassatt's letters to Havemeyer often mention Sears, and sometimes her daughter, providing a glimpse of certain aspects of their relationship. Cassatt's friendship with Sears, which spanned the period from 1906 to the end of Cassatt's life, was grounded in their common background as elite American women and in their common interests, especially the making and collecting of art.

In 1877 Sarah Choate, the nineteen-year-old daughter of one of Boston's wealthy upper-class families, married the twenty-three-year-old J. Montgomery Sears, who had just graduated from Yale University. He was "one of the first men of all New England in culture and in wealth," according to the *Boston Daily Globe,* and "the largest individual holder of real estate in Boston."[90] Their home became "the scene of brilliant gatherings," featuring music performances by leading composers and performers.[91] Although her class and marriage could have destined Sarah Choate Sears to a life as a socialite, wife, and mother, she succeeded in becoming also an artist, a collector, and a patron. Sears pushed beyond the dictate of her elite social circles that women's art making was acceptable as long as they remained amateurs.[92] She studied art in Boston, where she displayed her watercolors for the first time in 1884,[93] and in subsequent years frequently exhibited her art, won numerous prizes, received art reviews, and was a member of several art and photography organizations. In some of the organizations she joined, she not only exhibited but also was active—for example, as a jury member.[94] She worked in photography from 1890 to at least 1905, converting the entire top floor of her Boston house into a professional studio. She produced numerous photographic portraits of friends and acquaintances, including the painter John Singer Sargent, the art connoisseur Bernard Berenson, leading music performers and composers, and various women

FIGURE 1.2
Sarah Choate Sears, *Helen Sears,* 1895. Photograph,
platinum print, 9 × 7.4 in. (22.8 × 18.7 cm). The
Getty Museum, Los Angeles, CA. 84.XP.164.21.

of achievement, among them the feminist reformer Julia Ward Howe.[95] Sears also took numerous photographs of her daughter, Helen (fig. 1.2). She never photographed Cassatt, probably because during the period she spent in Paris, her focus had shifted away from photography to collecting. Cassatt, who liked Sears's daughter, Helen, immensely, did a pastel portrait of her in 1907 and dedicated it to her (fig. 1.3). She depicted the eighteen-year-old American woman as highly fashionable, in part by rendering her decorated hat so prominently that it almost overshadows her face. Yet Helen's serious expression represents her as anything but frivolous.

Unlike Cassatt, whose main interest was fine art by the old masters and French modern artists, Sears was also interested in photography as an aesthetic medium long before museums accepted it as art.[96] Sears's photographic work was inspired by modernist photography. A recent study of her photography inserts her into the history of American photography and acknowledges her contribution "to the rise of Modernism, and to the recognition of photography as a fine art."[97] It identifies Sears's photographs of lilies as having "opened the doors for subsequent artists such as Charles Demuth and Georgia O'Keeffe" (fig. 1.4).[98] Sears's photographs were widely exhibited, including in Boston, Philadelphia, Chicago, San Francisco, and New York, as well as in Vienna, Berlin, Hamburg, Paris, London, and the Hague.[99] Her photographic practice brought her into contact with numerous contemporary photographers, among them the Bostonian Holland Day, whose homoerotic photographs included male nudes; Frances Benjamin Johnston, Washington, DC's well-connected, prominent press photographer and quintessential "new woman"; and Gertrude Käsebier, whom Alfred Stieglitz recognized as "the leading artistic portrait photographer of the day."[100] Sears

FIGURE 1.3

Mary Cassatt, *Portrait of Helen Sears, Daughter of Sarah Choate Sears,* 1907. Pastel on paper, 26.8 × 22.4 in. (67.9 × 56.5 cm). Courtesy Norton Museum of Art, West Palm Beach, Florida. Gift of Elsie and Marvin Dekelboum, 2005.52.

knew Stieglitz and became a member of his Photo-Secession. He acquired two of Sears's works and published them in *Camera Work.* She also provided some financial support for Stieglitz, as well as for some American artists and art-related causes.[101] Sears's network in the world of modernist photography extended into territory that reached beyond Cassatt's network of artists, collectors, and dealers of paintings.

FIGURE 1.4
Sarah Choate Sears, *Untitled (Lilies)*, ca. 1892–1905.
Photograph, platinum print, 9.2 × 7.4 in. (23.3 ×
18.9 cm). Harvard Art Museums/Fogg Museum.
Gift of Montgomery S. Bradley and Cameron
Bradley. Photo courtesy of President and Fellows
of Harvard College. P1984.30.

Despite these differences, Cassatt and Sears had much in common. Both were artists who were seriously engaged in art collecting and moved in some of the same elite American circles. Each had a diverse network of friends and professional contacts. Their closeness grew after each of them suffered devastating losses—Cassatt with the untimely death of her older brother, Alexander, in 1906, and a few years later of her younger brother, Gardner, and Sears with the death of her husband, in 1905, followed by the death of her twenty-five-year-old son in 1908. This deepened their emotional bond and stimulated their involvement in spiritualism, particularly séances, in which they sought comfort by communicating through mediums with their deceased beloveds. Cassatt often attended Sears's séances, which were held every other week in her Paris apartment, just a few blocks away from Cassatt's. Conducted by a well-known medium, Mme. de Thèbes, these sessions were attended by notable figures, including, among others, the American philosopher and psychologist William James. For both Sears and Cassatt, this activity formed part of a broader spiritual outlook. As Cassatt wrote, "We are on this planet to learn. I think it very stimulating to believe that here is only one step in our progress."[102]

Sears's collection included close to two hundred paintings and works on paper.[103] She greatly admired Cassatt's art and acquired quite a few of her works.[104] Sears benefited from Cassatt's advice and art world connections, especially during her prolonged times in Paris, between 1905 and 1907 and again for several months in 1908.[105] Cassatt's correspondence with Havemeyer shows that Cassatt and Sears were engaged in an ongoing conversation about collecting. For example, Cassatt told Havemeyer of Sears's deliberations about which artwork to acquire at an upcoming sale of the

collection of Henri Rouart, the major collector, artist, industrialist, and longtime friend of Degas.[106] Cassatt was even privy to such details as the sum that Sears was offered by a dealer for a Cézanne still life in her collection.[107]

Despite Sears and Cassatt's communications on collecting the work of modern French artists, Cassatt's role in Sears's collecting was limited. Sears followed Cassatt's taste only up to a point. She did so in her acquisitions of an artwork by Courbet, several by Manet, and five by Degas. Cassatt would also have approved of Sears's acquisition of the work of other French artists, including Morisot, Jean-Baptiste-Camille Corot, Jean-Auguste Dominique Ingres, and Charles-François Daubigny. And she was doubtless supportive of Sears's acquiring ancient Persian pottery from her friend Dikran Kelekian, who worked with the Havemeyers and other leading American collectors. But Sears also charted an independent course as an art collector. In 1910, when young artists admired Cézanne, Sears bought a still life by him from Cassatt, who had acquired it in 1894 but changed her mind about the artist. Fourteen years younger than Cassatt, Sears moved in artistic circles in early twentieth-century Paris and New York that were entirely outside of Cassatt's orbit. In Paris she frequented the salon of Gertrude Stein and her brother Leo, and in 1908 she took Cassatt there, though she realized this was a risky move. Cassatt felt intensely uncomfortable at this gathering, which, unlike her usual circle, was not dominated by elite American collectors but consisted of a diverse international group. Cassatt distrusted the Steins as collectors and attributed to them unflattering motivations that smacked of anti-Semitic prejudice, and which she indeed believed stemmed from their Jewish descent.[108] She described her experience at the Stein salon thus: "I have never in my life seen so many dreadful paintings in one place; I have never seen so many dreadful people gathered together, and I want to be taken home at once."[109] Sears also collected works by artists that Cassatt disapproved of, including Sargent, who was Sears's personal friend and who painted portraits of her and her daughter (fig. 1.5). Moreover, Sears collected the work of Pierre Matisse, as well as that of Marie Laurencin (who was in the Apollinaire/Picasso circle), both of whom belonged to a younger generation of artists whose work Cassatt detested.[110]

Unlike Cassatt, Sears also collected the work of some young American artists. Living in the United States and practicing art there, Sears was connected to a younger generation of American artists, whereas Cassatt, who was of an older generation and lived across the Atlantic, was distanced both geographically and mentally from the scene of young American artists that emerged during the early twentieth century. Sears was one of a small group of Americans who began collecting the art of American modernists as early as 1915 and perhaps earlier.[111] Notably, she was a lender to the legendary 1913 Armory Show, sending one of her two Cézanne paintings to the exhibit.[112] Among the American modernists she collected were artists who were exhibited in the Armory Show or in Stieglitz's 291 gallery, including Maurice Prendergast, Arthur Davies, Charles Demuth, John Marin, and Alfred Maurer.[113] Though she is not often recognized as such, Sears was "one of the earliest supporters of American modernism."[114]

The generational difference between Cassatt and the more liberal Sears was also evident in their different responses to the "irregular union" (in Cassatt's words) of Sears's godson, Royall Tyler.[115] An art historian and connoisseur of Byzantine art, as well as an author and a diplomat, Tyler fell in love with Elisina Palamidessi de Castelvecchio, the wife of his publisher, Grant Richards. She was the great-great-granddaughter of Napoleon's brother, Louis, and in 1909 she cofounded and edited *The Englishwoman*, a feminist monthly journal. The couple had a son in October 1910 and married four years later, after her divorce was finalized.[116] Cassatt discontinued all contact with Royall and Elisina and wrote to Havemeyer: "I think perhaps Mrs. Sears thought I ought not to drop him & her, do you think I am under any obligation to support them in such a course?"[117]

Cassatt was critical of Sears on various counts. For example, she asserted that "Mrs. Sears seeks constant pleasure and excitement."[118] Cassatt also disapproved of rivalry

between collectors as a motivation for collecting and criticized Sears for such competitiveness, writing in a letter to Havemeyer: "Mrs. Sears wants to buy a thirteenth-century virgin at K[elekian]'s, but I doubt that she will. Her *real* reason is that she alone in Boston will have such a statue, & then what a heartburn for Mrs. [Isabella Stewart] Gardner. You don't get things for such a reason."[119] Despite possible rivalries between Sears and Gardner, Cassatt reported to Havemeyer that they "were both in Paris" and "going about seeing collections."[120] Cassatt herself, however, who was entirely identified with the Havemeyers' collection, was deeply offended by Sears when she stated that Mrs. Gardner's collection was a better place to see art than the Havemeyers' collection. For several months afterward, Cassatt saw very little of Sears;[121] but then she moved past it, and Sears came to her country residence for a few days.[122]

In 1920 Cassatt was again eagerly awaiting a visit by Sears after Americans resumed their travel following the end of World War I, writing to Havemeyer: "I shall see Mrs. Sears with her I have so much in common."[123] Sears was in all probability supportive of suffrage, otherwise Cassatt would likely have noted her lack of support as objectionable in one of her letters to Havemeyer, as she did in the case of other mutual friends, like Stillman. Moreover, Sears lent six artworks to the 1915 Cassatt and Degas exhibition organized by Havemeyer in support of women's suffrage, suggesting that she agreed to be identified with this cause. This was in contrast to several other American collectors who refused to lend works to the exhibition because of their objection to suffrage.[124] Sears herself experienced the gender inequality in the art world, and we know about at least one instance in which she took action to remedy this condition. She joined other female officers of Boston's Society of Arts and Crafts (of which she was one of the founders) in a successful campaign to mandate that at least one woman participate in the society's jury meetings, counteracting the gender bias that excluded women from passing judgment on artworks, especially those made by men.[125] Following this change, Sears served on the society's first Jury of Standards in 1897.[126] Finally, Sears's support of women's equality is also suggested by her friendship with Howe, the Bostonian feminist activist, editor, and author, who worked for women's equality from 1869 to the end of her life.[127] Sears took Howe's photographic portrait.

Of special note is the fact that Cassatt and Sears had a strong intellectual connection. Sears, who was herself recognized for her "rare intellectual force,"[128] wrote that Cassatt's "mentality was so far above average that I look back on many years of our friendship as one remembers a luminous star—for I know nothing like it will ever come into my life again."[129] Alongside Cassatt's closest friendship, with Havemeyer, her friendship with Sears was deeply meaningful both personally and professionally, and played a major role in her transatlantic network.

THEODATE POPE

Cassatt's cross-generational friendship with the American Theodate Pope, who was twenty-three years her junior, was unique for her (fig. 1.6). She met Pope through her

FIGURE 1.6

Unknown photographer, *Theodate Pope,* ca. 1915. Mounted photograph, 7 × 5 in. (17.8 × 12.7 cm). Archives, Hill-Stead Museum, Farmington, CT.

connections with American collectors of Impressionism—Pope was the daughter of the industrialist Alfred A. Pope, who was one of the early American collectors of Impressionist art.[130] Cassatt met Alfred, his wife, Ada, and daughter, Theodate, in the 1890s,[131] and later on corresponded with Ada and Theodate. Her independent friendship with Theodate Pope developed during the latter's visits to Cassatt in France in the early twentieth century. Cassatt found Pope to be a courageous young woman, who, although idiosyncratic, in some ways also represented the next generation of modern women who chose to lead their lives as they wished. Cassatt developed a real closeness with Pope, based largely on their strong mutual interest in the spiritual dimensions of human experience. The brief discussions of Cassatt and Theodate Pope in the Cassatt literature thus far have foregrounded Pope's rejection of private art collecting and their mutual interest in spiritual séances.[132] As we will see, however, the foundation of their friendship was broader than this and included their choice to become professional women, their shared passion for their chosen fields (art and architecture, respectively), their common deep interest in education, and their support of suffrage, as well as their spiritual outlook. Pope may have reminded Cassatt of her own young self, since Pope, too, like Cassatt before her, rejected the normative path to marriage and motherhood and believed "women should be *someone*," in Cassatt's words.[133] (Pope did eventually marry, at age forty-nine; when she informed Cassatt of her engagement, to John Wallace Riddle, an American diplomat, Cassatt congratulated her but added: "The news came as a great surprise as you had planned your life so apparently definitely.")[134] In her diary, the twenty-two-year-old Pope wrote that she was "born with a desire to *do* and *be* some thing in *particular*."[135] Pope went on to become an architect, designing and building private homes, schools, and a monument. She was one of the first successful American women architects.[136] Her passion for architecture was as much the center of her life as the passion for art was for Cassatt. Pope also broke with convention by taking three orphans as her wards, the first of them while she was single.[137]

Like many of Cassatt's American friends, Pope was from a privileged upper-class American family (although her inherited wealth was much greater than Cassatt's). The two women had common friends from among the wealthiest American circles, including the Whittemores, the Havemeyers, and the Vanderbilts. Yet Pope, like Cassatt, was averse to leading the life of a socialite. The nineteen-year-old Pope wrote in her diary that "[s]ociety looks so thin to me" and that to be "agreeable . . . I must talk sweet nothings"; when ingratiating herself, she felt that "I have not been true to myself or my friends."[138] Cassatt similarly regarded "society" as a waste of time and was selective in whom she chose to see, "resisting meeting with princes and princesses with nonchalance."[139] Cassatt felt comfortable with Pope also because, like herself, she spoke her mind freely, rejecting the conservative dictate that women had to be acquiescent and charming. Like Cassatt, Pope was critical, forthright, and intellectually engaged. She did not hesitate to assert her controversial critical views not only in private but also in public. In 1932, at a conference on architecture held at the Museum of Modern

Art (MoMA) in New York (co-organized by Pope's young cousin, the acclaimed architect Philip Johnson), Pope pronounced that modern architecture was a failure because it was cold, sterile, and ignored human needs.[140]

Pope first visited Cassatt in France in 1903, two years after completing her first building—the Pope family's Hill-Stead residence, in Farmington, Connecticut—and then again in 1905. On both occasions, she came with the educator Mary Hillard, who had been her teacher at Miss Porter's School in Farmington (which she had attended from 1886 to 1888) and with whom she was presently engaged in a discreet intimate relationship. Cassatt greatly enjoyed the company of the two young women,[141] corresponding with each after the visit and expressing her hope to spend more time with them.[142] Although she usually resisted being photographed, Cassatt felt comfortable with Pope, responding to her asking if Cassatt would be willing to be photographed: "Certainly I would sit for you."[143] Pope was a talented amateur photographer who photographed her family and close friends. She took two rare photographs of Cassatt in her home environment: one shows her sitting in an armchair in her Paris apartment reading a newspaper (fig. 1.7); the other shows Cassatt seated at the dining table in her country residence having tea with Hillard (fig. 1.8).

Cassatt, who sometimes complained about guests who were women of leisure and could not understand her need to work, felt in her element with Pope and Hillard, both active professional women who, as Cassatt noted approvingly, were "full of plans & working happily."[144] Cassatt believed strongly in the importance of education and regarded Hillard's work in education as "a splendid occupation" that possessed the potential to "influence whole generations."[145] She was undoubtedly enthusiastic about the two women's ambitious plan to create a new school for girls, designed by Pope and headed by Hillard—the Westover School, in Middlebury, Connecticut. In 1905, during their second visit with Cassatt, Pope and Hillard were planning this school.[146] Cassatt appreciated the two young women's collaboration, writing approvingly of their "joint effort," and a year after the school opened, in 1910, she wrote to Pope, "You ought to be happy to have cooperated."[147] It was a school where girls could "find real freedom to become themselves,"[148] as described by a friend of Pope's and Hillard's, an objective that aligned with Cassatt's own preferences and feminist agenda. Her interest in the progressive school was expressed, for instance, in the act of sending Hillard a rare publication that dealt with the topic of "The Influence of Women on the Progress of Knowledge," by the English historian Henry T. Buckle, in order for Hillard to share it with her students.[149] She also recommended that the school library get *The Englishwoman*, a pro-suffrage publication.[150] The reputation of Hillard's school spread quickly among young girls. One of them, a daughter of friends of Cassatt's brother Gardner and his wife, "was wild about the school,"[151] and Cassatt's niece, Eugenia, was also interested in it.[152]

Cassatt addressed the theme of education in some of her artworks, depicting women as sensitive mentors guiding toddlers or children in their various learning

FIGURE 1.7
Theodate Pope, *Mary Cassatt*, 1903–5. Stereographic image, 3.1 × 3.1 in. (7.9 × 7.9 cm). Archives, Hill-Stead Museum, Farmington, CT, no. 288.

efforts (I discuss these depictions in chapter 5). Cassatt believed in the power of education as a catalyst for change.[153] In a letter to Pope, she referred to Elizabeth von Arnim's 1901 novel *The Benefactress* (also discussed in chapter 5), which recounts the failure of a young woman's philanthropic endeavor to open up the small countryside estate she has inherited to middle-class women "who have no money, and who are

FIGURE 1.8
Theodate Pope, *Mary Cassatt and Mary Hillard*, 1903–5. Stereographic image, 3.1 × 3.1 in. (7.9 × 7.9 cm). Archives, Hill-Stead Museum, Farmington, CT, no. 290.

dependent and miserable," believing it would bring them happiness.[154] For Cassatt, the novel demonstrated that "[w]e can do so little for others except for education."[155]

Cassatt appreciated Pope's deep dedication to education, beyond her interest in architecture. Cassatt was almost certainly shown the Westover School for girls during her last visit to the United States, in 1908, when she visited the Popes in Farmington together with their common friend Havemeyer. Pope was recognized by the American philosopher and educational reformer John Dewey as a progressive educator for her creation of another school—the Avon Old Farms School for boys in Avon, Connecticut (opened in 1927).[156] In addition to designing and overseeing the construction of this school, Pope also financed it, conceptualized its educational goals, and oversaw their

implementation. It is not clear to what degree Cassatt knew about this later project, which was recognized as a "bold and far looking experiment" by Harvard's president, Charles W. Eliot, in an article in the *New York Times*.[157] Cassatt would surely have appreciated Pope's goal for Avon Old Farms: to replace the common mission of elite prep schools—turning out "pleasant little gentlemen"[158]—with the intention to "educate boys to become strong decisive and enlightened men who . . . would accept progressive and spiritual ideas—the most important of which was that the souls of all human beings transcend class, gender, race, religion, and nationality."[159]

Suffrage was another area in which Cassatt and Pope saw eye to eye. When Pope visited Cassatt in France in 1903 and 1905, she was not yet a supporter of suffrage, and in 1910 Cassatt urged her, "I do hope you are going to be interested in the suffrage."[160] In another letter, she asserted, "What we ought to fight for is equality."[161] Pope's father, Alfred Pope, was a staunch anti-suffragist, and since Theodate was exceptionally close to him, she felt obliged not to take a pro-suffrage stand as long as he was alive.[162] In 1911 she even appeased him by signing an anti-suffrage petition published in a local newspaper, but she qualified her support with the words "against the suffrage for the ensuing ten years."[163] After her father's death in 1913, Pope became openly pro-suffrage and took several actions in support of the cause, especially in her home state of Connecticut. Among these was hosting an informal reception at Hill-Stead for women suffragists, including Emmeline Pankhurst, the British suffragette whom Cassatt regarded as excessively radical for using violence (chapter 4).[164] During this visit to Connecticut, the charismatic Pankhurst had given a rousing speech in Hartford, "Freedom or Death," to raise funds for her suffrage activities in England. Pope's reaction to Pankhurst's talk was likely not far from that of Havemeyer: the latter wrote to Cassatt about the event, and Cassatt in turn wrote to Pope that Havemeyer "was quite carried away by her [Pankhurst]" and saw her as "the Joan of Arc of the movement."[165] Pope and Pankhurst corresponded over the following two years, and in 1915 Pankhurst visited Pope in London while Pope was recovering from the trauma of surviving the sinking of the British transatlantic ocean liner RMS *Lusitania* by a German navy U-boat during World War I.[166]

Unlike some anti-suffrage art collectors, Pope was willing to support suffrage publicly in 1914 by lending artworks from her deceased father's art collection, at Havemeyer's request, for her exhibit of Cassatt, Degas, and the old masters that was dedicated to the cause of suffrage—though in the end, Theodate deferred to her mother's refusal to lend works out of loyalty to her late husband's strong opposition to suffrage. Pope publicly supported suffrage in both individual and group actions, including traveling to Washington, DC, in 1918 with a Connecticut delegation to convince George P. McLean, at the time a Republican senator (who earlier on had been Pope's suitor and the governor of Connecticut), to support the suffrage amendment.[167] In 1920 she published a letter to the Connecticut governor in the *Hartford Courant,* in which she stated that the world war would result in "the enfranchisement of women

the world over," whereas "our little state of Connecticut hesitates . . . because you refuse to call a special session of the legislature."[168] She ended with the words "You cannot hold back this wagon of progress by holding the spokes of the rear wheels."[169]

An unpublished letter written by Pope in 1915 to Havemeyer, Cassatt's closest friend, reveals that Pope was part of the American pro-suffrage network, and as such knew of plans ahead of time. In the letter, she expresses regret that "a one-day strike of women in New York was given up," noting that "it was an excellent idea and should be kept up the sleeves of the suffragists for use in some future time."[170] She added a comment that showed her deep aversion to the anti-suffrage dictates for women: "I can't imagine anything that would be a better answer to the sickening repetition of 'women in the home.'"[171] Referring to the suffrage leaders, she wrote, "The next best thing the leaders could have done would have been to have a statement from the men employers giving fully their idea of the complete disarrangement that such a strike would mean."[172] This letter also reveals Pope's impression of Cassatt in 1915. As she conveyed to their mutual close friend Havemeyer, Pope was "rather shocked by the change in her," noting that Cassatt's poor health was visible, her eyesight was diminished, and her step was not as firm; "but of course her wonderful mind is flaming with its keen interest in the horrible facts of the war."[173]

The spiritual played an important role in both Cassatt's and Pope's lives. Cassatt believed, for example, in the possibility of telepathy[174] and of communicating with deceased loved ones through a medium in séances or transmitting messages through automatic writing,[175] and she believed that every person has "an earthly mission."[176] Like Theodate, Cassatt read widely on spiritual topics, from Indian philosophy to reports on the latest psychic research, and the two women sent each other books and pamphlets of interest on these topics.[177] So, for example, Cassatt sent Pope "a series of interviews, collected in book form" about "the opinions of prominent Frenchmen, especially writers, on the new views as to a future life. I think you will be surprised to see what strong spiritualists many of these men are."[178] Pope sent Cassatt the 1903 two-volume book *Human Personality and Its Survival of Bodily Death*, by Frederick W. H. Meyers, who was one of the founders of the Society for Psychical Research. Cassatt's response to receiving this book from Pope suggests that their exchange of this kind of material made her feel particularly close to Pope: "You have been so constantly in my thoughts, ever since I received your kind present of Meyers' book that I feel as if you must know what is passing in my mind. What a book!"[179]

Cassatt and Pope exchanged information on which mediums were best for séances, and in some cases, Cassatt asked Pope to write to her about what the medium had said in a particular séance; in one instance, she even offered to ask questions for Hillard in a séance she was about to attend.[180] Pope, for her part, used some of her resources to fund a position for a Harvard scholar in the field of psychic research, was closely involved with the choice of that person, and was generally motivated to help find scientific proof for psychic phenomena.[181] Both Cassatt's and Pope's interest in the

spiritual world was not merely intellectual. It provided personal comfort and consolation when a loved one died—as Cassatt wrote to Pope, "Oh! We must not lose that faith, the faith that life is going on though we cannot see it"[182]—and contributed to their own well-being (after receiving the Meyers book, Cassatt told Pope that reading it "has kept me up").[183] When Pope went through a difficult time after completing her first building—her parents' Hill-Stead residence—she wrote, "When I learned my lesson that I could not build my ideals in wood & mortar, I turned my eyes inward and found a whole world to open up in speculative thought."[184] In 1915 Pope came to Cassatt's country residence still deeply affected from having barely survived the *Lusitania*'s sinking and feeling that she had lost interest in life. Corresponding after the visit, Cassatt encouraged her, in one case by referring to Pope's spiritual life purpose: "If you were saved it is because you have still something to do in this World."[185] (This 1916 correspondence was the last of Cassatt's letters to Pope that survived.)

While Cassatt and Pope were in harmonious agreement about the spiritual world, Pope's objection to private collecting was an affront to Cassatt. This point of contention emerged during Pope's very first visit with Cassatt, in 1903. Cassatt wrote to her friend Mrs. Whittemore: "I had a very pleasant visit from Miss Pope and her friend . . . though I was sorry to see Miss Pope so antagonistic to art, especially painting."[186] Cassatt wrote to Pope that her belief about "the wickedness of private individuals" possessing art was "a false way of seeing things."[187] She attempted to convince her young friend of the crucial importance of private collecting for museums, for the artist, and for the collector.[188] Pope objected (as reported by Cassatt) to hanging paintings in ornate gold frames and preferred "bare walls."[189] Cassatt described to Mrs. Pope that her daughter even "wanted to banish the Japanese prints to the portfolio" (rather than hang them on the walls), adding with irony that the prints "would be surprised to find themselves there . . . [given that they were] created especially in a decorative intention."[190]

Pope's position on this question changed over her lifetime. Cassatt would have been pleased with her friend's enthusiastic comment in her diary at age nineteen: "I wish I had lots of money to spend for pictures!"[191] She would also have approved of Pope's private study of the history of art and architecture with a Princeton professor, and of her visits to numerous museums and private collections, including Durand-Ruel's, while on a European tour with her parents and her suitor at the time, Harris Whittemore, who went on to become an important collector of Impressionism, collected a lot of Cassatt's artwork, and also visited Cassatt in France and corresponded with her.[192] Cassatt would have been thrilled about Pope's accompanying her father to Paris galleries that showed contemporary art, her testaments in her diary as early as 1889 that she liked Impressionism for its "freshness," and her recommendations to her father to acquire certain artworks, including a particular Monet that she described as "the best picture by that artist I have ever seen," adding of her father that "he will regret not getting it someday."[193] Yet by the time Cassatt met her, Pope's attitude

toward art had undergone a change. In 1900 she wrote: "[P]ictures have been dead long ago to me—the ones that please me, please only at first sight—after that they are paint and nothing more."[194] By contrast, she was passionate about architecture: "[I] felt that the ugliness of our buildings actually menaced my happiness and felt breathlessly that I must help in the cause of good architecture."[195] Cassatt, whose interests were always wide, discussed architecture with Pope,[196] recommended that she take an architectural tour in France,[197] showed her residences near her country home, the Château de Beaufresne, and pointed out to her the influence of those kinds of French country houses on architecture in the United States.[198] Despite Pope's negative opinions on art and its private collecting, she kept most of her father's collection after inheriting it, and designated the Popes' Hill-Stead residence as a museum in which the Impressionist paintings assembled by her father would be exhibited and accessible to the public (as they are to this day). Cassatt, had she been alive to witness this, would have wholeheartedly approved.

SARA T. HALLOWELL

Once Cassatt met the American art curator Sara T. Hallowell in 1892, the two women developed a friendship that lasted through their old age (fig. 1.9). This was a friendship between two American women professionals living in Paris who were highly active in the transatlantic art world. Like Cassatt's other friendships, it consisted of a mix of professional and personal bonds and activities, including excursions to see art outside of Paris. Yet unlike Cassatt's other close American women friends—Havemeyer, Sears, and Pope—Hallowell was a Quaker, did not come from a wealthy family, and struggled throughout her life to earn her living as a curator and an advisor. Hallowell carved out a pioneering role for herself as a female art curator, mounting large group exhibitions of several hundred modern artworks at the Chicago Interstate Industrial Expositions. After twenty years as a curator there, she relocated to Paris, working as a freelance curator and advisor. But though she was a consummate professional with unparalleled expertise in her field, Hallowell encountered obstacles in advancing her museum career because of gender bias.[199]

Hallowell and Cassatt met in Paris after Cassatt received the commission to paint a monumental mural in the Woman's Building of the 1893 Chicago World's Fair. Hallowell, who had a close friendship and professional relationship with Bertha Palmer, the president of the board that organized the Woman's Building of the 1893 fair, recommended Cassatt for the mural, which was titled *Modern Woman*. Hallowell and Cassatt got to know each other professionally while Cassatt worked on the mural, since Hallowell, who was in Paris at the time, acted as Palmer's representative and oversaw the process. Cassatt must have been impressed with Hallowell, who by then had years of experience as a curator, working with numerous American artists, collectors, and museum administrators. During this period, Cassatt saw that Hallowell was a trustworthy colleague and friend, so that when Hallowell moved to Paris after the fair, in

FIGURE 1.9

Mary Fairchild [MacMonnies], *Portrait of S.H. (Sarah Tyson Hallowell)*, 1886. Oil on canvas, 38.3 × 44 in. (97.2 × 111.8 cm). Robinson College, Cambridge University, Cambridge, gift of Marion Hardy.

1894, Cassatt was interested in developing the friendship further. She invited Hallowell to spend her first two weeks in France with Cassatt and her mother in the South, and after resolving certain logistics, Hallowell went "direct to Miss Cassatt . . . at Cap d'Antibes, the loveliest spot on the Riviera."[200]

Cassatt and Hallowell had much in common. Born in the mid-1840s, just two years apart, they belonged to the same generation, and both grew up in Philadelphia. Both were devoted to their careers, chose not to marry, and lived with their American family members in France. Both moved to Paris as adults to pursue their professional careers and succeeded in establishing an excellent reputation in the art world, becoming known for their discerning eye. Each of them advised American collectors on buying modern and contemporary art, and they shared a strong commitment to the development of American art and museums. Central to each of their professional lives was their respective expanded transatlantic network of artists, critics, museum professionals, and important collectors. Hallowell realized the crucial importance of her network, writing that her experience and her "wide acquaintance and friendship with the first people in our country" was "all the capital I have."[201] Cassatt and Hallowell exchanged information about the art world and its prominent collectors and advisors.

For example, Hallowell informed Cassatt about the embarrassing failure of the well-known connoisseur and art advisor Bernard Berenson, who "went with Mrs. Potter Palmer to buy Chinese porcelains, she bought a number & then sent for an expert who told her they were all false! So she sent them back."[202]

Cassatt and Hallowell both contributed to the transatlantic art exchange between France and the United States, each in different ways. Cassatt exhibited her art in the United States (in addition to France) and advised American collectors on collecting Impressionist painting and some old masters with the intention that these artworks end up in American museums. Hallowell, after her move to Paris, curated annual exhibitions at the Art Institute of Chicago that featured what she regarded as the best contemporary art by American artists working in Paris. She was also the art advisor of Bertha Honoré Palmer and her husband, the real estate magnate Potter Palmer. The Palmers were the preeminent Chicago collectors and assembled one of the most important American collections of Impressionist paintings, a good part of which is now in the Art Institute of Chicago. Thus, Hallowell was indirectly responsible for the fact that Chicago has one of the best American Impressionist collections, while Cassatt, through her close and extended advising of the Havemeyers on assembling a preeminent collection of modern French art (as discussed in the next chapter), played an important role in the excellence of their collection and the fact that much of it was bequeathed to the Metropolitan Museum of Art in New York. Cassatt was surely satisfied when Hallowell advised the Palmers in directions that she supported, as in 1891–92, when they made extensive acquisitions of Impressionist paintings, but if Cassatt had an impact on these purchases, it was likely indirect. As Palmer's biographer stated, "Cassatt was the inspiration, Sara was the work horse."[203] And some of the Palmers' choices as collectors reflected Hallowell's rather than Cassatt's influence, such as the acquisition of American paintings and the fact that they bought only a few works by Degas but numerous works by Monet.[204]

When Cassatt met Hallowell, each already had an established reputation. Cassatt did not have a competitive attitude toward Hallowell in terms of work with collectors but rather supported her efforts. For example, Cassatt proposed that Harry Havemeyer hire Hallowell as an agent to find paintings by Camille Corot for his friend Colonel Oliver H. Payne.[205] Earlier on, she paved the way for Hallowell to gain access to Harry Havemeyer by encouraging him to lend artworks to Hallowell's exhibition at the 1893 Chicago World's Fair. Cassatt most likely also encouraged her brother Alexander to lend paintings to that exhibition. Well aware of the importance of networking for artists and curators alike, Cassatt helped Hallowell by connecting her to artists. This, in turn, helped the artists, both French and American, by connecting them with Hallowell. Pissarro, for example, wrote in 1894 that his hope for sales rested on Cassatt's recommendations to Hallowell.[206] Cassatt also arranged for a young American artist, Eugenie Heller, to meet Hallowell, writing to Heller: "I should like you to meet Miss Hallowell, she may be useful to you & you to her."[207] She invited Heller to join her

on a daylong excursion with Hallowell and Cassatt's sister-in-law Jennie to St. Quentin, to see the pastels of the eighteenth-century artist Maurice Quentin de La Tour at the local museum.

Both Cassatt and Hallowell cared a great deal about the development of an American school of art. Cassatt's efforts toward this goal primarily involved working with collectors to enrich the collections of American museums, but she also attempted tirelessly to convince American museum curators to acquire European masterpieces—for example, in one case, a painting by El Greco.[208] Her motivation was the quest to amplify the art treasures available to the American public and to enable American art students to study art in their homeland and not have to go to Europe. Hallowell shared Cassatt's paramount goal of helping important artworks reach American museums, an objective that for Hallowell applied not just to European masterpieces but also to American art. As a *New York Times* article about Hallowell reported, she deplored the fact that James McNeill Whistler's famous painting of his mother, which was exhibited at the Art Institute, ended up at the time in the collection of the Musée du Luxembourg: "I did everything I could, to persuade the Art Institute to purchase it." Regarding the fate of this painting, the article noted that "strenuous effort was also made in New York by artists who had seen it in Chicago to have the Metropolitan Museum buy it . . . now the famous picture is the property of France and practically priceless."[209] Hallowell contributed to the goal of developing American art primarily by promoting American artists. Each year she selected promising American artists living in Paris for exhibitions in the United States.

Hallowell was aware of the problems that plagued the quest for an American art school, including the racial discrimination in the United States that had forced the African American artist H. O. Tanner to live in Paris and pursue his career there. Talking with a reporter for the *New York Times* in 1905, she referred to Tanner as "[t]he first Afro-American, perhaps, to win distinction in art," noting that "[p]rejudice against the colored race as it obtains in the United States" prevented him from living in his homeland, whereas in Paris "his worth as a man and gifts as a painter are appreciated, giving him an assured position."[210] That same year, Hallowell observed: "In the past dozen years no art has made such rapid and distinctive progress as American art."[211] The controversial notion of "progress" she referred to meant that American art was becoming recognized as a distinctive school, as evidenced by the creation at the Musée du Luxembourg of a gallery devoted to "American Art" and featuring some fifty paintings.[212] Hallowell herself claimed that she could recognize an American painting on sight but admitted she could not define its characteristics.

> I can pick it out anywhere without catalogue or looking for signature. It is not technique, for as technique is understood and practiced in the Old World Americans have little or none; it is not subject, for our artists abroad are given to foreign or abstract subjects. It is a subtle, identifiable something that proclaims it American. Rodin calls it "Race! Race!"[213]

One fundamental difference between Cassatt and Hallowell was their financial status. Cassatt was affluent, thanks mostly to the substantial money she earned from her art. Occasionally she supplemented her income by selling artworks she owned, created by her Impressionist colleagues, whose market value had risen considerably since the time she acquired them. She also had some investments in the United States, probably originating with money she inherited from her family (I return to this topic in chapter 4). Hallowell, by contrast, struggled to support herself and her mother. She encountered serious obstacles, due to blatant gender prejudice, in obtaining the job for which she was the best-qualified candidate—director of fine arts at the 1893 Chicago World's Fair. The *New York Times* noted the strength of her candidacy, reporting that "Sara Hallowell is the most favorably spoken of for the position. She has proven her wide knowledge of art and executive ability by making the Interstate exhibit second to none in the country."[214] And the Board of Lady Managers of the fair's Woman's Building stated explicitly: "Her sex is being urged as a disqualifying factor by some of the Committee on Fine Arts."[215] In the end, a man with lesser qualifications was appointed to the position, and Hallowell served as a secretary to him. Nonetheless, she managed to carve out her project at the 1893 fair—curating the exhibition of paintings in American collections, titled *Loan Collection, Foreign Masterpieces Owned in the United States*—and was fully credited for it. Hallowell traveled to New York, Philadelphia, Boston, and several smaller American cities to meet with collectors and persuade them to lend their artworks to the exhibit.[216] When it opened, critics hailed it as the best art exhibition at the fair.[217]

When the exhibition ended, Hallowell conceived the idea of "establishing an agency in Paris from where I could forward collections for exhibitions in America," counting on the working relationships she had already established with American museums.[218] She offered her services to a number of museums and secured an arrangement with the Art Institute of Chicago to receive $300 a year (the equivalent of nearly $10,000 in 2021) for curating an annual exhibition of American artists in Paris. She then had to find ways of supplementing this income. While Cassatt could afford to advise American collectors at no charge, Hallowell had to earn money from her advisory work. This was not at all simple. It appears that the Palmers, for example, usually paid Hallowell only for her expenses rather than remunerating her for her extensive work as their art advisor in Paris.[219] Hallowell benefited from the social and professional access she gained through the relationship with Mrs. Palmer,[220] but the gender stereotype of a woman "helping" rather than performing a professional service, coupled with their class difference, likely played a role in blinding even a feminist like Palmer to the need to pay her advisor. In an effort to secure a reliable income, Hallowell approached the dealer of the Impressionists, Durand-Ruel, and proposed a kind of retainer agreement in which he would pay her a basic monthly sum in return for clients she would bring to his gallery—but he rejected it.[221] It is not clear what remuneration, if any, Hallowell received from Durand-Ruel or other dealers for bringing American clients. Hallowell would in all likelihood have discussed these kinds of issues with Cassatt,

especially since Cassatt, who knew Durand-Ruel well, had her own difficulties with him and indeed complained that he shortchanged his artists, herself included.[222]

Cassatt and Hallowell both believed that women artists should not be defined by their gender. When a *New York Times* reporter asked Hallowell in 1905, "Who is the most distinguished American woman painter in Paris?," she answered: "The art world at large . . . recognizes no sex in Mary Cassatt's virile brush. Her work is so great that it may be said to be sexless."[223] Both Cassatt and Hallowell opposed separate exhibitions of women's art, regarding them as a phenomenon that further entrenched the unequal treatment of women, and Hallowell indeed tried to dissuade Mrs. Palmer from creating an exhibition of exclusively women's art at the Woman's Building and instead urged her to exhibit the women's work in the Fine Arts Building along with the men's. Cassatt was firmly opposed to sending her own work to exhibitions of art by women, which were usually not at her level of professionalism. She was justly angry that her principal dealer, Durand-Ruel, disregarded her explicit instruction on more than one occasion by sending her artwork to women-only exhibitions in the United States.[224] In accepting the mural commission for the Woman's Building, which was dedicated to the display of artwork by women only, Cassatt made an exception to this policy because of the project's high profile and high professionalism. This was not another small women's art show: here was a large commission at a historic event that supported women's achievements and feminist goals. She was also impressed with Bertha Palmer, who headed the ambitious project and was herself an important collector of Impressionist painting.

Cassatt and Hallowell continued their friendship into their old age. Around 1911, for example, when both of them were in their sixties, Cassatt reported from a place that administered radium treatment: "We are a party, an old English woman, a Lady Pirbright & a French *comtesse,* an Italian princess & Miss Hallowell."[225] Throughout their friendship, Cassatt and Hallowell shared a bond that was based on their identities as active, independent, professional American women, and more specifically based on their work in the transatlantic art world, their commitment to their homeland and to modern art, and their shared experience of struggling with, and challenging, gender-specific prejudices. Out of this camaraderie and respect for each other's accomplishments, they helped each other routinely by sharing their professional contacts, advice, and information. Both conducted their lives and professions in a way that was still new for women. The description in the *New York Times* of Hallowell could equally be applied to Cassatt: "This clever American, whose personality, no less than mentality, is so thoroughly representative of our finest type of progressive, self supporting womanhood."[226]

FORBES WATSON

During her later years, Cassatt's closest Impressionist colleagues—Degas, Morisot, and Pissarro—were no longer alive. She renewed her friendship with Auguste Renoir

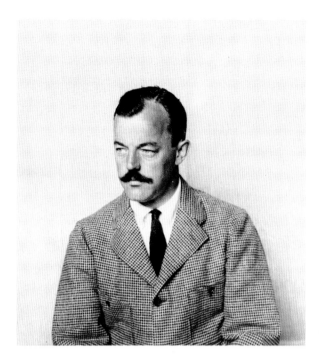

FIGURE 1.10

Unknown photographer, *Forbes Watson*, 1917.
Photographic print, 10.2 × 8.2 in. (26 × 21 cm).
Forbes Watson papers, 1840–1967, Archives of
American Art, Smithsonian Institution
(DSI-AAA) 7942.

during that period but did not develop new friendships with young French artists. In
fact, Cassatt disapproved of the art of the younger generation that was active in Paris
in the early twentieth century, as I noted earlier. Meanwhile, in stark contrast, she was
eager to maintain a connection with young American artists and critics. During this
period, Cassatt maintained friendships with the painters George Biddle and Adolphe
Borie, both from established Philadelphia families, and with the New York–based
critic Forbes Watson (fig. 1.10). All were more than thirty years younger than Cassatt,
but their Americanness and their established and affluent social backgrounds pro-
vided common ground.[227] Cassatt's friendship with the critic Watson, in particular,
demonstrates how such cross-generational friendships intersected with Cassatt's life
in France and expressed her persistent longing for a connection with Americans and
her eagerness to learn about the art world developments in her homeland.

Cassatt and Watson, whose friendship spanned the period between 1913 and 1920,
both came from privileged family backgrounds, and both dedicated themselves entirely
to art. Watson's father was a prosperous banker who frequently took his family to Europe,
so that as a child, the young Watson, like Cassatt, spent significant time in Europe.[228] By
the time the sixty-nine-year-old Cassatt met the thirty-four-year-old Watson, she had, as
Watson later described it, "long since won an international reputation . . . her name was
indelibly inscribed in the history of the period."[229] She was also well connected in both
France and the United States, and was knowledgeable about the art markets in both
countries. Watson, by contrast, was still at the beginning of his career, having just been

hired as art critic of the *New York Evening Post* in the previous year. Some eleven years later, he would become the art critic of the *New York World*,[230] as well as editor of *The Arts,* the most important American art magazine in the 1920s.

Still, by the time he met Cassatt, Watson was already thoroughly familiar with New York artists, galleries, art schools, and art students. The fact that he had been married to an artist, Nan Watson, since 1910 helped him become more involved with the artists associated with the Art Students League and the Ashcan School. He took part, for example, in gatherings at the studios of Robert Henri and George Bellows, who were associated with two of the leading modern artists' movements of the time that offered an alternative to the traditional academic art establishment in New York.[231] Before settling in New York in 1906, Watson lived in Paris for about two years, developing his writing while studying art, though he had no intention of becoming a professional artist. When he returned, he rapidly became a rising figure in bohemian, politically progressive circles of the New York art world. Alongside his immersion in contemporary art, however, Watson was also very knowledgeable about the old masters. His criticism, as Alfred H. Barr, the director of MoMA, noted, was "both conscious of the past and sensitive to the present."[232]

Cassatt, then, did not need to convert Watson to either modern art or suffrage, unlike her experience with Stillman. Watson marched with his wife in the parade for suffrage in New York in 1911, sharing the progressive mindset of the young New York artists—men and women alike—in the couple's circle (he was one of eighty-four men in the march).[233] His marriage to an artist no doubt sensitized him to the issues that Cassatt herself faced. His brief writing about the 1915 exhibition in support of suffrage in which Cassatt participated (I return to the exhibition in chapter 6) referred to Cassatt as an artist "who appreciates all the obstacles which the reactionary attitude of mind places in the path of the woman of liberal and independent mentality."[234]

Their dialogues on art were the most important aspect of Cassatt and Watson's association. Reflecting her much older age and high status in the art world, Cassatt took center stage in these conversations. Watson described the forceful impact of her speech:

> [O]ne couldn't listen to her, pouring out her ardor and her understanding, without feeling his conviction in the importance of art to civilization intensified. She increased the desire for more and still more knowledge. She made you share her intense hatred for aesthetic prevarication and compromise.[235]

As was the case with Cassatt's other professional ties, her friendship with Watson consisted of a mixture of socializing and discussions about art. Sometimes Cassatt had Watson over for lunch or tea in her Paris apartment,[236] and they would discuss art, the art market, and art prices (though Watson noted that Cassatt never attempted to promote her own art by suggesting that he take a look at it).[237] For example, on one

occasion in 1920, she mentioned that Durand-Ruel had given her five thousand francs for all of her remaining ninety-six drawings and etchings and a unique print proof by Degas. Watson responded that "they would make one hundred times as much."[238] A few months later, Cassatt gave Watson three drawings by Degas that belonged to Jeanne Manzi, the widow of Michel Manzi, an artist, printer, and collector who had been a close friend of Degas, so that he might sell them in the United States. Cassatt believed the drawings would sell for a better price in New York and knew that Durand-Ruel would not take them,[239] but above all, she wanted to help Jeanne Manzi, who had gotten little money for the artworks she inherited from her husband.[240] Watson was not able to sell the drawings and sent them back to Cassatt,[241] but the incident exemplifies Cassatt's wish to use her transatlantic network to further causes that were dear to her—in this case, helping a widowed woman friend.

Watson was a younger admirer of Cassatt, but also an American comrade. Their professional friendship relied on the fact that they were committed to similar goals. Both were critical of conservative art and institutions and in favor of independent exhibitions.[242] They shared a belief in the critical importance of collecting modern and contemporary art and did all they could, each in their own way, to encourage it. They also understood the important role of collectors in enabling artists, the development of contemporary art, and contributing to museums. Unlike Cassatt, who advised American collectors to acquire modern French art, Watson was primarily interested in Americans who collected American art at a time when most Americans were still interested in collecting French art.[243] Both were highly critical of the conservative attitudes of American museums, especially the Met, about collecting modern art; while Cassatt saw the importance of strengthening the representation of European and French art in American museums, Watson began crusading for a new museum devoted to modern art as early as 1915[244] and later was closely involved in advising the founders of the Whitney Museum of American Art. Both Cassatt and Watson were convinced of the importance of making modern art accessible in America to artists and the general public. Finally, both were passionate patriots and nationalists who shared a strong commitment to American art becoming a national school.[245] Watson worked in several ways to support the development of contemporary American art. First, he aimed con sciously to make his writing accessible to a wide audience, publishing it not only in the daily newspaper but also in numerous and varied magazines, from *Arts & Decoration* to *Parnassus*, *Ladies' Home Journal,* and *Vanity Fair.* His writing style was "urbane yet accessible, cultivated but anti-intellectual."[246] Second, he edited the influential art magazine *The Arts* (beginning in 1923), "the liveliest and most vital art magazine of the twenties."[247] And he was a close advisor to Gertrude Vanderbilt Whitney—the heiress, sculptor, art patron, and most important collector of contemporary American art at the time. He was also very close to Juliana Force, the director of the exhibition spaces Whitney funded that later culminated in the Whitney Museum of American Art, of which Force was the first director; and "[h]e was a key figure in the decision to found

the Whitney Museum of American Art."[248] Like Whitney and Force, he had a passionate conviction about the importance of encouraging, promoting, and collecting contemporary American art and representing it in an American museum. Since Cassatt was interested in the development of independent (rather than juried) exhibitions in the United States, of American art as such, and of American museums in particular, it is very likely that Watson told her about the venues created by Whitney and Force to exhibit American art. Finally, Watson, who defined himself as "an independent revolutionary,"[249] and Cassatt, who stated, "I am independent"[250] and demonstrated her not following artistic convention when she joined "the Independents" (the name she preferred to that of "Impressionists"), appreciated each other's autonomous stance.

Watson was fully engaged in the effort to develop an American art that, although still based on the European tradition, would constitute a distinct national school of art.[251] The nineteenth-century discourse about an independent American art echoed the mainstream narrative of American history, which spoke about a revolutionary and independent society of the new world, no longer submissive to a degenerate Europe. Art historian Wanda M. Corn notes that the beginning of the discourse about "what was inherently national and 'American' about American art and letters" occurred in the years around World War I.[252] Whereas Hallowell had anticipated this shift in discourse, Watson belonged to the generation that produced it. As early as 1914, his reviews of exhibitions of American artists, like Childe Hassam or Thomas Eakins, included comments on what made their art American. In Hassam's case, Watson identified the American nature of the work in "its note of delicacy, of refinement and charm, not the rude, strong note of youth that foreigners are continually expecting to find here";[253] in Eakins's case, he identified the trait of "sincerity."[254] Watson's knowledge of contemporary art in the United States was unmatched by anyone else in Cassatt's circle, and she was eager to learn about it from him. When he visited her eighteen months after the war was officially over, she queried him about the "condition of art in America." Yet Watson observed that her mind was preoccupied, even "still violent," as a result of the upheaval of the war,[255] and so "[t]he subject of politics constantly intervened." She criticized Germany, the leaders of the United States and France, "everyone except the Socialists."[256] On her interest in his area of expertise, he noted bluntly: "Of American art she enjoyed an ignorance born of almost half a century's absence from her native land."[257] Cassatt did not believe that a school of American art had yet emerged, declaring as late as 1911 that "we have produced nothing original yet."[258] Although she lived until 1926 and never gave up her ardent belief in a future school of American art, it remained for her an abstract ideal, a yearning.

In contrast to her unfamiliarity with contemporary American art, Cassatt was highly knowledgeable about American museums. She was passionate about American museums becoming a depository of old masters and of modern French art. As she saw it, this project was closely connected to Watson's ardent interest in developing American art. Watson described Cassatt

launching into a plea to save the coming generation of American art students from turning into café loafers in Paris and from all other forms of the uprooted ex-patriotism that had "destroyed so many of them."

"When I was young it was different . . . our museums had no great paintings for the students to study. Now that has been corrected and something must be done to save our young American artists from wasting themselves over there" [on the Left Bank].[259]

The passionate practice of fighting for the cause of art was common to Cassatt and Watson. Cassatt was known for expressing her opinions frankly and for her sharp tongue, and Watson for enjoying a good fight and for battling long and relentlessly for American art.[260] Cassatt and Watson practiced their professions, as artist and critic, respectively, in ways that far exceeded the typical boundaries of these professions, and both made important contributions to American art and culture—Cassatt through her own art and strong involvement with American collectors, Watson by interpreting contemporary American art and developing the public's interest in it through his roles as art critic, journal editor, lecturer, curator, and advisor. For Cassatt, the friendship with an American three and a half decades her junior who shared her passion allowed her to nurture her lifelong intertwined commitment to art and to her homeland even as she was so utterly distant from it in her old age, not only geographically but also because of the effects of the war.

From 1914 and throughout the years of World War I, most wealthy Americans, including many of Cassatt's friends who before the war had visited France annually, suspended their trips across the Atlantic. However, once the United States entered the war, many young Americans, including Watson, came to volunteer in France. Watson joined an American ambulance service in France in the summer of 1917 and later joined the Public Information Branch of the Military Affairs Division of the American Red Cross.[261] During his assignment in France, Watson was also able to pursue his interest in art, visiting, for example, the site of the new Rodin Museum in Paris,[262] and in all likelihood was able to visit Cassatt. After the war, some of Cassatt's American friends resumed their visits to France, enabling her to see them again in person, while other friends passed away—Degas in 1917, Stillman in 1918. During her final years, Cassatt felt the disempowering effects of aging, but with the help of her household staff, she continued to entertain family members of the younger generation and friends, including American artists such as George Biddle and Adolphe Borie of Philadelphia.[263]

THE HAVEMEYER COLLECTION

Finally, Louisine Havemeyer, as I noted earlier, was Cassatt's closest friend as well as the most important figure in her transatlantic network. Before turning to explore this seminal relationship in greater depth in chapter 2, let us end this chapter with a brief word about the way in which Cassatt used the Havemeyers' art collection as a key strategy for expanding her network.

Her motivation was to nurture potential American collectors, and to expose young American artists to modern French art of the kind not yet collected by American museums, including works by Courbet, Degas, Pissarro, and others, as well as her own work. The Havemeyer art collection was the preeminent collection of modern French art in the United States, and Cassatt had a strong and ongoing involvement in shaping it. As Cassatt fully realized, to visit the Havemeyer collection was a lesson not only in art but also in collecting. Over the years, she wrote countless letters to Havemeyer requesting that she show her collection to specific people. For example, in the case of Carroll S. Tyson, a young Philadelphia artist whom Cassatt met in Paris, she informed him: "I have already announced your visit to my friend Mrs. Havemeyer . . . Do go and see this collection, take a friend with you, an artist, write to her telling her I want you to see the gallery."[264] Five years later, she facilitated Tyson's second visit to the Havemeyer collection.[265] Seeing this collection stimulated Tyson's "urge to own a group of French paintings himself," according to John Rewald.[266] Tyson's collection of Impressionist paintings (assembled years after Cassatt's death) was eventually bequeathed to the Philadelphia Museum of Art.

Class and wealth played a role in the protocol of these visits. When Cassatt asked Havemeyer to show the collection to a young artist such as Tyson, the artist was to write to Havemeyer to initiate the visit, and access would be granted while Mrs. Havemeyer herself might or might not be at home. When Cassatt hoped to turn a wealthy American into a collector—as, for example, in the case of Mrs. Vanderlip—she asked Havemeyer to extend an invitation herself and to guide the visitor personally through the collection. Before Vanderlip's visit, Cassatt wrote to Havemeyer that she was "a nice young woman, *do* write & ask her this spring to see the pictures [in your gallery], she will appreciate it & I promised for you."[267] (A few weeks later, Cassatt almost lost hope of converting Mrs. Vanderlip into a serious collector, since she had learned that the Vanderlips "bought the most terrible picture in London at the Royal Academy, 'Spring conquering winter!'" Exasperated, she wrote to Havemeyer: "I doubt if you [can] educate her.")[268] Cassatt's requests were sometimes relentless. For example, since she liked Stillman's sisters very much, she wrote Havemeyer about them several times, explaining that she admired them for being "such thorough ladies,"[269] and for their artistic taste and knowledge.[270] Writing again some two months later, she urged: "I am sure you would like them if you met them, I do, so very much."[271] This last comment also demonstrates Cassatt's wish to include her best friend, Havemeyer, in her own expanding circle of friends, creating more overlap in their respective networks.

This chapter has demonstrated the central role that Cassatt's transatlantic network played in her life, both personally and professionally. I have proposed viewing her various art-related enterprises as involving significant social activity with many different actors on both sides of the Atlantic, and especially with her American friends. Notably, some of these friends were female art professionals—a curator (Hallowell), an architect (Pope), and an artist and a collector (Sears). I have also showed how Cas-

satt made a significant contribution to the transatlantic art world of the last quarter of the nineteenth century and the first years of the twentieth by nurturing, urging, mentoring, and helping American artists and collectors with the goal of furthering the cultural development of American art, artists, museums, and the general public. Cassatt's greatest contribution to American museums was achieved through her part in creating the Havemeyers' seminal art collection, much of which is now in the Metropolitan Museum of Art. In other words, it was achieved through her interactions with the principal player in her transatlantic network, Louisine Havemeyer.

2

CASSATT AND LOUISINE HAVEMEYER

Collaboration, Suffrage, Alliance, and Affective Bond

> You are a friend Louie, and is there anything rarer.
>
> **MARY CASSATT TO LOUISINE HAVEMEYER, 1906**

———

CASSATT'S FRIENDSHIP WITH LOUISINE HAVEMEYER was by far the closest, longest, and most important friendship of her lifetime. It provided unqualified mutual support, solidarity, alliance, intellectual cohesion, and emotional closeness. It also had a lasting impact on American culture, since with Cassatt's guidance, Havemeyer, along with her husband, Henry O. Havemeyer (called Harry), became a preeminent American collector of nineteenth-century French avant-garde art and bequeathed a good part of the collection to the Metropolitan Museum of Art. For Cassatt, the friendship with the New York–based Havemeyer was significant in multiple ways. It was a conduit through which Cassatt could maintain her lifelong sense of belonging to the American nation even as she lived in France for over half a century; it integrated her great commitment to art and to her homeland through the two women's collaboration on the Havemeyer collection, ultimately enabling Cassatt to realize her vision for art in the United States (I expand on this in chapter 7); and last but not least, it played a crucial role in providing her with

solid emotional support that included a bond of love, affection, and appreciation. Havemeyer was Cassatt's confidante throughout most of her adult life. Their mutual care and respect and their shared passion for art and women's equality were critical to both of them in their endeavors.

The transatlantic distance was always present in this friendship, which was conducted most of the time through letters. Cassatt's letters to Havemeyer constitute an unparalleled source of information about her since she wrote them with the candidness of a diary. Most of Cassatt's letters to Havemeyer have not been published (Havemeyer's letters to Cassatt did not survive), and scholars have studied them primarily with an eye to filling out information about Cassatt's life or the Havemeyers' collecting.[1] Thus, Cassatt's everyday articulations of affect and emotions in her letters to Havemeyer as well as her thoughts about diverse issues have rarely been addressed. In this chapter, I read the letters closely in order to shed light on the importance of this friendship to Cassatt's life and to her most important achievement as an advisor on collecting—making a major contribution to shaping the Havemeyer collection—which, in turn, led to the transfer of modern French art and some European old masters to the United States. The letters manifest an emotional, cognitive, and intellectual intimacy between Cassatt and Havemeyer. They show a deep caring and closeness, loyalty, and a strong bond grounded in shared goals and a free exchange of perspectives and feelings, all of which infused their collaboration. Cassatt's self-disclosure and candor in the letters—sharing confidential information and feelings about events, people, and herself—suggest her utter trust in Havemeyer.

The Cassatt-Havemeyer relationship has not received the major place that it deserves in scholarship of the period. It was absent as a topic of investigation in two major exhibitions and their catalogues, which focused on the Havemeyer collection and on Americans collecting Degas, respectively—the 1993 exhibition *Splendid Legacy: The Havemeyer Collection* at the Metropolitan Museum of Art, New York, and the 2001 exhibition *Degas and America: The Early Collectors* at the High Museum of Art, Atlanta. Notably, the catalogue of the latter does devote a chapter to "Louisine Havemeyer and Edgar Degas."[2] Such studies unwittingly continue the long Western tradition of dismissing women's friendships, based historically on the view, professed by Aristotle and Nietzsche, among others, that friendship was possible only among men. The recently evolving field of friendship studies has begun to counteract such misogynistic stereotypes, studying female alliance and friendship and their political significance.[3] This chapter analyzes the personal and historic significance of a transatlantic friendship between two elite American women. It shows that contrary to stereotypes that limit the purview of women's friendships to "feminine" concerns, Cassatt and Havemeyer's friendship exemplifies how the private and affective dimensions intersected with the professional, public, national, and political ones. The personal friendship of these two art lovers, cultural leaders, and feminists on both sides of the Atlantic has had an impact that continues to this day on the availability of an extensive collection of modern French art in the United States. Tracing a friendship that spanned more

than five decades, I explore the changes that it underwent over time, from the exhilarating bond of two young women in Paris discovering avant-garde art and the metropolis; to the change in the constellation of the friendship after Louisine's marriage to Harry Havemeyer, when Cassatt's friendship extended to him; and finally the complexities of the friendship of two older women who had gained achievements, power, and respect, each in her field, and whose relationship by now included, in addition to mutual respect, devotion, and alliance, also tensions and disruptions.

MENTORING LOUISINE ELDER, 1874–1883

Cassatt and Havemeyer met in Paris in June 1874. The thirty-year-old Cassatt had just decided to settle in Paris after years of traveling in Europe to study art (following her studies at the Pennsylvania Academy of the Fine Arts), and the nineteen-year-old Louisine Elder came to the city with her mother and two sisters after the untimely death of her father and spent several months there rounding out her cultural education (fig. 2.1).[4] She was learning French and living with the family of Madame Del Sartre, who rented out rooms to young American women.[5] In those years, there was a great disparity in experience and knowledge between Cassatt and Elder. Cassatt had by then acquired in-depth knowledge of European museums, was a savvy traveler, had honed her knowledge of the art of old masters, and greatly appreciated the art of Courbet, Manet, and Degas. She was already an ambitious professional artist whose paintings were accepted by the Paris Salon six times—the first of these in 1868, just one year after her arrival in Europe, and the last in 1876, after which she decided not to submit her work again to the conservative Salon jury.[6]

Thus, Cassatt became not only Elder's friend but also her mentor. She guided her around Paris, showing her the city through her own eyes and demonstrating resourceful ways to enjoy what the city had to offer, even on a limited budget.[7] Havemeyer wrote in her memoir that Cassatt "opened her heart to me about art while she showed me about the great city of Paris. She took me to the Opera, where without depleting our pockets, she found a place where we could hear well and could enjoy the fine ballets that were attracting Degas' attention at that very time."[8] Cassatt also helped Elder to develop her own understanding of some of the newest art made in the city. She emboldened her young friend to form an original taste, like her own, far outside the consensus of the time. Cassatt herself was pursuing her ambition in art, gaining recognition, and admiring contemporary art, including the art of Degas and the Impressionist group, which was still despised by many. Elder saw Cassatt as a shining example of how a young American woman of her own class could be daring and independent, living her life without succumbing to the norms that limited women to the private sphere or conforming to conventional artistic tastes; moreover, she did all this without a loss of class status or respectability. Thus, although it was still decades before they would explicitly discuss suffrage and become strong supporters of women's full emancipation, Cassatt already showed the way for the young Elder toward some central feminist values.

FIGURE 2.1

Unknown photographer, *Portrait of Louisine Waldron Elder Havemeyer*, date unknown. Gelatin silver print, 10 × 8 in. (25.4 × 20.3 cm). Collection of Shelburne Museum Archives. PS3.1–26.

Elder utterly admired her mentor:

> I felt then that Miss Cassatt was the most intelligent woman I had ever met, and I cherished every word she uttered and remembered almost every remark she made. It seemed to me no one could see art more understandably, feel it more deeply or express themselves more clearly than she did.[9]

She esteemed Cassatt for being "resourceful, self-reliant, true, and brave,"[10] qualities that she perceived as still rare in women at the time; and appreciated her "independent mind," "generous heart," "judgment," "perception," "courage," and "enterprise."[11] The young Elder clearly saw an exciting role model in her more mature friend.[12]

Cassatt pushed Elder to go beyond her comfort zone in art and to buy Degas's work. So completely did Elder trust her mentor that she bought her first Degas, *The Rehearsal of the Ballet Onstage,* ca. 1874, simply because Cassatt insisted on it and despite the fact that she herself did not yet understand its merits. Years later she recalled: "It was so new and strange to me! I scarce knew how to appreciate it, or whether I liked it or not . . . she [Cassatt] left me in no doubt as to the desirability of the purchase and I bought it upon her advice."[13] Elder acquired the Degas for 500 francs (about $100 at the time, equivalent to about $2,581 in 2023), a large sum for her at a time when she was limited to a modest monthly allowance.[14] With this acquisition, Elder became the first American collector of Degas and began what would eventually become "the largest and most complete collection of Degas' work ever formed."[15] For Cassatt, too, this acquisition was of great importance. It was the first time she acted as an advisor to an American art collector, and moreover, it marked the beginning of her efforts to shape a new type of American collector, one who, rather than acquiring French academic art or paintings of the Barbizon School, bought the modern art that she herself believed in—Courbet, Manet, and Degas, and some of the other Impressionists. Cassatt's artistic success in her first participation in the independent Impressionist exhibition in 1879 must have only increased Elder's appreciation of her friend as an artist. The wide coverage of that exhibition and the fact that many reviews mentioned Cassatt and praised her art made her known in the artistic circles in Paris, and some important French collectors began to acquire her work.[16]

Elder admired Cassatt's art early on in their friendship, as evidenced by her purchase of Cassatt's *Portrait of the Artist,* 1878 (fig. 2.2). Cassatt made this self-portrait while preparing paintings for her first participation in the exhibition of the Impressionist group, in 1879. She depicted herself leaning on an armchair rather than comfortably seated in it, a pose that demands alertness. The diagonal composition further adds to the dynamic sense of the picture and creates an asymmetrical composition that together with the severely cropped armchair demonstrates Cassatt's incorporation of modernist strategies. Rather than situating Cassatt within an articulated domestic environment, the cropping reduces the armchair to the point of merely hinting at an interior. Living in Paris by now for about three years and preparing to exhibit for the

FIGURE 2.2

Mary Cassatt, *Portrait of the Artist*, 1878. Watercolor, gouache on wove paper laid down to buff-colored wood-pulp paper, 23.6 × 16.2 in. (60 × 41.1 cm). The Metropolitan Museum of Art, New York. Bequest of Edith Proskauer, 1975. 1975.319.1. Image © The Metropolitan Museum of Art.

FIGURE 2.3
Alphonse J. Liébert & Co., *Mary
Cassatt*, ca. 1867. Photograph.
Private collection. Image courtesy
of Nicole Georgopulos.

first time in an independent Impressionist exhibition, Cassatt represented herself
as a fashionable and urban woman. Her body is active as she leans against the arm
of an upholstered chair, and her attire—an elegant white dress, long white gloves,
and a colorful decorated bonnet—is an outdoors costume signaling that she belongs to
the metropolis. Looking sideways at an unspecified location, her face appears thought-
ful. Cassatt's way of dressing, her confident body language, and her pose all show quite
a transformation compared with her appearance in a photographic portrait of around
1867 (fig. 2.3). Taken on a visit to Paris when she was twenty-three and traveling in
Europe to study art, the photograph shows Cassatt still reflecting her Philadelphia
origins: a "properly" dressed young American, hatless, rather than a fashionably

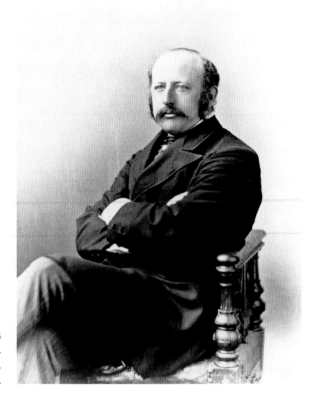

FIGURE 2.4
Unknown photographer, *Mr. Henry O. Havemeyer*, ca.
1883. Gelatin silver print, 10 × 8 in. (25.4 × 20.3 cm).
Collection of Shelburne Museum Archives, PS3.1–9.

dressed Parisian wearing a decorated hat.[17] Sitting with stooped shoulders and a con-
cave body posture that suggests passivity, looking out with a vacant gaze, the Cassatt
featured in this photograph contrasts with the later self-portrait in which she depicts
herself as a stylish and self-confident young woman.

Cassatt's mentoring of Elder was a feminist act: she educated her, rather than main-
taining the power/knowledge differential between mentor and mentee. With Cassatt's
encouragement, Elder developed her own understanding of the new painting during
the late 1870s and early 1880s. By 1883, at the age of twenty-eight, Elder had already
acquired, in addition to Degas's pastel, one work each by Claude Monet, Camille Pis-
sarro, and Jean-François Raffaëlli, as well as five pastels by James McNeill Whistler.[18]

COLLABORATING WITH HENRY AND LOUISINE
HAVEMEYER, 1889–1907

Cassatt's friendship with Louisine entered a new phase after she married Henry O.
Havemeyer, the fourth generation in the Havemeyer lineage to join the sugar-refining
business in the United States, and the family's "most distinguished member" (fig. 2.4).[19]
Havemeyer's vast fortune allowed the couple to collect art on a grand scale, yet during

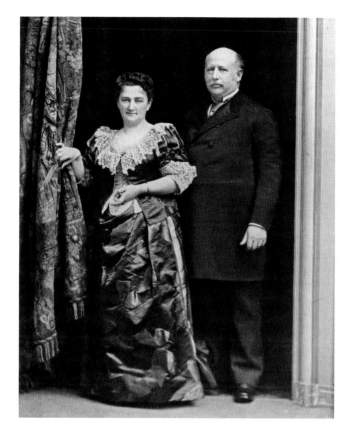

FIGURE 2.5

Unknown photographer, *Louisine Elder Havemeyer and Henry Osborne Havemeyer in Paris*, 1889. Gelatin silver print, 8 × 10 in. (25.4 × 20.3 cm). Collection of Shelburne Museum Archives, PS3.1–12.

the early years of the marriage, he was not yet converted to Cassatt's and his wife's passion for French avant-garde art.

Whereas until her marriage, Louisine usually came to Paris for annual visits with her mother, after her marriage she did not return to Paris for some six years, during which time she gave birth to three children, Adaline, Electra, and Horace. In 1889, when Louisine and Harry came to Paris together for the first time (fig. 2.5), bringing their three young children with them (fig. 2.6), Cassatt met Harry Havemeyer. Over the next years, she would gradually establish a friendship, mentorship, and collaboration with him too. Her friendship with Harry was based on her respect for him but was also an extension of her friendship with Louisine, and unlike the two women's close relationship, theirs remained more formal. She addressed Louisine as "Dear Louie," and Harry as "Dear Mr. Havemeyer." Whereas in her letters to Louisine she touched on a wide range of topics and shared her thoughts freely, her letters to Harry focused more strictly on discussing paintings for the collection.[20]

Harry Havemeyer's sincere interest in art predated both his acquaintance with Cassatt and his marriage to Louisine, but it was the partnership with his wife, the collaboration with Cassatt, and the exposure to their tastes that set him on course to owning,

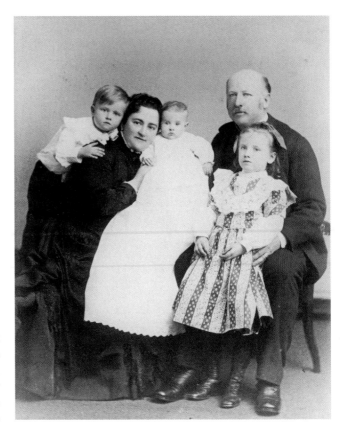

with Louisine, the preeminent American collection of modern French art. Prior to his marriage, Harry had collected mostly Asian decorative arts, French academic paintings by artists who were successful in the Paris Salon, and some Barbizon paintings, as well as a Delacroix.[21] He tended toward "impulsive buying" and liked to acquire decorative art in quantities.[22] It took several years into the marriage, patience, and Louisine's artistic alliance with Cassatt to bring him around to their taste for French avant-garde painting. In 1888 Harry began to acquire old masters, buying two Rembrandt portraits.[23] He also pursued his own taste for Dutch old masters, such as de Hooch and Hals, and established nineteenth-century French artists, including Decamps, Delacroix, and Millet. During the couple's visit to Paris in 1889, Harry declined to acquire the painting by Courbet that Louisine wanted most. Cassatt had first introduced Louisine to Courbet two years before her marriage, taking her to see an important Courbet exhibition that featured thirty-three of his works.[24] Cassatt impressed upon her that "Some day *you* must have a Courbet."[25] The interaction between the wife and the husband in 1889 shows the dynamics that prevailed between them in the period before Harry took his wife's artistic choices seriously. Louisine recalled:

I expressed desire for this splendid *Landscape with Deer,* and Mr. Havemeyer told me: "Surely you don't want that great big picture," "But I do," I answered, whereupon he said: "Come over here and look at the De Hooch. That's the sort of thing to buy."[26]

After the Louvre acquired this Courbet painting, Harry realized his mistake and instructed Durand-Ruel to find a Courbet for their collection. Louisine noted that the work they acquired on this occasion was a "fine but not a remarkable Courbet" but that this led to their buying "many another picture by the great painter."[27]

It was not until 1895 that Cassatt and Louisine succeeded in bringing Harry fully on board with the notion of creating an extensive collection of Courbet, Manet, Degas, and other Impressionists,[28] and convincing him, moreover, of the importance of making this collection for the future of the United States. From this point on until Harry Havemeyer's untimely death in 1907, the work on the collection became a three-way collaboration. Louisine described this period:

> It is difficult to express all that our companionship meant. It was at once friendly, intellectual, and artistic, and from the time we first met Miss Cassatt, she was our counselor and our guide. We corresponded constantly when we were apart and always traveled together when abroad. She was ever ready to go with us or to do for us, and rarely did we go to Europe that she had not traced some fine picture for us to consider, or had not skillfully had a fuse into some rich mine of art for our benefit; occasionally the fuse was short, and a sudden upheaval resulted in a valuable acquisition, or the fuse might be long, burning slowly, and only after years of patient waiting would we see the flash and know we had unearthed a treasure.[29]

Cassatt excelled at mentoring Harry Havemeyer about avant-garde French art, leading him gradually and tactfully to becoming one of its most committed collectors. She created a conceptual framework that could bridge Harry's own interest in old masters with her passion for the moderns, explaining early on: "To make a great collection it is necessary to have the modern note in it, and to be a great painter, you must be classic as well as modern."[30] This was a statement that she both believed sincerely and knew would appeal to him. Upon learning that Harry had purchased three Rembrandts, she wrote a letter to Louisine in which she once again draws a link between the old master and the moderns while tactfully withholding from Harry the full extent of her ideas to avoid offending or antagonizing him. After noting that she and the critic and art agent Theodore Duret agreed that Courbet "comes nearest to Rembrandt in modern times,"[31] she adds that Courbet

> had that large noble touch, which is so characteristic of Rembrandt. . . . Do tell me whether you feel as I do about this. I know Mr. Havemeyer does not so don't tell him, what I say, only tell him that such a critic as Duret says that he has two of Rembrandt's finest portraits painted in his best period, and the third is also a very fine Rembrandt of a later date.[32]

Persuading Harry Havemeyer was a process that took several years, since, as Frances Weitzenhoffer notes, "although willing to take risks as a businessman, Harry preferred to put his money into 'blue-chip' pictures rather than speculate on the avant-garde."[33] By the mid-1890s, when the Havemeyers' collecting of avant-garde French art increased greatly, Courbet, Manet, and the Impressionists were gaining more acceptance in the United States.[34]

Cassatt affirmed her great appreciation of Harry's friendship when she wrote to Louisine about two years after he passed away, "Ah! my dear I'll never have a friend like Mr. Havemeyer again."[35] She was deeply touched when she learned from the son of Paul Durand-Ruel, Joseph, who worked with his father, that Harry had at one time offered to pay for a picture of hers to enter the collection of the Berlin Museum (he was turned down because the German emperor, known for despising modern French art, refused to have Cassatt's work presented there).[36] Harry's gesture was at once an act of loyal friendship toward Cassatt and an expression of his appreciation for her art, and she was grateful for it, writing to Louisine: "You may imagine how I felt, & of course to you too, thanks dear."[37] Cassatt valued Harry's love of art and real understanding of it. She compared him favorably to another American man of enormous fortune who collected art, James Stillman (discussed in chapter 1), noting that for Harry Havemeyer, art was a serious engagement, not just "a pastime."[38]

Cassatt's involvement in the collecting practices of the Havemeyers was extensive. She was always on the lookout for the best works available on the market, using her network of art dealers and agents, critics and collectors to keep up-to-date on the art world's developments. She took the Havemeyers, and later Louisine, to studios and galleries in Paris, and traveled with them to locate masterpieces in private European collections. When necessary, she traveled on her own to see a particular work for their collection. For example, she went to Madrid for a quick twenty-four-hour trip to view the portrait of the Duke of Wellington by the Spanish artist Francisco Goya, right after the Havemeyers' cable arrived asking her to assess this work for them. Acting immediately, as in this case, required Cassatt to give priority to the collection when an opportunity for a purchase arose.

Cassatt's collaboration with the Havemeyers accelerated in the mid-1890s, when Harry was ready to collect French avant-garde paintings. In 1891 the Havemeyers moved into their new mansion in New York City, which included an art gallery, and beginning in 1901, Cassatt and the Havemeyers traveled together during the summers. From their first joint visit to Italy and Spain in 1901, Cassatt expended a great deal of energy on the pursuit of old master paintings for the Havemeyers to acquire, searching for them beyond the market, in private collections, and establishing contacts with agents in Italy and Spain. In addition to the summer travels, she also sometimes joined the Havemeyers for brief trips outside of France to check on a painting that had become available. In April 1907, for example, she went with the Havemeyers and Duret on a one-day trip to Brussels to see a Courbet portrait, which the Havemeyers then acquired.[39]

For Cassatt, every artwork had to be considered in depth and on its own, in contrast to the practice of some of the wealthiest American collectors, including, for example, a case in which the American William Walters bought an entire collection for three and a half million francs. She wrote to Harry Havemeyer: "It would not be my way of buying pictures."[40] In considering any given artwork for acquisition, Cassatt was also thinking about how it related to the makeup of the collection as a whole and to the level of the works already in the collection. She wrote to Harry in 1906 regarding the potential purchase of a particular work by Jean-Baptiste-Siméon Chardin: "I have to think of all the great things you have in your gallery, even exclusive of the Rembrandts the painters represented there are greater than Chardin, are on a different plane, all the same this is a very perfect thing."[41] Cassatt and the Havemeyers worked closely together. The trust between them, as well as the level of Cassatt's hands-on involvement, led the Havemeyers to entrust her with a sum of money so that she could act swiftly on acquisitions when necessary.[42] But the sum she had access to was modest compared with the sums wielded by some other American collectors of great fortune and sometimes also their agents—as in the case of J. P. Morgan, who, as Cassatt informed Louisine, had given a credit of a million francs to an art agent.[43]

In searching for works for the Havemeyer collection, Cassatt was also mindful of Harry's sensitivity to nudity and sexuality in paintings. Nonetheless, she strongly recommended that they purchase Ingres's *Turkish Bath*, a painting that represents numerous naked women staged around a pool in a harem and that suggests Sapphic eroticism by including a woman embracing another woman and caressing her breast. In the first of several letters that she wrote to Louisine about this work, Cassatt mentioned that she was sending her a photograph of the Ingres painting because there was talk that it would soon be coming on the market, as the owner, Prince Amédée de Broglie, had committed suicide and left behind a gigantic debt.[44] In her second letter to Louisine on this topic, she made it clear how much she wanted this painting to enter the collection:

> I was sure you would like the "Bain Turque[,]" of course I have seen the picture[,] that is what made me send you the photo, it is not a large picture, the figures are small, I don't see why you should not own it, I confess I long to have you [own it], it is so rare a thing, and you would have one of the most extraordinary pictures of Ingres . . . I think with you that it is so naively innocent, it remains to be seen what Mr. Havemeyer thinks, I am sure the oriental feeling will appeal to him.[45]

As Cassatt knew, Harry's opinion on the nudity and eroticism was the main obstacle to adding this masterpiece to the collection. Her letter indicates that Louisine agreed with her that Ingres's treatment of the subject is "naively innocent." When, by late December, she had not yet received a response, Cassatt reminded Louisine, "I am inquiring about the 'Bain Turque.'"[46] And in early January, she raised the subject yet

again, urging Louisine to gain her husband's agreement: "As to the Bain Turque, I hear who is to be approached on the subject and hope to have him discretely [*sic*] sounded."[47] That the Havemeyers did not acquire this painting likely indicates that Harry could not be persuaded. But the case shows Cassatt's determination to sway the Havemeyers, so that the United States would have major masterpieces in its still relatively new museums. She persisted not only in the face of Harry's resistance but also despite knowing that the French government would probably not allow the painting to leave its shores, as she alerted the Havemeyers.[48] Five years later, the Louvre Museum accepted Ingres's painting.[49]

The Havemeyers housed their art collection in a two-story gallery in their mansion on Fifth Avenue and Sixty-Sixth Street.[50] Louisine had always been the one responsible for hanging the artworks and choosing their backgrounds. She did this so well that experts admired the skillful hanging, among them the major American collector Henry Clay Frick and the German museum director Ludwig Justi.[51] Although the Havemeyers preferred not to be heavily engaged in New York's high society world, they hosted Sunday afternoon concerts in their music room, after which the guests were encouraged to view the rest of the home and the art collection.[52] The home and the collection attracted numerous visitors, some very well known, including many Americans and some Europeans and Asians.[53]

Harry Havemeyer's death in December 1907 ended the couple's eighteen-year collaboration with Cassatt. But the deep friendship between the two women continued, and so did their collaboration, as I describe in the next section. After Harry's death, Cassatt wrote to her niece: "I lose in Mr. Havemeyer a friend and am sincerely grieved, but of course my feeling I have is swallowed up in sympathy for her."[54] Louisine, who was in her early fifties, suffered greatly from the unexpected loss of her husband, and she faced enormous challenges, including two giant lawsuits brought by the government against the Havemeyer Sugar Trust, accusing it of fraudulent weighing of imported sugar over many years to reduce duty payments.[55] The unfavorable press coverage of the Havemeyer Trust greatly impacted Louisine, and Cassatt often expressed her solidarity and sympathy. Cassatt further showed her caring for her friend by making one of her very rare Atlantic crossings despite violent seasickness, sailing to New York in 1908 to be with Louisine on the first anniversary of her husband's death.

CASSATT AND LOUISINE HAVEMEYER'S FRIENDSHIP AND COLLABORATION, 1908–1926

During the years that followed Harry Havemeyer's death, the friendship between Cassatt and Louisine Havemeyer intensified, becoming an important source of support in difficult times for both of them—initially for Havemeyer, during the early years of her widowhood, and then for Cassatt, who suffered greatly from the unexpected death of her brother Gardner in 1911. Cassatt also experienced hard times from 1914 on, due to the war as well as her own aging, diabetes, and diminishing eyesight.

Cassatt encouraged Havemeyer to continue collecting after her husband's death, writing to her: "Go on for his [Harry's] sake & your own."[56] Havemeyer did resume collecting, with Cassatt's advice. Collecting vigorously, she became a seasoned collector, who in addition to deciding on acquisitions from the artistic perspective now also took charge of the financial aspects of the collection, which her husband had previously handled.[57] Unlike in the early years of building the collection, Cassatt's and Havemeyer's work on it now became a collaboration of equals. And in addition to their work on the Havemeyer collection, Cassatt recruited Havemeyer to participate in her campaign to turn other wealthy Americans she met into collectors of the kind of art she believed in. Writing in 1910, she reminded Havemeyer:

> Do invite Mrs. Vanderlip to see your collection, & do explain things to her. She will be very grateful, & you must try & educate. It isn't easy but I try & you must too. The trouble is they have already taken to liking poor things. But she is educatable, excuse the word.[58]

In this case, Cassatt's hope did not materialize, but in other instances Havemeyer and her collection did play an important role in influencing American collectors, as we learn from Cassatt's note to Havemeyer: "Our friend Mr. S[tillman] . . . says you have taught him, you & I. Now dear see what use you are."[59]

In the years that followed Harry Havemeyer's death, Cassatt continued to draw on her contacts with dealers, critics, agents, collectors, and artists to advance the Havemeyer collection, making sure always to stay informed about the art world and to keep abreast of opportunities on the market. She evaluated the artistic quality of any given work as well as its condition—whether it was in good shape or somehow damaged. Cassatt's advice often included her opinion on prices, based on her knowledge of the art market, and in some cases she negotiated the prices herself.[60] Sometimes she even knew of certain collectors' plans for a sale before the bid was announced, as in the case of the posthumous auction of the collection of Degas's friend Michel Manzi.[61] Cassatt always alerted Havemeyer ahead of time about important upcoming art auctions. Since she had personally visited the important collections of modern French art, years before they were auctioned off, and remembered specific artworks in them, she could notify Havemeyer in advance about the sale of specific works. Among the important auctions she informed Havemeyer about in advance were the 1912 auction of the collection of Henri Rouart—an industrialist, collector, painter, and good friend of Degas—where Havemeyer acquired Degas's *Dancers Practicing at the Bar* for 478,500 francs ($95,700 at the time, equivalent to about $3,029,000 in 2023), then a record price for a work by a living artist;[62] and the 1914 auction of the collection of Roger Marx—a museum administrator, an art critic, a collector, and a friend of Cassatt—where Havemeyer acquired Cassatt's painting *Woman with a Sunflower,* ca. 1905 (fig. 5.33), two Cassatt color prints, and Degas's *A Woman Having Her Hair Combed,* ca. 1886–88.[63] Of course, she also communicated with Havemeyer ahead of the 1918 auction of works

in Degas's studio following his death; at that auction, Havemeyer acquired Cassatt's painting *Girl Arranging Her Hair,* 1886 (fig. 3.2). Cassatt never recommended the buying of her own works when they were included in auctions of collections, partly out of a real modesty about her own work. As Havemeyer testified in her memoir, "One of her great charms was the contrast between her frank admiration of others and a timid, modest appreciation of herself."[64] Thus, when Havemeyer bought Cassatt's artworks, she did so on her own initiative.

Cassatt was also highly involved in the process that led to Havemeyer's extensive acquisitions of Degas's sculptures. Degas had worked on small-scale sculptural figures of horses and of women dancers and bathers throughout most of his career, investigating bodies, movement, gestures, and form. He modeled them in wax, clay, and plasteline, but never had them cast in bronze, treating them as private experimentations.[65] After he died, his heirs considered casting these sculptures in bronze, and Cassatt, who had an established relationship with Degas's niece, Jeanne Fèvre, was privy to these deliberations within the family. Fèvre visited Cassatt on several occasions to update her, heard Cassatt's opinion, and relied on her to convey information to Havemeyer. The Degas bronzes were posthumously cast by Adrien A. Hébrard, and in the spring of 1921 Cassatt viewed them at the Hébrard Gallery. Based on Cassatt's recommendation, Havemeyer cabled Hébrard about her intention to acquire a set, and in August of the same year, when she came to visit Cassatt after a long hiatus caused by the war, she finally saw the Degas bronze casts herself. She acquired the full set, which consisted of seventy-two pieces, becoming the first collector in the world to own them.[66]

Havemeyer's interest in Degas's sculpture had been sparked back in 1903, when Cassatt took her and her husband to Degas's studio. There, Havemeyer saw Degas's large wax sculpture *The Little Fourteen-Year-Old Dancer* and wanted to buy it, but Degas objected "on the pretext that the wax had blackened" and he wanted "to do it all over again."[67] After Degas's death in 1917, Louisine Havemeyer and Cassatt corresponded about this sculpture on numerous occasions, discussing its uncertain condition and changing price. Havemeyer decided not to acquire the wax "danseuse" sculpture, and Degas's heirs decided to have the sculpture cast in bronze.[68] Cassatt expressed to Havemeyer her exasperation over the heirs' decision to raise its price[69] and her hope that her influence with them would serve Havemeyer.[70] In 1922 Havemeyer finally acquired a posthumous cast of Degas's *The Little Fourteen-Year-Old Dancer* for one million francs (fig. 2.7).[71]

Cassatt and Havemeyer were intent on creating the best American collection of French painting compared with those of any other collector, male or female. But they nonetheless felt particularly competitive with women collectors, including the Bostonian Isabella Stewart Gardner and the French Nélie Jacquemart-André. Responding to a letter by Havemeyer that mentioned a disturbing visit by Gardner to the Havemeyer collection, Cassatt reassured Havemeyer that her collection was the best: "No my dear, you & I are about the only two, I saw no others . . . well Louie dear we

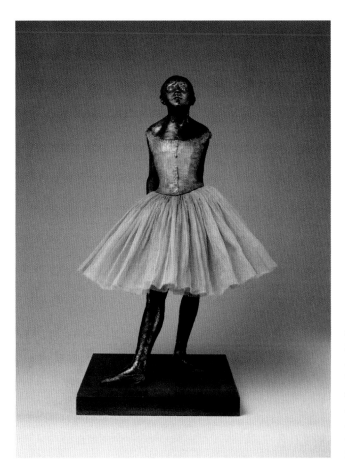

FIGURE 2.7

Edgar Degas, *Little Fourteen-Year-Old Dancer,* 1922 (cast), 2018 (tutu). Partially tinted bronze, cotton tarlatan, silk satin, and wood, 38.5 × 17.25 × 14.37 in. (97.8 × 43.8 × 36.5 cm). Metropolitan Museum of Art, New York, H.O. Havemeyer Collection. Bequest of Mrs. H.O. Havemeyer, 1929. 29.100.370.

two must just do the best we can, helped by men."[72] (This comment, from 1903, suggests that even during the lifetime of Harry Havemeyer, and despite her great respect for him, Cassatt considered the work on the Havemeyer collection to be primarily a collaboration between herself and Louisine.) Gardner, whose visit to the Havemeyer collection took place just one month after she had opened a private museum in Boston to house her collection, was eager to assess the competition. Havemeyer reported that Gardner had made her uncomfortable with her attitude that "she knows it all,"[73] and Cassatt in her response tried again to reassure her, intimating that this attitude was driven by envy: "Of course Mrs. Jack Gardner did not like to see the riches of your house."[74] Although Gardner did invite the Havemeyers to see her collection in Boston, she refused to admit them when they called on her.[75] Once again supporting her friend, Cassatt asserted Havemeyer's advantage by stating that Gardner had no understanding of the moderns. She mentioned as evidence for this Gardner's admiration of John Singer Sargent and of the society portraitists, the French Paul César Helleu and the Swedish Anders Zorn—none of whom Cassatt appreciated.[76]

As for Jacquemart-André, Cassatt discussed her in a 1913 letter to Havemeyer written soon after she visited the newly opened Musée Jacquemart-André.[77] With a similar mix of dismissing the competition and extolling Havemeyer, she noted that the collection "is of no great account[,] only very few fine things. . . . No my dear your collection is the one, this of the Andres has nothing of the nineteenth century French, and nothing very good in the eighteenth century. We will see it together in Paris, I hope."[78] Jacquemart-André, who died in 1912, bequeathed the collection and mansion in which it was housed to the Institut de France, as she and her husband, Edouard André, who had died earlier, had agreed to do. Before her marriage, Nélie Jacquemart had been a portraitist, who exhibited in the Salon during the 1860s and won a medal in 1870. Cassatt had heard from the "vendeuse" who served them both at the fashion house of La Ferièrre[79] that Jacquemart said "she was to be married and could then throw away her palette!"[80] Such a lack of commitment to one's art was offensive to Cassatt, who concluded that "she wasn't an artist."[81] This perception, along with her wish to reassure her friend, likely colored Cassatt's later evaluation of Jacquemart-André's collection.

Just a few years earlier, Havemeyer and Cassatt had felt victorious when the Havemeyer collection received special praise in a 1910 *New York Times* article that compared various American collectors. The article quoted extensively from Professor Ludwig Justi, an art historian and the director of the Berlin National Gallery (1901–1933), who had visited the most important private art collections in the United States, including those of Frick, Gardner, John G. Johnson, J.P. Morgan, Colonel Oliver Payne, Peter A.B. Widener, and Havemeyer.[82] He singled out Havemeyer's collection for its unique quality: "She has not a picture that may not be described as a gem. . . . Her gallery is a monument to American taste. I should call her one of the real pioneers of the art life of your country."[83] He also credited Havemeyer for "hanging her pictures in a perfectly ideal way, color schemes and lighting," adding that "most impressive of all was the fact that this place of treasures is ruled by a woman of real art understanding. Mrs. Havemeyer is artistic through and through. American womanhood has cause to rejoice in her."[84] In the unofficial competition among American collectors, Cassatt felt they had come out on top. When Havemeyer sent her a copy of the article, she responded: "The interview of Justi is but justice & I am very glad he spoke out. Won't it make Mrs. Gardner furious? Some other people too."[85]

Cassatt had experienced great difficulties since 1911 after her younger brother Gardner's unexpected death, suffering a prolonged depression during which she was unable to paint.[86] She wrote to Havemeyer about her "sleepless nights" and "being nervous about myself."[87] She was so affected that, although always eager to see Havemeyer in person, she asked her to delay her visit. When she returned to art making in 1913, Cassatt was impeded by old age and weakening eyesight. Nonetheless, she was determined to make progress. In July of that year, she was able to

do some work and showed a nearly finished pastel to Joseph Durand-Ruel, who wanted it.[88] In November she wrote, "My own pictures I am told are the best I have done."[89]

Cassatt's difficulty in continuing to make art roughly coincided with the outbreak of World War I. Living in France while it was attacked by Germany, she heard the cannons and felt isolated and despairing. In addition, she lost her closest source of support—Mathilde Valet, who had originally been employed by Cassatt's mother and continued to run Cassatt's household after her mother passed away. Valet had become a companion and almost like family to Cassatt during her later years, but as a German national, she was not permitted to stay in France during the war. Cassatt continued to pay her throughout the war years and visited her in various locations in Europe on several occasions.[90] Cassatt's staff, which normally included a cook, a driver, a chambermaid, one or two gardeners, and Valet, who oversaw them all, was now reduced to one Swiss chambermaid.[91] Cassatt was also greatly impacted by wartime restrictions on mobility, feeling "virtually in prison."[92] Trains were rare, and she had to overcome a lot of bureaucratic red tape and wait long periods to obtain permission to travel to her country residence.[93]

Havemeyer's letters were a lifeline for Cassatt during the war years: "I never felt so isolated in my life as I do now. Your letters are the things that made me feel not altogether abandoned."[94] The transatlantic distance coupled with the unreliability of the post, especially with the disruptions of war, caused delays and sometimes loss of correspondence. In response to Havemeyer's invitation to come to New York and get away from the war, Cassatt wrote in July 1918: "It is too dear of you to want me. Many times I wish I was over there. I am of no use here, how can I be? Yet I don't see how I can ever get away, just now not even from here."[95] In her typical openness with Havemeyer, she wrote: "I am so alone . . . Dearest Louie life is too much of a struggle now & oh! So wish I was at the end. My letters from friends are sad, the young in constant danger. When will it end?"[96] Confronting her mortality, Cassatt was at her most vulnerable in the letters from this period. In late November 1920 she wrote, "we die by the inches,"[97] and then quotes part of a long poem by Elizabeth Browning:

> I have lost oh! Many a pleasure
> Many a hope & many a power
> Studious health & merry leisure
> But the first of all my losses
> Was the losing of the bower.
>
> I have lost the dream of doing
> And the other dream of done.[98]

Although Cassatt was greatly impacted by her personal suffering, her "dimmed sight," feeling "helpless," and the experience of being "old and feeble,"[99] one of the most difficult aspects of her wartime experience was her awareness of the suffering of many others—the effect of the shortage of food on people with restricted means, the widespread destruction, the war injuries and deaths of soldiers and the deep effect of these on wives and whole families. Cassatt involved herself in various humanitarian causes to help locally in the communities she was living in—Paris, Mesnil-Théribus on the Oise, and Grasse in the South of France. She felt it was important for her to be useful, and suffered when she felt she was being useless while so many of her countrymen and countrywomen were joining the French war effort. Soon she involved Havemeyer, too, in the aid initiatives. In late 1914, writing to Havemeyer from Paris, she mentioned having given some money to a *soupe populaire* (soup kitchen) in Montmartre. Cassatt was always personally involved in the initiatives she supported, rather than just giving money, and in this instance she wrote to Havemeyer: "I am going to see all they are doing in Montmartre [about providing food]."[100] She also suggested that Havemeyer contribute "if you want to do some good."[101] Cassatt mostly helped children in need, including a group of blind children and a one-legged boy in Grasse who wanted to become an artist and whose pension she supplemented.[102] She also gave funds that enabled children from Paris to be sent to Brittany, noting: "Had it not been for the bombardment of Paris the poor little creatures would never have had these months by the sea. Surely our industrial civilization leaves much to be desired."[103] She reported receiving gratitude: "I get touching letters for the little I can do."[104]

Soon, Cassatt turned this, too, into a collaboration, finding causes for Havemeyer to give funds to, in addition to her own contributions (for example, to soldiers, who had "no pensions after giving service for years. Often their health is gone and they cannot work").[105] Cassatt wrote to Havemeyer: "I will try and find some interesting cases and give some of your money";[106] and a few months later: "I sent to the convalescent home at Grasse 1000 fcs half from you and half from me. I like to do things with you, and it has been tugging at my heart strings for some time that these poor boys may fall victims to tuberculosis just for the want of a little extra food."[107] With Cassatt's intervention, Havemeyer's money supported two blind boys. Cassatt had them over for tea and reported to Havemeyer good news about "your two blind boys, they are doing so well as masseurs, one making more money than they ever could have made before, and are happy."[108] She felt that "[t]he more one hears of money given the more one sees that small sums given personally are much more useful than these larger donations distributed one knows not how."[109] Cassatt acted as a kind of "agent" in finding cases for Havemeyer to support in France through direct donations of this sort. Meanwhile, Havemeyer was very active in her homeland during the war. She spoke widely to promote Liberty bonds, campaigned for a bill to give military rank to nurses, and recruited women to the land army throughout New York State. She became well known especially for the work she did to advance food conservation

for American soldiers, overseeing the production and shipment to France of twenty thousand pounds of jam in one year and thirty thousand pounds of jam the following year.[110]

During the war years, Cassatt continued to advise Havemeyer. From 1915 onward, when Cassatt's deteriorating eyesight prevented her from making art, the extensive energies she spent on advising Havemeyer no longer competed with her art making. By now in her seventies, Cassatt was still eager to make a contribution, and her letters make clear how important it was for her to feel useful. Immersion in all the work involved in advising Havemeyer on collecting was a welcome substitute for art making. Importantly, her collaboration with Havemeyer on the making of the art collection, intended for a major American museum, was also a way of realizing her commitment to her nation (this is discussed more extensively in chapter 7). From early on, she had imparted to the Havemeyers, with characteristic conviction and enthusiasm, her vision of creating the collection for the benefit of the American public and American artists. The dealer Ambroise Vollard recalled that Cassatt "had persuaded [Harry Havemeyer] that he could make no better use of his money, since his pictures were to enrich the artistic heritage of the United States."[111] Louisine Havemeyer joined Cassatt in impressing upon her husband the importance of this goal. For example, even though she realized that the mores of the time would not allow for Courbet's painting of a nude, *Woman with a Parrot*, 1866 (Metropolitan Museum of Art), to hang in their home, she pleaded with her husband to buy the painting, "just to keep it in America, just that such a work should not be lost to the future generations nor the students who might with its help, and that of other pictures, someday give national art to their own country."[112] This was the very argument Cassatt articulated on numerous occasions. It was thus through her friendship and collaboration on collecting with Havemeyer that Cassatt integrated her great passion for art and her loyalty to her homeland, uniting them into a single vision of contributing to the cultural life of the United States.

FRIENDSHIP, GIFTS, AND EXCHANGES

Today it is difficult to imagine that the kind of extensive, highly involved, skilled, and detailed professional work that Cassatt did for the Havemeyers would not be financially remunerated. At the time, it was not uncommon for American artists, including, for example, William Morris Hunt, William Merritt Chase, and John Singer Sargent, to lend their art expertise on occasions to American collectors,[113] but whether or not they were paid, Cassatt's case was exceptional even in those days primarily because her work with the Havemeyers was consistent and ongoing for several decades. Other art world personalities, like the French art critic Duret, advised Louisine Havemeyer, going through Cassatt as an intermediary, but unlike Cassatt, Duret received a commission, which, as Cassatt reminded Havemeyer, meant that he was not disinterested.[114] Cassatt was also not remunerated for her work for Durand-Ruel, the chief

dealer from whom the Havemeyers acquired art, or for Ambroise Vollard, the other prominent dealer of modern art.[115] This was Cassatt's choice. Laura D. Corey has suggested—accurately, I believe—that "Cassatt wanted to be perceived as a trustworthy advisor, not tainted by a financial stake in her recommendations," and that she was "too committed to her own principles" to be a representative of Durand-Ruel.[116] But as we shall see, some additional considerations were involved.

Like Louisine Havemeyer, Cassatt belonged to the American upper class. Splitting her time between her country château and rented apartment in Paris, supported by a house staff of several employees, she was partaking in a style of life associated with an upper-class bourgeois "lady." Yet her resources were far more modest than those of the extraordinarily wealthy Havemeyers and some other American friends she advised on collecting. Cassatt's choice not to receive financial remuneration for her work as advisor allowed her to keep her social rank and maintain an equal status with her advisees despite the great discrepancy of economic resources between them. Had she accepted payment for this work, their relationship would have turned into a commercial exchange. Moreover, Cassatt regarded her work with collectors as a mission rather than a mere job. She shared her great passion for art and her vision for the United States in a collaboration that was to become a gift to her nation.[117]

Thus, although Cassatt happily accepted gifts from the Havemeyers over the years, she objected to receiving money. When Louisine offered Cassatt financial help during the difficult war years, Cassatt responded: "No dear I don't need money, for I still have 25000 fcs in [the] bank and all my debts are paid."[118] Throughout the years, the Havemeyers and later Louisine on her own expressed their appreciation and gratitude for Cassatt's work by sending her numerous gifts, such as vases and bowls from their collection of Asian ceramics.[119] On one occasion, they sent her a Japanese comb she had admired, and Cassatt wrote back to Louisine: "My comb dear Louie, to come to decorative Art, is really a gem, far too fine to wear, it ought to be in a cabinet. Thanks a thousand times for the lovely present, I will paint it in a models hair if I find one with hair *properly washed!*"[120] In late November 1914, Louisine Havemeyer sent Cassatt a tea service, which brought her great solace.[121] Every Christmas, the Havemeyers sent Cassatt festive food items, such as pheasants.[122] On various other occasions, too, Louisine sent food items, including candy, pâtés, and mint, which Cassatt "generously but reluctantly" shared with her visitors;[123] and mindful of Cassatt's health needs, she often sent various kinds of nuts and fruit.[124] The food items Havemeyer sent had the added value of reminding Cassatt of American flavors. Cassatt, too, sometimes sent the Havemeyers gifts with friends who crossed the Atlantic: for example, she sent Greek snake bracelets with Sarah Choate Sears, who was returning to New York.[125]

One gift stands out from the rest. In 1906 the Havemeyers gave Cassatt a twenty-horsepower Renault limousine-landaulet. Possessing an automobile was still rare, and the experience of "motoring" was new and exhilarating. Illustrated posters, which

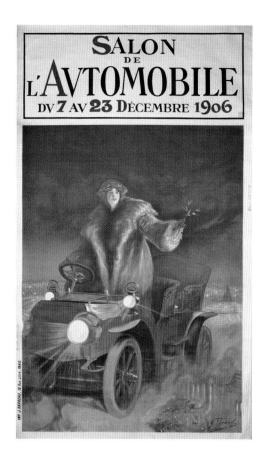

FIGURE 2.8

Georges Picard, *Salon de l'Automobile*, 1906. Imp. J. Barreau, Paris. Poster, lithograph. 79.92 × 46.85 in. (203 × 119 cm). Bibliothèque Historique de la Ville de Paris, 1-AFF-002173.

were the primary form of image-centered advertising at the time, give a sense of the status of this new form of luxurious individual transportation. A 1907 French poster by Louis Foret, *Automobiles Renault*, placed the Renault convertible in nature, highlighting the car as a luxury vehicle for recreation, and referred to its speed by showing a small airplane in the sky. Georges Picard's 1906 French poster *Salon de l'Automobile* advertised an automobile show in the Grand Palais by depicting a woman cloaked in a gigantic fur coat and donning a pair of aviator goggles pushed back above her forehead, standing in a red convertible with one hand on the wheel (fig. 2.8). A modern woman with short reddish hair, she embodies an imaginary consumer cast as a contemporary goddess of speed and luxury.

Cassatt converted the stables at her country residence into a garage and kept a chauffeur on her permanent staff, insisting that he maintain the car in excellent condition. She used the same Renault for twenty years, until her death.[126] Her driver shuttled her between her residence in the countryside and the Paris apartment, and also drove her to the South of France, where she spent winters. Beyond this, "motoring" was part of her regular regime—she rode for pleasure and for the healing effects of the air, wind,

speed, and mobility. In February 1912, at a time when she was attempting to recover physically and mentally after her brother Gardner's death, Cassatt wrote from Cannes: "The motoring here is wonderful & when the weather is possible I am at it all the time."[127] A few weeks later, still not well enough to work, she wrote: "When I am not eating or sleeping, I am out in a motor."[128] When, in early 1912, she felt "very depressed," one of her doctors suggested that motoring was "by far the best thing" for her.[129]

But the benefits to Cassatt from her enormous work on the Havemeyer collection went far beyond a stream of material gifts. First, there was the gratitude, which was very important to her. She liked to help a wide range of people, from her staff and their family members or children in her village to the major French dealer Durand-Ruel when he was in financial trouble, American artists coming to France for their art education, and American collectors. On several occasions, she complained that people she had helped did not express gratitude and that those who did were in the minority.[130] She wrote to Havemeyer: "Yes I like to help people but they might acknowledge it. You, you dearest Louie write too much of what I have been able to do for you."[131] Havemeyer indeed expressed her gratitude profusely in her letters to Cassatt, and she also acknowledged her in her memoir, describing Cassatt as her "inspiration" and "guide" and "the god-mother" of her collection.[132] As much as Cassatt appreciated personal gratitude, however, she objected to public mention of her work with the Havemeyers on collecting. When Duret brought her a copy of his 1910 book on Manet and the Impressionists, in which he notes in passing that the Havemeyer collection "was formed partly with the advice of their friend Miss Mary Cassatt,"[133] she wrote to Havemeyer: "Now why did he think it necessary to refer to our affairs? Mr. Havemeyer & you appreciated the full everything I was able to do for your collection, it was no one's business except just we three, how tactless to put that in a book. But he isn't delicate."[134] Cassatt was shocked to see her role in advising the Havemeyers appear in print for the first time, because even though her advising was ultimately for a public cause, to her it was part of a private friendship. Her reaction underscores her extreme preference for privacy.

Second, she benefited simply by honing her abilities. As she wrote to Havemeyer: "The constant preoccupation about your collection developed my critical faculty."[135] She also found the practice of scrutinizing works for acquisition "an excellent wit sharpener, good for an artist."[136] Viewing masterpieces in museums and private collections inspired and stimulated her desire to create great art, though she also sometimes found it daunting. On some occasions, she believed that her encounter with a particular work had a direct impact on her work, as in the case of a French Gothic sculpture, *The Saint* (acquired by Havemeyer based on Cassatt's recommendation): "To tell the truth I find my profit in studying these things, the sincerity of them, give me courage. I took two pictures to town with me & D.R. said one was the best picture I ever did, that I owe to the Saint bless it."[137]

Another important benefit to Cassatt from her ongoing complex exchange with Havemeyer was the expansion of her social network and enhancement of her status in

the Parisian and transatlantic art worlds. By becoming a crucial link between French dealers and important American collectors, Cassatt gained a position of power in the art world, thereby also adding to her own recognition as an artist. Although she certainly deserved the exhibitions of her work at major galleries based on its merit, her role as art advisor gave her clout that dealers may sometimes have considered in organizing exhibitions of her work. It also affected her status in the eyes of artists such as Degas and Pissarro, and generally added to her prestige on both sides of the Atlantic.

Aside from Havemeyer's gifts to Cassatt, she supported Cassatt's art in several ways. She acquired artworks by Cassatt (usually from Durand-Ruel) and included some of them in her bequest to the Metropolitan Museum of Art. She organized a large museum-scale exhibition in a New York gallery in 1915 featuring Cassatt alongside Degas and some old masters (the topic of chapter 6). She lent out works by Cassatt from her own collection to exhibitions. She also devoted a chapter of her memoir about collecting to Cassatt.[138] Havemeyer promoted Cassatt's art whenever possible—for example, when traveling to Chicago in late 1910, she discussed Cassatt's work with officials at the Art Institute of Chicago.[139] She also gave talks on Cassatt's art—for example, at a large exhibition of Cassatt's graphic work at the Grolier Club in New York (on February 12, 1921).[140] Havemeyer's interest in Cassatt's art and her support of her friend meant that she would travel out of town when necessary to view an exhibition in which Cassatt was participating. In 1920 she traveled to Philadelphia to see the *Exhibition of Paintings and Drawings by Representative Masters* at the Pennsylvania Academy of the Fine Arts, where a room was devoted to Cassatt's work. This meant a lot to Cassatt, especially because of her disappointment and offense at the fact that her own family, despite living in Philadelphia, did not come to the exhibition.[141]

Perhaps the greatest rewards Cassatt received for her work with Havemeyer were the friendship itself and the satisfaction of having helped make the collection. Responding to a letter from Havemeyer, she said of her work on the collection, with characteristic modesty: "It is a great consolation to think that I have been of some use in the world. Just think what it has been for me to have known you and Mr. Havemeyer."[142] Consistent with her spiritual beliefs, Cassatt viewed the friendship with Havemeyer and their collaborative work on the collection in terms of destiny: "If you are destined to do something you meet the people who can help you. Now you are destined to accomplish something & I have probably been a help, just as you & Mr. Havemeyer have been to me."[143]

FEMINIST ALLIANCE: SUPPORTING SUFFRAGE, 1909–1924

From 1909 onward, Cassatt's and Havemeyer's common passions broadened to include women's suffrage and full emancipation. When Cassatt first suggested to Havemeyer that she work for women's suffrage, she wrote that suffrage "means great things for the future."[144] At the time, she urged Havemeyer to pursue this cause not only because she

cared about it deeply but also because she believed such an engagement would support her dear friend's then fragile mental health. In 1908, in the aftermath of Havemeyer's unbearable losses—the death of her husband, followed by the death of her mother and twin grandchildren—she attempted to take her own life. Cassatt sensed that Havemeyer needed a new purpose in her life and an outlet for her considerable energies. In later years, Havemeyer would describe Cassatt as "an ardent suffragist" who was "always stimulating me to renewed efforts for the cause."[145] Cassatt's urging resonated with Havemeyer partly because Havemeyer's own mother had supported emancipation and was friends with the pioneers of the movement. As Havemeyer recalled, "Susan B. Anthony and Lucy Burns were familiar names to me in my childhood."[146] From 1910 onward, Havemeyer became more and more involved in working for suffrage.[147]

The Cassatt-Havemeyer friendship now became an explicitly feminist alliance. Earlier on it had been implicitly so, as these two women supported each other in accomplishing important work, apart and together, transcending the strictures that governed the lives of most women of their class. Cassatt and Havemeyer were united in their deep commitment to suffrage and women's full emancipation, and they shared a decisive position against the American anti-suffragists. Cassatt's tone in a 1910 letter to Havemeyer that mentions suffrage clearly suggests their agreement on the topic: she writes about the head of the anti-suffragists in New York who "thought it unnecessary for women to vote in America, even though paying taxes, 'because they could influence men.' I hope you are laughing."[148] Whereas collecting was a common transatlantic project, suffrage was a cause that Havemeyer worked for in the United States without Cassatt. Living in France, Cassatt could not actively participate in working for suffrage with Havemeyer, but she did take a great interest in the progress of the cause and in Havemeyer's opinion on it. For example, in March 1913 Cassatt wrote: "Tell me about the suffrage question, I thought New York was only waiting for the Governors assent."[149]

Cassatt followed reports on suffrage news in the United States in the *Paris Herald*, which was a Paris-based international edition of the *New York Herald*, and was particularly interested in Havemeyer's own participation in suffrage-related activities. In May 1913 she wrote to Havemeyer:

> I have just been reading an account of the suffrage parade in New York, and did not find your name among the paraders, so I conclude you had duties other where. I hope all has gone well, but I am anxious for news. The parade must have been a pretty sight, it is a pity the "antis" [the anti-suffragists] showed their disapproval openly, when the parade passed their headquarters.[150]

The 1913 parade was larger than that of the previous year, which had attracted twenty thousand marchers and half a million people on the sidewalks.[151] In her next letter, having apparently been updated by Havemeyer that she had in fact joined the parade, Cassatt expressed her optimism and her support for Havemeyer's participation: "I am

glad you walked in the procession . . . I think the vote for women is surely coming. The 'antis' had better prepare for it, instead of standing in the way."[152]

Havemeyer wrote to Cassatt about her activities, including speaking publicly for suffrage, as indicated by Cassatt's response of November 1914 that refers to "your musicale & your speech."[153] Cassatt also tried to glean more information from family members and common friends, like the architect Theodate Pope, who visited Cassatt in 1915 and later mentioned in a letter to Havemeyer that Cassatt "was so keenly interested in your speaking for the suffrage."[154] Initially hesitant about speaking in public, Havemeyer gradually gained confidence and became a seasoned speaker. Cassatt was eager to contribute to the contents of her speeches as much as she could from afar,[155] and as an avid reader, she mined books for ideas that Havemeyer could use in her speeches. In 1917, for example, she recommended that Havemeyer read a book about the French naturalist Jean Henri Fabre, in whom she had taken an enthusiastic interest,[156] remarking: "He thinks that the emancipation of their [women's] sharing political power will abolish war. You must read what he says. . . . You can use his ideas in your speeches."[157]

In 1912 and again in 1915, Havemeyer integrated her passion for collecting with her advocacy of suffrage by organizing exhibitions in support of the cause. She stated: "It goes without saying that my art collection also had to take part in the suffrage campaign. The only time I ever allowed my pictures to be exhibited collectively was for the Suffrage cause."[158] Havemeyer's political and activist work for suffrage intensified in the period leading up to the ratification (in August 1920) of the Nineteenth Amendment, and her work for women's full emancipation continued thereafter. Having just recently joined the ranks of activists in the National Woman's Party (NWP), she took a leading role in the events that celebrated the successful outcome of the NWP's suffrage campaign. In May 1922 she presided over the elaborate ceremony of the dedication of the party's permanent headquarters facing the Capitol in Washington, a dedication that was attended by politicians and foreign dignitaries and was widely reported in the press. Havemeyer also contributed money to the party and lent her home for a meeting of its National Advisory Council and for fundraisers.[159] She worked on all aspects of the campaign and at all levels, from licking stamps and addressing envelopes to lobbying legislators and contacting officeholders, presidents, and governors.[160] Havemeyer also negotiated with the Smithsonian Institution about accepting materials on the NWP campaign. In general, she was a great problem solver for any issue that came up. To give just one example, when a large temporary storage place was needed for the twenty-six-thousand-pound marble monument carved by Adelaide Johnson of the three pioneering suffrage leaders, Elizabeth Cady Stanton, Susan B. Anthony, and Lucretia Mott, which the NWP presented as a gift to the US Capitol, Havemeyer secured the Washington, DC, studio of the American-born Beaux-Arts sculptor Paul W. Bartlett (who lived most of his life in France).[161] Remarkably, Havemeyer juggled intensive political work with art collecting activities and all the while continued to support Cassatt's art.

FIGURE 2.9

Mary Cassatt, *Portrait of Mrs. H. O. Havemeyer*, 1896. Pastel on wove paper, mounted on canvas, 28.75 × 23.5 in. (73 × 59.69 cm). Collection of Shelburne Museum. Gift of J. Watson Webb Jr., 1973-94.2.

In 1896 Cassatt created *Portrait of Mrs. H. O. Havemeyer* during Havemeyer's visit, completing it after her departure with the aid of a photograph (fig. 2.9). Despite their long years of friendship, she chose not to represent an intimate viewpoint of a "private" Louisine, instead portraying her as an authoritative figure, sitting erect with a pensive, serious expression.[162] As Linda Nochlin notes, Cassatt represents Havemeyer "as uncompromisingly unglamorous" and as a "forceful individual character usually

FIGURE 2.10

Mary Cassatt, *Woman in a Loge*, 1879. Oil
on canvas, 32.6 × 23.44 in. (81.5 × 59.53 cm).
The Philadelphia Museum of Art. Bequest
of Charlotte Dorrance Wright, 1978.
1978-1-5.

reserved for the male sitter, rather than the conventional beauty and elegance consid-
ered appropriate to the upper-class female one."[163] Havemeyer is wearing an elegant
evening gown, signaling her high social status, but with no displays of excessive wealth,
such as expensive jewelry. Havemeyer's voluminous dress with puffed sleeves, which
were fashionable in the 1890s, lends her a literally grand presence. Through this extra
volume and by depicting Havemeyer from close-up so that she takes up the entire
space of the picture, Cassatt leaves no room for a domestic interior to contain her
subject. Cassatt depicted the fan—usually an accessory to fashionable femininity in the
theater and opera—in a highly unusual way, turning it into a sign of power: the closed
fan looks like a baton or "a queen's scepter."[164] Moreover, Havemeyer presses it firmly
against the fabric of her dress in a decisive gesture that expresses determination and
agency. Her other hand energetically grasps the sash of her dress. These vigorous ges-
tures are markedly different from the delicate handling of fans in the hands of elegant
women, mature and young alike, in countless Impressionist paintings—including Cas-
satt's own *Woman in a Loge*, 1879 (fig. 2.10). Havemeyer's grip on the fan evokes an
authoritative presence, as befits a confident major collector.

FIGURE 2.11
John Singer Sargent, *Isabella Stewart
Gardner,* 1888. Oil on canvas, 74.8 × 31.5 in.
(190 × 80 cm). The Gardner Museum,
Boston, P30w.1.

FIGURE 2.12

Anders Leonard Zorn, *Mrs. Bertha Honoré Palmer*, 1893. Oil on canvas, 101.6 × 55.6 in. (258 × 141.2 cm). Art Institute of Chicago, Chicago, Potter Palmer Collection, 1922.450.

This rare case of depicting a woman as a powerful person is starkly different from society portraits of other important American women collectors of the time, such as Sargent's 1888 portrait of Gardner (fig. 2.11). Sargent shows Gardner's full feminine body and glorifies her by forming a halo around her head with the decorative background. Cassatt's portrait of Havemeyer also differs greatly from the Swedish artist Anders Zorn's portrait of the prominent collector of Impressionist painting Bertha Honoré Palmer (fig. 2.12), in which he elevated Palmer to the status of royalty by

depicting her holding a scepter and with a tiara on her head. Clothed in elegant evening garb and adorned by a two-string pearl necklace, Palmer stands in front of a wall hung with paintings, presumably from her collection. Zorn was commissioned to do the portrait by the Board of Lady Managers of the Woman's Building at the 1893 Chicago World's Fair. Palmer was the president of this board, heading the enormous project of exhibiting the work of women in art, craft, and culture around the world. (She also commissioned Cassatt's mural for the Woman's Building, discussed in chapter 5.) In contrast to Cassatt's portrayal of Havemeyer, both the Sargent and the Zorn portraits have the distinct air of society portraits.

Cassatt painted the portrait of the forty-one-year-old Louisine Havemeyer during the period when she and her husband were in the process of becoming "the most active collectors of modern French art in America."[165] She valued the weight of accomplishment and maturation of character as most important in portraying a woman such as Havemeyer, and therefore represented her as the historical figure she knew her friend would become.

THE FINAL YEARS, 1923–1926

In late 1923, a painful break occurred in the Cassatt-Havemeyer friendship. The seventy-eight-year-old Cassatt and the sixty-eight-year-old Havemeyer now had five decades of close friendship and collaboration behind them (fig. 2.13 and fig. 2.14). Having lost most of her eyesight, Cassatt had become entirely dependent on her housekeeper and companion, Valet, and on the judgment of those around her. The incident that led to the rift between Cassatt and Havemeyer began when Valet found twenty-five old copper drypoint plates stored in a closet in Cassatt's home and thought that they had never been printed before. Cassatt then asked the son of the late Auguste Delâtre, the noted engraver, who had been her printer, to judge the plates.[166] She had him pull proofs from the plates, and since he was satisfied with their quality, instructed him to print several editions.[167] Cassatt sent two sets to Havemeyer for the purpose of showing them to William Ivins, the print curator of the Metropolitan Museum of Art, with the idea that if the museum was interested, one would be for exhibition and the other for purchase.[168] Havemeyer informed Cassatt that Ivins recognized the prints as proofs from worn-out plates, and she suggested that Cassatt had been misled by the printer or by Valet. Cassatt became incensed, convinced that her own integrity was being questioned and that Valet was being made a scapegoat.[169] She expressed her rage at Havemeyer in letters to Joseph Durand-Ruel; Frank Weitenkampf, the print curator of the New York Public Library; and Harris Whittemore, the industrialist and collector of Impressionist paintings.[170] To Joseph Durand-Ruel she wrote: "I have broken off completely with her";[171] and to Whittemore: "Of course all is over between us."[172] For her part, Havemeyer did not air her sentiments with others, which surprised Cassatt, who wrote to Joseph Durand-Ruel: "I will never forgive that poor woman, she didn't utter a word, make a gesture, nothing that one might have expected. But since she had

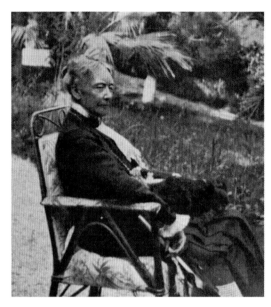

become a politician, journalist, speaker, she is no longer anything."[173] Cassatt's scornful comment reveals that a deep anger had turned her former high esteem for Havemeyer into disdain.

How to interpret this break? It may be, as Frederick A. Sweet, Cassatt's first American biographer, suggests, that Cassatt's emotional resilience was affected by age, disease, and the war.[174] Yet according to the preeminent Cassatt scholar Nancy Mowll Mathews, Cassatt "remained vigorous both mentally and physically into her eighties," and "the older Cassatt got, the more firmly rooted was her self confidence."[175] Nonetheless, Cassatt was clearly in a vulnerable position because of her dependence on those around her. One reason it was difficult for her to admit that she may have been wrong was that this would imply blaming Valet, the person on whom she counted for help with everything in her daily life. Cassatt perceived the fact that Havemeyer did not defend her before Ivins as a deeply hurtful betrayal, and she went on a fierce attack. To her, this was a disloyalty she could not bear. She wrote to Joseph Durand-Ruel: "I have a letter from Mrs. Havemeyer. It seems that Mr. Ivins has no desire to exhibit my drypoints, according to him inferior, the plates worn. Mrs. Havemeyer didn't say a thing. She accepts Mr. Ivins' opinion! . . . Strange way to treat a friend."[176]

But there were also other factors, more deep-seated, that contributed to the break between Cassatt and Havemeyer, and they have been overlooked. Cassatt had strong reservations about Havemeyer's increased immersion in politics. Before the break, in 1919, she wrote to Jane Miller (the daughter of one of her doctors, Louis Moinson): "I hear very often from Mrs. Havemeyer who has often given me news of you but she is immersed in politics which I greatly regret, not that I am not strongly for suffrage, but there are limits."[177] Havemeyer became more militant and more involved in politics than Cassatt could ever have imagined, and she felt uncomfortable about it.[178] In her 1924 letter to Joseph Durand-Ruel, Cassatt wrote: "To console me she [Havemeyer] assured me that my well-known name was to be used by their political party! I had written earlier to say that I absolutely disapprove of their ideas."[179] This was not merely a difference of opinion on how to support suffrage, but a shift in values and priorities that had deep emotional resonance: Cassatt registered a growing distance between herself and her closest friend. Havemeyer did continue to collect and seek Cassatt's advice until their breakup, but the fact that she was so deeply engaged in political activism meant that she was no longer primarily a collector devoted to collecting art, the project on which the two friends had collaborated for decades.

Havemeyer's militancy must have stood out for Cassatt in the spring of 1922, when she no doubt read Havemeyer's two-part article "Memories of a Militant," printed in *Scribner's* in the May and June issues.[180] As the accompanying notes about the author stated, Havemeyer's essay was "the first intimate account of a series of exciting and spectacular episodes in the fight for woman's suffrage."[181] Cassatt in all likelihood not only disagreed with certain militant actions in which Havemeyer engaged and which were described in the articles, but as a strong believer in the importance of privacy she would also have had a hard time with Havemeyer's choice to publicize them. Havemeyer's identity as an activist was made all the more palpable—and public—by the photographs that accompanied the articles; one photo showed her passing the torch of liberty to the suffrage representative of New Jersey (fig. 2.15), and another was a portrait of Havemeyer holding the torch of liberty, looking more like a seasoned fighter than a respectable pillar of high society (fig. 2.16). These articles and photos were proof that Havemeyer now moved in a very different world from Cassatt's. They made it crystal clear that Havemeyer had undergone a transformation during more than a decade of campaigning for suffrage.

A fracture was also noticeable around Cassatt's and Havemeyer's differences on the peace terms at the end of the war. Although during the war Cassatt and Havemeyer were in agreement and even collaborated on providing financial support to humanitarian causes in France, they held different political positions on the appropriate terms for peace. This discord was quite upsetting to Cassatt, as she expressed in her letter to Havemeyer of May 1919:

FIGURE 2.15
Louisine Havemeyer campaigning, passing the Torch of Liberty to a member of the New Jersey branch of the Women's Political Union, August 7, 1915. Photograph. "The Suffrage Torch, Memories of a Militant," *Scribner's Magazine*, May 1922.

> I felt so badly when I read your letter as to the Peace terms! How little we are in accord. How little you feel as I do, as *all* my friends feel. It is the *ruin* of France. This exhausted nation, exhausted in men and money, to keep a great army on the frontier for years. . . . You talk sentimentality but revenge & hatred don't pay.[182]

Although Cassatt's identification as an American did not falter, she understood the situation in Europe at the end of the war quite differently from Havemeyer simply because she experienced the conditions on the ground.

Their disagreement over the war also intersected with their tensions over how to fight for suffrage. Havemeyer belonged to the NWP, which concentrated on passing the federal amendment for women's suffrage, instead of seeking state-by-state votes. When World War I broke out and pressure mounted to be "patriotic" by focusing exclusively on the war effort, the party refused to cede the priority of obtaining suffrage. After over four decades of campaigning through speeches, parades, pageants, lobbying, petitioning, and inventing all kinds of publicity stunts, the leaders of the NWP realized that the time had come to wage their campaign differently.[183] When the Democratic president Woodrow Wilson failed to secure the last two votes needed to support suffrage in the Democratic-controlled Senate, the NWP organized substantial picketing in front of the White House—the first protest ever to be held there. From January 1917 onward, over two thousand women from thirty states came to

Washington, DC, to participate in picketing shifts, demonstrating against President Wilson in front of the White House, in all weather conditions. Protestors torched copies of the president's speeches extolling democracy, to symbolize that they had turned out to be empty words. A photograph from January 1919 shows the watch fire, a woman standing by the NWP's flag, and two women in front of a banner denouncing Wilson (fig. 2.17). The banner charged that Wilson was "deceiving the world," posing as "the prophet of democracy" in wartime Europe while back home he opposed those who demanded democracy, and that he was responsible for the disenfranchisement of millions of Americans. On June 20, 1917, the police began arresting women at the White House demonstrations.[184] In November of that year, Alice Paul, the chairwoman of the NWP who was serving a seven-month jail term for demonstrating at the White House, went on a hunger strike.[185] These NWP strategies were based on those of the militant British suffragettes, with whom Paul had worked while she was in Britain. Cassatt strongly disagreed with these methods (I return to this in chapter 4).

In 1918 Havemeyer, too, picketed in front of the White House, and she struck a match to burn an effigy of Wilson, "a small cartoon of the President, making some unkept promise as usual."[186] Then she delivered a speech:

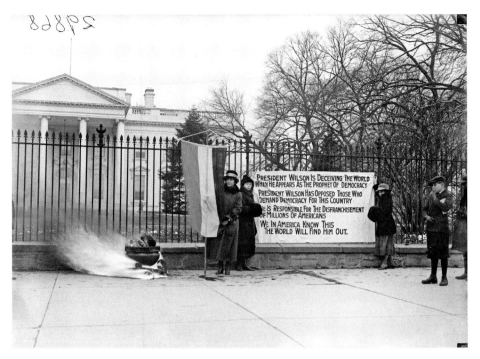

Harris and Ewing, *Members of the National Woman's Party Picketing President Woodrow Wilson in Front of the White House*, 1918. Photograph from glass negative, 5 × 7 in. (12.7 × 17.78 cm). Prints and Photographs Division, Library of Congress, Washington, DC, Harris & Ewing Collection, LC-H261-29868.

> Every Anglo-Saxon government in the world has enfranchised its women. In Russia, Hungary, in Austria, in Germany itself, the women are completely enfranchised, and thirty-four are now sitting in the new Reichstag. We women of America are assembled here today to voice our deep indignation that while such efforts are being made to establish democracy in Europe, American women are still deprived of a voice in their government here at home.[187]

At this point in her speech, she was arrested. Havemeyer chose to go to prison rather than pay a $5 fine. Her arrest made front-page headlines in the news, and later on, describing this moment in the *Scribner's* articles, she admitted that "it was hard for my children to read in the morning papers that their little mother was in prison."[188] Cassatt would not have missed those headlines. She surely would have opposed Havemeyer's choice to go to prison and concurred with most of Havemeyer's family members, who were greatly disturbed by her imprisonment and besieged her with telegrams demanding that she pay the fine and return home.[189] Some of these relatives were sincerely concerned for her welfare, but many of them conveyed their horror at the damage caused to the family's reputation. Cassatt, who never experienced being an activist herself and was likely also influenced by the more conservative French

environment in which she lived, was leery of militant activism. Her raging letter to Whittemore in 1924 about the matter of the disputed print edition also shows that she was worried about potential damage to her own reputation by her name being linked to militant suffrage activities: "In case you should hear that I am a mad suffragette please don't believe it. I have allowed Mrs. Havemeyer to use my name far too freely but as soon as I knew what her party was about I withdrew my name."[190] For Cassatt, the longtime unqualified mutual support between herself and Havemeyer, their solidarity, alliance, intellectual cohesion, emotional closeness, and adherence to a common standard of decorum—all of these were now fractured.

There was yet another factor that contributed to the distance between Cassatt and Havemeyer: the lack of opportunity to talk face-to-face for seven full years (between 1914 and 1921, and again, after Havemeyer's last visit in late summer and fall of 1921). This long stretch must have added to Cassatt's brewing resentments and facilitated misunderstandings between the two friends. The amendment guaranteeing American women's right to vote was ratified on August 26, 1920. In early September of that year, Cassatt was hopeful that she would soon see Havemeyer, writing to her: "Keep well Louie dear, now you can have time to rest."[191] She did not realize at that point that rest from political activity was not on Havemeyer's agenda.

The fact that Havemeyer did not rush to France to visit Cassatt as soon as suffrage had been won must have been a great disappointment for Cassatt. She likely felt that their friendship was taking a back seat to Havemeyer's life of political action. After the vote for women was won, the NWP adopted a new goal—the Equal Rights Amendment, drafted by the party's leader Alice Paul and first introduced to Congress in December 1923.[192] The seventy-year-old Havemeyer took on a strenuous schedule of appearances, traveling, speaking, giving interviews, and lobbying politicians for the amendment. Her intensive involvement in campaigning prevented her from visiting Cassatt until 1921, a full year after the passage of suffrage. Moreover, whereas in previous years there had been a significant overlap in Cassatt's and Havemeyer's networks, now Havemeyer was part of a network of feminist political activists, none of whom Cassatt knew. As Havemeyer stated, the NWP opened up for her a "new world of women . . . I am glad to have known them, and I feel privileged to be counted as one of the party workers—one of them."[193] A photograph of Havemeyer shows her in a group photo with members of the NWP congressional campaign in New York in 1916 (fig. 2.18). Cassatt must have felt left out, and that her close friend had become a different person through the process of her activism. All these factors no doubt contributed to the breakup of 1923.

Near the end of 1925, Havemeyer took the first step toward reconciliation with Cassatt. Feeling her own mortality as she convalesced from an injury caused by a serious fall, she wrote to Cassatt and Valet. She received answers from both, though the several handwritten pages by the nearly blind Cassatt were mostly indecipherable.[194] After that correspondence, Valet kept Havemeyer abreast of Cassatt's condition,

informing her in the spring of 1926 that Cassatt had been very pleased by Havemeyer's letter and had said: "Yes, you are right, Mrs. Havemeyer is my best friend."[195] Cassatt and Havemeyer never saw each other again after 1921. Cassatt died at age eighty-two on June 14, 1926. Havemeyer wrote to Durand-Ruel: "Her death is a very, very sad loss to me. It is the breaking of a lifelong friendship."[196] She sent Valet money to plant trees by Cassatt's tomb.[197]

Havemeyer supported the *Mary Cassatt Memorial Exhibition,* held at the Museum of Art in Philadelphia in the spring of 1927, by lending five works from her collection. On this occasion, she let her name be listed among the lenders, in contrast to her usual practice of lending art anonymously.[198] She also gave the organizers her writings on Cassatt. In the spring of 1928, after recovering from a mild stroke the previous year, Havemeyer sailed to France. She visited Cassatt's grave at Mesnil-Théribus and placed on it red roses, which were Cassatt's favorite flowers.[199] Of her lifelong emotional bond with Cassatt and what it meant for her, Havemeyer rarely spoke as personally as she did in a lecture she gave on April 20, 1920, to women artists at the National Association of Women Painters and Sculptors in New York, where she described the effect of Cassatt's letters on her:

> I cherish the letters which only I can read. I believe I could read them in the dark, part by feeling. I have learned to type mine and one can constantly hear the click click as I keep her in touch with all that is going on about me. The end I trust is far off, but short or long the joy and gladness of our lifelong friendship will make the close bright for us, come what will. Memory, the staff of the old, will sustain us.[200]

Equal Rights

VOL. XIV, No. 52
FIVE CENTS

SATURDAY,
FEBRUARY 2, 1929

Mrs. Henry O. Havemeyer

Veteran Feminist and devoted member of the National Woman's Party, who died at her home in New York City on January 6, 1929. She was a valiant worker for woman suffrage and for Equal Rights, and her memory will always be cherished by the members of the National Woman's Party.

FIGURE 2.19

Cover of *Equal Rights* commemorating Louisine Havemeyer, February 2, 1929. Box OV 43, folder 8, group V. Printed Matter. *Equal Rights*, 1927–1929. National Woman's Party Records. Manuscript Division, Library of Congress.

Havemeyer died at age seventy-eight on January 6, 1929, in her home in New York. A eulogy published by the New York branch of the NWP acknowledged "the tremendous impetus she gave to the passage of the suffrage amendment and to the Equal Rights movement."[201] *Equal Rights*, the journal of the NWP, commemorated Havemeyer by putting a photograph from her later years on the cover of its February 2, 1929, issue (fig. 2.19). The caption reads: "Veteran Feminist and devoted member of the National Woman's Party. . . . a valiant worker for woman suffrage and for Equal Rights."

3

CASSATT AND DEGAS

Camaraderie, Conflict, and Legacy

The distinguished person and her friendship on which I pride
myself.

EDGAR DEGAS (ON MARY CASSATT, [1879])

Degas died at midnight. . . . I am sad, he was my oldest friend here,
and the last great artist of the 19th Century.

MARY CASSATT, [1917]

―――――――

CASSATT'S FRIENDSHIP WITH DEGAS, which began in 1877
and lasted until his death in 1917, was one of the two most
important friendships of her life (the other being with
Louisine Havemeyer). Yet for many years, a slanted narrative pre-
vailed in art historical scholarship that obscured this fact. On the
one hand, Degas literature overlooked or drastically minimized
his friendship with Cassatt; and on the other hand, much of the
Cassatt scholarship tended to exaggerate Degas's role in her life
and career while misrepresenting it in several ways, all of which
cast her as his follower rather than as a friend and an artistic col-
league.

So, for example, the scholarly exhibition catalogue of a preem-
inent Degas exhibition held in 1988 mentions the artist's friend-
ship with Cassatt only in a catalogue entry for an artwork by
Degas for which she modeled.[1] Even a chapter on Degas's "Artist
Friends" in a biography of Degas mentions Cassatt only as an
aside in discussing other Degas friendships.[2] More recently, in a
2005 volume on Manet, Morisot, Degas, and Cassatt, none of the

eight chapters devoted to Degas considers the two artists' relationship, but a full chapter (of a total of only three) on Cassatt is devoted to her relationship with Degas.[3] With rare exceptions, scholarship on Degas does not investigate the importance of Degas's relationship with Cassatt, resulting in a belittling of both the friendship and Cassatt's status.

Much of the writing on Cassatt, meanwhile, has been plagued not merely by the converse tendency to give disproportionate place to Degas's role (in a 1975 Cassatt biography, over 130 pages—covering the bulk of her career—are grouped under the title "Art and Degas"),[4] but also by several misrepresentations of the nature of their relationship: first, overstating Degas's "advising" role and his "influence" on Cassatt, and presuming that she could thrive "only when she was surrounded by strong influences";[5] second, and closely related to the first misconception, erroneously referring to Cassatt as Degas's "protégé" or "pupil," thereby casting a shadow on her originality;[6] third, discussing a presumed and factually unsupported romantic relationship between Cassatt and Degas, thereby shifting Cassatt's status from an independent and professional artist to a woman appended to Degas; fourth, crediting Cassatt's achievements to Degas; and finally, assuming that the influence in this relationship ran only in one direction and thereby failing to explore what Cassatt may have contributed to Degas, his career, and his legacy. Taken as a whole, the narrative that results from these misrepresentations portrays Cassatt as a follower of Degas, the master.

Surprisingly, some of these problems persisted even in the late twentieth century in two articles about Cassatt and Degas by important scholars of Impressionist art—Barbara Ehrlich White and George T.M. Shackelford.[7] Notwithstanding their valuable attention to the Degas-Cassatt friendship, these essays perpetuated some of the problems described above. White misrepresents the relationship by stating that "their friendship was primarily a business relationship between a celebrated older painter who became mentor to one lesser known,"[8] and Shackelford does so by similarly arguing that from the 1890s to the end of Degas's life, "a decidedly commercial aspect" characterized their relationship, "in addition to their old ties of friendship."[9] These claims are contradicted by the fact that Cassatt received no financial remuneration for her efforts to draw American collectors to collect Degas's art.[10] Moreover, as I will argue in this chapter, Cassatt's efforts were an integral part of her overall friendship and camaraderie with Degas.

Shackelford's article also continues the tendency of crediting Degas for Cassatt's own accomplishments. For example, in suggesting that Degas could "guide her away from the picturesque subjects of her earlier European career,"[11] the article overlooks a much more likely explanation for Cassatt's shift in the late 1870s toward depicting scenes from Parisian life—namely, her own encounter with the modern metropolis and vibrant Paris art scene after settling there in 1874. Furthermore, during this period she was preparing a new body of work for her first exhibition with the Impressionists.

Feminist scholarship has had a significant impact on the representation of the Cassatt-Degas relationship. In 1981 Nancy Mowll Mathews's slim catalogue for an exhibition at the San José Museum of Art, San José, California, *Mary Cassatt and Edgar Degas,* charted an important new idea: that there was reciprocity in the friendship. She wrote: "They were simultaneously advisor and advisee, enthusiastic collaborators, and mutual sources of inspiration for their own individual directions."[12] The 2014 exhibition *Degas Cassatt* at the National Gallery of Art, in Washington, DC, curated by Kimberly A. Jones, explored in some depth their "true artistic dialogue."[13] But despite the important development, in feminist-inspired scholarship, of an in-depth consideration of the artistic dialogue between Degas and Cassatt, much remains to be explored in their relationship.

This chapter focuses primarily on the nature of the Cassatt-Degas professional and personal relationship, its dynamics and interactions, the changes it underwent over time, and Cassatt's contribution to Degas's career and legacy. It offers a revisionist narrative of the Degas-Cassatt friendship that emphasizes Cassatt's agency and her status as Degas's colleague and valued comrade. It analyzes the complexity of this friendship, including its conflicts, which were intensified by Cassatt's late nineteenth-century feminist thinking and by the activism that characterized this period. This consciousness impacted the dynamics of their friendship, I will argue, because it called into question the androcentric bias in the social/professional structure. Finally, considering what Cassatt contributed to Degas within a transatlantic framework, I will demonstrate Cassatt's crucial impact on Degas's transatlantic legacy through her tireless work with American collectors.

HOW CASSATT MET DEGAS AND JOINED THE IMPRESSIONISTS

From 1877, when the thirty-three-year-old Cassatt met Degas, who was ten years her senior, her most significant artistic relationship was with him. What led to their meeting? The standard narrative, which first appeared in Achille Segard's monograph on Cassatt, highlights Degas's active role in inviting Cassatt to join the Impressionists, and her "acceptance" of this invitation.[14] Without discounting any of the facts provided by Segard, based on what we know about Cassatt's personality and professional conduct, it seems she played a more proactive role than this picture allows. The revisionist narrative presented below foregrounds Cassatt's agency, initiative, and active role in her own career, all of which have been obscured in the standard account.[15]

The French artist Joseph Gabriel Tourny introduced Cassatt to Degas. Cassatt met Tourny during the summer of 1873 in Antwerp, where she was copying Rubens at the museum as part of her studies of the art of the old masters.[16] Tourny was a professional copyist who had won the Prix de Rome in engraving in 1847[17] and was commissioned by Adolph Thiers to create large-scale copies of celebrated paintings for the French state.[18] In Antwerp, Cassatt spent a great deal of time with Tourny and his wife, who was also a painter. Cassatt wrote to her friend Emily Sartain:

I met here Mr. & Mrs. Tourny. Mr. T. copies in water colours for Mr. Thiers, Madame T. paints also, & sells her pictures, the latter fact astonishes Mother immensely . . . she is a lively little woman, and has perfect confidence in her own abilities. . . . We see a great deal of them[,] too much in fact[,] for they spend every evening here and prevent me from writing to anyone.[19]

But though Cassatt would have preferred to have some of her evenings free, connecting with the Tournys proved to be fortunate.

Tourny was a longtime friend of Degas. The two originally met in Paris in 1854–55 through Tourny's friendship with Degas's father.[20] A few years later, they became close while both were in Italy—Degas studying art at museums and Tourny painting commissioned copies.[21] Working in Florence, the twenty-four-year-old Degas was feeling "a lonely man"[22] and very much looked forward to Tourny's arrival in the city.[23] Degas also spent time with Tourny in Rome, where he used him as the model for a figure in *Dante and Virgil*, 1854–57, and did his portrait in etching.[24] The friendship continued after both returned to France. In the 1870s, Degas did another portrait of Tourny,[25] and in 1874 he tried to help Tourny to sell his work, writing to a London dealer that Tourny was "very good"[26] and asking, "Do you happen to have in your contacts, people who would enjoy this style?"[27]

In 1874, when Tourny and Degas were visiting the annual Paris Salon together, Tourny pointed out to Degas Cassatt's painting *Ida*, 1874 (collection of Mike C. Abraham, Las Vegas).[28] Degas responded positively to Cassatt's painting, saying, "It is true, here is someone who feels as I do."[29] Despite the painting's modest size, it stood out among other academic paintings and thus was among the few caricatured in the *Journal amusant*.[30] Cassatt's realist portrait showed vigor, in part by avoiding any attempt to represent feminine charm. The depiction of a woman wearing a green mantilla, which Cassatt painted in Rome, reflected the artist's encounter with the art of Rubens a few months earlier in Antwerp. That Degas now encountered her painting was not "a chance discovery" by him, as Cassatt's first American biographer put it,[31] but rather the direct result of Cassatt's establishing a meaningful connection with the Tournys. When Tourny brought Degas over to see Cassatt's painting in the Paris Salon of 1874, he must have told him about the young American artist with whom he had spent so much time in Antwerp.

Three years passed from the day Degas saw Cassatt's painting at the Salon until he first came to her Montmartre studio, in 1877, accompanied by Tourny.[32] We may never fully know what happened during these three years. We do know that Cassatt had admired Degas's art, probably since 1875, well before she met him or knew anything about him as a person.[33] Initially, she saw Degas's pastels in the window of a picture dealer on the Boulevard Haussmann: "I would go there and flatten my nose against the window and absorb all I could of his art. It changed my life. I saw art then as I wanted

to see it."[34] Cassatt and the Tournys must have seen each other in Paris after Cassatt settled there, about a year after they spent time in Antwerp. Given that they were friends whose common focus was art, Cassatt most likely heard from them about Degas's response to her painting *Ida*. She could not but be thrilled about that, and no doubt let them know about her own admiration for Degas's art. This would have led Tourny to realize that Cassatt was most interested in meeting Degas. It is possible, indeed, that she asked him to invite Degas to her studio. Thus, Tourny bringing Degas for a visit to Cassatt's studio might have been due at least in part to her own initiative.

During Degas's visit to Cassatt's studio, he invited her to join the Impressionists. She responded enthusiastically, recognizing at once that she was about to begin a new phase in her life as an artist: "At last I could work with an absolute independence without considering the opinion of the Jury! . . . I began to live."[35] When Cassatt first met Degas, it was after years of studying, exhibiting, traveling, and networking with artists, critics, and collectors. The oft-repeated narrative according to which Cassatt was Degas's pupil is, as Havemeyer asserted, "not true."[36] Cassatt met Degas some fifteen years after completing her studies at the Pennsylvania Academy of the Fine Arts, and after close to a decade of studying on her own in museums in Italy, Spain, France, and Holland, as well as with teachers in Rome and in France.[37] In 1867, merely a year after she traveled to Europe, the twenty-three-year-old Cassatt was already ambitious, outspoken, and highly confident, saying she "wanted to paint *better* than the old masters."[38] That year, she submitted her work to the Salon for the first time and was rejected. Undaunted, she submitted again in 1868 and was accepted. Her work appeared at the Salon six times: in 1868, 1872, 1873, 1874, 1875, and 1876. She experienced the same frustration with the jury's conservative criteria as her future Impressionist colleagues. When Cassatt met Degas, she was looking not for a teacher but for a like-minded colleague. She found this in Degas. Developing a friendship with him was artistically inspiring for her, having studied his work on her own before they met in person.

Few artists made the decision to cease exhibiting at the Salon and participate instead in the independent group shows of the Impressionists. As August Renoir explained, he sent two portraits to the Salon every year because "[t]here are hardly fifteen art lovers capable of liking a painter who is not in the Salon," and it was almost unheard of in Paris to commission portraits from artists unless they exhibited at the Salon.[39] Cassatt's sense of independence motivated her decision to join the Impressionists even though from a career standpoint, at that time most would have considered this risky, even counterproductive, considering the negative response to the early Impressionist exhibitions. Cassatt's decision to join the Impressionists was exceptional also among the numerous American artists working in Paris, who embraced the Salon. The young American painter J. Alden Weir expressed characteristic dismay at the third Impressionist exhibition in 1877:

I never in my life saw more horrible things. . . . They do not observe drawing nor form but give you an impression of what they call nature. It was worse than the Chamber of Horrors. I was there about a quarter of an hour and left with a head ache.[40]

Not until the 1890s and long after returning to his homeland did Weir embrace Impressionism in his own art. By then, Impressionism was no longer controversial and was accepted by influential American collectors. Cassatt's decision in 1877 to exhibit with the Impressionists testifies to her self-confident judgment and courage to follow her convictions.

Cassatt's debut with the Impressionists in 1879 drew the attention of several critics. A letter from her father reported:

She is now known to the Art world as well as to the general public in such a way as not to be forgotten again so long as she continues to paint!! Every one of the leading daily French papers mentioned the Exposition & nearly all named Mame [Cassatt's family nickname]— most of them in terms of praise.[41]

Important French collectors, such as Henri Rouart, and Antonin Proust, the critic who would soon become minister of fine arts, bought her paintings. At the end of the exhibition, Cassatt and Degas exchanged artworks. Cassatt found in Degas an inspiring colleague with whom she formed a camaraderie as she began a new phase in her life and work.

CAMARADERIE

Degas and Cassatt developed a strong friendship that grew and deepened during the period when both exhibited with the Impressionists, until 1886. Cassatt recalled: "When criticism was at its worse," Degas said to her, "They are all jealous of us, and wish to steal our art."[42] During the winter of 1879–80, Degas and Cassatt (as well as Camille Pissarro) produced prints for the planned publication *Le jour et la nuit*, the project that scholars have recognized as a "collaboration" between Cassatt and Degas.[43] Pissarro, Cassatt, and Degas worked in proximity to each other, using Degas's small etching press and tools.[44] They constantly shared work, techniques, and ideas. Degas, for example, wrote to Pissarro: "I hurried to Mademoiselle Cassatt with your parcel. She congratulates you as I do in this matter."[45] The publication did not come to fruition, probably because during this period Degas was still under great pressure to make money (to pay off the debts of his father's failed bank): "It's impossible for me with my life to be earned, to fully pursue this quite yet."[46] Cassatt's mother offered another explanation: "As usual with Degas, when the time arrived to appear, he wasn't ready. . . . Degas never is ready for anything—This time he has thrown away an excellent chance for all of them."[47]

During the early phase of their friendship, Cassatt and Degas introduced each other to their friends and family members and socialized together in the company of artists

and writers, including Stéphane Mallarmé; Berthe Morisot; the sculptor Albert Bartholomé and his wife, Prospérie; the painter Jean-François Raffaëlli; Georges Clemenceau; and others.[48] For example, in 1885 Degas mentions the arrangements for a meeting with the Bartholomés at an exhibition: "So the meeting is already set with Miss Cassatt on my side. On your side are you bringing the de Fleurys? As for Raffaëlli, he will come by his own means and will pick us up, except for Clemenceau."[49] In 1888, in a letter to Mallarmé, Degas referred to Cassatt as an "excellent and good friend."[50]

Cassatt and Degas attended various art exhibitions together, as well as apart on each other's recommendations. For example, in May 1886, Degas "insisted" that Cassatt go "at once" to see Claude Monet's works at the Georges Petit gallery, as he wanted her to "judge" them.[51] In 1890 Cassatt and Degas went to see the exhibition of Japanese prints at the Beaux-Arts, which was pivotal to Cassatt's printmaking.[52]

Cassatt and Degas saw each other in Paris, at Cassatt's country residence, and before she acquired the latter, in the summer homes that Cassatt's family rented in the countryside. In 1892 Degas wrote: "this month I plan to get off to Antibes to join the Cassatt family. . . . There are plans to go with Miss Cassatt and her sister-in-law [Marie Buchanan Cassatt, wife of Alexander Cassatt] and the said Bartholomé to Florence and Venice."[53] After she bought her country residence, the Château de Beaufresne, in the Oise region, north of Paris, Cassatt entertained friends regularly, and Degas was among the guests.[54]

In the early years of their friendship, during the late 1870s and early 1880s, Cassatt modeled for Degas on several occasions.[55] The Impressionists portrayed each other quite a bit, but Degas's use of Cassatt as a model was different. He did not portray her as herself so much as depicted her assuming various roles, such as a spectator looking at paintings in the Louvre or a consumer trying on hats in a millinery shop. In one instance, Degas did a portrait of Cassatt in which her facial features are clearly recognizable, but here, too, she is playing a role, though it is not entirely clear what role. Leaning forward, she is holding three cards, perhaps *cartes de visite*, with indiscernible images (*Mary Cassatt*, ca. 1880–84; fig. 3.1).[56] Cassatt owned the portrait and displayed it in her salon, but at age sixty-eight, thinking about the fate of her artworks and collection after her death, she decided to get rid of it, explaining that "I certainly don't want to leave it to my family as a portrait of me."[57] She thought that it had "some artistic qualities" but felt that it depicted her as "such a repugnant person that I don't want anyone to know that I posed for it."[58] Following her wishes, Ambroise Vollard sold it to a Japanese collector, thereby ensuring that it was far away from the United States and France (the painting later returned to the United States and is currently in the National Portrait Gallery at the Smithsonian Institution in Washington, DC). As Jones points out about the paintings for which Cassatt posed, we do not know how to answer the questions "how active a part did Cassatt play in Degas' artistic process; to what extent was she guided by, or did she in turn guide, Degas in the creation of these

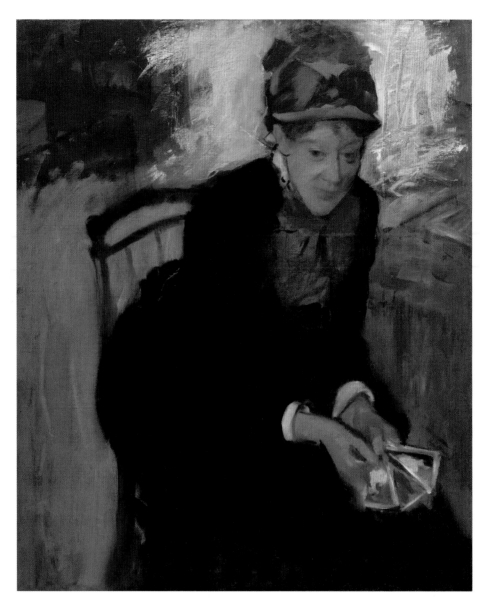

FIGURE 3.1

Edgar Degas, *Mary Cassatt*, ca. 1880–84. Oil on canvas, 28.9 × 23.6 in. (73.3 × 60 cm). National Portrait Gallery, Smithsonian Institution. Gift of the Morris and Gwendolyn Cafritz Foundation and the Regents' Major Acquisitions Fund, Smithsonian Institution, Washington, DC. NPG.84.34.

works; what were her reasons, beyond friendship, for agreeing to pose?"[59] One likely motivation was that modeling for Degas enabled Cassatt to observe his working process. Havemeyer attests that Cassatt had watched Degas while he worked on some of the works in her collection.[60] For her part, Cassatt did a portrait of Degas, presumably a painting, which according to Segard did not survive.[61] And an etching with aquatint

attributed to Cassatt that is a portrait of Degas in profile was included in the sale of Degas's studio.[62]

Cassatt was very interested in exchanging opinions on art with Degas. Scholars have often assumed that Degas advised Cassatt, while she was merely a recipient rather than an interlocutor who expressed her own opinions to Degas.[63] This was not the case. Cassatt valued Degas's advice, yet this was only part of the story. Havemeyer's memoirs make it clear that Degas and Cassatt critiqued each other's work and that, indeed, Degas needed Cassatt's comments on his art even more than the other way around: "After they met sometime later, long years of friendship ensued, of mutual criticism. . . . She could do without him, while he needed her honest criticism and generous admiration."[64] Degas valued Cassatt's judgment of his art, as suggested by his response to Durand-Ruel when the dealer did not appreciate Degas's nudes: "They must be good, for Miss Cassatt admired them."[65]

Cassatt had strong opinions about art and did not hesitate to voice them. She also expressed herself with great confidence, and her art criticism was sought-after even before she met Degas. For example, Cassatt's friend Emily Sartain, with whom she had studied at the Pennsylvania Academy of the Fine Arts and traveled in Europe to study art, described Cassatt's enormous success in Parma in 1872: "All Parma is talking of Miss Cassatt. . . . The compliments she receives are overwhelming. . . . One of the professors has begged her to come to his studio and give him criticism and advice."[66] Sartain herself was eager to hear Cassatt talk about art:

> Oh, how good it is to be with some one who talks understandingly and enthusiastically about Art. . . . I by no means agree with all of Miss C's judgments—she is entirely too slashing,—snubs all modern Art,—disdains the Salon pictures of Cabanel[,] Bonnat and all the names we are used to revere,—but her intolerance comes from the earnestness with which she loves nature and her profession."[67]

At twenty-nine years old, some four years before meeting Degas, Cassatt was already independent in her thinking and expressed her passion for art in her discussions. Like Degas, after exhibiting in the Salon several times, she came to disdain it and the academic painters who were revered by most.

Those who knew Cassatt well as a mature person emphasized her "discriminating penetration" in looking at art and the "undoubting conviction [with which] she formed her judgments" on it.[68] They recognized her power of persuasion. As the American art critic Forbes Watson observed:

> One couldn't listen to her, pouring out her ardor and her understanding, without feeling his conviction in the importance of art to civilization intensified. She increased the desire for more and still more knowledge. She made you share her intense hatred of aesthetic prevarication and compromise.[69]

These were no doubt among the qualities Degas appreciated in Cassatt as their friendship matured.

Unlike many of Degas's friends, Cassatt did not express herself in a way that accepted his authority in discussions on art and politics. Degas's friend the painter and author Jacques-Émile Blanche testified to this in his descriptions of weekly dinners at the Bartholomés, "where fellow guests included Mary Cassatt, Georges Jeanniot and his wife, Huysmans, Gustave Geffroy, and Raffaëlli."[70] Topics of discussion at the dinners included "music, painting, literature, and, above all, politics. Degas, as ever an intransigent nationalist, took the lead with an authority that was accepted by his fellow guests, except for Mary Cassatt, 'the independent American,' as Blanche called her."[71]

In addition to specific advice and criticism on their art, Cassatt and Degas provided for each other attention, interest, understanding, and encouragement in their art making. It was a broad mutual support that strengthened the ability of each to continue in the direction they were pursuing. Cassatt and Degas spoke frankly about art, including his works on topics that at the time were considered improper for a "lady," such as his controversial paintings of naked women washing and drying themselves, many of them prostitutes, and his painting on "moral rape." Cassatt wrote about his painting *Interior*, 1868–69 (also known as *The Rape*) (Philadelphia Museum of Art): "Curiously enough, Mrs. B., when I asked her what she thought the picture represented, said a moral rape or words to that effect, now that is just what Degas told me he meant to represent."[72]

About a year after they met, Cassatt showed Degas her painting *Little Girl in a Blue Armchair*, 1878 (National Gallery of Art, Washington, DC). Years later she wrote that Degas "found it was good, and advised me on the background and he even worked on it."[73] Cassatt's description indicates that her interaction with Degas in this case was harmonious. It was quite a different scenario when Edouard Manet took the liberty of working on a painting by Berthe Morisot in 1869–70. As Morisot described it, he found her painting "very good except for the lower part of the dress"[74] and began by making a few accents on the painting, but quickly got carried away: "nothing could stop him; from the skirt he went to the bust, from the bust to the head, from the head to the background. He cracked a thousand jokes, laughed like a madman."[75] Morisot's letter shows that she was anguished by Manet's disrespectful intervention, whereas Cassatt was proud of Degas's contribution to her painting.

To his credit, Degas by all accounts never said of Cassatt the kind of self-aggrandizing and plainly false statement that Manet made about Morisot, who was his friend and colleague (never his pupil) and the wife of his brother: "My sister-in-law would not have existed without me; she did nothing but carry my art across her fan."[76] On the contrary, Degas shared his compliments about Cassatt with friends and art professionals. For example, he told the dealer Vollard, "She has infinite talent."[77] He also made enthusiastic comments to Durand-Ruel after seeing Cassatt's paintings, and to Pis-

sarro about her prints.[78] Moreover, Degas's high appreciation of Cassatt's work, especially her prints, was evident in his choice to collect them in large numbers (about one hundred impressions by Cassatt, compared with over thirty prints by Pissarro).[79]

As this discussion demonstrates, Cassatt's and Degas's critiques of each other's work, and their conversations on art and politics among a group of friends and colleagues, reveal a friendship and a professional relationship that was much less defined by the traditional social and professional gender hierarchy than has typically been assumed. Cassatt was not merely a recipient in their artistic relationship; she occupied the position of an equal to Degas, expressed her own strong opinions, and, unlike many of his friends, did not simply accept his authority.

CONFLICT

Degas and Cassatt, who were in agreement in their admiration of Japanese prints, art of the old masters, and Impressionist painting, had opposing views on politics. Although Cassatt was not free of anti-Semitism, she was pro-Dreyfus, while Degas was strongly anti-Dreyfus, and his virulent anti-Semitism caused him to sever relationships even with old Jewish friends like Pissarro.[80] Another point of contention was women's rights. It is not clear to what extent Cassatt discussed this issue with Degas, but if at some early point she attempted to, she most likely quickly learned to skirt the issue. She was well aware of Degas's views and strong emotions on the topic of women's rights, and even if she avoided explicit discussion, this remained an undercurrent of conflict in the friendship.

Degas could not tolerate any discussion of women's rights, as we learn from a letter that was only recently published. In 1887 Degas responded favorably to an invitation to dinner by Mme. Marie de Fleury (whose frequent dinner invitations he welcomed) but added a warning: "Political talk will be banished, but if the young Italian woman starts in on women's rights, I don't know what my anger will make me do."[81] Even if the style of his comment had a touch of the kind of playful banter Degas engaged in at times,[82] he was also likely quite serious in pressing Marie de Fleury to perform her role as hostess in a way that suited his intolerance. Nonetheless, it is clear that Degas appreciated women who, like Marie, did not follow conservative gender conventions. Born to Russian immigrants, Marie de Fleury earned a degree in literature at the Académie de Genève in 1877, when this was still uncommon for women, demonstrating that she espoused feminist ideas about women pursuing higher education.[83] And of course, Degas was interested in the friendship of strong, independent women like Cassatt and later Suzanne Valadon, who became an artist after she had been his model.[84]

Cassatt mentions the issue of Degas's intolerance toward women's equality in a 1907 letter to her friend Roger Marx, the critic, collector, and museum official.[85] Responding to Marx's article on Morisot, Cassatt draws a comparison between female artists and female novelists, and then reveals that the mere name of George Sand "infuriates Degas, you have to hear him [talk] about her and about the abasement of men in her novels!"[86]

Both comments—Cassatt's about Degas and his own comment to Mme. Marie de Fleury—suggest that Degas had strong negative emotions about feminist issues. The charge that Degas was a misogynist, which has influenced interpretations of his art and biography, is not my direct concern here.[87] The question that interests me is how the tension related to Degas's negative emotions about women's equal rights played out in his friendship with strong women, and in particular with Cassatt. We find this tension expressed in Degas's double-edged compliments to Cassatt. Praising her as an artist, he nonetheless foregrounded her gender as inferior, as in his comment "no woman has a right to draw like that,"[88] about Cassatt's painting *Young Women Picking Fruit*, 1891–92 (Carnegie Museum of Art, Pittsburgh, Pennsylvania). Cassatt reported this comment to Segard, who described it thus in his monograph: "[Degas], a bit of a misogynist, once murmured without bitterness in front of a Cassatt work, 'I don't accept that a woman can draw as well as this.'"[89] Seeing the strength of an actual woman artist like Cassatt contradicted Degas's belief, prevalent at the time, about masculine superiority.

A similar tension is present in Degas's response to Cassatt's painting *The Oval Mirror* (*Mother and Child*), ca. 1899 (fig. 7.4). When Degas first saw it, at Durand-Ruel's gallery, he was struck with sheer admiration, saying to the dealer, "Where is she? I must see her at once. It is the greatest picture of the century."[90] Cassatt described what ensued when she saw him: "He went over all the details of the picture with me, and expressed great admiration for it, and then, as if regretting what he had said, he relentlessly added: 'It has all your qualities, and all your faults—*c'est l'Enfant Jésus avec sa bonne anglaise*'" (it's the infant Jesus and his English nurse).[91] The urge to backtrack after his admiring comments reflects Degas's inner conflict about admitting that a woman could paint this well.

Perhaps the most interesting encounter we know about between Degas and Cassatt took place in 1886. Segard reports:

> The story is that one day, in front of Degas, while Miss Cassatt was appraising a great painter, who was one of their friends, she dared to say "he has no style." Degas began to laugh, shrugging his shoulders, in a movement that meant: "Look at these women who meddle by judging! Do they even know what style is?"[92]

In response to Degas's offensive remarks, Cassatt painted *Girl Arranging Her Hair*, 1886 (fig. 3.2). Segard goes on to explain that in this painting, Cassatt

> chose as a model a woman who was quite ugly, a sort of servant, a most vulgar type. She had her pose in a shirt next to her dressing table, in the manner of a woman preparing to go to sleep, the left hand at the nape of her neck seizing the thin braided hair and the other pulling on this braid to tie it. This girl is seen almost entirely in profile. Her mouth is open. The expression is stupid and weary.
>
> When Degas saw this painting he wrote to Miss Cassatt, "What drawing! What style!"[93]

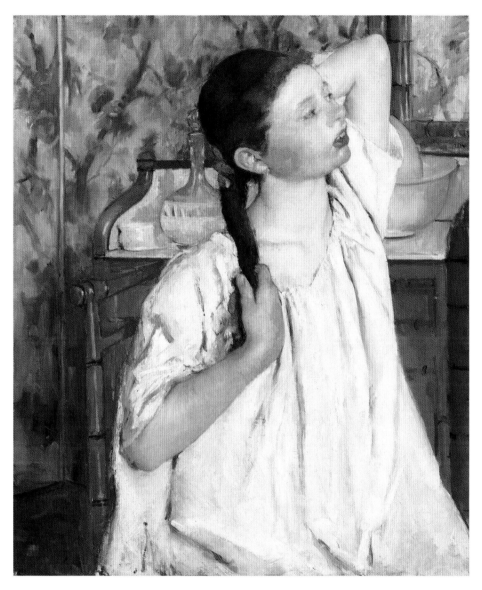

FIGURE 3.2

Mary Cassatt, *Girl Arranging Her Hair,* 1886. Oil on canvas, 32.1 × 25.9 in. (81.6 × 65.7 cm). Courtesy National Gallery of Art, Washington, DC. Chester Dale Collection, 1963.10.971.

Rather than get mired in a fruitless verbal exchange or withdraw, Cassatt turned Degas's disparaging remarks into a challenge. She fought back by painting, and produced one of her strongest artworks up to then.

Cassatt depicted the girl looking at herself in an invisible mirror, in a moment of private reflection. She contrasted her topic and manner of representation with Degas's depiction of bathers in several important ways. First, unlike Degas's female nudes

bathing or drying themselves, whose faces are for the most part hidden or indistinct, the face of the female figure in Cassatt's painting is central while her body is covered up. Second, and no less important, the topic in her painting is a girl looking at herself, quite the opposite of Degas's emphasis on the nude being looked at from an inscribed voyeur's position. Third, while Degas's representation of the nudes emphasizes the sculptural corporality of their bodies, Cassatt represents the girl primarily as a conscious subject. Rather than revealing her body, she paints the solid materiality of the fabric of the girl's white chemise with vertical folds rendered in bluish paint. Yet the girl's young "femininity" is nonetheless made powerfully present by echoing the reddish color of her lips and cheeks in the smudgy reddish floral wallpaper. The painting was well received while Cassatt was still working on it, as her father attested in a letter to her brother: "The two or three experts or artists who have seen it praise it without a stint. As for Degas, he was quite enthusiastic for him."[94] After it was exhibited in the 1886 Impressionist exhibition, Degas chose this painting for his exchange of artworks with Cassatt and displayed it prominently in his living room.[95] Cassatt's victory was complete.

The dynamics of this incident demonstrate Cassatt's proactive stance, her fortitude and determination. But not all the conflicts between Degas and Cassatt were as successfully addressed and processed, if not resolved. For example, in 1892 Cassatt accepted a commission to paint a monumental mural for the Woman's Building at the 1893 Chicago World's Fair. The Woman's Building featured women's contributions to culture around the world, inspired by the suffrage movement in the United States. Degas was enraged that Cassatt took this project, as she revealed in a letter to Havemeyer:

> When the Committee offered it to me to do, at first I was horrified, but gradually I began to think it would be great fun to do something I had never done before, and as the bare idea of such a thing put Degas in a rage and he did not spare every criticism he could think of I got my spirit up and said I would not give up the idea for any thing. Now, one has only to mention Chicago to set him off.[96]

This suggests that Degas attempted to make Cassatt "give up the idea" of painting this mural, a rather radical reaction. And as Cassatt notes, the prospect of a woman doing such a mural highly provoked him: "You ought to hear Degas on the subject of a woman undertaking to do such a thing, he has handed me over to destruction."[97] To commission a woman for a monumental-size mural was unprecedented at the time, a fact that may partly explain Degas's great difficulty in accepting this. It very likely also triggered his artistic rivalry. And then there was the feminist context of the commission—the Woman's Building—which must have further aggravated him.

Notwithstanding these issues, Degas also had artistic reasons for his negative attitude. He believed that a decoration on a building wall had to be done "with a view to its place in an ensemble, it requires the collaboration of architect and painter. The decorative picture is an absurdity, a picture complete in itself is not a decoration."[98]

Yet no matter how valid his point, it cannot explain his emotional outburst. Cassatt, who had to complete this mural on a short deadline, knew she had to protect herself from Degas's brutal criticism. In a letter to the Chicagoan Bertha Palmer, who, as the president of the Board of Lady Managers of the Woman's Building, had commissioned the mural, Cassatt reported:

> I have been shut up here so long now with one idea, that I am no longer capable of judging what I have done. I have been half a dozen times on the point of asking Degas to come and see my work, but if he happens to be in the mood he would demolish me so completely that I could never pick myself up in time to finish for the exposition. Still, he is the only man I know whose judgment would be a help to me.[99]

Knowing from past experience that "he dissolved your will power," Cassatt chose in this case to forego Degas's criticism.[100]

Degas's cruelty toward friends was directed at both men and women, and there is evidence that this habit troubled him. About two years before his virulent response to the mural commission, the fifty-eight-year-old Degas wrote a rare apology, revealing that he was quite aware of his destructive tendency, even understood its origin, and also registered its impact. He wrote this candid letter to his old friend Évariste de Valernes, an impoverished painter and drawing teacher:

> I was, or seemed to be hard on everyone, with a sort of habitual brutality that came from my self-doubt and bad humor, I sensed myself so badly built, so badly equipped, so soft, while it seemed to me that my calculations in art were so correct. I was bad-tempered with everyone and with myself. . . . I've wounded your very noble and very intelligent spirit, perhaps even your heart.[101]

Cassatt was certainly aware that Degas's "habitual brutality" was directed not merely at her, and perhaps this figured in her ability to manage it at least some of the time. Havemeyer astutely observed that "Degas was addicted to throwing verbal vitriol, as the French called it, upon his friends."[102] She also made the point that Cassatt stood up to Degas, noting that "Miss Cassatt would not have been the daughter of the French Cossards if she had not been equal to answering his taunts."[103] ("Cossards" was the original spelling of the French ancestors of the Cassatts at the end of the sixteenth century.)[104] To Havemeyer's question "How could you get on with him?," Cassatt answered:

> I am independent! I can live alone and I love to work. Sometimes it made him furious, that he could not find a chink in my armor, and there would be months when we just could not see each other, and then something I painted would bring us together again and he would go to Durand-Ruel's and say something nice about me, or come to see me himself.[105]

Cassatt's response reveals straightforwardly and assertively that she succeeded in holding her own with Degas thanks to her independence and to the fact that her work was her anchor. His appreciation of her art played a major role in the renewal of their communication after periods of distance. Havemeyer recounts one of the times when common friends of Degas and Cassatt invited them to dinner to bring about a reconciliation, after a conflict had kept them apart for some time. Cassatt reported that Degas "was very nice and did not say a disagreeable word." Havemeyer's response to this sums up more accurately than most observations the fundamental nature of the Cassatt-Degas relationship: "Of course he didn't. How could he? Were they not old, old friends, good comrades, with a deep respect for each other's talent lying firm beneath any momentary differences of opinion?"[106]

CARING AND KINDNESS

Notwithstanding their conflicts, Degas and Cassatt had genuine care for one another. Early in their friendship, Degas helped Cassatt find a dog, writing on her behalf to his friend, the artist and dog breeder Ludovic Lepic. He wrote:

> I also think that it is unnecessary to give you any information on the applicant, whom you know is a good painter. . . . This distinguished person and her friendship on which I pride myself, as you would in my place, asked me to also appeal to you for the youth of the little subject. She needs a young *male dog,* a very young one, so that it will love her.[107]

These last words suggest his care for Cassatt's emotional well-being. In September 1888, Degas expressed concern for Cassatt after she had had a riding accident, writing about it to his best friend, Albert Bartholomé,[108] and he was full of empathy when she had a more serious riding accident in the summer of 1889. He wrote to his friend Rouart:

> [P]oor Miss Cassatt fell off her horse, broke the shinbone in her right leg and dislocated her left shoulder. . . . She is fine, and for a long time there she is, first immobilized during the long summer weeks, then deprived of her active life and perhaps also of her riding passion.[109]

In multiple letters to common friends and family, Degas mentions Cassatt, indicating her importance to him, especially during the early phase of their friendship.[110]

Cassatt, in turn, expressed empathy for Degas in relation to a variety of professional and personal issues. For example, she expressed concern and indeed anger at the way in which he was handled by the Durand-Ruel gallery: "When one thinks of how they treated Degas, he would not have had any money to live on if [the dealer] Vollard had not paid [him] much better than they ever did."[111] She also cared about Degas's posthumous legacy: when his heirs considered producing a limited edition of Degas's

wax sculpture *The Dancer,* she expressed her objection: "As a unique thing and in the original it is most interesting, but 25 copies in wax takes away the artistic value in my opinion, they don't think of that. What would Degas have thought of this?"[112]

Cassatt was saddened by Degas's aging. She wrote to Havemeyer after one of the times in which a conflict had kept her apart from Degas for a time: "He has aged, dear, aged so very much it made me sad."[113] She was also sensitive to his loss of friends. After the death of Rouart, whom Degas regarded as "my family in France,"[114] she wrote, "I saw Degas there [at an exhibition of Rouart after his death] looking very old, but well, he surely must miss his old friends. Most of them are now gone, all of those I used to know, this is a shifting scene."[115] Cassatt stayed well informed about Degas's situation. In 1912 she was aware of his upcoming traumatic move from his home and studio, where he had been since 1890: "Degas is almost out of his mind for he has to move & he hasn't even dusted his pictures for years. His temper is dreadfully upset."[116]

Of all Degas's friends, it was Cassatt who took it upon herself to ensure that he would be well taken care of in the last years of his life. Initially she went to visit Degas's favorite niece, Jeanne Fèvre, in the South of France, to make her aware of the fact that in the near future Degas would need to be cared for. In 1913 she invited Fèvre to visit her for the day at her country residence to discuss Degas's situation:

> I urged her to come to Paris and see for herself and for her sister and brothers her uncle's state. She is staying with him and writes that he is just as I said, immensely changed mentally but in excellent physical health. Of course, he may live for years yet. He is 79, but his family will have to take care of him later.[117]

Cassatt kept following Degas's state, writing in 1914, "He is still wandering all day through Paris streets, I must go and see his nieces soon."[118] Around 1915, Fèvre, the unmarried niece, came to live with Degas and took over his care until his death in 1917.[119] She had worked at the military hospital in Nice, where she received enough training to know how to take care of him.[120] Yet initially she hesitated to follow Cassatt's advice, afraid that Degas "might not like her to come, but I told her she would not be there a week before he would not be willing to part with her, of course she found this true."[121] Cassatt's consistent efforts to convince his niece to move into his apartment and look after him showed her great care for him as a person. Assuring his well-being in old age meant a lot to her. After his funeral, she wrote to Havemeyer:

> Of course, you have seen that Degas is no more. We buried him on Saturday[,] a beautiful sunshine, a little crowd of friends and admirers, all very quiet and peaceful in the midst of this dreadful upheaval [World War I] of which he was barely conscious. You can well understand what a satisfaction it was for me to know that he had been well cared for[,] and even tenderly nursed by his niece in his last days.[122]

Over the years, some scholars have speculated about a romantic relationship between Cassatt and Degas.[123] Both artists flatly denied it when asked. In answer to a relative's question if she had had an affair with Degas, Cassatt stated, "What, with that common little man? What a repulsive idea!"[124] Responding to a question by Cassatt's friend, the American critic Forbes Watson, Degas reportedly said, "I would have married her but I could have never made love to her."[125] Although these are secondhand reports, they should not be ignored, especially in view of the fact that no evidence whatsoever supports the speculations about a romantic involvement. Degas's biographer, Roy McMullen, considered the issue and concluded that their intimacy "was obviously based on a shared devotion to their art, on admiration for each other's talents, on common social origins, and on a hard-to-define dialectical tension that always accompanies a lasting relationship between two strong personalities."[126]

Havemeyer mentioned that Cassatt "did not keep" Degas's letters,[127] leading some to speculate that she wanted to hide an affair. The reason, however, was quite different. Cassatt cherished her privacy and did not keep the letters she received from others as well, including those from her closest friend, Havemeyer. Like Paul Cézanne, Cassatt believed that artists should present only their art to the public, not biographical details.[128] Rife with conjecture, speculations about a Cassatt-Degas romantic relationship have the effect of undermining Cassatt's standing as an artist by diverting the discussion away from her professional persona and achievements. Cassatt, the determined artist, friend, colleague, and comrade of Degas, is thereby misappropriated. Rare was the perceptive comment Watson made based on his personal acquaintance with Cassatt, explaining her choice to remain unmarried:

> She had certainly, so far as I knew her, convinced herself at an early age that with all the flourishing prejudices against woman as a creative artist nothing could be accomplished in the difficult art of painting without a devotion capable of primary sacrifices.[129]

Caring and kindness was an important component of the Cassatt-Degas friendship, and one that is rarely addressed, compared with the frequent mention of the popular fantasy that they had an affair.

CASSATT LOOKS AT DEGAS'S NUDES

Cassatt's deep appreciation of Degas's art played a fundamental role in their relationship, and as Havemeyer reported, "The nudes of Degas were a special admiration of Miss Cassatt," who was "one of the first to appreciate" them.[130] A selection of Degas's nudes was exhibited in the 1886 Impressionist exhibition, where the catalogue described them as a "suite of nudes of women bathing, washing, drying, wiping themselves, combing their hair or having it combed."[131] Cassatt selected *Woman Bathing in a Shallow Tub*, 1885 (fig. 3.3) for her exchange of works with Degas at the end of the exhibition.[132] She noted that this nude was "considered by everyone as one of his

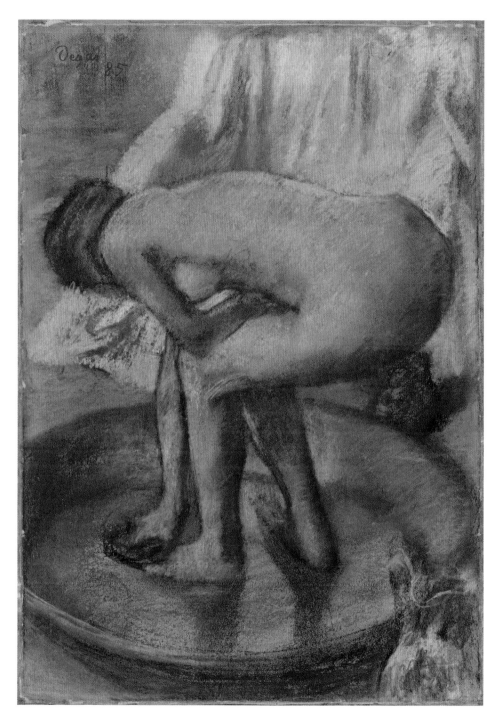

FIGURE 3.3

Edgar Degas, *Woman Bathing in a Shallow Tub*, 1885. Charcoal and pastel on light green wove paper, now discolored to warm gray, laid down on silk bolting, 32 × 22.1 in. (81.3 × 56.2 cm). The Metropolitan Museum of Art, New York. H.O. Havemeyer Collection. Bequest of Mrs. H.O. Havemeyer, 1929. 29.100.41.

best."[133] Cassatt recommended Degas's nudes to several American collectors, including, among others, Louisine Havemeyer, whose collection eventually featured eight of them, and Sarah Choate Sears, a Boston artist, collector, philanthropist, and Cassatt's friend, who acquired three.[134] (Bertha Honoré Palmer owned two, and Theodate Pope inherited one.)[135] Clearly, Cassatt was not deterred by constraints of conventional propriety. She despised the idea that "ladies" should not acquire art that featured nudes. In 1913, soon after Havemeyer added to her collection one of the Degas nudes, Cassatt wrote to her: "I can just see Sallie Williams laying down the law as to what a 'lady' could buy or not. She was never gifted with much brains."[136] Degas himself had a decisive opinion on the matter. When he heard about a man who had ordered his restorer to cut off the lower part of a painting of a woman's torso because of the many society ladies who come to his house, he responded: "To think that an imbecile like that hasn't been locked up yet!"[137]

Cassatt's great admiration of Degas's nudes did not waver despite their condemnation by numerous critics. As Martha Ward noted, for many who reviewed Degas's nudes in 1886, he was "a ferocious misogynist who willfully debases women to animal."[138] Many critics saw Degas's nudes as voyeuristic, and some condemned his representing woman "only in her animality."[139] Everyone seemed to agree that they did not arouse sexual desire, and saw "the figures as decidedly ugly and repulsive, probably poor, and indecent."[140] Cassatt and Havemeyer responded quite differently. In 1913, after Havemeyer acquired Degas's *Bather Stepping into a Tub,* ca. 1890 (fig. 3.4), Cassatt wrote to her: "Degas' art is after all for the very few. I cannot believe that many would care for the nude I have. Those things are for painters and connoisseurs."[141] On one level, surely, Cassatt and Havemeyer appreciated the nudes from a connoisseur's point of view—namely, by focusing on Degas's masterly execution. Yet how, specifically, might they have perceived Degas's interpretation of the subject matter of the female nude? Most importantly, Cassatt and Havemeyer, unlike numerous French (male) critics, did not condemn or judge the women represented by Degas. That much is clear. Beyond that, scholars have interpreted their appreciation of Degas's nudes differently. Richard Kendall suggested that Cassatt, Havemeyer, and Palmer (all of whom owned Degas's nudes) were unconcerned about voyeurism.[142] For Heather Dawkins, Cassatt's and Havemeyer's enthusiasm for Degas's nudes demonstrated that "women could subscribe to masculine structures of spectatorship."[143] And Erica E. Hirshler proposed that American women collectors "identified with the intimate moments common to every woman."[144] Yet identification, which is essentially a feeling of being closely associated with the identified object, would have been an unlikely sentiment in this case. For elite American women like Cassatt and Havemeyer to identify with Degas's nudes would have required an intertwined cross-class and cross-cultural identification on their part, as Degas's nudes represented French women from the working class, some petite bourgeois women, and many who were perceived as prostitutes.[145] For "respectable" women to closely associate themselves with women

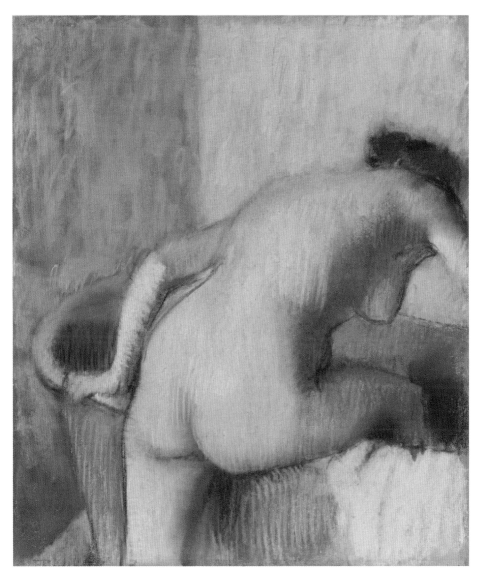

FIGURE 3.4
Edgar Degas, *Bather Stepping into a Tub*, ca. 1890. Pastel and charcoal on blue laid paper, mounted at perimeter on backing board, 22 × 18.7 in. (55.9 × 47.6 cm). The Metropolitan Museum of Art, New York. Bequest of Mrs. H.O. Havemeyer, 1929, 29.100.190.

who were considered "depraved" by society at large was hardly an option—all the more so given that Cassatt and American women collectors enjoyed a particularly privileged status, with some of them, like Havemeyer, belonging to their nation's wealthiest elite. Furthermore, although they admired French culture, it was nonetheless a foreign culture to them, and in this sense, too, they would not naturally associate themselves with the women depicted in the paintings. Cassatt and Havemeyer, then,

could not have formed their viewpoint based solely on their gender without taking into account other intersecting aspects of their identity. Rather than identifying with the depicted women, it is more likely that sentiments of compassion figured in their aesthetic experience.

Havemeyer, whose opinions on art were to a large extent formed by her dialogues with Cassatt, reveals that she thought Degas's nudes frankly expressed "poor human nature in its vulgar banality."[146] Unlike the French critics, she avoided defining the women themselves as vulgar, and her choice of the adjective "poor" expressed a mixture of pity and empathy. Such a point of view toward prostitutes was consistent with late nineteenth-century upper-class Euro-American feminist positions, which were not free of patronizing language and attitudes. Feminists recognized that prostitutes were not born sinners but rather were victims of poverty, due to diminished wages, educational opportunities, and access to male-dominated professions.[147] Cassatt read the moralist feminist novel *Where Are You Going To . . .?* (also known as *My Little Sister*), by Elizabeth Robins, about two innocent, impoverished young sisters who travel to London, where a procuress masquerading as their aunt abducts them to a brothel.[148] In response to this novel, Cassatt asserted, "[W]omen need to vote to stamp out that crime."[149] She well understood that the issue was not morality but gaining political power.

In 1913, the same year the novel was published, American sculptor Abastenia St. Leger Eberle, a suffrage activist who was a member of the Woman's Political Union (to which Havemeyer also belonged), created a sculpture protesting child prostitution, titled *The White Slave* (fig. 3.5). The work expresses empathy with the young girl, whose naked body is fully exposed, put on display by a coarse-looking man who is auctioning her off. Her hands tied behind her back, the captive girl lowers her head to hide her face, attempting to protect what little privacy she can. This small-scale bronze was displayed in the Armory Show, where it deeply touched some spectators but did not elicit much critical attention.[150] Havemeyer, who visited the Armory Show, would have seen this work. Familiar and sympathetic with feminist perspectives on prostitution, it would have likely evoked her compassion rather than condemnation—like Cassatt's and Havemeyer's responses to Degas's nudes, and especially those depicting prostitutes.

An important factor in Cassatt's admiration for Degas's nudes was their contesting of the tradition of the idealized, mythologized, sometimes eroticized, and often sexualized passive female nude—an inert, docile, pretty object on display. In contrast to this tradition, Degas abstained from making the nude bather sexually appealing, turning her first and foremost into an active, energetic figure. Many of the bathing nudes are vigorous figures, some of them muscular, none of them placid. Scholars writing about Degas's nudes have often called attention to their "ungainly postures,"[151] often also described as "awkward"[152] or tortured. Although these descriptions accurately capture the contortion of the bodies and their strained poses, especially in comparison to the typically "graceful" postures of the female nude in Western art, they obscure the

important fact that Degas represents the nudes in the midst of active movement. This is reinforced by Degas's use of pastel in a way that shows the material traces of his own hand motions as they create the layers of paint, thereby introducing a further sense of movement and action into the painting. His way of applying the pastel highlights its quality as matter—tactile, palpable, fragile, yet material—and this, in turn, underscores the materiality of the depicted bodies.

In his depiction of contemporary naked women engaged in mundane daily activities, Degas always showed them in active poses that stressed their dynamic stance. Whether they are taking a bath, stepping in or out of the bathtub, standing, sitting, or crouching in a shallow tub, bending forward, sitting and stretching out an arm to reach their toes with a rag, scrubbing their shoulder with a sponge, drying their back with a towel, or combing their hair, the poses all emphasize the body's active movements. Consider, for example, *Woman Bathing in a Shallow Tub,* 1885 (fig. 3.3), which Cassatt owned, and *Bather Stepping into the Tub,* ca. 1890 (fig. 3.4), owned by Havemeyer.

Depicting a woman in motion, Degas's focus in both paintings is not on the traditional eroticism of the female body but on its dynamic corporality and energy.

Unique testimony by a Degas model underscores this point. A memoir published (eighteen months after the artist's death) in the *Mercure de France* under the name Alice Michel (yet written in the third person, about the model) reveals what she appreciated most in Degas's progressive work on a sculpture figurine for which she modeled.[153] The French model, a working-class woman, valued Degas's refining of "the form" of the statuette so as to make it "more and more energetic."[154] Investing the figure that represented her body with increasing energy as Degas advanced in the work, she wrote, strengthened her active stance and brought out the figure's life force. By contrast, the model was disappointed that Degas did not represent her facial features, which she had "been told, were elegant and pretty. But he gave the statuette the same vulgar expression that had shocked her already when she saw it repeated over and over in his drawings."[155] This was not a matter of vanity so much as a sense that Degas had erased her individuality. The model felt that Degas reduced the women he represented to a single vulgar expression irrespective of the specific model he so carefully observed.

Like Degas's model, Cassatt and Havemeyer could value the modern and irreverent reinterpretations of the tradition of the female nude in Degas's works, not only in the context of art history but also in the context of feminism's goal to advance women's status as active subjects. As feminists, they wanted to see a new world materialize in which women were equals, and thus they could welcome the fact that none of Degas's nudes were posed to elicit desire, in contrast to many of the French male critics, for whom this was cause for chagrin. As Broude notes, Degas's women bathers "are among the very few representations of the female nude by male artists in the Western tradition that challenge the societal assumption that nude women can exist only for the pleasure and the purposes of dominant males."[156]

Unlike the French critics, who never considered the New Woman in the context of their writing on Degas's nudes, the New York–based critic James Huneker, who wrote on Degas's nudes in 1910, evoked the existence of the New Woman, suggesting that the fact that she is present undermines "old fashioned, stupid, masculine standards of beauty":

> Let us suppose that gay old misogynist Arthur Schopenhauer would visit the earth. . . . What painted work would be likely to attract him? Remember he it was who named Woman the knock-kneed sex—since the new woman is here it matters little if her figure conforms to old fashioned, stupid, masculine standards of beauty. But wouldn't the nudes of Degas confirm the Frankfurt philosopher [Schopenhauer] in his theories regarding the "long-haired, short-brained, unaesthetic sex," and also confirm his hatred for the exaggerations of poet and painter when describing or depicting her?[157]

Cassatt embodied the point of view of the New Woman. While she also appreciated the old masters' depictions of female nudes, she clearly valued the modernity of

Degas's nudes. By contrast, she was critical of Renoir's late nudes: "The most awful pictures or rather studies of enormously fat red women with very small heads."[158] And while Cassatt's view of Degas's nudes may have differed in some respects from Degas's own, he must have liked her deep appreciation of these controversial artworks. Moreover, he was undoubtedly grateful to Cassatt for recommending the nudes to collectors, since, as he often complained, people only ever wanted his ballet scenes.[159]

CASSATT'S NUDES

Though she admired Degas's female nudes, Cassatt did not follow in his footsteps in her own rare representations of nudes, painted during the mature phase of her career. Instead, her inspiration came from the large exhibition of Japanese woodcut prints at the École des Beaux-Arts in 1890. The exhibition aroused extraordinary enthusiasm in Cassatt, as evident in her letter to Morisot inviting her to visit the exhibition together: "You couldn't dream of anything more beautiful. I dream of it and don't think of anything else but color on copper."[160] Cassatt made two representations of nudes, as part of her acclaimed suite of ten prints made in 1890–91 (fig. 3.6, fig. 3.7). First exhibited at Durand-Ruel's Paris gallery in 1891, this print suite is considered among Cassatt's best works. Degas particularly admired Cassatt's drawing of the back of the woman in *The Woman Bathing (La Toilette)*, 1890–91 (fig. 3.6), and he purchased this work from Durand-Ruel along with two other prints in the suite.[161] Cassatt's *Woman Bathing* highlights the elongated naked back of the depicted woman, who is dressed from the waist down. She is washing her body in the privacy of her room, and the front of her nude body, as well as her face, are invisible. The image conveys the sense of a delicate, quiet ritual performed in solitude. The visible part of the body is highly stylized to the point that the body's abstracted flat form replaces a sculptural corporal presence, materiality, and flesh. A heightened sense of feminine self-containment characterizes the figure of *Woman Bathing*.

Cassatt's second nude, the print *The Coiffure*, 1890–91 (fig. 3.7), also shows a woman from the back, dressed from the waist down. Seated in front of a mirror as she arranges her hair, the woman's nude front is reflected. Her body "is awkward—her arms are compressed, and the breasts are amorphously slung together, deliberately simplified and stylized."[162] Cassatt thus avoids a seductive display of the female nude for male desire in both of her prints of partially nude women.[163] She represented these women as subjects who are absorbed in their activity within their own quiet world. Though the face reflected in the mirror in *The Coiffure* remains somewhat indistinct, it seems that Asian features are suggested.[164] The same hints of Asian facial features appear not only in *The Coiffure*, where the woman is half naked, but also in the fully dressed woman depicted sealing an envelope in Cassatt's *The Letter*, 1890–91 (fig. 1) and in her *Maternal Caress*, 1890–91 (fig. 5.18). Although the women's dresses and the furnished environments in which they are set are European, they, too, are hybridized by being rendered in a Japanese-inspired style. Thus, in these prints Cassatt braided the European

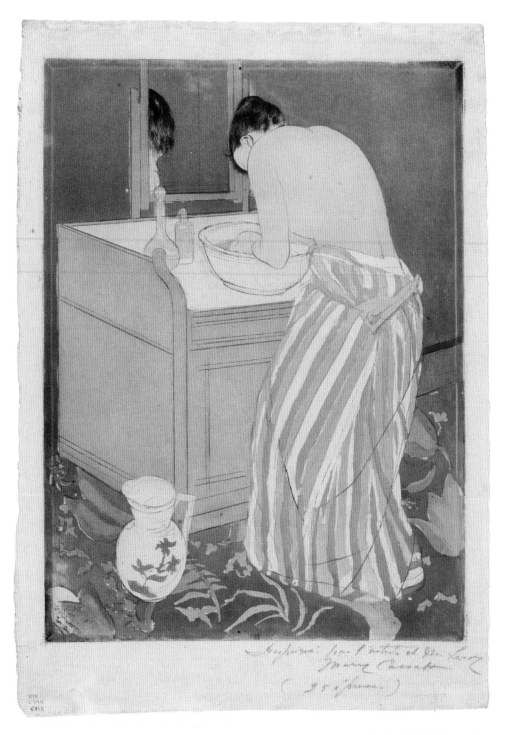

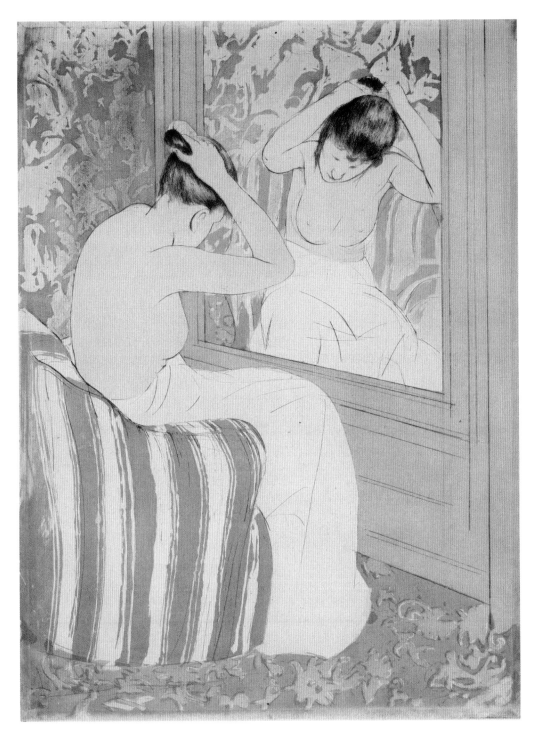

FIGURE 3.7

Mary Cassatt, *The Coiffure*, 1890–91. Color drypoint and aquatint on laid paper, 17 × 11.9 in. (43.3 × 30.2 cm).
Courtesy National Gallery of Art, Washington, DC, Chester Dale Collection. 1943.3.2758.

and the Asian. As Anne Higonnet has astutely observed, Japanese prints allowed Cassatt (and Morisot) to see "the female body through foreign eyes," providing a way out of the impasse of the European tradition of the female nude.[165]

Expanding on Higonnet's insight that the Japanese prints allowed Cassatt a foreign perspective on the European tradition, I propose that Cassatt's personal transatlantic experience played an important role in these prints. Living in France, the upper-middle-class American Cassatt was herself a foreigner. She and Pissarro (who was born in the Danish West Indies) were excluded by the Society of Peintres-Graveurs from the exhibition the group planned to hold at Durand-Ruel's in 1891. Cassatt had participated in the society's 1889 and 1890 exhibitions, and shared the group's dedication to exhibiting original prints,[166] but when the group incorporated as the Société peintres-graveurs Français (in December 1890), its members decided to exclude foreign-born artists from exhibitions, unless invited.[167] Cassatt no doubt shared Pissarro's stance regarding this policy: "They intend to invite foreign-born artists, but I will not accept any invitation from them. How officious they are!"[168]

Cassatt, as usual, was proactive. Segard reports that she "gathered her courage" and obtained an adjacent space from Durand-Ruel to exhibit her full suite of ten prints at the same time as the "Patriots," as Pissarro named the society members.[169] Pissarro displayed his prints in a separate room as well.[170] He judged Cassatt's prints to be far superior to those of members of the group.[171] The success of Cassatt's show turned the group against her. When she attended a dinner at Bartholomé's on the day after the opening, members of the group made hostile comments to her, intensifying her sense of exclusion and causing her to leave the event almost in tears.[172]

After decades of being steeped in European painting, Cassatt's encounter with the exhibition of Japanese prints caused her to become entirely enthralled by a culture alien to her own. Deeply touched by the aesthetics of Japanese prints, she developed a new hybrid visual language. The abstracting style of her prints was constituted of flat masses of color contained in contours—masterly lines, at once firm and delicate. The style of her prints was distinct from the tradition of European painting in foregrounding decorative patterns, using subtle coloration and an elevated viewpoint, and avoiding the Western linear perspective as well as the three-dimensionality created by light and shade modeling. This "foreign" style resonated deeply with Cassatt, prompting her to engage in an artistic process of incorporating and assimilating it to create something new. In some ways, this process was analogous to her daily experience of adapting and assimilating herself while still remaining different as an American living in France. Such experiences of assimilation into a foreign culture have different nuances—from feeling alien, to feeling less than native, to feeling partial or complex belonging—all of which fed into Cassatt's adaptation of the Japanese style to her prints. In other words, her own cross-cultural transatlantic experience, which remained dominant throughout her life, found a unique expression in her Japanese-inspired prints.

CASSATT'S CONTRIBUTION TO DEGAS'S TRANSATLANTIC LEGACY

The transatlantic experience was also a crucial factor in Cassatt's dedication to bringing Degas's art to the United States. It was Cassatt's early recognition of Degas's major importance that caused her to urge her friend Louisine Elder (later Havemeyer, through marriage) and her own brother Alexander to become Degas's first collectors in the United States. With Cassatt's help, the Havemeyers assembled the largest collection of Degas in the world, and eventually—and most crucially for Degas's legacy—Mrs. Havemeyer's bequest to the Metropolitan Museum of Art ensured Degas's extensive representation in New York's preeminent museum. None of this would have happened without Cassatt. She was the moving force behind the Havemeyers' collection of Degas, the "godmother" of the collection, as Havemeyer put it, who consistently educated, encouraged, informed, and advised them on specific acquisitions.[173]

Several studies have probed Cassatt's work with American collectors, yet some issues, especially regarding Cassatt and Degas, remain to be explored.[174] In this section, I will focus on the questions of how Cassatt's advising of American collectors contributed to Degas's transatlantic legacy, and how it affected Cassatt's relationship with Degas. Cassatt's choice to advise American collectors to acquire Degas's art was integral both to her friendship with him and to her passionate dedication to developing her homeland's art collections. As discussed earlier, Cassatt did not benefit financially from advising. She began her role as advisor to American collectors very soon after she met Degas, in 1877, and became his comrade by joining the Impressionist group. Around the same time, she influenced the young American Louisine Elder (later Mrs. Havemeyer) to acquire Degas's *The Rehearsal of the Ballet Onstage*, ca. 1874.[175] It was the first time an American acquired a Degas.

During the late 1870s, in the early phase of Cassatt's friendship with Degas, he was in an acute financial crisis. Under constant strain to meet deadlines for payments due to the failure of his father's bank, he was attempting to earn money from the sales of his artworks, and at times was forced to turn to friends for urgent help.[176] When a friend in financial difficulties—Ernest Hoschedé, a very early collector of Impressionist art, whose collection included a Degas—appealed to Degas for help, the artist described his own predicament by way of explaining why he could offer no assistance:

> [M]y own times are just as hard as yours! I am more than short of money. I am finishing a miserable picture as best I can in order to make some money. I cannot get a penny before Thursday. I have, I swear, barely enough to last this long. I'm really sorry.[177]

Degas's financial difficulties were compounded by the fact that in the 1870s, his work was not yet selling well. Although his art filled an entire room at the 1877 Impressionist exhibition, only one work was sold.[178] He was thus especially appreciative of Cassatt's role in Louisine Elder's acquisition of his work (for five hundred francs, or

$100, the equivalent of $2,478 in 2021). He wrote Cassatt "a note of thanks when he received the money, saying he was sadly in need of it."[179] Cassatt's role in influencing Americans to buy Degas's art was simultaneously an act of friendship, collegial support, and professional judgment. It was a concrete expression of her enormous appreciation of his art. Thanks to Cassatt, Degas enjoyed a certain freedom from the pressure to exhibit in order to sell art for his livelihood. Pissarro commented in 1886 that Degas "doesn't have to sell, he will always have Miss Cassatt."[180] During the 1890s, Degas's art was selling well, but his need to generate income from sales continued, as he wrote in 1891: "Alas, I've never known how to save money."[181] Cassatt's dedication to promoting Degas's art to American collectors continued to help him both professionally and financially, resulting in the expansion of his circle of collectors, in a growing demand for his work, and eventually in its extensive representation in American museums.

In 1879, after Cassatt first participated in the Impressionist exhibition, Degas reciprocated by helping to sell her painting *The Nurse*, 1878, which was included in the exhibition. He asked his friend Félix Bracquemond (who also exhibited with the Impressionists) to talk to Charles Havilland, the owner of a porcelain factory where Bracquemond was in charge of the design studio. As Degas wrote, "Tell Havilland, who was very fond of a little painting by Miss Cassatt and wanted to know the price, that it's only a matter of 300 francs, that he should reply to me if it's not acceptable, and to Miss Cassatt 6 Boulev[ard de] Clichy, if it is."[182] Thanks to Degas's intervention, Havilland eventually bought Cassatt's painting *The Nurse*.[183]

After Louisine Elder's initial acquisition of works by Degas, Cassatt continued her efforts to develop new American collectors of his work (as well as of some of her other Impressionist colleagues). In 1880 she began to urge her brother Alexander to acquire Degas's art and sent him photographs of it.[184] The following year, she purchased the first Impressionist paintings for Alexander—a Degas on the subject of ballet, as well as a Monet and a Pissarro. These were among the earliest Impressionist artworks to reach the United States. Cassatt's choice of a Degas for her brother was entirely her own initiative and involved a certain risk on her part, not only because Degas was not yet well known but also because of her brother's more conventional taste at the time. Cassatt's mother worried that "Alexander would be shocked by its [Degas' work's] eccentricity."[185]

From about 1889, Cassatt advised the Havemeyers, and after Harry Havemeyer's death in 1907, she continued to advise Louisine Havemeyer through the early 1920s. The Havemeyers' collection of Degas included sixty-five paintings, pastels, and drawings, numerous prints, the set of seventy-two posthumously cast small-scale bronze sculptures, and the life-size bronze sculpture cast of *Little Fourteen-Year-Old Dancer*, ca. 1880 (cast in 1922) (see fig. 2.7). Havemeyer collected more works by Degas than by any other artist. By comparison, her collection of French modern artists included forty-five works by Courbet, thirty by Monet, twenty-five by

Manet, twenty-five by Jean-Baptiste-Camille Corot, seventeen by Cassatt, and thirteen by Cézanne.[186]

When Cassatt brought the Havemeyers to Degas's studio, it was not simply the prelude to a sales transaction. These visits were intertwined with Cassatt and Degas's friendship, professional relationship, and comradeship. Havemeyer described a memorable moment at one such visit, when she called Degas's attention to the wax figure of *The Little Fourteen-Year-Old Dancer*, which was displayed in a vitrine in his studio:

> [I]t seemed to awaken pleasant memories and he became animated and began an interesting conversation with Miss Cassatt about the past, snapping sidelights upon the work of his contemporaries, and making personal allusions which I did not understand but which greatly amused Miss Cassatt.[187]

Degas enjoyed these studio visits. He was moved by the admiration the Havemeyers and Cassatt showed for his work, as Louisine Havemeyer noted in her subtle description of their interaction on the occasion of another studio visit. As she describes, Degas opened a portfolio and "tenderly lifted the drawings one by one and showed them to us. We could see how greatly he prized them"; but when "Mr. Havemeyer requested Degas to let him have some of them," Degas

> seemed reluctant to give them up, unable to part with a single one of them. Miss Cassatt took up one drawing and called my husband's attention to it. . . . It was a superb drawing and Degas watched us as we admired it. Suddenly, he selected two others, signed them all and handed them to Mr. Havemeyer. . . . No word of price was spoken. It was a solemn moment and all details had to be arranged by our kind intermediary, Miss Cassatt.[188]

Cassatt's effectiveness in advising Americans to acquire Degas's art coincided with the period when American collectors were crucial players in an emerging transatlantic art world system. The transatlantic market for French art became important in tandem with the changes in the French art world system: over the course of the nineteenth century, with the disintegration of state patronage and of the central annual Salon in Paris, the success of French artists gradually depended less on their nation and more on private collectors and gallery dealers.[189] By the time the Impressionists emerged, their livelihood, careers, and recognition depended on a system of private collectors, critics, galleries, and auctions, not only in France but also in the United States and to some extent in Europe (especially Germany).[190] Both Degas and Cassatt were represented by Durand-Ruel in Paris, and from 1887 also in his New York branch. Other Paris galleries similarly opened branches in New York to support their sales in the United States.

Together with Havemeyer and Durand-Ruel, Cassatt played a crucial role in opening and sustaining the transatlantic art market for Degas. In 1912 Havemeyer set a

price record when she acquired Degas's painting *Dancers Practicing at the Bar*, 1876 (Metropolitan Museum of Art, New York) at the Henri Rouart sale in Paris. An old friend of Degas, Rouart was an industrialist, an art collector, and a painter who exhibited with the Impressionists.[191] Cassatt, who had known Rouart and his choice collection, alerted Havemeyer to this important upcoming sale. The highest pre-auction estimate for Degas's painting was $10,000, but Havemeyer ended up buying it for 478,500 francs, or $95,700 (the equivalent of approximately $3 million in 2023), setting a record not only for Degas sales but also for the highest price paid up to that day for the work of a living artist.[192] Degas (who did not benefit from this sale as the work already belonged to a collector who had bought it from the artist long before his prices rose) famously said he felt like the horse that has won the Grand Prix and gets nothing for it but his oats.[193]

Cassatt's role complemented that of Durand-Ruel. She corresponded with American collectors, and when they visited Paris, she escorted them to the galleries or else sent them on their own and alerted the dealers to show their best work. More rarely, as in the case of the Havemeyers, Cassatt also took collectors to Degas's studio. Usually she directed American collectors to Durand-Ruel and to other dealers, among them the agent Alphonse Poitier and Vollard.[194] She also set an example for other Americans by displaying Degas's works in her home.[195] Cassatt's ability to promote Degas's art was aided by the fact that she herself was an American, who, like the collectors she advised, belonged to the upper class, a status that gave her easy access to American collectors and a facility of communication with them. Her authoritative assessment of Degas's assured place in the art historical canon and her sheer enthusiasm about his art contributed further to her power of persuasion among collectors.

The impact of Cassatt's direct work in guiding American collectors was accelerated by the indirect effect of chain reactions: the collectors with whom Cassatt worked inspired others in their elite circle to collect the same artists, and so the process multiplied itself. In addition, with Cassatt's encouragement, the collectors she advised lent their artworks to exhibitions in the United States, and through these exhibitions Degas's art became visible to a wider American public and received more critical attention there. Most importantly, the collectors bequeathed Degas's works to American museums, where he is thus well represented to this day, with the most extensive of these bequests—by Louisine Havemeyer to the Metropolitan Museum—securing his canonization in the United States.

A closer look at a couple of concrete examples of the kind of chain reactions that extended Cassatt's work to promote Degas will serve to demonstrate how this dynamic operated. The fact that Alexander Cassatt was preeminent in Philadelphia's elite and one of the nation's most powerful corporate leaders meant that when he collected Degas and other Impressionists, friends and colleagues were inspired to do so as well.[196] For example, his Philadelphia lawyer, John G. Johnson, acquired three Degas artworks (one of them based upon Mary Cassatt's direct recommendation), which he

later bequeathed to the Philadelphia Museum of Art.[197] In turn, while in Paris, Johnson escorted to galleries his Pennsylvanian friend Peter A. B. Widener, who became one of the early American collectors of Degas.[198]

But it was perhaps Harry Havemeyer who went to the greatest lengths to "convert" an esteemed friend—Colonel Oliver H. Payne, "one of the great men of our country," in Louisine Havemeyer's words—into a Degas collector.[199] Payne, who had fought in the Union Army and subsequently made his fortune in iron, oil, and tobacco, was a neighbor and friend of the Havemeyers, with whom they spent many pleasant evenings.[200] When Durand-Ruel—who knew Payne's taste for pictures of pretty women—asked Harry Havemeyer to help him by suggesting a second-rate eighteenth-century painting to his friend Payne, Havemeyer instead made it his goal to introduce Payne to the kind of paintings he himself collected. He repeatedly suggested various fine paintings to Payne and at times "even let him have one he had intended to buy."[201] In one case, he relinquished "one of Degas' fine oils, just to make his friend Colonel Oliver Payne appreciate Degas as he did."[202] After that purchase, Payne proceeded to acquire another Degas at Havemeyer's urging.[203] Although we do not know whether Cassatt directly advised Payne, it is clear that she sometimes encouraged him to collect Degas, transmitting her communication through Louisine Havemeyer. For example, Cassatt asked her friend to convey a message to Payne encouraging him to acquire Degas's art by comparing him favorably to Vermeer. She wrote to Louisine that Durand-Ruel had just returned from a visit to Vienna, where he saw a Vermeer, and added: "Two million marks was asked or refused for it, I forget which. Col. Payne's Degas is more beautiful than any ver Meer [*sic*] I ever saw. Tell him that."[204] As these examples show, Cassatt's influence on Americans to collect Degas's art reached significantly further than her own direct advice.

Another way in which the chain reactions operated was that committed American collectors like Alexander Cassatt and the Havemeyers actively lent works from their collections to numerous exhibitions. For example, Alexander lent seven works to the 1886 exhibition of Impressionist painting in New York.[205] He also lent Degas's works to the acclaimed exhibition (organized by Cassatt's friend Sara Hallowell) *Loan Collection, Foreign Masterpieces Owned in the United States* at the 1893 Chicago World's Fair.[206] With Cassatt's encouragement, Louisine Havemeyer frequently lent works by Degas to exhibitions in the United States. As early as 1878, she lent a work by Degas to the National Academy of Design in New York, shortly after acquiring it at Cassatt's urging. This was the first time a Degas artwork was shown at an exhibition in the United States, and it prompted a *New York Times* critic to discuss it, writing that Degas is "a real Impressionist. . . . He is uncompromisingly realistic in fact he rather prefers the ugly to the beautiful."[207] Havemeyer not only lent many of her Degas paintings but also curated a museum-scale exhibition of Cassatt and Degas along with some old masters (I return to this in chapter 6).

In 1921, again with Cassatt's encouragement, Louisine Havemeyer acquired the full set of Degas's posthumously cast bronze sculptures, right after they were cast. Since

Degas's small-scale sculptures had not been exhibited during his lifetime—meaning that the market value of this form of his art had not yet been tested—Cassatt made a point of reassuring Havemeyer of their value: "Degas' statues are as fine, as great as anything the Greeks or Egyptians ever did. They will constantly appreciate in value. They are just as fine as his paintings."[208] This was an important endorsement, since it confirmed the excellence of Degas's sculpture by comparing it to his own two-dimensional art, which was already highly valued, as well as to Greek and Egyptian sculpture; and it also affirmed its market value. Havemeyer became the first collector to acquire the bronze sculpture set. As soon as it arrived in New York, as she reported, "I put it at once on exhibition in order that the great artist should again be honored and appreciated by a rising generation."[209] In addition to the sculptures, she lent drawings, pastels, two fan mounts, and four prints to the prestigious Grolier Club in New York for its 1922 exhibition *Prints, Drawings, and Bronzes by Degas*.[210] Thus, with Cassatt's encouragement, Havemeyer was responsible for the first showing in the United States not only of a Degas pastel but also of his sculpture.[211]

Through her frequent lending of Degas's work, Havemeyer assured the artist's visibility to the American public even before museums collected his work and prior to her 1929 bequest to the Metropolitan Museum of Art. By 1918 the museum's curator, Bryson Burroughs, noted that "the most conspicuous lack in the Museum collection of modern pictures is the absence of any paintings by Degas."[212] That same year, the museum acquired prints and drawings from Degas's estate, and in 1922 it acquired a pastel, but it did not have a single painting or sculpture by Degas until Havemeyer's bequest.[213] Havemeyer included in the bequest to the Metropolitan Museum of Art 35 Degas pictures, numerous prints, and 69 bronze cast sculptures—a total of 112 Degas works.[214] It is thanks to her bequest that Degas is "probably better represented here [at the Metropolitan Museum of Art] than anywhere else."[215] The quality and scope of the Havemeyer bequest attracted other American collectors of nineteenth- and twentieth-century French painting to select the Metropolitan Museum of Art as the destination for their gifts.[216] Works in the Havemeyer collection that were not included in the bequest or kept by family members went on the market. Today, many of them are owned by numerous American museums, including the National Gallery of Art, in Washington, DC; the Brooklyn Museum; the Denver Art Museum; the J. Paul Getty Museum, in Malibu; and the Nelson-Atkins Museum of Art, in Kansas City.[217]

As emerges clearly from this discussion, Cassatt was highly invested in Degas's legacy. She understood the importance of placing his works in American collections, confident that many of them would end up in American museums.[218] When she wrote to dissuade Havemeyer from holding a raffle of artworks by Degas and herself at the 1915 exhibition in support of women's suffrage, she expressed concern that an artwork by Degas would fall "into the hands of someone knowing nothing of ART."[219] Cassatt continued to care a great deal about Degas's legacy after his death. She advised the curator of the Metropolitan Museum of Art on which Degas works to acquire from the

1918 sale of the artist's studio;[220] made sure that Degas's works in her own possession were safely stored with Durand-Ruel during World War I; and saw to it that Havemeyer acquired from her own collection Degas's pastel *Woman Bathing in a Shallow Tub* in 1917, which eventually led to its being given to the Metropolitan Museum of Art.[221] So much of Degas's work crossed the Atlantic that as early as 1910, a British critic observed, "One can get to know Degas from all sides in America."[222] Although Degas scholarship rarely adequately credits Cassatt for her role in building Degas's transatlantic legacy, Hirshler's 1998 study on Cassatt's work with American collectors laid a solid foundation for understanding the scope of Cassatt's contribution.[223] A few years later, Ann Dumas offered a rare full acknowledgment of Cassatt's major role, stating: "Nobody played a more crucial role in promoting Degas' work among American collectors than Mary Cassatt."[224]

4

CASSATT'S TRANSATLANTIC FEMINISM

Will women be able to do anything? I don't care very much how they
vote. It is the far-reaching influence they will exercise when they have
equal political power with men.

MARY CASSATT, 1920

CASSATT'S SUPPORT OF SUFFRAGE and other feminist
causes, which for many years was largely overlooked in
scholarship, has been widely acknowledged in recent
decades.[1] Yet surprisingly, it has not been the focus of an in-depth
study, and Cassatt's specific feminist views and emotional invest-
ments are yet to be explored. In this chapter, I examine Cassatt's
feminist beliefs in the context of the debates of her time on both
sides of the Atlantic. The chapter charts Cassatt's positions on the
issues of suffrage, marriage versus career, choosing professional
work over a life of leisure, financial independence, equal citizen-
ship, taxation without representation, women artists, all-women
exhibitions, and the nineteenth-century doctrine of the gendered
separation of the private and public spheres.

Cassatt was a transatlantic feminist in the sense that she devel-
oped her pro-suffrage position and feminist outlook in France,
where she lived, but all the while kept a close affiliation with her
homeland—personally, nationally, and socially. She followed
American suffrage activities and general politics by reading the

Paris-Herald and primarily through her correspondence with her closest friend, Louisine Havemeyer. She also developed her ideas by talking with numerous other American friends and acquaintances. Her letters to Havemeyer leave no doubt that Cassatt was passionate about suffrage, but a careful reading of them reveals many more nuances about her views on this and other feminist issues.

SUFFRAGE

Cassatt's American identity and her belief in suffrage were thoroughly intertwined. She led her life with a remarkable degree of autonomy from early on, leaving her home to go to Europe to complete her art education. We do not know at what point she began to identify with the collective claim for women's rights, including the vote, but she probably encountered discussions of these matters while still in the United States, where American feminists embraced suffrage from the mid-nineteenth century, planting a seed that grew later on, as she gained life experience. While still in Philadelphia, she likely learned about Lucretia Mott, the prominent Philadelphia abolitionist and women's rights activist who was one of the five organizers of the 1848 Seneca Falls Convention, which launched the women's suffrage movement in the United States.[2]

Although the struggle for women's rights was nation specific, and tied to the particular politics of each nation, feminists recognized the transnational validity of the demand for women's equality. They developed international congresses and networks, formed comparative views of the state of suffrage in their own nation vis-à-vis developments in the world, and used victories in other nations to urge their own nation not to lag behind.[3] Winning suffrage for women in their own nation was paramount, and American suffragists watched intently when any new state granted women suffrage. Henry Mayer's 1915 illustration *The Awakening* (fig. 4.1) encourages a pro-suffrage vote in the upcoming New York State referendum by depicting an allegorical female Liberty figure holding up a torch as she walks across the map of the United States, progressing from the western states, where women had already won the vote, toward the eastern states, where women still eagerly awaited the vote.[4] Although she lived in France, Cassatt kept her American citizenship and was primarily interested in the rights of women in the United States. Yet like other suffragists, she also supported voting rights for women everywhere. Cassatt's comments in her letters to Havemeyer show her interest in the issue of women's status in other counties, though her comments on women in Egypt and Algeria were not free from a typical patronizing Western attitude. After visiting a harem in Egypt, she wrote to Havemeyer: "In the East, really women have been slaves & perhaps still are[,] why don't we improve."[5] In a discussion with one of her guests about women in Algiers, she remarked: "When women of the East are free it will surely change the world, & surely it needs changing."[6] During World War I, she wrote: "If only the German women would rise in revolt. They may when they see their children suffering."[7] Like other suffragists, Cassatt compared the relative progress, or lack thereof, in different nations, writing in 1917: "Russian women to vote before English[,] French or American!"[8]

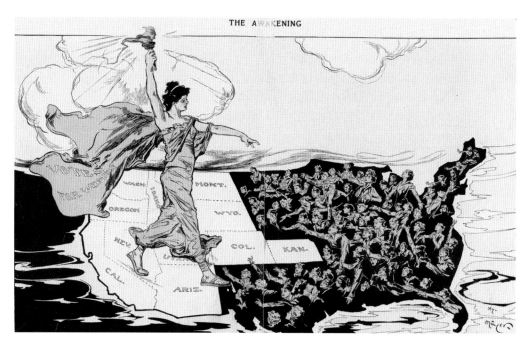

FIGURE 4.1

Henry Mayer, *The Awakening,* 1915. Offset photomechanical print. Illustration published in *Puck* 77, no. 1981 (February 20, 1915), centerfold, pp. 14–15. Prints and Photographs Division, Library of Congress, Washington, DC, 20540 98502844.

Cassatt's feminist awareness was likely further developed in France during the early 1880s, when she may have seen the press coverage of the first French campaign for suffrage, mounted by Hubertine Auclert in 1880–81 and discussed, for example, in *Le Petit Parisienne*, then one of the most widely circulating papers in Paris.[9] Auclert made suffrage a national issue as she attempted to register for the vote, interpreting the eligibility for the vote of "*tous les Français*" ("all the French") as including French women.[10] Her act might have reminded Cassatt of the American precedent—in 1872 Elizabeth Cady Stanton, Susan B. Anthony, and other women voted in the presidential election based on the argument that they were included in the right of all citizens. Arrested and subsequently tried in court, these suffragists were found guilty by an all-male jury of illegal voting.[11] In France, Auclert's courage converted some women to the cause, including Jeanne Oddo-Deflou, who went on to become a leading turn-of-the-century French feminist and said of Auclert's influence: "Who will count them, the conversions determined by that energetic act?"[12] Cassatt may have been one of them.

Cassatt was also likely aware of numerous feminist congresses held in Paris from 1878 onward. For example, she likely read about the first French feminist congress to place women's suffrage on its program, in 1896, an event on which *Le Temps* reported for seven consecutive days, twice on the front page. *Le Figaro* (a newspaper read regularly by Cassatt's mother) and other daily newspapers also reported on the congress.[13]

Although these congresses resulted in few political and legal changes, they made important contributions to a changing discourse.

We know that Cassatt certainly embraced American suffrage by 1909, when she first recommended to Havemeyer to work for this cause. But it is likely that her interest in suffrage developed some years earlier, because the timing she chose for urging Havemeyer to engage in this campaign was dictated by her wish to help her friend regain her energies after the devastating loss of her husband, and not primarily by a new discovery in her own life. A few years later, the war further convinced Cassatt of the urgent need for women to take part in politics. As she urged Havemeyer soon after the war broke out: "Work for suffrage, for it is women who will decide the question of life and death for a nation."[14] Why did Cassatt not become an activist herself, as she urged Havemeyer to do? In 1915, about one year into the war, the seventy-year-old Cassatt, who was no longer able to paint due to her diminishing eyesight, wrote to Havemeyer: "Do you think if I have to stop work on account of my eyes I could use my last years as a [suffrage] propagandist?"[15] The question reflected her care for the cause, but it was also related to the void she felt when she could no longer make art and to her sense of isolation during the war years, which generated a yearning to connect with others and to be useful.[16] Still, it was a telling fantasy.

According to Nancy Mowll Mathews, for Cassatt, feminism was of a "personal nature" and was "shaped and expressed in a private forum."[17] One reason for this may have been that becoming an activist while she was still able to paint would have conflicted with her total commitment to her art. But there was another important reason. Cassatt's passionate interest was primarily in suffrage in her homeland, whereas in France, where she lived, she always felt a foreigner to some extent, and as such was less involved and invested in the public cause. Hers was a vicarious "participation" through Havemeyer's activism. She kept up-to-date on suffrage in her homeland—for example, writing to Havemeyer in 1913: "I see that New York may give women the vote. I suppose the Government is not opposed? And there was a majority in the Senate for an amendment."[18]

Cassatt also kept informed about suffrage by discussing it with Americans who visited her in France. This exposed her to conservative, even anti-suffrage, views. For example, she reported on a conversation with Dr. Nicholas Murray Butler (the then president of Columbia University and a Republican nominee for vice president of the United States in 1912): "He thinks it would only give some more irresponsible votes & we have too many."[19] Cassatt did not reveal her own view of Butler's use of the "irresponsible" voters claim. But it was a typical anti-suffrage argument: educated women's vote was said to be "irresponsible" because of their lack of political experience, while uneducated poor women's vote was branded "irresponsible" because of their lack of education, even though no parallel qualification applied to male voters. And sometimes, as a 1912 anti-suffrage poster issued in Wisconsin shows, the "irresponsible" argument simply expressed the typical fears of anti-suffrage male voters (fig. 4.2). This

DANGER!

Woman's Suffrage Would Double the Irresponsible Vote

It is a MENACE to the Home, Men's Employment and to All Business

(SAMPLE)
Official Referendum Ballot

If you desire to vote for any question, make a cross (X) or other mark in the square after the word "yes," underneath such question; if you desire to vote against any question, make a cross or other mark in the square after the word "no" underneath such question.

Shall Chapter 227 of the laws of 1911 entitled 'an act extending the right of suffrage to women' be adopted?

Yes ☐ No ☒

The above is an exact reproduction of the separate ballot printed on pink paper which will be handed to you in your voting place on November 5. Be sure and put your cross (X) in the square after the word "no" as shown here, and—be sure and vote this pink ballot.

Issued and Circulated by
PROGRESS PUBLISHING CO
WATERTOWN, WIS.

FIGURE 4.2

Danger!, anti-suffrage poster, Wisconsin, ca. 1912. Poster issued by Progress Publishing Company of Watertown, WI. Wisconsin Historical Society, Madison, WI, WHI-1932.

anti-suffrage typographic poster read: "DANGER! Woman's Suffrage Would Double the Irresponsible Vote. It is a MENACE to the Home, Men's Employment and to All Business."[20] It attempted to convince male voters to reject women's suffrage in the 1912 referendum held in Wisconsin. Such anti-suffrage posters were often funded by the liquor industry, which feared that women would support prohibition. Posted in and around saloons, they were part of a well-financed campaign by the powerful liquor industry in the state of Wisconsin.[21]

Sometimes, women who visited Cassatt expressed anti-suffrage opinions, and this could arouse her emotions. For example, she wrote to Havemeyer: "Miss Adams and Miss Hooper were here for dinner, both 'antis'[,] I rather lost my temper."[22] She reported that they had made a "silly argument" to prove that women are not fit to vote, and Cassatt explained to Havemeyer her reaction to the women: "I hated to hear that women despise women. These youngish women who have never done a stroke of work in their lives."[23] Thus, Cassatt's ire was directed here specifically at American anti-suffragist women ("the Antis") who were mostly of her own class. Carrie Chapman Catt and her coauthors of *Women Suffrage and Politics* defined the Antis as "mainly well-to-do [women], carefully protected, [who] entertained the feeling of distrust of the people usual in their economic class,"[24] women who were worried "lest the privileges they enjoyed might be lost in the rights to be gained."[25] The Antis formed their organization sometime before 1890, initially "sending a male lawyer to protest in their name" against the vote, but after some years "these ladies grew bolder and made their own protests before committees."[26]

One of these "ladies" was the Philadelphian Jennie Carter Cassatt, the widow of Cassatt's younger brother, Gardner. Cassatt was aghast that Jennie went to Washington, "No doubt to do her best as head of the anti suffragettes to prevent suffrage!"[27] She described her as "rabid" about the suffrage question,[28] and it stunned her that Jennie took on the Antis cause with so much fervor: "I never knew Jennie to be so enthusiastic over anything before, as this trying to keep women from voting."[29] Cassatt wrote to Havemeyer about her distress over an article in the *Herald* that quoted her sister-in-law:

> I feel distinctly upset, the *Herald* of yesterday reproduced Jennies [*sic*] remarks as to *spanking* the militant suffragettes! Fancy any woman let alone a lady saying such a thing, proposing such a thing about other women. . . . The insolence of a woman in her position, never having known anything of the struggles of life judging for other women. I must not think of it too much or I should let myself go to telling her what I think of such *vulgarity*.[30]

The title of the article was quite a provocation: "Spank Militant Suffragists, Says Mrs. J.G. Cassatt: Declares It Will Be More Effective Than Jail." It quoted Jennie stating the typical anti-suffrage argument: "Women in politics means neglect of the home, a woman's true province, and the destruction of the sacredness of the family fireside, the backbone of civilization."[31] In addition to being disturbed by the "vulgarity" of

Jennie's words, Cassatt was offended by the contempt and condescension expressed in the notion of "spanking"—as if the suffragettes were misbehaving children rather than political opponents. Suffrage remained a loaded issue between Cassatt and her sister-in-law; "Jennie never mentions the subject nor I," Cassatt wrote to Havemeyer.[32] This, along with the insult Cassatt felt at Jennie's lack of interest in her art, led Cassatt to state: "We haven't a thing in common."[33]

Cassatt herself, however, was not free of the prejudices held by most Americans of her class, nor was Havemeyer. Writing to Havemeyer about the suffrage campaign, Cassatt expressed the kind of bold racism and anti-immigrant bias that was typical of many Americans at the time: "By the way[,] do propose a limited vote for women in America[,] only native born white women[,] one native born parent, I assure you the men I have spoken to about this are rather struck, the only objection they find, is that it will never pass."[34] Suffragist arguments repeatedly relied on anti-immigrant sentiments. So, for instance, they objected to the fact that European male immigrants "could vote in all States after naturalization, and in fifteen States without it" and were thus "qualified to pass upon the questions of the enfranchisement of American women."[35] And on various occasions in the 1860s, in response to anti-suffragist fears that "woman suffrage would supplement the immigrant vote,"[36] Stanton made the argument, with which elite white women like Cassatt and Havemeyer no doubt agreed, that the vote of educated (white) women would counteract the influx of "millions of foreigners" and freed Black men, whom she associated with ignorance and degradation.[37]

In another letter, Cassatt responds with distinctly racist overtones to a comment by Havemeyer that wrongly attributed to African Americans the defeat in the 1912 Kansas state referendum on the constitutional amendment granting women the right to vote: "It seems to be a pretty bad state of affairs if negroes can keep white women from voting. As you say was the case in Ohio."[38] Like several other referendums on the suffrage amendment, this one was lost because of business interests, mostly of the liquor industry.[39] Cassatt's and Havemeyer's racist assumptions partook in a long history of prejudice that plagued the battle for suffrage for Black men and Black and white women. Suffragist leaders, including Susan B. Anthony, Stanton, and Mott, all initially fought alongside abolitionists like Frederick Douglass for the right to universal suffrage, extending the vote to Black men as well as Black and white women. In 1865, however, the suffrage leaders were told by abolitionist leaders to defer women's suffrage and give precedence to Black men's suffrage, in what was called the "Negro's hour." Stanton and Anthony disagreed with the claim that they must give up their own political interest so as to prevent it from acting as a "distraction" from the cause of Black men's suffrage,[40] and insisted on continuing to demand the vote for white and Black women.[41] Unlike Mott, they did not support the Fifteenth Amendment, ratified in 1870, granting the vote to Black men only.[42]

Cassatt believed in the importance of the vote to correct a wide array of problems affecting women through legislation. In 1913, after reading the newly published novel *Where Are You Going To . . .?* (also known as *My Little Sister*), by Elizabeth Robins (an

American-born author, actress, and suffragette who lived and worked most of her life in London), about the abduction of two innocent young sisters into a brothel, Cassatt wrote to Havemeyer: "Yes my dear[,] women need to vote to stamp out that crime."[43] The novel narrated an instance of what was then a widespread international phenomenon of trafficking in women and children, referred to as the "white slave trade."[44]

Cassatt's beliefs about the vote and its feasibility, like those of many American suffragists, evolved over time. Before the war, there was a sense in France that the movement for women's rights was progressing well, but the outbreak of the war effectively sidelined it,[45] and Cassatt wrote: "I think they will surely get the vote here when they want it."[46] She also believed "that the vote will be given freely [in the United States] when women want it.[47] Soon after World War I began, Cassatt thought women should take collective action to gain political power in order to stop the war, writing that they "must be up and doing, let them league themselves to put down the war."[48] She wrote to Havemeyer that suffrage for women "was the question of the day, the huge hope for the future" and added: "Surely, surely! Women will wake to a sense of their duty and insist upon passing such subjects as war, insist upon a voice in the world's government."[49] Cassatt, like many, was overly optimistic in thinking that because women "are now doing most of the work,"[50] suffrage would simply be given to them after the war. Even though women took up a wide array of jobs, proving their capabilities and making a crucial contribution to the national effort, neither American nor French women were handed the vote. Removed from the daily reality of the battles of suffragists in their respective national political spheres, Cassatt was not cognizant of the extent of the political work needed to overcome deep-seated objections to suffrage.

During the war, Cassatt engaged in local philanthropic activities, assisting some of those who were in need, and especially children and youth. It was also the only time she supported a local feminist effort, contributing five hundred francs of her own money, and adding the same amount on behalf of Havemeyer, to aid a suffrage paper edited and published in Nice, while she was living in the South of France. She wrote to Havemeyer about the editor of this publication: "I am sure you will approve as she edits the suffrage paper in Nice. She is a woman who has immense energy and intelligence & has had a most dramatic life."[51] Living through the war in France aroused in Cassatt a sense of connectedness to her immediate environment and empathy with those suffering in these communities, and for the first time also with the cause of French feminism.

Whereas Cassatt had no actual experience of taking part in the battle for the vote, some of the suffrage leaders at the forefront of this struggle had become disillusioned with the idea that advocacy alone could bring about change. Alice Paul, founder of the National Woman's Party (NWP) in the United States (in which Havemeyer was active), and Emmeline Pankhurst, founder of the Women's Social and Political Union (WSPU) in England, concluded that advocacy proved to be insufficient.[52] Between 1912 and 1914, Pankhurst and the WSPU launched a campaign of militant action. Pankhurst was repeatedly imprisoned, went on hunger strikes, and was brutally tortured by being

force-fed in prison, all of which brought the cause of suffrage a lot of press coverage. Cassatt had a decidedly negative opinion of Pankhurst and her methods. When Pankhurst came to the United States in 1913 to raise funds for the cause in England, Havemeyer attended her rousing speech at the Connecticut Woman Suffrage Association in Hartford, titled "Freedom or Death." She must have mentioned this in a letter to Cassatt, prompting Cassatt to respond: "No my dear, I don't care for Mrs. Pankhurst[,] I am sorry she took back $20,000 [the equivalent of over half a million dollars in 2022] of American money with her.... Violence never yet advanced a cause."[53] Cassatt believed that Pankhurst's militant tactics "kept back women's suffrage in England." She also wrongly attributed to Pankhurst responsibility for the death of Emily Davidson, a British suffragette and leading member of the WSPU who died after being hit by King George V's horse during an act of protest. Cassatt stated that Pankhurst "pushes people to do what that poor girl did who threw herself under the Kings horse";[54] but in fact Davidson, who was apparently aiming to place two suffrage flags on the horse, acted on her own with no authorization from the WSPU.[55] Cassatt believed that Pankhurst was irrelevant to Americans: "Americans are not Englishmen in their treatment of women."[56] Finally, she disapproved of Pankhurst's character, reporting that Sir William Ramsay, a prominent scientist who supported women's suffrage and had hosted Pankhurst at his house for a week, found that she was not a pleasant guest.[57]

Yet the fundamental belief in women's equality was becoming increasingly central to Cassatt, so much so that she could not feel comfortable in the company of women whom she thought led a spoiled life that had no purpose other than leisure: "It is hard for a suffragette like me to have two of the most incapable & lazy women in France here."[58] She was always interested in the question of where her American friends stood on the matter of suffrage, and regretted anyone not believing in the importance of the cause. For example, she wrote to Havemeyer about Havemeyer's sister: "I am sorry Annie isn't interested in suffrage."[59] As her letters to Havemeyer show, she also assessed the younger generation on this issue and tried to influence their minds when she could. When she learned that a mutual friend had been widowed, she suggested to Havemeyer: "Try to make a suffragette of the poor girl."[60] It seems that during her later years, suffrage was always on her mind. On August 26, 1920, the suffrage amendment to the US Constitution was formally adopted and certified.[61] Soon after this victory, Cassatt made the point that the vote was just the beginning: to make a difference, women had to enter politics and gain "equal political power with men."[62]

MARRIAGE VERSUS DEDICATION TO WORK, AND ECONOMIC INDEPENDENCE

Cassatt, who never married, would likely have agreed with Susan B. Anthony that

[t]rue marriage, the real marriage of soul, when two people take each other on terms of perfect equality, without the desire of one to control the other, is a beautiful thing. It is the

highest condition of life; but for a woman to marry for support is demoralizing; and for a man to marry a woman merely because she is a beautiful figure or face is degradation.[63]

Would she also have agreed with American feminists who couched their critique in stronger terms, like Stanton's claim that "man-made marriage [. . .] makes man master, woman slave"?[64] Perhaps this phrasing was too radical for Cassatt, but in principle she would have concurred with feminists on both sides of the Atlantic who fought to change the laws so as to grant married women rights to keep their earnings, initiate divorce, and gain custody of their children. Cassatt herself made no critical comments that we know of about marriage, although the topic interested her. In 1913 she asked Havemeyer if she had read H.G. "Wells on 'Marriage,'" referring to the author's recently published novel *Marriage,* but her brief comment does not reveal her views on the treatment of marriage in the novel.[65] It seems that in her old age, Cassatt was more interested in the novel's overall "critique of modern life" than in its representation of marriage.

Although she herself did not marry and led an independent life devoted to work, Cassatt did not believe this was the right choice for every woman. In one letter to Havemeyer, discussing the case of a woman who was interested in art and was planning to write about it, Cassatt explicitly recommended marriage: "She is a girl (not young[,] 34.) of many qualities, but I do not think Art is one of her gifts. I strongly advise matrimony especially as there is someone."[66] Cassatt was happy about the marriages of her nieces and nephews, as well as those of the Havemeyer children. And she was far from indifferent to weddings. Declining Havemeyer's invitation to attend the wedding of her daughter Electra, she revealed that she did not like going to wedding ceremonies because they always made her cry.[67]

For Cassatt, as for other middle- and upper-class women who deliberately chose a life of professional work over a life of leisure or domesticity, this was a feminist choice. It involved a conscious view of her work as a priority. Feminists like Stanton had long criticized women who "lounge on velvet couches,"[68] and many others rejected women's "idleness."[69] Women who belonged to the middle or upper class were expected to devote themselves to the duties of wife and mother, and to be available for various social and philanthropic activities. Thus, when a woman of this era chose uncompromising dedication to her work, this was a feminist challenge to the prevailing norm. Women who fought for the right to work, whether because they wanted to work or because they needed to work, had to overcome the widespread conviction (of most men but also many women) that work was a masculine prerogative.[70] Even when the French Workers Congress held in Paris in 1876 published a resolution that was progressive in "recognizing a woman's right to work," its members added: "We would prefer that she do nothing outside of the household."[71] In addition to the general gender prejudice against women joining the workforce, working-class men were also concerned that women were taking their jobs, and they strongly opposed women's enter-

ing trades defined as "male," such as printing.[72] Male professionals, like doctors and lawyers, were no less prejudiced, even obstructive.[73] And those women who were able to gain employment faced the problem of exploitative low wages paid to women, which in the late nineteenth and early twentieth century prompted feminists on both sides of the Atlantic to launch efforts to achieve equal pay for equal work.[74] In the field of art, the Impressionists, who held independent exhibitions, were more open to women's participation, perhaps in part because, at the time, these exhibitions were still on the margins of the art world.[75]

Cassatt's dedication to becoming a professional artist developed early on in her life. At sixteen, she was already interested in going to Rome to study art.[76] A year later, she began her studies at the Pennsylvania Academy of the Fine Arts in Philadelphia.[77] Already at twenty years old, Cassatt understood that to be a professional artist necessitated not only to paint but also to exhibit, have one's work critiqued by colleagues, receive critics' reviews, and find collectors. She expresses this in her passionate plea to Eliza Haldeman (with whom she had studied at the academy):

> Now please don't let your ambition sleep but finish your portrait of Alice so that I may bring it to town with me & have it framed with mine, sent to the Exhibition with mine, hung side by side with mine, be praised, criticized with mine & finally that some enthusiastic admirer of art and beauty may offer us a thousand dollars a piece for them. "Picture it—think of it!"[78]

In the 1860s, when Cassatt was in her twenties, she also mustered the courage to go against the norms that curtailed the freedom of middle-class women to travel alone. To leave Philadelphia for Europe, she had to overcome her father's strong opposition. In Europe, she devoted herself to work, with focus and tenacity, even in difficult circumstances. For example, when she went to Seville on her own, "It was horrid and I was alone, but I braved it out for a year";[79]and later when she moved to Parma to study Correggio, "I stayed there for two years, lonely as it was. I had my work and the few friends I made. I was so tired when my day was done I had little desire for pleasure."[80]

Cassatt worked eight- to ten-hour days and declined many social invitations because of the importance she placed on this work schedule.[81] She was perturbed when some of the women friends who visited her did not understand that she could not spend the day with them.[82] Even on Christmas Day she sometimes worked, writing in 1909, for example, that she tends to forget about "such festivals that interfere with work" and complaining that her model had "promised to come Xmas but did not."[83] Cassatt also carefully planned her travel so that it would interfere as little as possible with her work, typically trying to schedule it so that it would follow intensive bouts of work.[84] Although she was always eager to spend time with Havemeyer, she gave priority to her work when necessary, as evidenced by a letter from 1910 in which she declines the invitation to visit her friend in the United States: "As to going over to you,

I cannot this summer. I have so much to do, so much to accomplish before next December."[85]

For a woman, succeeding in her work and earning her own money from it was the main building block of independence. Cassatt would have wholeheartedly embraced the observation of the popular French author Marcelle Tinayre, who said in 1906 that a woman who supports herself "could conquer something else besides her daily bread, her clothing and her housing: moral independence, the right to think, to speak, and to act as she sees fit, this right that man has always had and that he always refused her."[86] American middle- and upper-class women who were ambitious, hardworking professional artists, like Cassatt, were an emerging phenomenon during the late nineteenth century in the United States. Cassatt noted that even Theodate Pope, who was going to inherit a large fortune, was "only dying to succeed & make money as an architect."[87] Nonetheless, it was still a minority of middle- and upper-class women who were dedicated to working in a profession and earned their living from it.[88] As Cassatt wrote, "I can bear a good deal of fatigue, of course very few women work. I mean at a profession."[89]

Succeeding in one's profession required a support system at home. The Philadelphia-born painter Anna Lea Merritt, who was active in London, wrote in 1900: "The chief obstacle to a woman's success is that we can never have a wife," someone who "keeps his house," "writes his letters," "wards off intruders," is "always an encouraging and partial critic," and in all these ways makes her husband's success possible. By contrast, "A husband would be quite useless. He would never do any of those disagreeable things."[90] And the French suffragist Auclert wrote about women's double burden—doing paid labor as well as "all those unproductive tasks that are assigned to women" without pay.[91] She noted that women were regarded as men's servants rather than as equals, and mounted an early defense of shared household labor.[92]

For women in Cassatt's class, who could hire help, the issues Merritt and Auclert described posed less of a problem. Although she took care of her sick sister and later her mother, Cassatt's productivity was affected by this only during certain periods: most of the time, she had a house staff that enabled her to focus on her work. With the exception of the years of World War I, when her staff was severely reduced, Cassatt usually employed a coachman, who from 1906 became a driver, up to three gardeners, and several farmworkers to tend to the grounds of her country residence, a cook, a chambermaid, and a housekeeper—Mathilde Valet.[93] Valet, who helped Cassatt oversee the rest of the staff, also served as a lady's maid, becoming, as I mentioned earlier, more of a companion.[94] A year before she died, Cassatt wrote about Valet: "She has been with us for 43 years[,] therefore is a member of the family."[95]

Cassatt set up her residences in Paris and the countryside so that she could work in each. In addition to maintaining painting studios in both locations, she converted a small mill on the grounds of the country residence, Château de Beaufresne, into a printing studio and installed her printing press there (fig. 4.3). Although many painters chose to have printers do the entire work of producing their prints, Cassatt, like Toulouse-

FIGURE 4.3

Mary Cassatt's printing studio on the grounds of her country residence, Château de Beaufresne. Photograph by Michal Iskin, 2018.

Lautrec, insisted on producing her own prints, with assistance from a master printer. Commenting on the importance of doing the work herself, she said: "It makes a great difference, for no two impressions are exactly alike."[96] Another advantage was that by doing the printing work, an artist learned the distinctive possibilities of the medium.

Havemeyer described Cassatt's rigorous schedule as well as the hard physical labor involved in pulling prints:

> Eight o'clock in the morning would find her in her gray blouse in the small pavilion over the dam . . . where she had installed her printing press. There she would work while daylight lasted with the aid of a printer. She did her own coloring and wiping of the plates. It was at the cost of much physical strain for she actually did the manual work.[97]

To create art was an existential necessity for Cassatt. She lived to work: "I do pity those who cannot work anymore, may I go before I must sit with idle hands."[98] Once, at sixty-seven years of age and traveling with her brother Gardner and his family, Cassatt's enjoyment of her niece, Ellen Mary, made her reflect: "It seems an odd life I am leading, all work & little play."[99] But a month later, she was back to the familiar tune: "I am pining to get back to work. There are things I am dying to do."[100] During the long period in which she could not work following Gardner's sudden death at the end of their family trip, Cassatt wrote: "I so long to work[,] it is the only consolation for all one's ills."[101] In the spring of 1913, Cassatt was thrilled to begin working on her art again, and in the summer she wrote: "My work is exciting, it is so good to be able to work again."[102] But this was short-lived, and Cassatt's last known works are dated to 1914.[103] After forty years of working on her art, she stated: "I feel I need forty more."[104]

Cassatt was not only a hard worker but also supported herself from her art sales. She earned a living from her art at a time when only a small number of women

professionals in liberal professions achieved this. To be self-supporting was a matter of principle to her, as it was for many feminists. American suffrage leaders lamented the fact that it was seen as "a disgrace for women of the middle or upper classes to earn money," and even the unmarried woman from these classes was "forbidden by public opinion to support herself" and was expected to become "a dependent in the home of her nearest male relatives."[105] French feminists similarly recognized women's economic independence as "the key to women's emancipation,"[106] and in 1893 they called for "the right to an economic life" (*le droit à la vie économique*),[107] which included "a minimum wage, equal pay for equal work, equal access to the professions, careers and vocations, public services, and administrative functions."[108] Cassatt no doubt agreed.

In the 1870s, while she was still in an early phase of her career, Cassatt's father insisted that she cover at least the expenses associated with making her art, including her studio, supplies, materials, models, and travel.[109] Even before she moved to Europe, Cassatt had attempted to sell her work in Philadelphia, New York, and Chicago. She also managed to secure commissions by a Pittsburgh bishop for copies of two Correggio paintings in Parma.[110] Years later, after Cassatt achieved success in Paris, she was determined to attain it also in her homeland, as her mother testified in 1891: "Mary is at work again, intent on fame & money, she says, & counts on her fellow countrymen now that she has made her reputation here."[111] Cassatt's work was sold by the major dealers of Impressionist art, primarily by the Durand-Ruels in their Paris and New York galleries, to both French and American collectors. Later in life, Cassatt occasionally supplemented her income by selling some Impressionist artworks from her small personal collection after their prices rose. By the 1890s she had earned substantial sums of money from the sale of her own art. At age fifty-one, the total sales from her solo exhibition in Durand-Ruel's gallery in New York (spring of 1895) amounted to $7,100 (the equivalent of $239,900 in 2022—a considerable sum even after deducting Durand-Ruel's commission).[112] In 1911, when she drew up her will, Cassatt's holdings amounted to about $200,000 (over $5.5 million in 2022).[113]

Since Cassatt labored to earn her living through her art, she was particularly irked when people mistakenly assumed that she was living off her older brother's fortune. A daring leader in the development of the American railroad, Alexander J. Cassatt was responsible for building railroad tunnels under the Hudson and East Rivers and New York City's Penn Station.[114] He amassed a huge fortune, lived with his family in grand style in Philadelphia, and was far better known in the United States than his sister.[115] After his death, a Philadelphia daily newspaper erroneously reported that Cassatt was "an heiress to millions, the richest artist living" (but added that she "worked away with untiring energy all the while living in an unostentatious manner").[116] Cassatt confided in Havemeyer that she was deeply offended by people's assumptions about the source of her money, and in a later letter stressed that in fact it was she who was responsible for her brother's best investments: "Do you wonder that I feel a certain

bitterness, people think I was a pensioner on my brother's bounty";[117] "The truth is that he never made such an investment as when he bought those pictures through me. Think of that fine Manet sold for 250 fcs!"[118] Cassatt likely calculated that such profits from art sales were greater than any money she may have received from Alexander. It was she who had convinced her brother to collect and she who was the moving force behind his acquisitions of avant-garde French art before its value rose. As early as 1880 and 1881, she bought artworks in Paris and shipped them to him, including works by Pissarro, Monet, and Degas, making him one of the earliest Americans to collect Impressionist paintings.[119] Based on Cassatt's recommendations, Alexander's collection also included works by Morisot, Raffaëlli, and Whistler, several works by Degas, Renoir, and Manet, and many Monets.[120]

Given the import Cassatt, like other feminists, placed on economic independence, it is clear why she was so deeply offended that some people assumed she had to rely on her brother's fortune. This belittled her own achievement, dismissing the fact that she had succeeded in making considerable money from her art, even if her funds were supplemented by inheritance. It also reiterated the stereotype that women's work "did not produce economic value of significance."[121] Cassatt's letters to her confidante Havemeyer did not state details about funds she may have received from her brother, probably because Havemeyer was familiar with this information. Cassatt was the sole beneficiary of her parents' holdings, since both of her brothers were much wealthier.[122] She also inherited $10,000 (close to $300,000 in 2022) from her younger brother Gardner and probably inherited at minimum a similar sum after Alexander's death.[123] During the time that Cassatt's parents lived with her in Paris, Alexander helped them cover the expenses associated with keeping a carriage (stable, horses, a salaried coachman, a garage),[124] but there is no evidence that he regularly supported them financially beyond that, nor that he left his sister a trust fund.[125]

Cassatt had some money invested in the United States (probably the inheritance from her parents and brothers), which she regarded as a reserve and did not use for routine expenses. Even when unexpected expenses came up, like when the United States instituted a federal income tax and around the same time the rent on her Paris apartment was increased, she did not touch these funds.[126]

CITIZENSHIP

Women's battle for the vote and other rights formed part of the broader goal of attaining equal citizenship. One of the ways in which citizenship laws in the United States discriminated against women was codified in the Expatriation Act of 1907, according to which any woman who married a foreigner thereby lost her own nationality and became a national of her husband's country. But in actuality, such a woman would remain stateless if the laws of her husband's country did not enable her to become a citizen.[127] By contrast, male American citizens who married foreigners not only retained their citizenship but also extended it to their wives and children.[128] When the

Supreme Court rejected a feminist's challenge to the law, it declared that the marriage of an American woman to a foreigner must be judged as an act that is "as voluntary and distinctive as expatriation."[129]

Cassatt's case shows that even an unmarried American woman could suffer repercussions from the gender-based discrimination of the 1907 act. In 1910 Cassatt went to the American legation in Paris to obtain her passport (in preparation for her trip to Egypt) and was deeply upset by what she had to undergo to receive the passport. Though she was unmarried, the mere fact that she was a woman who had lived abroad for many years made her eligibility for citizenship questionable. She felt humiliated and still shaken when she wrote to Havemeyer: "They actually administered the 'iron bound' oath to me before giving me a passport. What are the suffragettes about to submit to that."[130] Her comment suggests that she was indignant about the gender discrimination and expected change. The "ironclad" oath, an order signed by Lincoln in 1861, was a loyalty test to the Union during the Civil War, which became a requirement for all those appointed to federal office.[131] When her loyalty was tested at the legation, Cassatt experienced on her own flesh the contingent nature of a woman's American citizenship: far from an independent, unconditional birthright, it was derivative, tenuous, and vulnerable.

Cassatt was right that suffragists would not agree to this discriminatory law. After obtaining the vote, the NWP lobbied for equal nationality and succeeded in passing the 1922 Cable Act that asserted the principle of independent citizenship for married women. This act overturned the law that deprived American women of their citizenship when they married a foreigner,[132] but effectively it retained an inequality between men and women by stipulating that if an American woman lived for two years in her husband's country or five years in any foreign nation, she would be deprived of her American citizenship.[133]

Taxation was another core feminist issue at the time, and like other suffragists, Cassatt opposed the gender-based discrimination inherent in the American tax system. When the United States enacted the federal income tax in 1913, Cassatt and other suffragists objected to this law because it required women to pay taxes even though they could not vote and thus were unable to influence legislation that affected them. Many suffragists regarded "no taxation without representation" as one of the arguments for obtaining the vote.[134] When the National American Woman Suffrage Association (NAWSA) published its first propaganda postcard series in 1910, to counteract anti-suffrage postcards, they featured this text on a postcard: "A fundamental principle of this government is TAXATION WITH REPRESENTATION. We are all taxpayers, both WOMAN and MAN. Hence—EQUAL SUFFRAGE. IT ADMITS OF NO ARGUMENT."[135]

Cassatt's firm belief in the connection between the right to vote and the duty to pay taxes is evident in a letter to Havemeyer in which she scoffs about the head of the anti-suffragettes in New York who "thought it unnecessary for women to vote in America,

even though paying taxes, because 'they could influence men.'"[136] The feminist debate about women paying taxes without representation in fact first arose over half a century before the federal income tax amendment, over women's obligation to pay local property taxes to the individual states. Strategically associating themselves with the rallying cry of the American Revolution, American feminists proclaimed as early as 1852 that "taxation without representation" was tyrannical, and argued that representation for taxpayers was an American right.[137] Stanton, Lucy Stone, and others called on American women to resist paying taxes, and although tax resistance did not become a large movement in the United States, some women did refuse to pay taxes as an act of political resistance.[138]

Cassatt did not refuse to pay taxes but shared the suffragists' objection to taxation without representation. And though unmarried, she shared their objection to the discriminatory Expatriation Act. These were not mere abstract ideas to her. The difficulties she encountered with renewing her passport provided firsthand experience of how an American woman living abroad could be excluded by her nation based on her gender.

WOMEN'S ART, EXHIBITIONS, AND JURIES

For Cassatt, being a feminist did not mean endorsing artists because they were women. Furthermore, she objected to some women artists, as she did in the case of certain male artists. So, for example, she made critical comments about the eighteenth-century painter Elisabeth Vigée Le Brun[139] and was known to disapprove of the Philadelphia painter Cecilia Beaux, her near contemporary, and of the early twentieth-century painters Romaine Brooks and Marie Laurencin, who were active in Paris.[140] In fact, Cassatt did not think there had been great women artists in the past and did "not see the great original female painter appearing on the horizon."[141] In one letter to her friend Roger Marx, the critic, collector, and museum official, who himself was supportive of women artists, she stated: "I believe that women have never held first place or even second place in the plastic arts."[142] She noted that this contrasted with the fact that some superb women writers existed in literature:

> Only why has no woman really done anything in top-notch Art? This is what I think after reading your article [on Berthe Morisot],[143] Madame Vigée-Lebrun is the only one who survived, so to speak, and the portrait of David that I saw recently seemed to me to contain all of her work. In literature women have been so superior. I'm not talking about Georges [sic] Sand . . . But there are in England female novelists of the very first rank. McCauley was not afraid to compare Jane Austen to Shakespeare.[144]

She concluded with the pessimistic pronouncement: "Ah! do you think a woman will ever be a great artist. I doubt."[145] In her youth, when Cassatt exclaimed that she "wanted to paint *better* than the old masters,"[146] she had aspired to greatness and

believed that it was not out of reach because of her gender. Yet in her mature years, as her letters to Marx reveal, she came to espouse a different opinion. Her comment that Vigée Lebrun was the only female artist who had entered history demonstrates that Cassatt, like many others in her time, was unaware of some of the strongest women artists from the Rennaisance onward, like Artemisia Gentileschi, to mention just one example. This is understandable in light of the fact that the art of Gentileschi and other historical women artists began to be recuperated only during the late twentieth century.

One might wonder whether Cassatt's objection to separate exhibitions for women artists (discussed briefly in chapter 1) was an antifeminist position. Like Morisot, she did not join the Union of Women Painters and Sculptors (l'Union des femmes peintres et sculpteurs), founded in 1881 by Hélène Bertaux, and never chose to exhibit in its annual Salon.[147] It is known that she was furious at Durand-Ruel for sending her artworks to various amateur or nearly amateur women's art exhibitions in America, contra her explicit instruction.[148] Yet Cassatt's letter to Marx reveals another quite different reason for her objection. When Marx invited her to participate in an exhibition of women artists in Vienna, she declined, even though given that the invitation came from Marx, it was most likely not an exhibition of amateurs. Cassatt even told him that she regretted *his* support of such exhibitions. Since she respected Marx a great deal as a critic, connoisseur, and collector (he was also an important collector of her own work), she added: "I also regret not doing what you ask of me."[149] She told Marx that she had received many invitations to participate in women's art exhibitions, and "always answered with a categorical no."[150] Her reason for this, Cassatt explained, was her staunch belief that male and female artists were on "an equal footing," though she qualified the statement by adding, "at least" when presenting their artwork to the public.[151] This must have been based on her own experience as part of the French Impressionists, a group that included a total of four women, and in whose independent exhibitions her art drew considerable attention from critics and collectors. Thus, Cassatt replied to Marx:

> I gave as reasons that men have never refused women artists their part in exhibitions and the rewards, now we want to separate men and women in art. How can you approve of this? I do not understand your attitude about this question and how can I, after the way I have responded to requests for competitions by *women* painters, now accept to be part of this Vienna exhibition? *No,* in the Arts at least man and woman are on an equal footing, at least when presenting themselves before the Public. . . . Here, dear Sir, are my reasons for not taking part in this new women's exhibition, why are you interested in this?[152]

Cassatt's objection to all-women exhibitions, then, was not necessarily an antifeminist position. Instead, it can be understood as a different feminist position, if highly idealist, on this complex issue—namely, a view that insists on full integration and

equality. This was in tandem with Cassatt's own conduct in both her professional and social life, where, from her early days in Italy (which I discuss in chapter 3) and on, she befriended male artists, and argued and competed with them.

Another point, not mentioned in her letters to Marx but which likely fed into Cassatt's objection to all-women art exhibitions, is that for women who were established professionals, participating in all-women exhibitions could be detrimental, because these were often associated with amateur art. The Philadelphia-born female artist Merritt wrote in 1900 that doing so could "risk the place they [women artists] already occupied. What we so strongly desire is a place in the large field: the kind ladies who wish to distinguish us as women would unthinkingly work us harm."[153]

The American journalist, writer, and editor of magazines Mary Fanton Roberts, who wrote art criticism under the pen name Giles Edgerton, gave another objection to women's separate exhibitions. In her 1908 article "Is There a Sex Distinction in Art? The Attitude of the Critic toward Women's Exhibits," she argued that the treatment of women artists should be equal to that of male artists, whereas labeling an exhibition as a show of "women's art" leads to a patronizing attitude instead of honest criticism.[154] She also asserted that women's exhibitions were "out of harmony with present-day" developments toward equality between men and women.[155] These were types of feminist positions against gendered exhibitions that Cassatt would have agreed with. In matters of art and its exhibition, Cassatt saw her place squarely among her Impressionist colleagues.

Although Cassatt was initially enthusiastic about her female Impressionist colleague Morisot, she later changed her opinion. Her unpublished letter to Marx throws new light on this. She writes that when she met Morisot, in 1878 (about a year after meeting Degas), she "understood her talent" and "had an enthusiastic admiration for her," but that "later I appreciated her talent less, not enough I think."[156] In another letter to Marx, Cassatt states that in those early days, she was "so moved" by Morisot's painting.[157] This was also reflected in the fact that around the same time, Cassatt acquired an artwork by Morisot for her own small collection and another for her brother Alexander's collection.[158] In later years, Cassatt apparently did not recommend Morisot to Havemeyer and to most other American collectors she advised. Writing to Marx around 1896, when she was in her early fifties, Cassatt responded thus to his article on Morisot (published soon after the latter's death):

> Yes Madame Morisot has given the true note of woman in Art—what you say at the end is true. And she was a woman, a true woman in heart and esprit, but she was of the 2nd Empire, this always struck me about her.[159]

Her letter suggests that in the early Impressionist days, Cassatt appreciated Morisot's femininity, in art and in life, but associating her with the French court, she did not see Morisot as a modern woman like herself, who was associated with the democratic

regime of the Third Republic (and in Cassatt's case, also with American democracy). Cassatt went on to clarify in the letter that she no longer had great appreciation for Morisot and associated her with Whistler, about whose art she also had reservations.[160]

Notwithstanding her position about the absence of great women artists, in her day-to-day life Cassatt was always willing to help younger American artists, men and women alike. But on one principle she would not compromise. As an artist who had joined the Independents (as the "Impressionists"—so called by the press—named themselves), she detested the jury system of the French Salon, and indeed opposed the use of juries anywhere. Throughout her career, Cassatt consistently refused invitations to serve on art juries, and she made no exception when Bertha Honoré Palmer, the president of the Board of Lady Managers (who commissioned Cassatt's large mural for the 1893 Woman's Building), appealed to her repeatedly to serve as art juror on the New York Art Jury. A consummate diplomat, Palmer began by asking this as "a favor" while acknowledging Cassatt's "hatred of art jury service."[161] Writing again, Palmer asked Cassatt to serve no matter what her "personal feelings may be," and stressed the significance of this opportunity for the status of women artists: "It will serve at least as recognition of women as artists and is considered a great compliment. I am quite sure that if you with-draw [*sic*] your name, no other women will be appointed in your place, and women artists would therefore lose this honor."[162] None of it influenced Cassatt. She stood fast to her lifelong principle.

Deviating from her general practice of not directly participating in any feminist activism, Cassatt publicly demonstrated her support for feminism on two occasions, both in her homeland. She did so by publicly linking her name and her own art to the cause of women's emancipation in the United States, in two important exhibitions: in 1893, Cassatt accepted the commission to paint a mural on "Modern Woman" for the Woman's Building at the Chicago World's Fair (I expand on this in the next chapter), and in 1915 she participated in the exhibition that Havemeyer organized in support of women's suffrage (the topic of chapter 6). Associating her name with the cause at that time was no small matter for Cassatt. Havemeyer and Alva Belmont (formerly Vanderbilt) were two prominent examples of enormously wealthy upper-class American women who became committed suffrage activists, but they were a minority. Most wealthy American women were fervently opposed to suffrage. Cassatt sent her works to the United States for both exhibitions, but despite warm invitations, did not herself cross the Atlantic in either case.

CASSATT AND FEMINIST CHALLENGES TO THE SEPARATION OF THE SPHERES

Cassatt did not conform her own life to the ideology of separate spheres, as demonstrated by her choices to remain single and to devote herself to her art, by her early decision to travel on her own to study art in Europe, and by the active life she led as a

professional who earned her living, exhibited and sold her art, negotiated with gallery owners, and advised collectors. Her class background and partial financial support from her family during her early years of study certainly helped her, but her decisions were still bold, and rare in her circle. How, then, might we understand her choice to depict women so often in the private sphere of their home?

According to feminist art historian Griselda Pollock's influential discussion in "Modernity and the Spaces of Femininity," the urban spaces of Parisian modernity as Charles Baudelaire wrote about them coincided with a masculine sphere, especially with bourgeois men's privileged claim to sexual exchanges with women of lower classes than their own.[163] Pollock argues that Cassatt and Morisot, the two women Impressionists, focused primarily on painting women in bourgeois domestic interiors because they lacked access to various metropolitan spaces, which their male colleagues regularly depicted in their art.

I would like to reconsider this interpretation. I propose that Cassatt's depiction of women in their homes was related less to the constraints on women's movement in public spaces (though some of these spaces were surely not as hospitable to women) and more to her identification with the political arguments of American nineteenth- and early twentieth-century feminists that in fact challenged the separation of spheres. These feminists strongly objected to the doctrine of separate public and private spheres because it confined women. For them, as for Cassatt, the public sphere was not so much the sexualized space of the streets of Paris as the political and citizenship rights of women to vote, obtain education, practice professions, and earn their living. As historian Ellen Carol Dubois argued, American feminists' demand for the vote radically "challenged the male monopoly on the public sphere."[164] They demanded the "right to shape the social order."[165] This meant participating directly in making the laws that affected women, forcing reforms in marriage and family laws to protect themselves from abuse and the loss of their children, as well as making education and new occupations accessible to women, and raising women's wages.[166] As early as 1853, American feminists in the New York Woman's Rights Convention made two resolutions: first, that the authority to be active in either sphere should not be a social dictate, but "each human being is the sole judge of his or her sphere, and entitled to choose a profession without interference from others";[167] and second, that obstacles to recognizing woman's equality had to be removed in the social order, so that woman "may have the highest motive to assume her place in that sphere of action and usefulness which her capabilities enable her to fill."[168] At the New York convention in May 1870, Mary A. Livermore demanded that woman "shall have just as large a sphere as man has."[169] She stated: "Let the sphere of woman be tested by the aspiration and ability of women's minds, and let it be limited only by what we are able to do."[170] By the early twentieth century, in France, too, feminists argued against limiting women to the private sphere. At the 1913 International Congress of Women, the French Marguerite de Witt-Schlumberger stated: "Women's sphere is everywhere . . .

The interest of men and women cannot be separated. Women's sphere is therefore everywhere that man's sphere is, that is to say the entire world."[171] Cassatt would have agreed.

But importantly, many of these feminists made use of women's roles in the home, and in particular their role as mothers and educators of their children, as a crucial argument for the necessity of women's participation in the public sphere. For example, in 1915 Henrietta W. Livermore published an article in the monthly New York City suffragist journal *The Woman Voter*, stating:

> The home is woman's creation, a place she cherishes, not a prison from which she wishes to escape. Government today has become more and more the organization of woman's sphere. Woman's sphere is and always has been the care of children, health, morals, and the place where woman works. Today government largely controls these things. Therefore women ask a voice in the government.[172]

Similarly, the educator Coralie Franklin Cook, who was the second African American woman to serve on the Board of Education in Washington, DC, argued that woman's role as mother entailed that she help "to make and to administer the laws under which she lives."[173] Feminists also argued that from their role as managers of their homes, women gained valuable experience for managing public spaces. As Jane Addams famously stated, "city housekeeping has failed partly because women, the traditional housekeepers, have not been consulted."[174]

In other words, part of the feminist discourse of Cassatt's time involved a deliberate emphasis on the value of women's role within the home, as a way of buttressing the argument for women's equal access to the public sphere and in particular to equal political rights. I am proposing that Cassatt's depiction of women and children at home echoed this discourse, and as such, was an active choice rather than a default choice resulting from lack of access. From studying Cassatt's feminist views, it is clear that she agreed with this feminist stance. She stated numerous times (in her letters to Havemeyer during the years of World War I and thereafter) that it was not sufficient for women to obtain the vote; they had to enter the public sphere of politics and make a difference.[175]

Cassatt spoke out explicitly against the double standard of the separation of the spheres—for example, in a 1915 letter to Havemeyer, in which Cassatt recounted that their common friend, the prominent banker James Stillman, had said to Durand-Ruel "that women and men have different spheres and each must stay in their own";[176] on which Cassatt noted: "I would like him to define these spheres. Nothing he enjoys more than ordering clothes for his daughter[-in-law], I should say that was their [women's] sphere."[177] In other words, in his habitual involvement with women's elite fashions (as I describe in chapter 1), Stillman himself, while preaching the importance of separate spheres, was in fact trespassing outside the boundaries of the supposedly

male sphere of business and public affairs. (Stillman was not alone—Degas and Manet, to give just two examples, visited the ateliers of well-known Parisian fashion designers.)[178] Cassatt's comments shifted the focus of the criticism from women and their transgressions to men and their transgressions (and hypocrisies).

I am suggesting that while on one level, Cassatt's representations of modern middle- and upper-class women and mothers depicted women's modern life at home, and as such they do not appear to challenge the separation of the spheres, on another level, her depictions of women align with the feminist discourse that exalted the value of this domestic role as a way of enabling women to be active outside of it as well. When viewed in this light, Cassatt's representations validate women's roles at home, emphasizing their dignity and dedication, the creation of affective bonds with their offspring, and their role in educating their children. Understanding Cassatt's feminist ideas in greater depth sheds light on her personality and opens some new avenues for interpreting much of her artwork. We now turn to examine in more detail how Cassatt's feminism impacted her art and how we can expand our understanding of it by contextualizing it within the contemporaneous feminist debates on both sides of the Atlantic.

5

CASSATT'S ART AND THE SUFFRAGE DEBATES OF HER TIME

AFTER ANALYZING CASSATT'S feminist convictions in the previous chapter, here I ask how her transatlantic feminism impacted her art. Art historians have broadened the understanding of Cassatt's art by introducing feminist perspectives, first during the 1970s and increasingly from the 1990s onward, into their analyses of a variety of subjects in her oeuvre, including modern women, the Cult of True Womanhood, the New Woman, women at the theater, mothers and children, domestic interiors, and the relationship between Degas and Cassatt.[1] These studies have contributed to a reevaluation of Cassatt that has challenged the long-held view that she painted only mothers and children.

Building on this scholarship, the present chapter further expands our understanding of Cassatt's work by situating it within the historical context of American pro- and anti-suffrage politics in the nineteenth century and her own views in particular. As I argue, these contexts, which have remained peripheral to the interpretations of most of her art (with the exception of her

mural, *Modern Woman*), are crucial to deciphering its complex meanings.[2] I also analyze topics in her art that have rarely been discussed: representations of older women; elite American fatherhood; women's community beyond the nuclear family; and women (not only mothers) as educators and mentors. And I offer an alternative interpretation of Cassatt's much-discussed paintings of middle-class mothers, one that shows the complexity of these works in the context of the political debates by pro- and anti-suffragists on feminism and motherhood. In order to situate Cassatt's art vis-à-vis the conservative and progressive political ideologies on gender of her time, I include a visual analysis of caricatures and propaganda posters and postcards, which played an important role in the mass media of the time, not only in England (as Lisa Tickner has shown) but also in the United States.[3]

"SPLENDID OLD WOMAN": REENVISIONING WOMEN'S AGING

Scholars have noted Cassatt's interest in the life stages of women, from babies to children, mothers, and old age, but they have typically focused solely on the first categories and overlooked the last.[4] In what follows, I argue that Cassatt made a significant contribution precisely in the latter category, creating a new kind of representation of mature and older middle- and upper-class women. As Susan Sontag wrote, "For most women, aging means a humiliating process of gradual sexual disqualification," whereas aging men are valued not for looks but for accumulating power and achievements.[5] During the nineteenth century, women were considered old after their childbearing years were over, with the onset of menopause. They were viewed as "aging" during their thirties and early forties, and as "old" from forty-five or fifty and onward.[6] The widely circulating discourse of the French medical profession reduced women's aging to the cessation of menses and differentiated the old age of women from that of men.[7] Contradicting the fact that women outlived men in France, the medical discourse claimed that women were the sicklier gender and devoted much writing to their presumed need of medical care.[8] The discourse in France about women's postreproductive life pathologized women's aging. This male discourse viewed the older woman in negative terms of lack: she became useless, lost her femininity, was no longer truly a woman, and was not desirable to men. It encouraged older women to renounce sexual activities, give up romantic pursuits, and withdraw from the world and the pleasure of urban life.[9] It also assumed that, for women, old age was a time of nervous crisis and depression.[10]

By contrast, women who spoke about aging based on their own experience and reflection regarded getting older in quite different terms. They tended to focus on the benefits of their gained experience and status, and on the positive possibilities that opened up for them when the bearing, raising, and educating of children was no longer their raison d'être.[11] In 1902 the well-known Parisian singer and performer Yvette Guilbert, who was also an author and a producer and whose café-concert performance

career spanned nearly fifty years, published a book titled *Les Demi-vieilles* (The half-old women) that presented a counter-discourse to the male medical one. She portrayed several "older" women—for example, a woman in her mid- to late forties—as "buzzing with erotic and romantic possibilities" and as ambitiously pursuing "creative work in the theatre as a higher pursuit, making meaningful, unique, and groundbreaking contributions to culture."[12] Guilbert discussed older women who pursued a youthful appearance and behavior and maintained a youthful spirit as using "a deliberate strategy to resist the pull of death."[13] She deplored men's "disdain for our Autumn" and presented her own view of the benefit of a woman's life experience: "Must one renounce the exquisite sentimentality of existence after one's thirties? But it is also the age when we are the most and the best aware of the bounties of life."[14] Thus, beyond asserting their rightful place in the realms of romance and sexuality, Guilbert also advocated for older women in the arts who wanted to continue to matter through their work.

For modern professional women like Cassatt and her female French Impressionist colleague Berthe Morisot, getting older was a positive stage of life, one in which they felt stronger and more accomplished than in their youth. At fifty, four years before she died, Morisot wrote: "Old age is happier. One is more in possession of oneself."[15] And Cassatt wrote in her seventieth year: "Old age with one's faculties unimpaired is the best part of life[,] otherwise a weariness & despair."[16]

Cassatt's views on aging were in harmony with the new understanding of older women as articulated by the American leaders of the women's rights movement. In 1885, on her seventieth birthday, Elizabeth Cady Stanton delivered an address titled "The Pleasures of Old Age," in which she famously stated, "Fifty, not fifteen, is the heyday of woman's life." Stanton discussed aging as a time of "added wisdom," "closer contact with humanity," and joy for "worthy work well done."[17] Feminist scholar Corrine T. Field notes that the women's rights movement elevated, publicized, and circulated new kinds of images of older women, such as leaders of the American women's suffrage movement.[18] These images represented older white women suffragists as national leaders, and they empowered women for a future in which they could hold high political office.[19]

The most iconic figure of an older suffrage leader is that of Susan B. Anthony. Suffragists inserted her image as "a grand old woman of America" into the national narrative as a founding mother.[20] A variety of images portray Anthony around her eightieth birthday, in 1900. For example, the pioneering Washington, DC–based woman press photographer Frances Benjamin Johnston photographed Anthony from below looking up, subtly heroicizing her (fig. 5.1). The formidable Anthony, her white hair parted in the middle and drawn back tightly in its signature style, is wearing the elegant outfit of her birthday celebration, replete with elaborate antique lace trimming. But the photograph also distinguishes Anthony from mere elegance in old age by depicting her looking sternly out at the spectator through a monocle, which represents her focused, critical outlook.

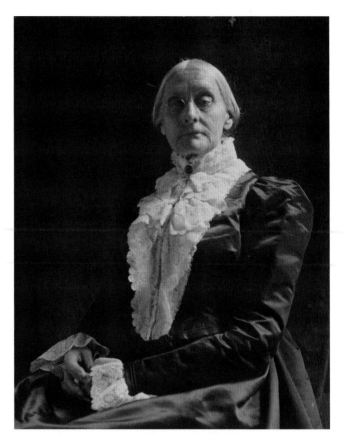

FIGURE 5.1
Frances Benjamin Johnston, *Susan B. Anthony*, 1900–1906. Platinum print, 8.19 × 6.38 in. (20.8 × 16.2 cm). Prints and Photographs Division, Library of Congress, Washington, DC, 2001704086.

American photographer and painter Sarah J. Eddy created a large portrait of Anthony to commemorate her eightieth birthday, *Susan B. Anthony on the Occasion of Her 80th Birthday*, 1900 (fig. 5.2). The birthday was a grand event that was held on February 15, 1900, at the Lafayette Opera House in Washington, DC, and was attended by women from all over the United States. Eddy was a lifetime member of the National American Woman Suffrage Association (NAWSA), and her mother had been a great supporter of Anthony and her major donor. Her painting depicts a moment in the spectacular birthday celebration in which children paid tribute to Anthony by approaching her one by one with a rose, creating an image of homage by the younger generation (a total of eighty children, apparently all white, lined up at the event to deliver flowers to Anthony).[21] Wearing her birthday costume, the dignified elderly leader bows her head slightly toward the children, appearing like the grandmother of the nation.

Cassatt herself—along with her artworks—was in tune with these contemporary contexts. Cassatt was active throughout her later years (as an artist until 1914, and after that continuing as an art advisor), and she maintained a distinctly fashionable and elegant appearance well into her sixties (fig. 5.3). Likewise, her artworks representing older

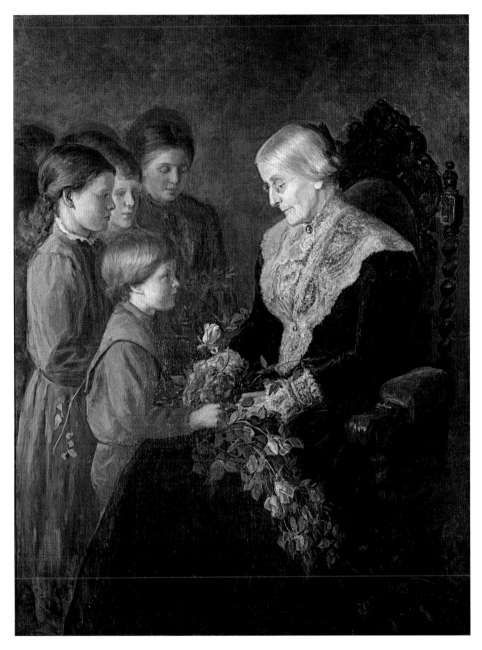

Sarah J. Eddy, *Susan B. Anthony on the Occasion of Her 80th Birthday,* 1900. Oil on canvas, 74 × 60 in. (188 × 152 cm). Division of Political History, National Museum of American History, Smithsonian Institution. PL.026158.

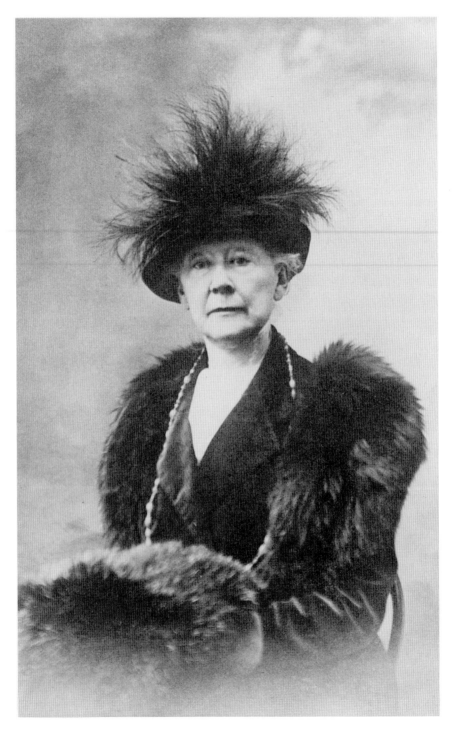

FIGURE 5.3

Unknown photographer, *Mary Cassatt (in Reboux Hat) in Grasse*, 1914. Photograph, 10 × 6.7 in. (26 × 17 cm). General Collections, Library of Congress, Washington, DC. 97513271.

women foreground their vitality. For example, Cassatt's *Portrait of an Elderly Lady in a Bonnet: Red Background,* ca. 1887 (fig. 5.4), and *Portrait of an Elderly Lady,* ca. 1887 (fig. 5.5), both show the same gray-haired older woman as lively, socially active, and fashionable. Dressed in a dark costume and brown gloves, she is sitting in an erect but relaxed posture that exudes class stature. In the first painting (fig. 5.4), a pink flower decorates her hat, echoing the pink brushstrokes and reddish lipstick that enliven her face. In the second painting (fig. 5.5), Cassatt painted the elegant older woman sitting upright and dressed in black; her gray hair is partly covered by a decorated hat, and her face shows her use of rouge to enliven her cheeks and a bright red lipstick on her lips. The bold, red free brushstrokes surrounding her slender figure energize her environment, enhancing her vitality. They are quite the contrast to an orderly, containing, and muted coloration of a domestic interior. In contrast to these paintings, portraits of old women by Van Gogh, Pissarro, and Cézanne often represented aged working-class women of the countryside as possessing a clearly diminished vitality, as in Van Gogh's *An Old Woman of Arles,* 1888 (Van Gogh Museum, Amsterdam), and Cézanne's *Old Woman with Rosary,* ca. 1895–96 (National Portrait Gallery, London). The most striking comparison, though, is between Cassatt's portrait and Cézanne's *Lady in Blue,* ca. 1900 (Hermitage Museum, St. Petersburg), which portrays his own governess, Madame Brémond, and was created near the end of his life. The well-groomed, elderly middle-class woman is wearing a tailored blue outfit that delineates her slim body and a matching hat. Her lips are covered with bright red lipstick and her cheeks with an equally reddish blush powder, but her tilted head and resigned facial expression suggest the diminished vitality of old age.

One of the best examples of Cassatt's unique representation of older women is the frequently discussed portrait of her mother, *Reading Le Figaro,* 1878 (fig. 5.6).[22] It depicts an older woman in her own domestic space and emphasizes the distinct status that age confers. The prominent place of the daily newspaper implies her connectedness to a world beyond this domesticity. Cassatt depicted her sixty-two-year-old mother seated in an upholstered chair and absorbed entirely in reading the French newspaper *Le Figaro.* Katherine Cassatt, who was in full command of the French language, was admired by Louisine Havemeyer for being "powerfully intelligent, executive and masterful," for her "sense of duty," and for her "tender sympathy."[23] In the context of Impressionist painting, the woman reading a newspaper represents a moment in modern life. Various Impressionist painters depicted men reading the newspaper—for example, Renoir's *Claude Monet Reading,* 1872 (Musée Marmottan, Paris), and Cézanne's *The Artist's Father, Reading L'Événement,* 1866 (National Gallery of Art, Washington, DC). But Cassatt's painting is unique among the work of her Impressionist colleagues in representing the intersection of the female gender and middle-class status with age. And although much has been written about this portrait of Katherine Cassatt, scholars have interpreted the portrait primarily in the context of motherhood, paying little attention to the figure's representation as an aged woman.[24] In what follows, I argue that the painting represents Mrs. Cassatt not as a mother but

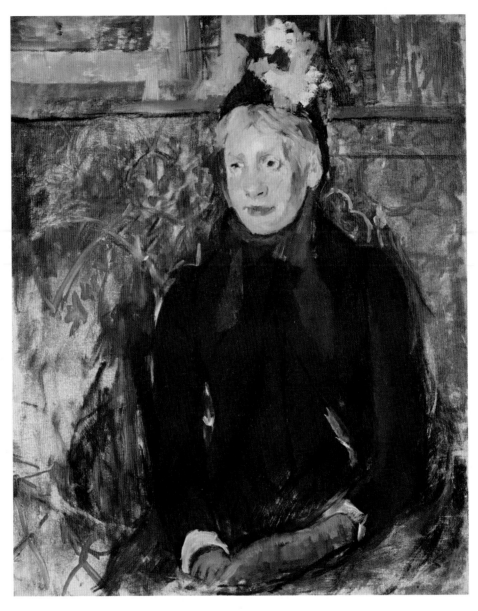

FIGURE 5.4

Mary Cassatt, *Portrait of an Elderly Lady in a Bonnet: Red Background*, ca. 1887. Oil on canvas, 41.5 × 34.8 in. (105.4 × 88.3 cm). Courtesy Birmingham Museum of Art, Birmingham, UK. Gift of the Mahdah R. Kniffin Estate, 1971.25.

rather as an educated older woman. When the portrait was exhibited by the Society of American Artists in New York in 1879, a critic who judged it as one of the "technically best pictures" of the exhibition (out of a total of 168 works) described Katherine Cassatt as "a capitally drawn figure of an agreeable-looking, middle-aged lady."[25] His comment that she looked "agreeable" is notable in light of the fact that reading the

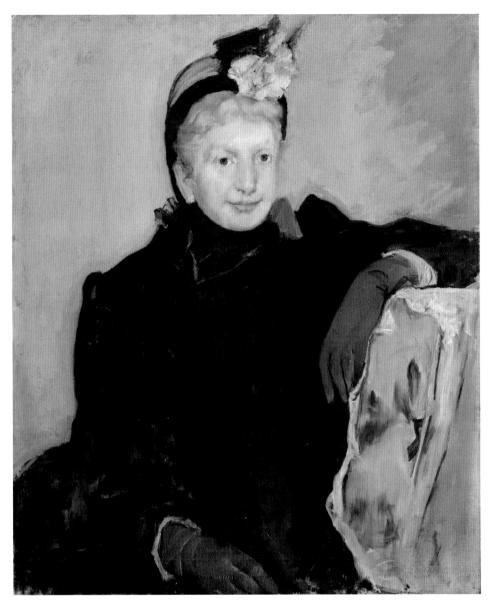

FIGURE 5.5

Mary Cassatt, *Portrait of an Elderly Lady*, ca. 1887. Oil on canvas, 28.7 × 23.7 in. (72.9 × 60.3 cm). Courtesy National Gallery of Art, Washington, DC, Chester Dale Collection. 1963.10.7.

newspaper was considered the province of men, and women were still discouraged from or even disparaged for breaking that norm; it is significant, therefore, that the sight should be described as agreeable.

Cassatt's portrait resonated with the contemporary discourse about women's right to education. In 1877 the French group Les Droits des femmes (the Rights of Women)

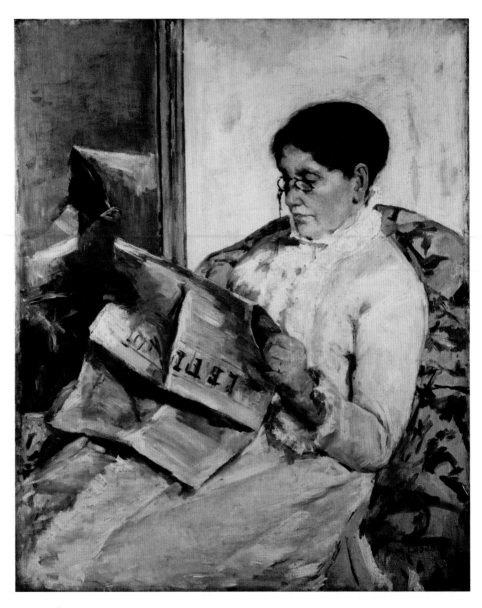

FIGURE 5.6

Mary Cassatt, *Reading Le Figaro*, 1878. Oil on canvas, 40.9 × 32.9 in. (104 × 83.7 cm). Collection Mrs. Eric de Spoelberch, Haverford, Pennsylvania. Photo © Christie's Images / Bridgeman Images.

demanded "[t]he right of women to develop their intelligence through education,"[26] and in the United States, the women's rights movement led to the founding of women's colleges as a way to counter the exclusion of women from institutions of higher education. The portrait also counteracted misogynist illustrations and caricatures of older women in the mass media. A prominent example of the latter is Honoré Daumier's

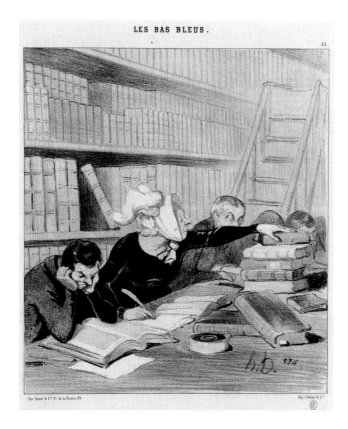

LES BAS BLEUS.

FIGURE 5.7
Honoré Daumier, "I beg your pardon sir, if
I am getting in your way . . .," *Le Charivari*,
March 8, 1844. Lithograph. Sheet: 8.66 ×
7.68 in. (22 × 19.5 cm). Los Angeles County
Museum of Art, www.lacma.org. Gift of
Mrs. Florence Victor from The David and
Florence Victor Collection (M.91.82.173).

caricature "I beg your pardon sir, if I am getting in your way . . ." *Le Charivari*, March 8, 1844 (fig. 5.7), in which the presence of an aged woman in the library is represented as a rude intrusion into masculine territory.[27] Transgressing her "proper" limits and taking up excessive space, her presence visibly bothers the men sitting beside her. Daumier also directly ridicules her old age in an accompanying text: in response to her explanation that she is writing a new novel and needs "to consult numerous old authors," a male voice calls out, "Old authors! . . . Heavens, she should have consulted them while they were alive, for she must have been their contemporary!"

Cassatt was attuned to different phases of aging. Eleven years after she depicted her mother as a robust middle-class lady reading *Le Figaro,* she painted her again, this time showing a woman whose aging has enfeebled her, seated in a "thinker's pose."[28] The portrait of her now seventy-three-year-old mother, made in 1889 in oil paint (de Young Museum, San Francisco) and as a softground etching (fig. 5.8), shows the frailty of the older Katherine Cassatt, a few years before the end of her life. In both the painting and the print, Mrs. Cassatt's gaze, which in the earlier painting had been turned on the newspaper, indicating her alert interest in the outside world, is turned inward. But whereas in the painting the inward gaze shows Mrs. Cassatt's withdrawal from the

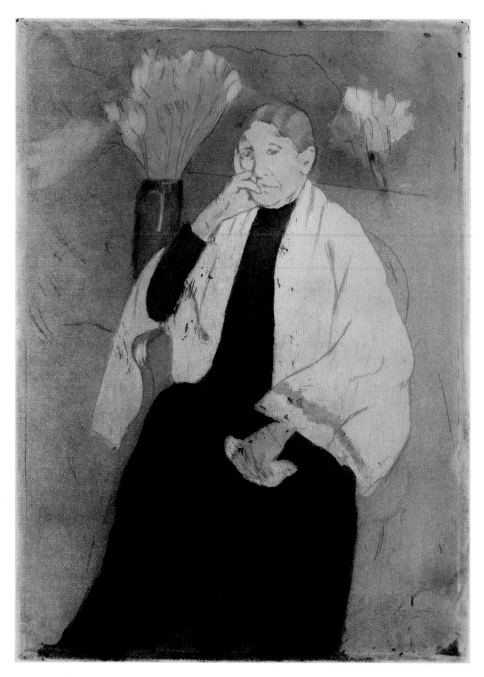

FIGURE 5.8

Mary Cassatt, *A Portrait of the Artist's Mother,* ca. 1889–90. Color softground etching and aquatint, 13.9 × 8.3 in. (35.2 × 21 cm). Courtesy National Gallery of Art, Washington, DC, Rosenwald Collection. 1946.21.90.

world and her diminished vitality, in the print, the older lady in the thinker's pose is represented in more abstracted flat shapes, which, unburdened by the many details in the painting, express a monumental stillness that signals the wisdom of old age.

Cassatt depicted another older woman in a thinker's pose in *Portrait of a Grand Lady*, 1898 (fig. 5.9). She made this commissioned portrait of her friend Mrs. John Howard Whittemore—Julia Spencer Whittemore—during her 1898 visit to the United States, while visiting the Whittemores in their home in Naugatuck, Connecticut.[29] Mrs. Whittemore, the wife of an industrialist who had made his fortune in iron manufacturing, was a person of high status in her community. She knew Impressionist art well, because her husband, John, and their son, Harris, were major American collectors of Impressionist painting. (Father and son were also advised by Cassatt and collected her art.)[30] Cassatt had a special appreciation for Mrs. Whittemore, writing to her, "One of my greatest regrets on leaving New York, was not seeing you once more before."[31] She also felt at home in the Whittemores' residence, with its beautiful natural surroundings, and in their social circle. Her letter to Mrs. Whittemore upon returning to France may be the only time she expressed a yearning for her homeland in the sense of wishing that she had a place of her own in the American countryside:

> I felt very homesick after I got here but am beginning to get used to my solitude once more. . . . I constantly think of Naugatuck and of your beautiful home, and wonder what you would think of this. I am going to send you a photograph of it; my little pond seems very small and insignificant after the rushing rivers of Naugatuck, and no place I am at home seemed to me so desirable as a summer home as Millbury. That beautiful lake and the woods are often in my mind, and all your circle enjoying the delights of it together.[32]

Although Cassatt chose the thinker's pose in both the portrait of Mrs. Whittemore and that of her own mother, she represented them quite differently. The painter's infirm mother, who is depicted wrapped in a cream-colored shawl and clasping a handkerchief, appears housebound. By contrast, Mrs. Whittemore's robust, carefully coiffed gray hair and fashionable attire reflect her social sphere. Her puff-sleeved dress, typical of the 1890s, is decorated with elaborate lace and a ribbon sash. Cassatt represents Mrs. Whittemore as a well-groomed, vigorous older American lady, who is intelligent, grounded, and in possession of familial and social power.

Another Cassatt portrait of an older woman, *Lady at the Tea Table*, 1883–85 (fig. 5.10), was described by Linda Nochlin as a "masterpiece" and "one of the most remarkable American portraits of the nineteenth century."[33] It is a portrait of Mrs. Robert Moore Riddle, a cousin of Cassatt's mother, with whom the Cassatts socialized a great deal in Europe along with Mrs. Riddle's daughter, Annie.[34] Cassatt depicts the dignified, aging upper-class American woman sitting erectly, emphasizing her high social status, self-control, and assured reign over her domestic domain, where she is shown presiding at tea. The Chinese porcelain tea set featured on the table (believed to be Japanese when

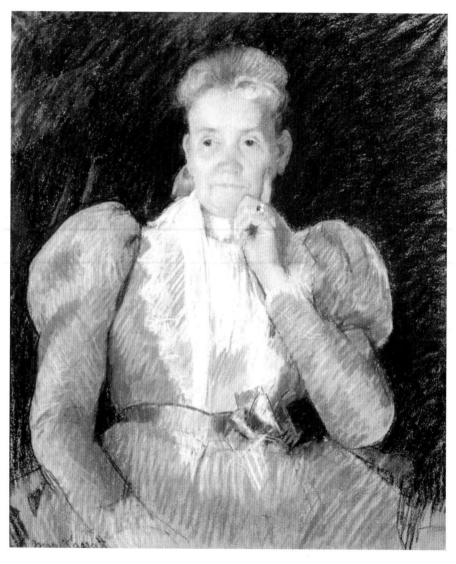

FIGURE 5.9

Mary Cassatt, *Portrait of a Grand Lady* (*Mrs. John Howard Whittemore*), 1898. Pastel, 28 × 24 in.
(71 × 58 cm). Private collection. Photograph by Randy Clark Photography, © Garnet Hill Publishing
Co., 2009.

it was acquired)[35] was a gift by Mrs. Riddle to Cassatt, who in turn made the portrait as
a gesture of returning the "kindness."[36] Mrs. Riddle and her daughter rejected the por-
trait, however, probably because they did not find it flattering, especially in view of Mrs.
Riddle's reputation earlier in her life as a legendary Pittsburgh beauty.[37] If so, their
response would have conformed to the common expectation that portraits of women
emphasize female beauty, associated with youthfulness. Although Degas praised the
painting as "distinction itself," Cassatt stored it away, and it was rediscovered only

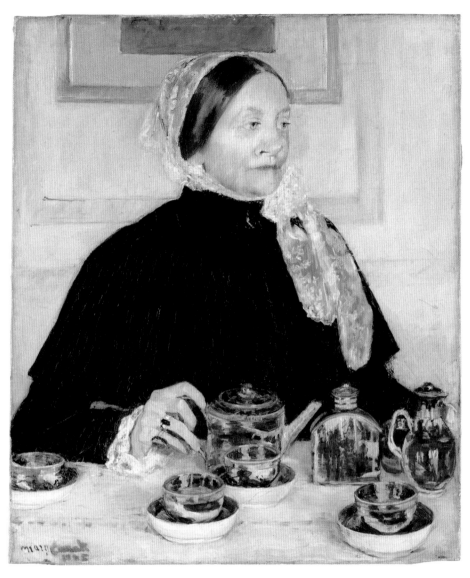

many years later by Havemeyer. After being exhibited in Paris and New York some three decades after its creation, it came to be regarded as one of Cassatt's best paintings.

Cassatt also explicitly expressed her preference for painting her best friend, Louisine Havemeyer, as an older woman. After making a portrait of Havemeyer at age forty-one (fig. 5.11), she wrote to her friend that she wished she could do her portrait as "a splendid old woman," but being eleven years older than Havemeyer, Cassatt realized that she would probably not be able to fulfill this wish.[38] Cassatt thought she had

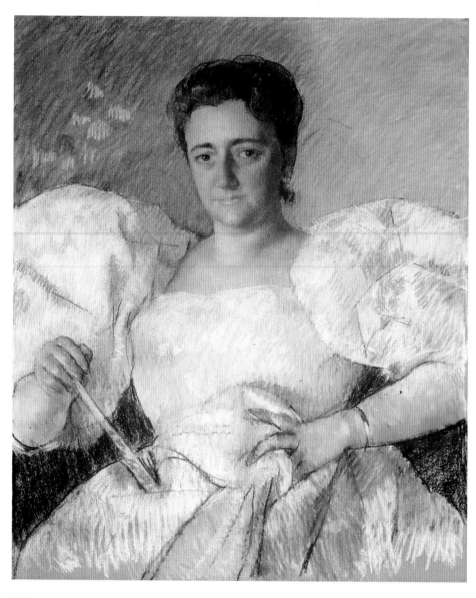

FIGURE 5.11

Mary Cassatt, *Portrait of Mrs. H.O. Havemeyer,* 1896. Pastel on wove paper, mounted on canvas, 28.75 × 23.5 in.
(73 × 59.69 cm). Collection of Shelburne Museum. Gift of J. Watson Webb Jr., 1973-94.2.

"succeeded" in the portrait, yet she noted, "I did not come near your maturity."[39] As
some of Havemeyer's photographs taken during the last decade of her life show, she
would indeed have made a striking subject in her old age: she looked like a veteran
warrior, whose suffrage battles were deeply registered on her face (fig. 5.12). As the
portraits discussed here show, Cassatt painted portraits of older women whose aging
signifies not a loss of beauty so much as a gaining of status, self-possession, and

FIGURE 5.12
Unknown photographer, *Louisine Havemeyer in Her Old Age*, date unknown. Library of Congress, Washington, DC.

wisdom. Some of the portrayals also stress a feminine vitality by showing the women's fashionable appearance and the fact that despite their age (they were perhaps in their sixties), they make ample yet appropriate use of cosmetics. These portraits echo the views of French women and of late nineteenth-century American feminists, and reflect Cassatt's (and Morisot's) own experience of older age as the best phase of life.

MOTHERHOOD, FATHERHOOD, AND THE BATTLEFIELD OF THE "SPHERES"

Cassatt depicted the theme of the mother with baby or child at home from the 1880s up until 1914, the last year in which she painted.[40] Scholars have offered different interpretations of Cassatt's representations of the maternal theme, from highlighting the relation of some of them with the subject of the Madonna to analyzing the critical reception of Cassatt's works on this topic over the years and offering a psychoanalytic feminist reading of the mother-daughter relationship.[41] Here I examine Cassatt's depictions of mothers (of both male and female babies and children) in the complex political context in which they were made—namely, the fierce pro- and anti-suffrage debates and their bearing on the notion of motherhood and the "separate spheres." I argue that when understood in this context, Cassatt's depictions of modern mothers of her own class and race with infants in the home gain a new meaning.

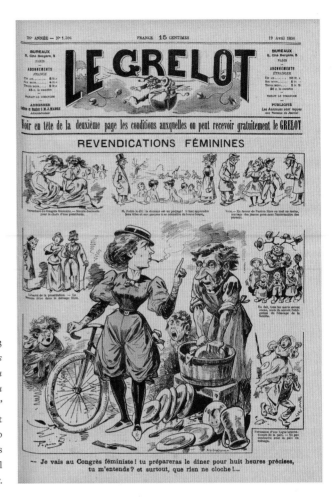

FIGURE 5.13

Edouard Guillaumin (Pépin), *"Revendications féminines: Je vais au Congrès féministe! tu prépareras le dîner pour huit heures précises, tu m'entends? et surtout, que rien ne cloche! . . . "* (*Women's Demands:* "I'm going to the feminist Congress! Prepare dinner for 8:00 sharp, do you hear me? And above all, nothing gets messed up! . . ."), *Le Grélot,* no. 1306, 1 (April 19, 1896). Heidelberg University Library.

During the period in which Cassatt depicted the maternal theme, both pro- and anti-suffragists embraced motherhood and claimed to be its true defenders. The first asserted that they valued the role but rejected the latter's demand that women be restricted to the role of mothers and to the domestic sphere. Suffragists embraced motherhood while fighting to create new conditions that would enable women also to be active professionally and politically in the public sphere. Anti-suffragists asserted that they were the only true mothers and wives (or in the case of male anti-suffragists, the only true defenders of motherhood), and they claimed that mothers were too busy to engage in politics and that the vote would ruin the family.[42] They delegitimized suffragists as mothers, asserting that suffrage leaders are "[n]ot the Mothers, but rather are the 'third sex.'"[43] Antifeminist images of mothers, fathers, and children in France and the United States used a common strategy, exemplified by the French caricature by Edouard Guillaumin (Pépin), *Women's Demands,* 1896, published in *Le Grélot* (fig. 5.13) and the American

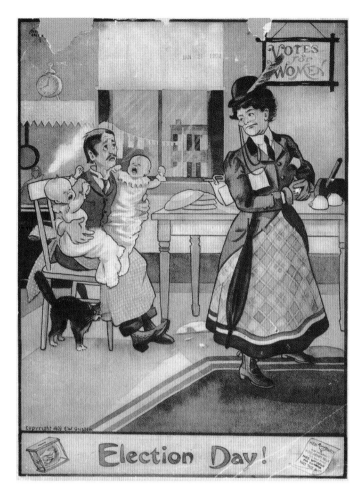

FIGURE 5.14
E. W. Gustin, *Election Day!*, ca. 1909.
Photogravure. Editorial cartoon.
Prints and Photographs Division,
Library of Congress, Washington, DC.
97500226.

editorial cartoon by E.W. Gustin, *Election Day!*, ca. 1909 (fig. 5.14): they stigmatized the pro-suffrage mother as one who was deserting her duty, and aroused sympathy for the "victimized" father and "abandoned" children; the home of a suffragist mother, as they depicted it, lay in disarray, signifying her failure to fulfill her household duties and by extension her threat to the familiar world order.[44]

A striking anti-suffrage American propaganda image, *The Suffragette Madonna*, 1909, visualizes the consequences of this dreaded change in the gender regime (fig. 5.15). The image was part of a commercial series of twelve color lithographic postcards opposing women's suffrage, produced in New York by the Dunston-Weiler Lithograph Company. Unlike other antifeminist images of fathers with their offspring, the father in this image is not clueless and the baby is not crying. He ably, if reluctantly, fulfills the mother's role by feeding the doll-like baby in his arms with a milk bottle.[45] A halo formed by the yellow plate behind him pronounces this white middle-class father a sanctified martyr.

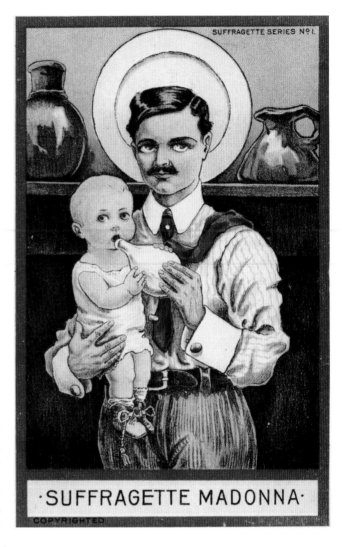

SUFFRAGETTE SERIES Nº I.

·SUFFRAGETTE MADONNA·

COPYRIGHTED

The title below the image, "Suffragette Madonna," attributes his "martyrdom" to the ills of the suffrage movement. The blatant depiction of the father as the Madonna, the ultimate mother, is presented as the epitome of the ridiculous, its strangeness contradicting the supposed naturalness of the female Madonna or secular mother. It rebukes women and exploits masculine fears of losing the status of head of the patriarchal family. Such images represented fatherhood as a role assumed solely as a consequence of the deplorable absence of the mother who has abandoned her traditional role.

Contrary to the claims of antifeminist propaganda, nineteenth-century and early twentieth-century suffragists fully embraced women's role as mothers, but they also used it as an argument to legitimize women's battle to gain the vote. They claimed that the very role of mothers in the private sphere justified extending their activity into the public

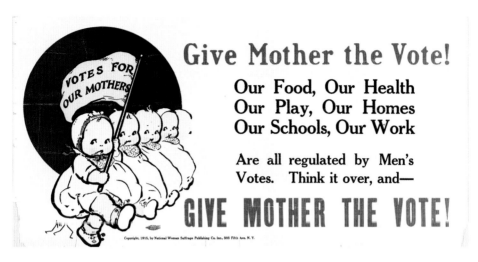

FIGURE 5.16

Rose O'Neill, *Give Mother the Vote!*, 1915. Chromolithograph poster. National Woman Suffrage Publishing Company, New York. Courtesy of the Missouri Historical Society, St. Louis, N20256.

sphere of politics and government. This line of argument is evident, for example, in the propaganda posters by Rose O'Neill, a highly successful American cartoonist and illustrator of magazines and books, who actively supported the suffrage movement.[46] Her posters featured images of the Kewpie character (named after Cupid), "a sort of little round fairy," in O'Neill's words. The most popular cartoon character before Mickey Mouse,[47] these genderless babies were active characters in O'Neill's posters. In a 1915 poster published in New York by the National Woman Suffrage Company, the Kewpies state their demand from their own vantage point: "Give Mother the Vote!" (fig. 5.16). Marching in a row, one of them holds up a yellow flag—the official color of NAWSA—that spells out their demand, with the accompanying text providing its rationale: "Our Food, Our Health, Our Play, Our Homes, Our Schools, Our Work, Are all regulated by Men's Votes. Think it over, and—Give Mother the Vote!" In this early twentieth-century poster, O'Neill does not depict motherhood but rather gives small children agency, joining the mothers in their demand for equality while attesting to their mothers' important roles as such.

It is not known which of these types of images Cassatt actually saw, and as I mentioned in the introduction, in considering them here I do not claim that they were iconographic sources for her. Rather, I see them as playing an important role in the cultural construction of the theme of motherhood at the time, specifically in relation to the political change advocated by suffragists. Cassatt was well aware of the fierce debate between anti- and pro-suffragists, and of the fact that this debate played out not only in published words but also in visual culture. In this context, I argue that Cassatt's interpretation of the topic of mothers and children was in tune with the pro-suffrage position of supporting the value of women's maternal role (discussed in the previous chapter). Most of Cassatt's works on the subject depict a leisurely bourgeois mother, holding, embracing,

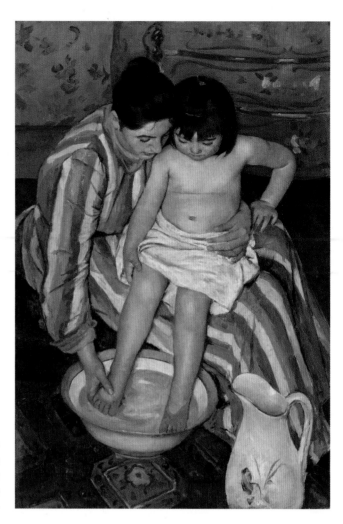

FIGURE 5.17
Mary Cassatt, *The Child's Bath*, 1893. Oil on
canvas, 39.5 × 26 in. (100.3 × 66.1 cm). The
Art Institute of Chicago, Chicago, IL, The
Robert A. Waller Fund, 1910.2.

caressing, and admiring her child, or communicating with it through her gaze. This is the case even in the works that depict the mothers performing mundane childcare activities such as washing the child (fig. 5.17), combing its hair, and nursing, feeding, or reading to the child (fig. 5.22). Even though Cassatt often used models who were working-class women from the village near her country residence, she did not portray the hardships and poverty of proletarian mothers.[48] In many of her works, Cassatt focuses on the close emotional relationship between mothers and offspring, yet, as so many art critics during Cassatt's time noted, her depictions avoid sentimentality. For example, in her print *Maternal Caress*, 1891 (fig. 5.18), the mother embraces the baby tightly, but gently, with great care; and the baby, in turn, hugs its mother, wrapping both little arms around her neck and resting its face on her cheek in a gesture that suggests the baby's active participation, an early indication of what will become the child's agency. The identical skin tone

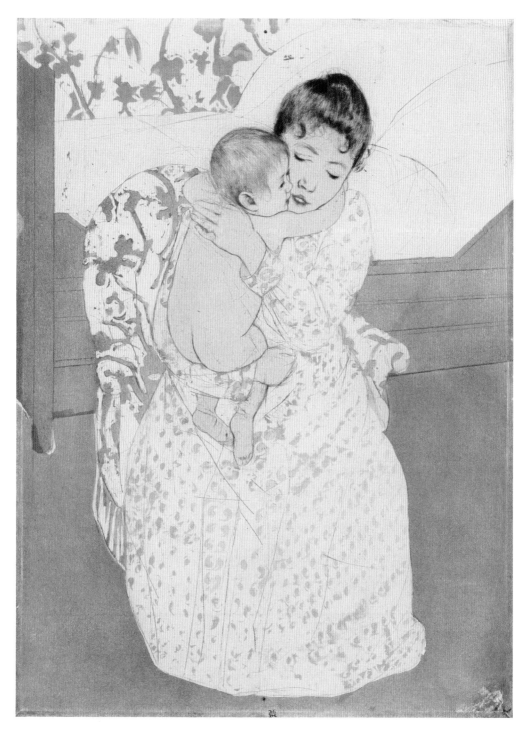

FIGURE 5.18

Mary Cassatt, *Maternal Caress*, 1890–91. Color drypoint, softground etching, and aquatint, and softground etching, 14.5 × 10.56 in. (36.7 × 26.9 cm). Prints and Photographs Division, Library of Congress, Washington, DC, 90707579.

of the mother and baby, and the way in which the baby is wrapped in the mother's embrace, nearly merging with her body, portray their closeness and imply the collaborative nature of their relationship and the reciprocal communication that can occur between mother and infant, coupled with their respect for each other's autonomy. The typical close emotional bond in Cassatt's images of mothers with their children or babies correlates with changes in the ideal of motherhood during the nineteenth century.[49] As Ellen M. Plante notes, "the Victorian family of the late 1830s–1850s was evolving from an economy-based unit in which everyone labored for the economic survival of the family, to one in which relationships were based on love, feelings and sentimentality."[50] Although the family was a patriarchal unit, in this new concept mothers held the chief role in the family as an emotional unit. David M. Lubin points out in his complex analysis of Lilly Martin Spencer's *Domestic Bliss*, 1849, that at the time, conservatives opposed "the sentimental family, with its exaltation of harmony, mutuality, and equality" in place of the family's patriarchal authoritarianism and hierarchical structure in which the father reigned over mother and children.[51] While Cassatt's depictions imply the context of the nuclear family, her focus on the close bond between mothers and offspring along with a consistent absence of fathers from the domestic realm was in tune with a progressive focus on women, children, and their reciprocal emotional relationship.

Although Cassatt's mothers and children were considered a "feminine" theme, and both French and American critics praised her portrayal of "domestic intimacies"[52] and "love,"[53] it is striking that during her lifetime, numerous critics praised Cassatt for breaking with the conventional representation of this theme. These critics, many of them American, recognized Cassatt's ability to depict a sentiment but avoid the kind of "weak sentimentality," in the words of New York curator Frank Weitenkampf, that pervaded so many "mother and child" pictures.[54] Weitenkampf also noted that Cassatt's depictions reveal "the beauty of the relation between mother and child without calling in the aid of a superficially pleasing prettiness."[55] Another characteristic mentioned in an American publication was Cassatt's depiction of the figures of mothers as "strong" and "alive," "unlike the conventional woman, elegant, sickly and insipid."[56] Several critics, French and American, noted that Cassatt's mothers and children alike "shine with fresh health"[57] and that maternal love for her "is not a pale blue emotion, to be draped with clouds and expressed with anemic physique."[58] An article in an American publication noted the "free, fearless, forceful technique" of her painting of mother and child.[59] A conservative reviewer writing in the *New York Times* in 1895 admitted that he would have preferred "charm" to Cassatt's approach, in which he identified "a rude strength."[60] A 1915 review in the same paper acknowledged Cassatt's originality: "Her mothers and their children are not like any other that have been painted before."[61]

The American painter and author Arthur Hoeber observed that Cassatt portrayed the "dignity of motherhood,"[62] while the critic (and Cassatt's friend) Forbes Watson noted that she depicted the children's "own young dignity."[63] An article in *The Craftsman*, a magazine published in New York, pointed out that Cassatt depicted the "peace

of accomplished maternity";[64] William Walton drew attention to the "directness and vigor of presentation";[65] and there was general agreement that the figures are "not idealized."[66] An American critic commented: "It is not the deification of motherhood . . . rather, the great possibilities of human achievement."[67]

Looking at Cassatt's artworks on the maternal subject from a contemporary viewpoint, they do appear to present an idealized picture of middle- and upper-class mothers and their children, one in which harmony and fulfillment prevail to the exclusion of other routine aspects of the experience of mothers and children, such as conflict, unhappiness, or frustration. Yet in the context of the central debate between suffragists and anti-suffragists about motherhood, Cassatt's representations of these mothers as strong and dignified women who are emotionally engaged with their children may be read quite differently: as playing a role in legitimizing modern women, including suffragists like Havemeyer, as simultaneously mothers in the private sphere and feminists and political activists in the public sphere.

One of Cassatt's most insightful works on the theme of mother and daughter is *Louisine Havemeyer and Her Daughter Electra*, 1895 (fig. 5.19). The double portrait represents a mother and daughter who belong to New York City's wealthiest upper class, yet Cassatt brings to it a sense of intimacy that excludes the formal aspects of being on display that characterize many official portraits. Cassatt's painting represents a mother's love that encourages the self-development of her daughter Electra by enabling her to occupy her own space. Sitting on her mother's lap, Electra's body is physically close to that of her mother, and their gestures—embracing each other with one arm while holding hands with the other—show their emotional intimacy. Yet the positioning of their bodies and their pensive facial expressions avoid any hint of sentimentality or of a symbiosis. Cassatt depicts their physical and emotional closeness as one that is reciprocal but at the same time allows for their independence from each other. The mother's and daughter's eyes look into the distance, each in her own direction, giving a sense that they have their own interior worlds. The mother's well-defined enormous puffed sleeves, which were fashionable at the time, invest her with a strong spatial presence, but the child's white and pink striped dress spreads over an even larger space of the painting, transforming in the lower left into abstracted marks that are free of solid form or defining outlines and thus assert the pictorial presence of the maker. Cassatt chose to equalize the presence of the mature adult and the seven-year-old child by giving extra weight to the child through the large amount of space allocated to her dress.

The portrait of Havemeyer and Electra shows the mother's respect for her daughter as a young individual subject. Louisine Havemeyer indeed raised her daughter in the feminist spirit of the time to be independent, and Electra would go on to become a collector who asserted her own tastes and direction. Unlike her mother, she did not acquire French avant-garde art; instead, she collected everyday American objects— from crafts and folk art to New England buildings. In later years, these kinds of objects would come to be valued as American heritage, but the fact that, at the time, they were

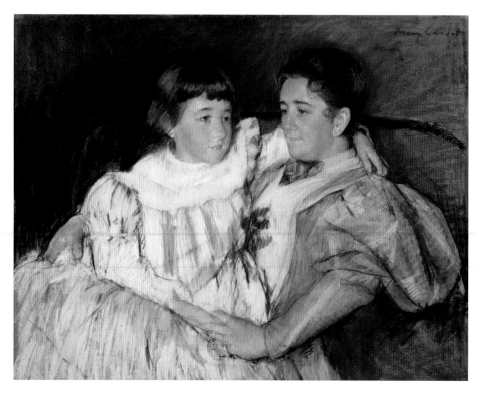

still considered by her own mother to be worthless indicates Electra's strong character and ability to forge an independent path. Also unlike her mother, who had bequeathed her European art collection to the Metropolitan Museum, Electra founded a museum to house her collection in the small town of Shelburne, Vermont.[68]

A little-known letter from Cassatt to Havemeyer reveals that she appreciated her friend's equal treatment of her son and her two daughters. In it, Cassatt also disclosed how she felt about her own mother's differential treatment of herself as a daughter and of her brothers: "You are the only mother I have known who had not a marked preference for her boys over girls, my Mother's pride was in her boys." Describing her own experience while growing up, she wrote: "I think sometimes a girl's first duty is to be handsome and parents feel it when she isn't, I am sure my Father did, it wasn't my fault though." By contrast, of Havemeyer's way with her children, she noted approvingly: "Well you may take pride in the looks of your daughters, and of your boy too."[69]

Cassatt's representation of a close, meaningful relationship between Havemeyer and her daughter stands out when compared with Renoir's celebrated painting *Madame*

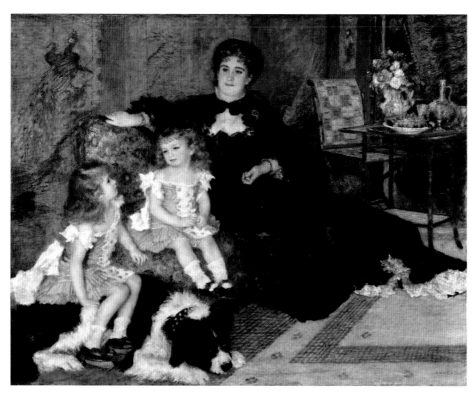

Auguste Renoir, *Madame Charpentier and Her Children, Georgette-Berthe and Paul-Émile-Charles,* 1878. Oil on canvas, 60.5 × 74.9 in. (153.7 × 190.2 cm). The Metropolitan Museum of Art, New York, Catharine Lorillard Wolfe Collection, Wolfe Fund, 1907. 07.122.

Charpentier and Her Children, 1878 (fig. 5.20). Marguérite-Louise Lemonnier, who was married to the powerful French publisher Georges Charpentier, was a prominent Parisian Salon hostess and, along with her husband, an important collector of Impressionist paintings. Madame Charpentier saw to it that this portrait was hung well at the 1878 Salon, where it garnered high praise.[70] It is a portrayal of an opulent bourgeois existence, with the inclusion of Japanese decor adding a nod to avant-garde taste. Renoir's painting depicts Charpentier's high social status through her elegant gown by an elite Parisian designer. Yet rather than representing her as a hostess, the painting portrays her as a mother: seated on the sofa beside her are her three-year-old son, Paul, and his older sister, Georgette, dressed identically, as was the custom at the time. The three sit at the "correct" distances from each other and are arranged hierarchically, their heads in descending heights. There is no visible bond between the children and their mother, such as a warm embrace or eye contact. Ironically, the greatest physical proximity and strongest affective expression depicted in the painting are between the daughter and the large family dog, which she is gently petting while sitting on him. Everyone is on display

and highly representative of the upper class, to which the Charpentiers belonged. This more official portrait contrasts starkly with Cassatt's portrayal of a blend of intimacy and respectful distance between mother and daughter. In painting motherhood, Cassatt portrayed an important part of women's lives in the domestic sphere, yet for her, as for other suffragists, such as Havemeyer, the importance of this role did not mean ceding the public sphere or women's political demands for education, access to the professions, and the right to vote. Rather, images of domestic bliss and attentive maternal care formed a vital part of the fight to legitimize these political demands.

Cassatt was equally sensitive to gender issues when she painted, for the first and only time, a portrait of a father and son—the *Portrait of Alexander Cassatt and His Son Robert Kelso*, 1884 (fig. 5.21). Most commentators on this work (for instance, Suzanne G. Lindsay, Nancy Mowll Mathews, and Judith A. Barter) suggested that it reflects the particular personal relationship between Alexander and his son Robert, and Alexander's good fatherhood.[71] Griselda Pollock succinctly stated that the topic of this portrait is "masculinity and its generations," but did not elaborate.[72] Building on this idea, I propose a reading of this portrait as a representation of upper-class American fatherhood and of patriarchal dynasty within an American democracy.[73] I will argue that Cassatt's portrait of Alexander and his son is about male progeny and posterity—a picture of an American dynasty in the making.

The colonial-era ideal of the American father as a stern patriarch was reshaped by the Industrial Revolution, when the American father became an emotionally distant breadwinner.[74] In the United States of the nineteenth century, the mother's role was to nurture (i.e., to provide "psychological, physical, intellectual, and spiritual support of children"),[75] while the father's was primarily economic, biological, legal, and social—the father conferred legitimacy, epitomized by giving his name to his children.[76] As a prominent member of the American industrial and business elite, Alexander Cassatt excelled in the role of breadwinner and provider of social status to his children. One of the most powerful American leaders of the industrial age, Alexander was educated as a civil engineer and rose from the position of surveyor (rodman) in 1860 to that of vice president of the Pennsylvania Railroad (1877–82), and then president (1899–1906). At the time, the Pennsylvania Railroad was the largest corporation in the world. The *New York Times* described Cassatt as a "remarkably capable executive" who was "both a financier and an operating man."[77] Alexander sat for Cassatt's portrait during his visit to France in late 1884, two years after resigning from the Pennsylvania Railroad and turning to his main interest—breeding racehorses and horse racing—by establishing the Chesterbrook Farm on six hundred acres that he owned in Pennsylvania.[78] Recognized as one of the great stock farms in the United States, the Chesterbrook Farm remained Alexander's priority until 1899, when he assumed the role of president of the Pennsylvania Railroad.[79]

In the portrait, the father and his eleven-year-old formally dressed son are seated on an upholstered chair in a modest middle-class domestic interior (the painting was made in the home of Cassatt's family in Paris). The son's arm wraps around his father's back

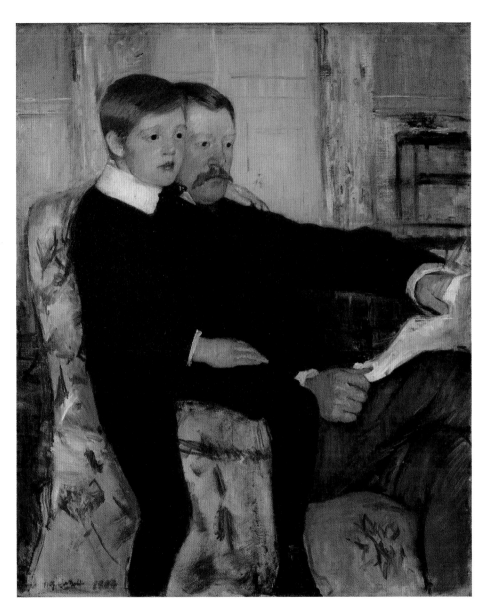

FIGURE 5.21
Mary Cassatt, *Alexander J. Cassatt and His Son Robert Kelso Cassatt*, 1884. Oil on canvas, 39.5 × 32.12 in.
(100.2 × 81.5 cm). The Philadelphia Museum of Art, Philadelphia, PA. Purchased with the W.P. Wilstach Fund
and with funds contributed by Mrs. William Coxe Wright, 1959. W1959–1–1.

and rests on his shoulder while the father holds up a newspaper with both hands and
looks at it; his attention is clearly not directed toward his son. When Cassatt portrayed
women reading to children or with children, by contrast, she typically showed the adult
woman and the child focusing on the same reading material. The act of reading, as a
form of communication, lay at the heart of their interaction. For example, in *Family*

FIGURE 5.22

Mary Cassatt, *Family Group Reading*, 1898. Oil on canvas, 22.2 × 44.3 in. (57 × 112.7 cm). Philadelphia Museum of Art, Philadelphia, PA. Gift of Mr. and Mrs. J. Watson Webb, 1942. 1942–102–1.

Group Reading, 1898 (fig. 5.22), the two adult women and the child all focus on the booklet. By contrast, in Cassatt's portrait of father and son, the reading is incidental, perhaps signifying that Alexander's interest was directed outward, to the world of business.

Father and son have a shared, equalizing grounding from which they emerge as parallel figures, and the direction of their gazes signifies a common course. They are seated on the same upholstered chair and are dressed alike—the father wears a black top, the son a black suit—and Cassatt paints them sitting so closely that no contours separate their black clothing and the sides of their faces touch. Besides the similar clothing and gaze, Cassatt also emphasizes their similar facial features and bodily comportment. By sitting on the arm of the chair, the son is "raised" so that his head is at about the same level as the father's; in this way, Cassatt creates a sense of egalitarianism rather than patriarchal hierarchy. Autonomy and authority coexist under the sign of male equality. Compare this, for example, to Cassatt's portrayal of her brother Gardner's children, *Gardner and Ellen Mary,* 1899 (fig. 5.23): here, too, brother and sister are seated on the same upholstered chair, but there is a clear hierarchy as the older, taller brother protectively embraces his younger sister.

Cassatt's double portrait of father and son reveals her insight about their relationship as related to forming an elite American lineage. The latter is based on the privilege afforded by gender, class, race, and wealth. Passing on status and prestige from one male in the family to the next is presented as a familial and social given: the eleven-year-old Robert Cassatt will mature to embody the social status established by his father. In his dark suit, he is represented as already performing the code of upper-class manhood.[80] Their bodies and clothing merging together, father and son appear made of the same stock, establishing a branch in the family tree.

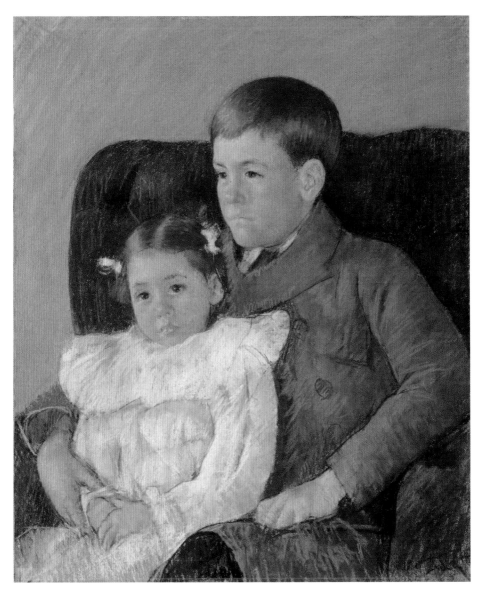

FIGURE 5.23

Mary Cassatt, *Gardner and Ellen Mary*, 1899. Pastel on wove paper, 25 × 18.9 in. (63.5 × 48 cm). The Metropolitan Museum of Art, New York. Gift of Mrs. Gardner Cassatt, 1957 (57.182). Image copyright © The Metropolitan Museum of Art. Image source: Art Resource, NY.

THE MURAL AND THE SUNFLOWER: THEMES OF SUFFRAGE, WOMEN AS EDUCATORS, AND CHILDREN'S AGENCY

In 1893 Cassatt received a unique commission: to paint a large mural, titled *Modern Woman*, for a feminist public space—the international exhibition of women's arts, crafts, and cultural achievements at the Woman's Building of the Chicago World's

FIGURE 5.24

The Hall of Honor, the Woman's Building, 1893, designed by Sophia Hayden. World's Columbian Exposition, Chicago. From Hubert H. Bancroft, *The Book of the Fair* (Chicago, 1893), 269.

Fair. The exhibition was conceived as an event that would demonstrate women's capabilities and claim their equality: "Able and earnest women from all quarters of the globe organized for the purpose of gathering evidence and demanding a hearing by the court of assembled nations."[81] The mural, 58 feet wide (17.67 m) and 14 feet high at its center (4.27 m), was painted on canvas and installed in the Hall of Honor, the most important exhibition space in the building (fig. 5.24).[82] At the other end of the hall was displayed the mural *Primitive Woman,* painted by the American-born Mary Fairchild MacMonnies, who lived in Paris. Both were installed high up, right under the glass roof (fig. 5.25). Together, the two murals were to show women's progress "[f]rom her primitive condition, as a bearer of burdens and doing drudgery . . . and as a contrast woman in the position she occupies today."[83]

Black-and-white photographs and a single color illustration of the mural published at the time are all that remains of the lost mural, yet easel paintings that Cassatt made in the early 1890s show the vibrant colors she used in this work (fig. 5.37).[84] Cassatt divided the mural into three scenes whose titles highlighted her intent to tackle issues of the public rather than the private sphere: the largest, central section is titled *Modern Women Plucking the Fruit of Knowledge and Science* (fig. 5.26); the left, *Young Girls Pursuing Fame,* and the right, *The Arts, Music . . . and Dancing.*[85] The central section was a feminist reinterpretation of the foundational narrative of

FIGURE 5.25
Mary Cassatt, mural of *Modern Woman*, 1893, installed on the South Tympanum of the Hall of Honor. Mural, oil on canvas. From Hubert H. Bancroft, *The Book of the Fair* (Chicago, 1893), 263.

FIGURE 5.26
Mary Cassatt, *Modern Woman*, 1893. Mural, oil on canvas, ca. 58 ft. wide (17.67 m) and ca. 14 ft. high (4.26 m) at its center. Reproduced in Maude Howe Elliott, *Art and Handicraft in the Woman's Building of the World's Columbian Exposition, Chicago*, 1893.

the Garden of Eden. Excluding Adam and the snake, Cassatt turned Eve's desire for the apple from a sign of weakness in succumbing to temptation into an autonomous eagerness to pursue knowledge and pass it on to the younger generation.[86] At the very center of the mural (seen here in a color reproduction of the time), a young woman standing on a ladder is bending down to hand the apple of knowledge to a girl who is looking up and raising her hand to grasp the fruit (fig. 5.27). Thus, Cassatt represented the girl, too, as having her own independent agency, manifested in the active effort she exerts.

Cassatt turned the idle Garden of Eden into an orchard that bustles with activity and work, yet the young middle-class women picking fruit are wearing fashionable outfits rather than peasants' clothes, indicating their class and modernity while suggesting that the scene has an allegorical dimension (fig. 5.28). Cassatt kept the allegory at a distance, as an added layer, since as an Impressionist (as opposed to a Salon artist) she did not paint allegories but rather scenes of modern life. Cassatt's symbolic treatment of a contemporary orchard as a post-Edenic site of seeking and

FIGURE 5.27

Mary Cassatt, detail from the middle of the central section of the mural *Modern Woman*, 1893.
Reproduced in William Walton, *World's Columbian Exposition Art and Architecture*, vol. 3 (Philadelphia:
George Barrie and Co.). Photogravure, facsimile typogravure, 16.7 × 11.8 × 1⁹⁄₁₆ in. (42.5 × 30 × 4 cm).
Gift of Lincoln Kirstein, 1970, 1970.565.127(3). Image copyright © The Metropolitan Museum of Art.
Image source: Art Resource, NY.

acquiring knowledge was in tune with feminists' understanding of the priority of education for women. As early as 1859, American feminists emphasized the importance of girls preparing themselves "for new spheres of duty," whether that meant studying medicine, divinity, or any field of their choice.[87] Education for women was central to the efforts of both French and American feminists, and especially access to higher

FIGURE 5.28

Mary Cassatt, *Young Women Plucking the Fruit of Knowledge and Science,* 1893. The central section of the mural, at the Woman's Building at the 1893 World's Columbian Exposition. *Harper's New Monthly Magazine,* May 1893, 837.

education, which would enable them to enter the liberal professions. Cassatt was convinced that nothing but education could counter women's subjugation. After reading the 1901 novel *The Benefactress,* by Elizabeth von Arnim, Cassatt stated: "We can do so little for others except in the way of education."[88] (The novel is about the failed philanthropic project of a young woman who invites several unmarried women of high social standing who lack the financial means for independent living to come and live with her on the rural estate she inherited.)[89] Cassatt was interested in the topic of women's knowledge and recommended to Havemeyer the lecture by the English historian Henry Thomas Buckle, "The Influence of Women on the Progress of Knowledge," in which Buckle argued that women are stronger than men in fast thinking, intuition, and imagination, and thus that their contribution to future knowledge is essential.[90]

The grace and feminine appearance of the figures in Cassatt's mural counteracted American and French popular culture images of the 1880s, 1890s, and early twentieth century that stigmatized the suffragists as masculine (fig. 5.13). Against this backdrop, Cassatt's challenge was to depict modern women as simultaneously feminist and feminine. This agrees with Wanda Corn's interpretation that Cassatt, like Palmer and others, "wanted to expand the meanings of 'feminine.' . . . They wanted their sex to have more options without having to give up their feminine refinement and sophistication."[91] This explains Cassatt's comment to Bertha Honoré Palmer (the president of the Board of Lady Managers, who organized the Woman's Building and commissioned the mural): "To us the sweetness of childhood, the charm of womanhood, if I have not

FIGURE 5.29
Evelyn Rumsey Cary, *Woman Suffrage...*
Give Her of the Fruit of Her Hands, ca. 1900.
Poster, Lithography, 41.5 × 23.37 in. (105.4 ×
59.37 cm). Schlesinger Library, Harvard
Radcliffe Institute for Advanced Study at
Harvard University, Boston, MA,
olvwork630196.

conveyed some sense of that charm, in one word, if I have not been absolutely femi-
nine, then I have failed."[92]

Some scholars criticized Cassatt's mural for appearing to be "far removed . . . from
contemporary concerns like suffrage, social reform, or adequate pay for women's work
outside the home."[93] Yet the modernity of Cassatt's mural stands out when compared
to some other American feminist images, such as a poster for women's suffrage
designed by artist and suffragist Evelyn Rumsey Cary, *Woman Suffrage,* ca. 1900
(fig. 5.29). Cary used Art Nouveau style and imagery, which often shows female

figures metamorphosing into nature. Featuring an allegorical figure, an ethereal woman dressed in timeless garb, Cary's poster represents her raised arms and hands turning into delicate tree branches bearing fruit, and her feet transforming into the roots of the tree. Below the image, a quote from Scriptures reads: "Give her of the fruit of her hands, and let her own works praise her at the gate."[94] While the text affirms the woman's agency (her "own works"), the image shows an immobile woman who is synonymous with nature, rather than an active human agent who creates culture.[95]

In contrast to this poster's overtly allegorical approach, Cassatt's mural represents scenes from daily life, and the women and girls who populate them are robust and contemporary rather than ethereal fantasies. Cassatt does include one allegorical figure in the mural: in the left panel, a young nude female figure, representing fame, soars in the sky with a barely visible trumpet and is pursued by several running girls. Cassatt commented briefly on the scene, noting that "young girls pursuing fame" seemed to her "very modern."[96] The right panel depicts three young women—one dancing, another playing the banjo, and a third in the role of the audience—showing women as performers and spectators of art.[97]

The most striking feminist aspect of the mural, however, is undoubtedly the central panel, and in particular Cassatt's choice to replace allusions to the nuclear family with an all-female group as a community unto itself. Here, in contrast to her easel paintings, the depicted girls and young women are not necessarily related to each other by familial ties, and as Cassatt herself confirmed, the mural represented "woman apart from her relations to man."[98] The experience of communities of women, working together in the pursuit of women's rights or on philanthropic reform projects, played a crucial role in enabling women to make inroads into the public sphere long before the vote. Photographic group portraits of American women who worked together for the suffrage cause were common by the early twentieth century. One example is the 1919 photograph portraying leading members of the National Woman's Party (NWP) (fig. 5.30) (Louisine Havemeyer is at the far left). This type of photograph presents a new iconography of women signifying a collectivity formed by a group struggle. Cassatt's central panel creates a picture of women and girls engaged in a group effort within the framework of the Impressionist imagery of figures in nature, which may be read as signaling a contemporary collective effort by women.

These kinds of communities of women were segregated by race in the United States. African American women and their organizations approached the Board of Lady Managers of the Woman's Building early in the process and made repeated attempts to take part in the project. They wanted to have a representative on the board and to assemble exhibitions of Black women's work, to show "the educational and industrial advancement made by the race."[99] Their goal was in tune with the project's idea of demonstrating women's progress, and they argued that special

National Woman's Party National Council, Washington, DC, 1915 (*left to right:* Mrs. Havemeyer, Annie Porrit, Mrs. George Day, Mary Winsor, Alva Belmont, Eunice Dana Brannan, Sophie Meredith, Elsie Hill). Box V 363, folder 6, part A, Action Photographs, Suffrage Campaign. National Woman's Party Records, Library of Congress, Washington, DC.

exhibits of Black women's work were necessary because otherwise it would be impossible "to distinguish the exhibits and handwork of the colored women from those of the Anglo-Saxons."[100] But paternalism and racism on the board resulted in a rejection of their proposals.[101] The 115 members of the Board of Lady Managers and the executive board of 25 were all white middle- or upper-middle-class women.

Little attention has been paid to the frame of the mural—a wide border, approximately 30 inches (75 cm) at the top and 35 inches (91 cm) at the bottom (fig. 5.31). Beyond its decorative function, the border also extended the symbolism of each scene. The vertical transmission of knowledge originates at the top border (above the ladder), where a small, winged figure extends her hands downward, transferring higher knowledge to the women in the central scene. The lower border features five babies, each placed in its own roundel, engaged in an activity related to the scene above it: the baby on the far left stretches its arm in the same direction as the three girls running after fame; on the far right, the baby plays the trumpet, echoing the woman playing the banjo; on each side of the central scene, a baby reaches up, striving to receive the apple; and below the center of the mural, a medallion features a baby holding an apple in each hand (fig. 5.32).

The mural's scenes are separated by two vertical borders, each of which features a portrait of a woman inside a diamond-shaped frame, and one in a circular frame appears above each (in the top border). These portraits may represent some of the women

FIGURE 5.31

Mary Cassatt, *Modern Woman,* 1893. The central section of the mural, including the borders. The Woman's Building at the 1893 World's Columbian Exposition, Chicago, IL.

FIGURE 5.32

Mary Cassatt, *Medallion with Baby,* detail from the lower border of the *Modern Woman* mural, 1893. Harper's *New Monthly Magazine,* May 1893.

honored in the Hall of Honor, which featured the names of Palmer and the Woman's Building architect Sophia Hayden (whose name is visible under Cassatt's mural) (fig. 5.25), as well as the names of women from history, such as Joan of Arc, Charlotte Corday, George Sand, and Madame Récamier. The rest of the approximately 30-inch-wide (80 cm) vertical borders that separate the central scene on each side are taken up by tall sunflowers. While Van Gogh, Gauguin, and others painted

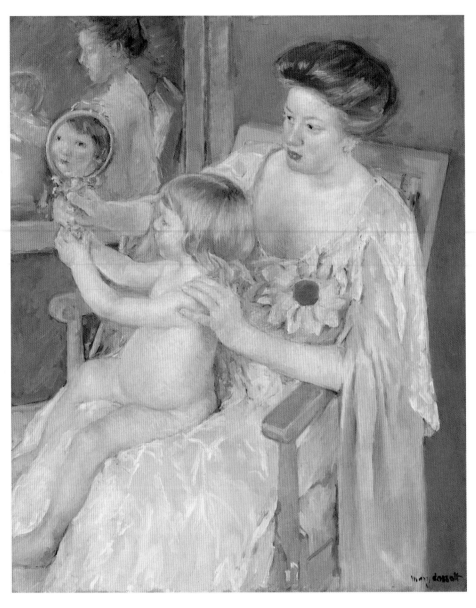

FIGURE 5.33

Mary Cassatt, *Woman with a Sunflower*, ca. 1905. Oil on canvas, 36.3 × 29 in. (92.1 × 73.7 cm). Courtesy National Gallery of Art, Washington, DC, Chester Dale Collection. 1963.10.98.

sunflowers in a vase or lying on a table in a home environment, Cassatt's sunflowers are undomesticated, depicted as they grow in the wild, their tall slender stalks filled with leaves and crowned by the large yellow flowers. Cassatt must have chosen to depict the tall sunflowers in the mural because they were a symbol of American suffrage (more on this below).

FIGURE 5.34

Anthony Van Dyck, *Self-Portrait with a Sunflower*, ca. 1632–33. Oil on canvas, 24 × 29 in. (60 × 73 cm). Private collection.

Several years after the mural, Cassatt returned to the sunflower in a striking easel painting, *Woman with a Sunflower*, ca. 1905 (fig. 5.33).[102] Here, a single large sunflower is prominently pinned on the woman's loose yellow dress (a peignoir worn by middle-class women at home).[103] Cassatt may have been emboldened to make the sunflower so prominent in this painting by an earlier work, Anthony Van Dyck's *Self-Portrait with a Sunflower*, ca. 1632–33 (fig. 5.34), which she could have seen in one of its several copies or engravings. (Van Dyck symbolizes his devotion to Charles I, his patron, through the large sunflower, which according to emblem books of the time stood for the subject's devotion to his monarch.)[104] But the symbolic meaning of Cassatt's use of the sunflower lies elsewhere.

Nicole Georgopulos recently offered a convincing interpretation of the sunflower in Cassatt's ca. 1905 painting as symbolizing suffrage.[105] As early as 1867, Stanton and Anthony adopted the sunflower—the state flower of Kansas—as a symbol during the campaign for the Kansas suffrage referendum, and Kansas suffragists referred to their yellow ribbon as their "sunflower badge."[106] Georgopulos gives several later examples of the use of the sunflower by American suffragists, including as a logo of

FIGURE 5.35
Suffrage button, "We Want to Vote for President in 1904."
Museum of the City of New York, New York. Gift of the Estate
of Mrs. Carrie Chapman Catt through Mrs. Alda H. Wilson,
1947. 47.225.12.

the suffragist organization NAWSA, and it was featured on some prints, badges, stickpins, and suffrage buttons.[107] So, for example, a button made close to the time of this painting depicts the yellow petals of a sunflower encircled with the words "We Want to Vote for President in 1904" (fig. 5.35).[108] Georgopulos aptly concludes that Cassatt's sunflower in this painting functions "like a surrogate" for suffrage accessories "pinned over her model's heart much as the badge would be to an activist's chest."[109] In light of its widespread use at the time as a symbol of American suffrage, there is little doubt that both Cassatt's initial use of the wild sunflowers in the mural and her use of the single sunflower in her later painting are references to American suffrage.

In *Woman with a Sunflower*, Cassatt referred to American suffrage not only through the sunflower but more generally through the predominant use of yellow, which along with gold was itself symbolic of suffrage in the United States (the anti-suffragists countered with their symbol of a red rose).[110] Yellow and gold became prominent colors of the American suffrage movement.[111] The weekly feminist newspaper *The Suffragist* interpreted the sunflower's color symbolism as "gold, the color of light and life" and likened it to "the torch that guides our purpose, pure and unswerving."[112] Cassatt's painting is dominated by shades of yellow—a light yellow long dress and the darker yellow of the sunflower's petals and of the long, loose sleeve hanging over the green chair. American suffragists were encouraged to wear yellow, including yellow ribbons, sashes, and buttons, to make their support visible, "to show their colors."[113] In this painting, Cassatt indeed showed her colors. And Havemeyer, who acquired the work in 1914 and displayed it in the exhibition in support of suffrage held the following year (see chapter 6), was likewise fully aware of Cassatt's use of the symbolic meanings of the sunflower and the color yellow.

Woman with a Sunflower is also particularly interesting as one of several artworks in which Cassatt represented a woman (not always a mother) as an educator. Here, the mother guides her daughter's process of learning by looking. Collaborating in the process, both are grasping the mirror's handle, and the mother further supports her daughter by placing her hand on her shoulder. The girl is observing the reflection of her own face in the round mirror. Her looking at herself in the mirror is anything but frivolous; it is depicted, rather, as a sustained and valuable process—learning to look as a mode of acquiring knowledge and developing a sense of herself as a subject. The girl's agency is emphasized, while the mother's gentle guidance provides her with the conditions needed for her own thriving. Cassatt strongly believed in the importance of looking, having herself spent countless hours throughout her life looking at paintings in museums and, of course, looking while painting. She was convinced that children ought to learn by looking at artworks in museums and not just by reading books. Writing to her friend Theodate Pope, she noted: "I used to protest that all the wisdom in the World was not between the pages of books" and recalled a visit to Boston in which she saw working-class boys "devouring books" on their own, with no guidance, prompting her to think "how much more stimulating a fine museum would be, it would teach all those little boys who have to work for their living to admire good work & give them the desire to be perfect in some one thing."[114] In *Woman with a Sunflower*, Cassatt strengthens the feminist message of empowering women and girls by creating a formal analogy between the sunflower and the mirror, which are similar in shape and size. Linked by formal means, the mirror as the medium of obtaining knowledge and the sunflower as the symbol of American suffrage are conceptually related.

The gold frame of the small mirror encircling the child's face doubles as a halo. The emphasis on the haloed child is in tune with American suffragists' belief in the younger generation as embodying the promise of a new age of equality. Havemeyer recounted an event in New York City that featured generations of suffragists: "I placed my little grandson upon a chair and said: 'Friends, if the men of your generation will not grant us justice now, you may be sure this generation will!'"[115] Children played a prominent role in the grand dedication of the NWP's new headquarters on Capitol Hill in Washington, DC, on May 21, 1922.[116] Presided over by Havemeyer, the elaborate ceremony, attended by several thousands, also featured daughters of the party leaders. The girls raised the new banner of the NWP, and "boys and girls walked hand in hand in token of the future equal partnership of men and women."[117]

Including children and emphasizing their agency formed part of a broader feminist belief at the time. It was a guiding principle at the 1893 Children's Building, which was adjacent to the Woman's Building, and was developed by women educators.[118] In France, children's agency was recognized in a 1901 exhibition titled *L'enfant à travers les âges* (The child across the ages), also titled *L'Exposition de l'Enfance* (The exhibition of childhood), at the Petit Palais. The French painter and poster designer Clémentine Hélène Dufau designed the poster for the exhibition (fig. 5.36). The poster depicts a

FIGURE 5.36

Clémentine Hélène Dufau, *L'enfant à travers les âges,* 1901. Poster, 59.1 × 39 in. (150 × 100 cm). BnF / Gallica.

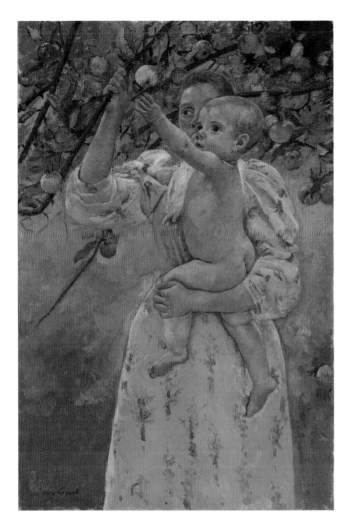

FIGURE 5.37

Mary Cassatt, *Child Picking a Fruit,* 1893.
Oil on canvas, 39.5 × 25.75 in. (100.33 ×
65.41 cm). Virginia Museum of Fine Arts,
Richmond, VA. Gift of Ivor and Anne
Massey, 75.18, photo: Travis Fullerton
© Virginia Museum of Fine Arts.

girl showing works at the exhibition to her younger sister and brother—a choice that invests the children with the agency of looking rather than merely the passivity of being the topic of the exhibition.[119]

Woman with a Sunflower is only one among several artworks in which Cassatt emphasized the role of a young woman as a mentor to youth or an educator of a toddler or infant. Another striking example is Cassatt's *Child Picking a Fruit,* 1893 (fig. 5.37), in which a young mother in an orchard lowers the branch of an apple tree so that the baby she holds in her arms can reach the apple on its own. Here, too, the mother's act is one of facilitation—she enables the infant's own grasping. The color scheme, the location, the woman's dress, and the theme of a mature woman helping the young to obtain the apple that symbolizes knowledge all connect this painting to Cassatt's mural of the same year. On several occasions, Cassatt also painted an older girl, or a young woman who is not the mother, mentoring a younger girl. In *The Crochet*

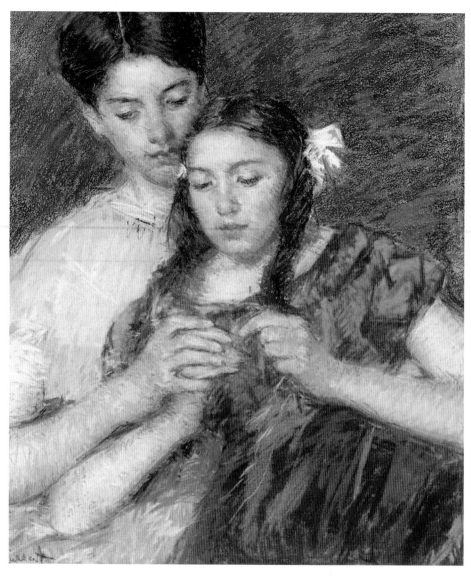

FIGURE 5.38
Mary Cassatt, *The Crochet Lesson,* 1913. Pastel on paper, 30.1 × 25.5 in. (76.5 × 64.8 cm). Photograph courtesy of Sotheby's, Inc. © 2023.

Lesson, 1913 (fig. 5.38), for example, the young woman's hand is carefully placed over the hand of the girl, turning the crocheting into a joint effort, while their physical closeness enhances the gesture as an act of support. Cassatt's *Banjo Lesson,* 1894 (fig. 5.39) similarly shows a collaborative activity performed with a sense of concentration and caring: it depicts a girl leaning on a young woman playing the banjo and observing her with attentive interest—learning by looking and listening.

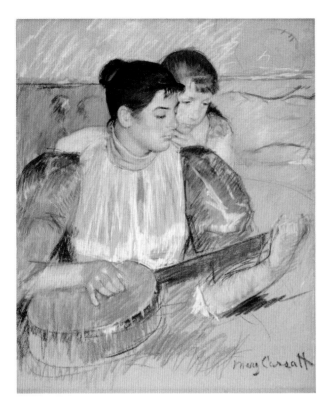

FIGURE 5.39

Mary Cassatt, *The Banjo Lesson*, 1894. Pastel over oiled pastel on tan wove paper, 28 × 22.5 in. (71.12 × 57.15 cm). Image courtesy of the Virginia Museum of Fine Arts, Adolph D. and Wilkins C. Williams Fund, 58.43.

Cassatt was "an ardent feminist," as Havemeyer testified on various occasions.[120] She was also a member of a privileged class, and while she herself chose not to live a domestic life of motherhood but to lead a professional life, she brought her feminist insights to the representation of middle-class girls, mature women, mothers, and aging women. For those who were steeped in the political battle for and against suffrage during Cassatt's time, her paintings of middle-class women, mothers, and children could be read either way: as merely affirming the traditional role of middle-class modern women as mothers, or else as casting motherhood and more broadly the role of women in educating the younger generation as a positive value that justified women's claim to be active beyond the private sphere. By interpreting Cassatt's work within the historical context of the suffrage debates of her time, I have attempted to show how she invested her art with feminist insights in a variety of subjects, from the much-discussed theme of mother and child to her rarely considered subjects of women's aging, women mentoring and facilitating education, women's community beyond the nuclear family, and the representation of elite American fatherhood.

6

THE 1915 CASSATT AND DEGAS EXHIBITION IN NEW YORK

ONE OF THE MOST IMPORTANT and unique exhibitions in Cassatt's career took place in New York in 1915. This museum-scale show was initiated, conceptualized, organized, and publicized by Louisine Havemeyer, with Cassatt's input. Titled *The Loan Exhibition of Masterpieces by Old and Modern Painters,* it was displayed in the Knoedler Gallery from April 6 to April 24, and featured artworks by Cassatt and Degas in the gallery's large central space and paintings by European old masters in two adjacent smaller spaces. For Cassatt, this exhibition was a unique experience because it teamed her up with Edgar Degas. It was also the only time she explicitly supported the cause of American women's suffrage in public: the proceeds from the show went directly to the New York suffrage campaign. (The 1893 mural *Modern Woman* supported feminist ideas about women's value and achievements, but the Woman's Building at the Chicago World's Fair did not explicitly support suffrage.) For Havemeyer, the exhibit integrated her two passions—art collecting and women's rights. Timed to contribute to and raise awareness of the

upcoming suffrage referendum in New York State (November 2, 1915), the exhibition raised substantial funds for the campaign by charging a $1 entry fee and a $5 fee for attending Havemeyer's lecture on Cassatt and Degas, all of which together netted $2,283 (the equivalent of $63,000 in 2022).

This exhibition was overlooked in Cassatt scholarship until the 1990s and began to be discussed only after it was explored in studies on the Havemeyers' collecting.[1] Here, I offer a revised account of the works that made up the exhibition, based on photographs that have only recently come to light, and accordingly propose a revised assessment of Havemeyer's goals as its curator. I also address several questions that have not yet been explored with respect to the exhibition: How did the critical reception of the exhibition position Cassatt vis-à-vis Degas, and how did American critics address the show's dedication to suffrage? What trajectory for exhibiting modernism did this exhibition establish? And what was the historical context of women's art exhibitions promoting suffrage in which the exhibition took place?

Wanda M. Corn has shown the central importance of transatlantic exchanges for the development of American art between 1915 and 1935.[2] Here I focus on the complementary role that transatlantic exchanges played in the practice of collecting and, in particular, the impact of American collecting of French art and European old masters on museums in New York in the period directly preceding the one Corn discusses. Transatlantic art collecting by women, including Havemeyer and Lillie P. Bliss, as well as Gertrude Vanderbilt Whitney's collecting of American art, contributed significantly to New York's transformation into a world art center—Havemeyer through her bequest to the Metropolitan Museum of Art, Bliss through her bequest to MoMA, and Whitney by founding the Whitney Museum of American Art and donating to it her own collection of American art.[3]

The exhibition was one of the early instances in which transatlantic art collecting by Americans played the dominant role, and in that sense, it was a precursor to New York's rise as a rival to Paris. As Havemeyer stated, "I doubt if such a collection as you now see here could be made even in France, where they [Degas and Cassatt] have always lived and worked."[4] The Degas, Cassatt, and old masters exhibition marked the first time that New York could claim to have outdistanced Paris in terms of the sheer volume of works by these artists available for viewing in the city. Havemeyer was able to assemble a large number of works by Degas and Cassatt for the exhibition thanks to her own collecting and that of other Americans over several decades. She lent many of the exhibit's artworks, other American collectors lent most of the rest, and Cassatt sent some of her own works.[5] This represented enormous progress for the American art world since the days of the first Impressionist group exhibition in New York, in 1886, when the French dealer Durand-Ruel had to ship most of the show's nearly three hundred artworks from Paris. In 1915 the war raging in Europe would have made it impossible to hold such an exhibition in Paris; but there was another reason why it could not take place there: joining Degas, who was considered one of *the* masters of

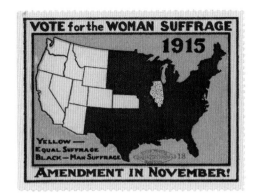

FIGURE 6.1

Caroline Katzenstein, *Vote for the Woman Suffrage Amendment in November!*, 1915. Poster Stamp, 1.96 × 2.55 in. (5 × 6.5 cm). Published by the Equal Franchise Society of Philadelphia. Cornell University, PJ Mode Collection of Persuasive Cartography. 1177.01.

modern art, with Cassatt, who was a woman artist and a "foreigner," did not fit French national and patriarchal values. In New York, by contrast, critics could embrace the exhibition, since Cassatt was an American whose art had gained recognition in Paris, the capital of the nineteenth-century art world, at a time when the young nation was seen as lacking an art of its own.

New York was also favorable ground for the exhibition because women's suffrage was topical at the time and discussed prominently in the press due to the upcoming referendum in which the state's male citizens (along with those of New Jersey, Massachusetts, and Pennsylvania) were to vote on women's suffrage. Havemeyer was among those who canvassed the state, speaking to crowds several times a day "at garden parties, clubs, the state fair, and on street corners."[6] Suffragists also disseminated a profusion of propaganda images, such as *Vote for the Woman Suffrage Amendment in November!*, 1915 (fig. 6.1), which used an image created by Caroline Katzenstein, who was a member of the National Woman's Party (NWP). It featured an image of the map of the United States to show the dynamics of granting suffrage moving eastward. This printed image of a stamp communicated a clear graphic message of progress, coloring the twelve states that had already voted for full suffrage in yellow (the color of American suffrage) and the rest of the states in black.[7]

THE CASSATT, DEGAS, AND OLD MASTERS EXHIBITION REVISITED

Initially, Havemeyer had intended to present a monographic exhibition of Degas.[8] With Cassatt's mentorship, she had by then assembled the world's largest collection of his art. When Havemeyer wrote to Cassatt of her idea for a Degas exhibition for the benefit of suffrage, Cassatt, who was supportive of both Degas and suffrage, was enthusiastic. She wrote back that "it will be a great thing to have the Degas exhibition," adding: "It would be 'piquant' considering Degas [*sic*] opinions"[9]—a reference to Degas's strong sentiments against women's rights (discussed in chapter 3). The eighty-one-year-old Degas, "a mere wreck," as Cassatt described him in 1913,[10] was by

then deaf and rarely visited by his friends because "he hardly recognizes them and does not talk with them."[11] Disengaged from his environment, almost blind, and unable to work, he wanted to be left alone.[12] Degas thus remained unaware of the exhibition.

The format of a two-artist exhibition, first conceived by art dealers, typically teamed up male masters. To name just one example, in January 1915, Stieglitz's 291 gallery exhibited recent drawings by Picasso and Braque along with African sculpture. Havemeyer began to develop the idea of a joint Degas-Cassatt exhibition during her lengthy visit with Cassatt in the spring of 1914.[13] At first, Cassatt was reluctant to participate in the exhibition, mostly because she believed that not enough of her works could be assembled. She likely anticipated that anti-suffrage sentiments would limit the number of American collectors willing to lend works. After Havemeyer succeeded in convincing her, Cassatt affirmed that if such an exhibition was to materialize, "I wish it to be for the cause of women Suffrage."[14] Once on board, Cassatt actively supported the exhibition, attempting to influence reluctant American collectors to lend their works, and also created five new works for the exhibition.[15]

According to my calculations, the exhibition displayed a total of at least seventy-six works, and not sixty-six as was reported in earlier scholarship.[16] These revised numbers, based on two previously unknown installation photographs of the exhibition (figs. 6.3 and 6.4),[17] include a total of fifty-six works by Degas and Cassatt—twenty-seven by Degas and twenty-nine by Cassatt—as well as a drawn portrait of Degas by Constantin Guys and a photographic portrait of Cassatt taken in 1913 for Achille Segard's book about her (fig. 6.2), both displayed next to the doorway separating the walls that exhibited Degas's and Cassatt's works, respectively.[18] The two previously unknown installation photographs, in other words, show that the exhibition included an additional eight works by Cassatt beyond the eighteen listed in the original catalogue of the exhibition, as well as beyond the additional three identified by Rebecca A. Rabinow.[19] In addition, while scholars believed that all of Cassatt's artworks in the show were created after 1900, with the exception of one painting from 1883,[20] the photographs show that Cassatt exhibited several works dated prior to 1900.[21] Among these were the pastel *The Long Gloves*, 1889 (private collection)[22] (visible in fig. 6.3); three paintings from the 1890s, *The Child's Bath*, 1893 (fig. 5.17)[23] (visible in fig. 6.3), *Summertime*, 1894 (fig. 6.5),[24] and *Breakfast in Bed*, 1897;[25] and a large pastel, *Portrait of Mrs. H.O. Havemeyer*, 1896 (Shelburne Museum, Shelburne, VT) (fig. 5.11)[26] (the last three works are visible in fig. 6.4). One of the installation photographs (fig. 6.3) also shows additional works by Cassatt created after 1900: *Woman in a Black Hat and Raspberry Pink Costume*, ca. 1905 (private collection),[27] and *Children Playing with Dog*, 1908 (location unknown).[28] A work depicting two female figures (not included in Breeskin's Cassatt catalogue raisonné) is also visible in this installation photograph.

This new information gleaned from the photographs about a nearly equal representation of Cassatt and Degas (Cassatt showed two works more than Degas) allows us to

FIGURE 6.2

Unknown photographer, *Mary Cassatt Seated in the Garden in Villa Angeletto, Grasse*, 1913. Image from Achille Segard, *Mary Cassatt, un peintre des enfants et des mères*, 1913.

FIGURE 6.3

Installation of Cassatt's artworks in *The Loan Exhibition of Masterpieces by Old and Modern Painters*, Knoedler Gallery, New York, 1915. Photograph. Getty Research Institute, Los Angeles, CA (2012 M54) (*left to right: The Long Gloves*, 1889; *Woman in a Black Hat and Raspberry Pink Costume*, ca. 1905; unidentified work; *Children Playing with Dog*, 1908; *The Child's Bath*, 1893).

identify Havemeyer's goals in this exhibition beyond the general idea of "showing great works of art" and, indeed, beyond raising money for the suffrage campaign.[29] Degas's reputation was far greater than Cassatt's, and Cassatt acknowledged this disparity while preparing for the exhibition, writing to Havemeyer: "I am surprised at the coolness I show in thinking of exhibiting with Degas alone."[30] Yet Havemeyer placed Degas and Cassatt on an equal footing, making a bold feminist statement about women's equality, their competence and rightful place in the halls that were dominated by men. When Cassatt congratulated Havemeyer on the success of the exhibition after it closed, she stated: "The time has finally come to show that women can do something," implying that she, too, saw her participation as supporting women's equality.[31]

The way in which the artworks were installed also treated the two artists as equals. Cassatt's and Degas's works were exhibited on different walls of the same large gallery. This allowed spectators to experience each artist within the context of his or her art first, and only secondarily in comparison to each other. Some of Cassatt's works were installed thematically—for example, *Children Playing with Dog*, 1908 (location unknown)[32] was hung next to *The Child's Bath*, 1893 (fig. 5.17), in a way that allowed for

FIGURE 6.4

Installation of Cassatt's artworks in *The Loan Exhibition of Masterpieces by Old and Modern Painters,* Knoedler Gallery, New York, 1915. Photograph. The Getty Research Institute, Los Angeles, CA (2012 M54) (*left to right: Summertime,* 1894; *Portrait of Mrs. H.O. Havemeyer,* 1896; *Breakfast in Bed,* 1897).

a comparison of her work on the theme of mother and child. But in other cases, the display juxtaposed works on different themes. For example, Cassatt's painting *Summertime,* 1894 (fig. 6.5), an idyllic Impressionist nature scene depicting a mother and daughter sharing a leisurely time on a boat, was hung next to *Portrait of Mrs. H.O. Havemeyer,* 1896 (fig. 5.11) (discussed in chapters 2 and 5). And on the other side of this formal portrait hung *Breakfast in Bed,* 1897 (visible in fig. 6.4), depicting a young mother lying in bed, her arms wrapped around her sitting toddler while a breakfast tray rests on a side table.

Although the exhibition featured none of Cassatt's early work from the 1870s and only two works from the 1880s, it showed a wide stylistic range in works spanning from 1883 to 1914.[33] The display included various depictions of middle- or upper-class mothers in informal scenes with toddlers, babies, and older daughters—some in outdoor scenes, others in indoor portraits, and one pastel depicting a peasant mother and her child, *Mother and Child,* 1914 (fig. 7.7) (which Cassatt created especially for the exhibition). By contrast, many of the Degas works depicted working-class women in action—dancers rehearsing, milliners decorating hats, laundresses ironing, a café-

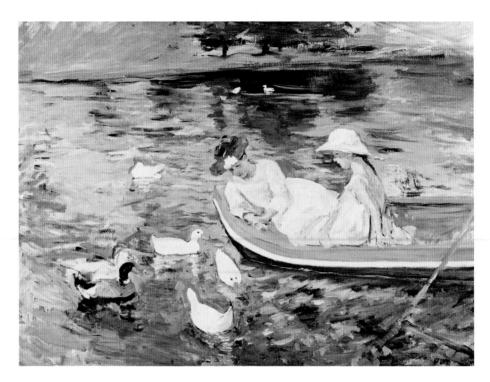

FIGURE 6.5

Mary Cassatt, *Summertime,* 1894. Oil on canvas, 32 × 39.6 in. (81.3 × 100.7 cm). Crystal Bridges Museum of American Art. Superstock/UIG/Bridgeman Images.

concert singer performing, and women bathing or drying themselves. These dissimilarities in the content of the works may reflect stereotypical gender differences in the sense that Griselda Pollock indicated when she wrote that Degas represented "sexualized spaces of masculinity" and Cassatt "intimate spaces of femininity."[34] Nonetheless, when considered in the context of the exhibition's equal representation of Cassatt and Degas, the underlying message of their juxtaposition emerges as one of gender equality.

The exhibition also made another important point. By placing Degas and Cassatt—"the moderns"—in the company of the old masters, it grounded them within the canon of European art and asserted their equality with the old masters. In doing so, it articulated a trajectory of modernism that emphasized continuation rather than a break with tradition (I return to this below). The exhibition included eighteen paintings by Dutch, Flemish, German, English, Italian, and Spanish masters, ranging from the sixteenth to the eighteenth centuries. It displayed six works by Rembrandt, two works by Rubens, and artworks by Holbein, Vermeer, Bronzino, Van Dyck, de Hooch, and several other artists.[35] The implication that the moderns occupied a legitimate place within an illustrious tradition of masters going back to the sixteenth century had

been Cassatt's position for many years, and Havemeyer had fully made it her own. In Cassatt's view, the art of Courbet, Manet, and the Impressionists was less a break with tradition than a continuation of the great chain of European masters over centuries. Cassatt, Degas, and other painters of their generation had spent many years studying the old masters in European museums. And Cassatt believed that "to be a great painter you must be classic as well as modern."[36] In her youthful audacity, Cassatt even announced that she wanted to paint "better than the old masters,"[37] and clearly they played a foundational role in her own artistic development.

Discussing the exhibition, Cassatt proposed to Havemeyer: "If you could get someone to lend a Vermeer for the old masters, it would show Degas' superiority."[38] Havemeyer did get a Vermeer, but kept the old masters in separate galleries and presented Cassatt and Degas as sharing a modern artistic statement. Yet in her lecture at the gallery, Havemeyer discussed Cassatt's idea, crediting her for it, and urged her listeners to compare the old masters with the moderns: "This exhibition will give you an opportunity such as may not occur again in a long time, and as far as I know has never been offered before—that of comparing the old with the new, of seeing the masters of the Flemish school beside those of the French modern school."[39] This strategy of legitimizing the moderns counteracted the earlier attacks levied against Manet and the Impressionists, primarily in Paris, when many believed that they were destroying the tradition of art.

The Cassatt, Degas, and old masters show received wide coverage and very favorable reviews by New York critics. Cassatt wrote to Havemeyer that "[t]he *Herald* [Paris edition] has an article about us"[40] and complimented her friend: "My dear I am so very glad about the exhibition. It has indeed been a success & you deserve all the credit."[41] The press addressed not only the artistic value of the exhibited artworks but also the political goal the exhibition supported, which at the time was still controversial. Most of the critical attention was decidedly positive. For example, the *Sun* stated, "The public owes the exhibition of masterpieces of art by Edgar Degas and Miss Mary Cassatt . . . to the fact that Miss Cassatt is an ardent suffragist."[42] *American Art* noted that Cassatt, an American and a woman, was "made to stand in this display, for suffrage."[43] Some statements by critics reflected an approach of gender parity for example, the *New York Times* described the choice to team up these artists as "two modern painters of the highest degree of distinction, one French and one American, Edgar Degas and Mary Cassatt."[44] It acknowledged a disparity between the two artists but justified their pairing: "The paintings of Mary Cassatt have a range of less wide and less monumental style, but they are well worthy of their present companionship with the art of the great French master." Discussing Degas's "deep genius" and his status as "perhaps the greatest living painter," the review did preserve a typical gender hierarchy that corresponded to the relative status of each artist at the time. Yet the same article also recognized Cassatt as an innovative artist, writing that she "has shown a courage even bolder than that of Degas in his entrance upon unbroken fields of

research," for in her depiction of the mother and child subject she entered a field that "the greatest painters of the world have cultivated and she has won from it a new type, a fresh victory. Her mothers with their children are not like any that have been painted before." An exception to the respectful reception of the exhibit's support of suffrage was the review in the *New York Herald,* whose critic found the very linking of suffrage to the old masters offensive, stating, "Who heard of suffrage in 1634? Saskia? Hendrikje? . . . Hardly."[45]

Anti-suffragists were strongly opposed to the exhibit, and Cassatt's and Havemeyer's own circle of wealthy elite New Yorkers, as well as some members of Cassatt's family, boycotted the show. Cassatt was disappointed by this, even hurt. She wrote to Havemeyer that her brother Gardner's widow, Jennie, "assured me that the exhibition would not be graced by her presence!"[46] A few months later, Cassatt confided in Havemeyer: "I consider that the conduct of Jennie . . . about the exhibition was simply *abominable.* . . . [T]o show me how little she cared[,] to go out of her way to be contemptuous[,] is enough for me."[47] Before the exhibition opened, some American collectors, among them friends whom she had advised on collecting, refused to lend works to the exhibition because of its association with suffrage.[48] After the exhibition closed, Joseph Durand-Ruel visited Cassatt and told her that "it was the cause which kept many people away" from the exhibition: "'society' it seems is so against suffrage. Many regretted to him that they missed seeing a fine exhibition but their principles forbade their going."[49]

As for the cause, when the New York State referendum was held in 1915, the anti-suffragists prevailed; but two years later, the state voted for suffrage.

THE POLITICS OF WOMEN'S ART EXHIBITIONS IN NEW YORK AROUND 1915

We gain a better understanding of the pro- and anti-suffrage responses to the Cassatt, Degas, and old masters exhibition by situating it in the context of the women's art exhibitions of those years—some of them also in support of suffrage—and their influence on the New York art world. During the first decade and a half of the twentieth century, women artists participated in numerous exhibitions of contemporary art, which were held mostly in commercial galleries. In addition, they organized some all-women art exhibitions.[50] Among these was a large exhibition of *Paintings by Women Artists* held at the Knoedler Gallery in 1908, which displayed eighty-two paintings by close to sixty leading artists from the United States and England.[51] In 1914 Ida Proper (artist, cartoonist, feminist activist, and charter member of New York's radical Heterodoxy Club) and the sculptor Malvina Hoffman opened an independent exhibition of their art in a studio they rented for that purpose.[52] This was a newsworthy event because such self-determining action was not yet associated with women. That same year, the Association of Women Painters and Sculptors held its annual exhibition at the Knoedler Gallery, displaying 122 artworks. (Havemeyer was listed in the slim catalogue as one of the association's "patronesses.")[53] These exhibitions made women artists

visible *as a group,* and they worked to undermine the conventional belief about the professional artist as male and the woman artist as either an exception or an amateur.

Between 1912 and 1915, explicit political action and the organizing of art exhibitions merged in New York in five shows mounted to support women's suffrage. Havemeyer created the first one in 1912: *Paintings by El Greco and Goya,* held at the Knoedler Gallery.[54] Anonymously lending all the works in the show, she publicized the exhibition with posters featuring the suffrage colors[55] and posted them on each side of the gallery entrance. She also, managed to place them "in the most important windows on Fifth Avenue."[56] Her chief aims were to support the cause of suffrage by raising awareness and funds. But already in this first exhibition she mounted for suffrage, Havemeyer learned about the fierce opposition to the cause even among some in her own circle. She reported that the exhibition caused "bitter animosity against us among certain classes, some of our best-known and important collectors not only refused to attend the exhibition, but threatened to withdraw their patronage from the dealer who had kindly loaned me his gallery for the exhibition."[57] A *New York Tribune* article titled "Art Show Offends 'Antis'" reported that the Knoedler Gallery hired guards in response to anti-suffragists' threats.[58] New York feminists were not deterred. In 1913 three women art patrons organized the *Suffrage Art Exhibit,* featuring some seventy portraits of prominent New York women painted by numerous artists, including Cassatt, James McNeill Whistler, John Singer Sargent, and Cecilia Beaux.[59] The proceeds from the show's $2 admission fee went to the Woman's Political Union (later renamed the National Woman's Party, or NWP, to which Havemeyer belonged).[60] By showcasing leading New York women as suffragists, this exhibition bolstered the social visibility and credibility of the cause among a wider audience.

Next came the Cassatt, Degas, and old masters exhibition in April 1915. Just a few months after it opened, another exhibition supporting women's suffrage was held at the Macbeth Gallery in New York: *The Exhibition of Painting and Sculpture by Women Artists for the Benefit of the Woman Suffrage Campaign.* The six American women artists who organized it began to meet in the spring of 1915, while the Cassatt, Degas, and old masters show was still on view, and perhaps it emboldened them to organize their exhibition.[61] Their show included over 150 paintings and sculptures, featuring close to one hundred American women artists from all over the United States. Many of these artists had studied or lived in Europe and then returned when the war broke out. As one article about the exhibition noted, "New York has gained some things that Paris lost."[62] Opening on September 27, 1915, the Macbeth Gallery exhibition was attended by "scores of suffragists,"[63] and the press reported that "all the exhibitors are suffragists."[64] The artists dedicated half of the proceeds from sales of artworks to the suffrage campaign, allowing the audience to enter free of charge. Like the Cassatt, Degas, and old masters show, the Macbeth Gallery exhibit was timed to influence the 1915 New York State suffrage referendum.[65] It was widely reviewed, and critics noted that the artworks were linked by "political convictions" rather than artistic style.[66] They commented on the

"suffrage spirit" that was evident in many of the works, like Jane Freeman's depiction of a mother and a male baby, titled *The Coming Voter,* ca. 1915 (location unknown).[67] Such titles linked the artworks explicitly to suffrage. Several critics discussed the profusion of babies and young children in the exhibited works, and one headline announced: "Babies Go with Vote for Women."[68] As I discussed in the previous chapter, women's role as mothers was a prominent theme used in various ways in the debate about suffrage.

The fifth exhibition in support of suffrage featured graphic works by Rose O'Neill (whose work was discussed in the previous chapter; fig. 5.16), a prominent American illustrator and cartoonist known for inventing the Kewpie. An active suffragist, O'Neill organized this one-woman show of her work in October 1915, shortly before the New York State referendum. She chose an unconventional site—the street corner of Broadway and Forty-Second Street. Describing the exhibition, she wrote: "[T]he Kewpies announced to all the passing world: 'We are for suffrage. So is President Wilson.'"[69] As a suffragist who marched in parades, O'Neill was accustomed to the street as a site of activism. But holding an exhibition there was a novelty. Although posters were usually plastered on the streets and, along with banners, were featured prominently in suffrage street parades in both the United States and England, exhibitions of posters and banners (to say nothing of exhibitions of paintings) were held indoors. For example, a 1908 exhibition of British banners, crowned as "the art exhibition of the year" by the *Times,* took place in London's Caxton Hall.[70] And the National American Woman Suffrage Association held a poster exhibition in its headquarters in 1917.[71] Thus, O'Neill's choice to exhibit her work on the street was quite unusual. It was also likely the first feminist art show on the streets of New York.

O'Neill designed a suffrage poster for the occasion, which was the antithesis of her charming Kewpies (fig. 6.6). Using an expressionist drawing style, this 1915 black-and-white poster responded to World War I by depicting a horrified mother shielding her baby with her own body from the threat of war. Her intense facial expression and the baby's bulging eyes convey their dread. A handwritten slogan above the image highlights the role of the mother as citizen: "She prepares the Child for the World. Help her to help prepare the World for the Child."[72] O'Neill's poster expressed a world torn by the war, one in which Cassatt—even if her health and eyesight had not by then prevented her from making art—could no longer have portrayed the harmonious well-being of mothers and children.

Notwithstanding their differences, the five suffrage exhibitions shared an important common characteristic—they all used artworks and the exhibition format to further the political cause of suffrage. Such exhibitions reframed the art exhibition and the objects on display from mere participants in the aesthetic realm to political players. The fact that anti-suffragists refused to attend such exhibitions confirmed their political efficacy in the sense that anti-suffragists felt that they could not look at the art in these exhibitions with an indifferent aesthetic gaze that was divorced from the political cause. Seen in the context of these exhibitions, Havemeyer's Cassatt, Degas, and old masters

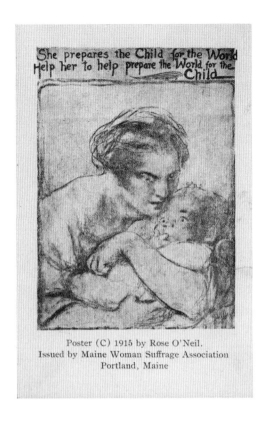

Poster (C) 1915 by Rose O'Neil.
Issued by Maine Woman Suffrage Association
Portland, Maine

FIGURE 6.6

Rose O'Neill, *"She prepares the Child for the World.*
Help her to help prepare the World for the Child,"
1915. Poster issued by the Maine Woman Suffrage
Association, Portland, Maine. Bonniebrook
Museum, Gallery, and Home of Rose O'Neill.

exhibition emerges, on the one hand, as part of a wider phenomenon—of claiming the equality of women artists and using art exhibitions for a political cause—and, on the other hand, as unique. It was the only exhibition to feature a well-known older woman artist alongside and on the same footing with a leading contemporary male artist. Given the high status of both Cassatt and Degas, not to mention that of the old masters, this exhibition was a greater affront to elite Americans who opposed suffrage.

TWO TRAJECTORIES OF MODERNISM

In 1913, two years before the Cassatt, Degas, and old masters exhibition, the Armory Show opened in New York. It was the most influential exhibition of modernist art in America. Titled the *International Exhibition of Modern Art*, the show was organized by the Association of American Painters and Sculptors. It included approximately 1,300 works by three hundred artists, and even though only about one hundred of them were European, the extensive coverage of the Armory Show in the press focused on the controversial French art of the early twentieth century, and in particular on Marcel Duchamp and Henri Matisse.

Women's participation in the Armory Show was more extensive than most studies have realized, if we take into account not only the exhibiting artists but also the areas

of funding and collecting.[73] Of the total of three hundred artists exhibiting in the Armory Show, fifty were women (16.7 percent). But an additional sixty-six women participated as collectors and financial contributors. Women contributed 48 percent of the funds for the exhibition, and a significant number of women collectors lent to the show or bought artworks from it.[74] This positively extensive participation of women was undergirded by the empowering effect of the battle for suffrage.

The Armory Show included an oil painting and a watercolor by Cassatt, both depicting a mother and child. The painting, *Reine Lefebre and Margot before a Window, 1902*,[75] was exhibited in Gallery O, among works by nineteenth-century contemporaries—Degas, Manet, Monet, Pissarro, Renoir, Seurat, Sisley, and Toulouse-Lautrec. (Lent by Cassatt's dealer, Durand-Ruel, it was listed for sale at $4,950, the equivalent of $137,808 in 2022.) Cassatt's 1890 watercolor (lent by John Quinn, one of the most important New York collectors of modernist art) was not for sale.[76] It was exhibited in Gallery J along with works by a mix of artists, among them Ingres, Daumier, Puvis de Chavannes, Gauguin, Redon, Picasso, Matisse, and Dufy.[77]

The Armory Show charted a different trajectory of modernism than the one presented in the Cassatt, Degas, and old masters exhibition. Whereas the latter began with sixteenth-century masters and positioned Cassatt and Degas (and implicitly the Impressionists more generally) as a continuation of the old masters, the Armory's narrative began with masters who between them were active from the late eighteenth century through the 1860s—Delacroix, Ingres, and Goya—and ended with early twentieth-century modernists. Thus, rooted in the recent past, the Armory Show focused on the present, and looked forward rather than backward in time. Whereas Cassatt's generation, as I discussed earlier, had measured themselves against the old masters, by 1913 young American artists were measuring themselves against the latest innovators in Paris. The New York art critic Harold Rosenberg observed that the European works of art in the Armory Show were no longer perceived as "monuments to the past" but rather as a "clocking device that told America where it stood on the calendar."[78] This was the case because by 1913 vanguard nineteenth-century artists were accepted as modern masters. Manet's *Olympia* had entered the Louvre in 1892, and in 1897 the greater part of Caillebotte's bequest of his collection of Impressionists was accepted by the Musée du Luxembourg in Paris, the museum of living artists intended to enter the Louvre a decade after their death. By the time the Armory exhibited the French Impressionists and Post-Impressionists, American collectors, too, regarded these artists as modern masters.

As for Cassatt, her own perceived trajectory of modernism ended with the Impressionists. When Havemeyer visited the Armory Show, she wrote about it to the seventy-one-year-old Cassatt and mentioned Matisse. Cassatt, who detested Matisse's art, responded: "Such a commonplace vision[,] such weak execution."[79] She believed that Matisse had achieved "notoriety" rather than "fame."[80] Others, like the New York art critic Royal Cortissoz, held a similar opinion of Matisse's art as "blatantly inept."[81]

Cassatt deplored what she saw as Matisse's carrying to an absurd point a tendency toward sketchiness initially set by the Impressionists: "Of course it is in a certain measure our set [the Impressionists] which has made this possible."[82] As the French critic Théophile Gautier noted, to understand "startling examples" of new art, one had to belong to the same generation as the artists.[83]

As New York continued its gradual ascent to the status of a world art center, each of its two major museums adopted a different narrative about modern art. The Metropolitan Museum of Art was in sympathy with the narrative of the 1915 Cassatt, Degas, and old masters exhibition. After it accepted the Havemeyer bequest in 1929, which included works by Courbet, Manet, and the Impressionists, the Met presented the Impressionists as the culmination of a great tradition of European art. When MoMA opened in 1929, its modernist trajectory was closer to the future-oriented narrative of the Armory Show. Alfred H. Barr, MoMA's first director, viewed the Impressionist and Post-Impressionist generation as "the principal founder . . . of the contemporary tradition."[84] Notwithstanding their differences, both of these major art institutions relied at the time on a transatlantic history of art in New York.

In the same year that the Met accepted Havemeyer's bequest, it rejected Gertrude Vanderbilt Whitney's collection of some seven hundred works of contemporary American art.[85] In response, Whitney decided to found a museum dedicated to American art. It was the next step in her long-standing dedication to providing an exhibition space for contemporary American artists, which she began in 1914 with her funding of the Whitney Studio in Greenwich Village, directed by Juliana Force. The Whitney Museum of American Art opened in November 1931, with Force as its first director. With its exclusive dedication to contemporary American art, the Whitney left behind the transatlantic phase of modern art collecting in America. At this historical juncture, New York became not only preeminent in its collections of European vanguard art, as well as of old masters, but also increasingly a metropolis that collected modern American art. After the Armory Show, a younger generation of American collectors took shape, with many of them beginning to collect or accelerating their collecting of transatlantic modernist art, and some also beginning to collect contemporary American art.

After the Armory Show, Degas and Cassatt appeared more in tune with a modernity that was accepted as tied to the tradition of the old masters than with the controversial modernism of the early twentieth century. Cortissoz, the *New York Herald Tribune* critic, aptly titled his review of the Cassatt, Degas, and old masters show "M. Degas and Miss Cassatt, Types Once Revolutionary Which Now Seem Almost Classical." He wrote: "It is amusing to reflect that Miss Cassatt and Degas were once grouped with the 'revolutionaries.' To-day their pictures are seen to possess an almost classical sobriety and balance."[86] Yet, as we shall see in the next chapter, after the Havemeyers' bequest was permanently installed in the Metropolitan Museum of Art, Cassatt's position took an unexpected turn.

7

CASSATT'S LEGACY

Art Museums and National Identity

N 1926, WHEN MARY CASSATT DIED, an American newspaper candidly discussed her legacy as a matter of national interest:

> [T]here are many speculations as to how much she belongs to us. Pittsburgh was her birthplace, and Philadelphia gave her the rudiments of her art; but she lived so long in Europe and became so identified with French art, that nothing now labeled "American" can seem to be applied to her. . . . Yet her fame, which has existed since the days of the great impressionists, Degas, Manet, Renoir, Berthe Morisot, is too much for us to surrender to any foreign ownership.[1]

France, too, claimed Cassatt for its glory:

> When the French Prime Minister, M. Clemenceau, in a recent speech referred to her as "*une de nos gloires artistiques*" [one of our artistic glories] he undoubtedly voiced the sentiment of the art public of France.[2]

The interest in a national "ownership" of Cassatt attests to her importance on both sides of the Atlantic. Cassatt was undoubtedly one of the most successful women artists of the nineteenth century in both France and the United States. She was also one of the most successful "expatriate" artists, as the American critic Forbes Watson noted: "[A] list of the men who painted better [than her] . . . would be very short."[3] Moreover, she was the only American who joined the Impressionist group in Paris, leaving behind the prestige of exhibiting in the Salon (after her art had been accepted several times) in favor of participating in what would become one of the most important groups of the French avant-garde. Like her Impressionist comrades, she was represented by their primary dealer, Paul Durand-Ruel, and had one-person exhibitions in his Paris and New York galleries, in addition to participating in numerous group exhibitions. Cassatt's artworks were collected by individuals and museums on both sides of the Atlantic and entered French and American museums during her lifetime. Today her art is owned and shown by major museums in Paris, as well as New York; Boston; Washington, DC; Chicago; and many other cities across the United States. In the almost one hundred years since her death, Cassatt's art has been the subject of numerous one-person exhibitions in major American museums, and several in France.

Cassatt's art has drawn the interest of American art historians and curators from the 1950s to today.[4] Second-wave feminism had an enormous impact on Cassatt's legacy, beginning in the 1970s and increasing in the 1980s and 1990s. It stimulated a new generation of art historians, primarily in the United States and England, to produce a broad range of Cassatt scholarship, which included reinterpretations of her art from feminist perspectives and the publication of catalogues raisonnés of her work, a volume of selected correspondence, and new biographies.[5] Feminism also influenced American museums to organize solo exhibitions of Cassatt's art and to feature it in various large group exhibitions of women artists. In some cases, the renewed interest in Cassatt influenced museums (usually American and on rare occasions French) to include Cassatt's art in smaller group exhibitions with the Impressionist Berthe Morisot and other French women artists.[6] This reevaluation also offered a critique of the gender bias that prevailed in much of the existing Cassatt literature and that had been an obstacle already in the initial formation of her legacy. Cassatt was stereotyped by her first biographer, Achille Segard, in his 1913 book *Mary Cassatt: Un peintre des enfants et des mères* (Mary Cassatt: A painter of children and mothers).[7] The narrow perception of Cassatt implied in the book's title began to be remedied only decades later, when feminist art historians discussed her mother and child pictures in depth but also paid attention to her depiction of contemporary life in Paris both inside the home and in the city: modern women reading the newspaper at home (fig. 5.6), basking in sun-filled gardens, and, at night, sparkling under the artificial light in opera loges (fig. 2.10); riding a bus; or holding the reigns and a whip while driving a horse and buggy in the Bois de Boulogne (fig. 7.10). They also focused on milestones in her career that were previously neglected, including the 1915 Cassatt, Degas, and old masters exhibition in

New York and Cassatt's monumental *Modern Woman* mural, commissioned by the first-wave feminist organizers of the Woman's Building at the Chicago World's Fair of 1893.[8] As we will see, despite Cassatt's wide representation in museums and research today, a close analysis of how American and French museums represent her art reveals that her legacy is still afflicted by several problematic issues related to nationality and gender.

This chapter considers Cassatt's legacy as it was shaped in the period from her death in 1926 to the present day, with a special focus on the role of museums in shaping this legacy. Earlier approaches had different emphases: the preeminent Cassatt scholar and biographer Nancy Mowll Mathews looked primarily at the scholarly literature on Cassatt (from 1910 through ca. 1990);[9] and Kevin Sharp focused on the role of dealers, collectors, and dealer-organized exhibitions during Cassatt's lifetime.[10] By examining Cassatt's legacy, I do not wish to suggest that her oeuvre or her position in the Western art canon is a fixed inheritance.[11] On the contrary: posterity is undoubtedly a dynamic process.[12] Studies about the politics of legacy have shown that artists' legacies are impacted by the shifting vested interests of numerous actors, including "artists, academics, curators, heirs, executors, dealers, and collectors."[13] Museums also belong on this list. The institutional recognition they extend to (or withhold from) artists plays a decisive role in determining whether artists survive beyond their own historical moment and in establishing their position (or lack of one) in the art canon. Art museums play a major role also because they are the primary gateways through which large numbers of people become familiar with an artist's work. As we will see, Cassatt herself was highly conscious of these roles that museums play in an artist's legacy in the era of the art market, and she saw the role of dealers and private collectors as that of intermediaries between artists and the museum.[14]

In what follows, I argue that the national interests of French and American museums and their differing strategies of displaying Cassatt's art resulted in creating two different narratives that shaped dissimilar Cassatt legacies—one as a French Impressionist, the other as an American artist. I propose that in addition to these competing national agendas, Cassatt's legacy was impacted also by the complex dynamics of her own transatlantic life course. As I have described in earlier chapters, on the one hand, she identified wholeheartedly with "our set," as she usually referred to the French Impressionists, and on the other, she identified consistently as an American, never giving up her American citizenship and always referring to the United States as "home." Looking closely at the representations of Cassatt in museums in France and in the United States, I show that their different strategies of displaying her art yielded, effectively, two different legacies—French museums represent her as part of the French Impressionists, and most American museums represent her as a nineteenth-century American artist—and that Cassatt's complex identifications played a role in enabling this. I discuss Cassatt's active steps to ensure her legacy in museums on both sides of the Atlantic, efforts that with the perspective of time have proved largely

successful, even if the androcentric tradition and lingering gender bias of museums still impact even a highly successful woman artist's legacy. Finally, I propose that an important part of Cassatt's legacy concerns her extensive work with American collectors, which resulted in the transferring of great numbers of important European artworks, mostly modern French and some European old masters, to private collections and eventually to museums in the United States.

MEMORIAL EXHIBITIONS AFTER CASSATT'S DEATH

A memorial exhibition in a major museum was an important juncture in establishing nineteenth-century artists' reputations after their death, taking place as they did at a unique moment in which the artist's oeuvre moved from partaking in the contemporary art of the time to becoming part of art history. This kind of exhibition was typically a retrospective—an exhibition that assembled a large number of the artist's works in different media. As the *Art News* noted in 1926, after Cassatt's death, her works, "though well known in the United States, have seldom been shown together in representative numbers," so that her memorial exhibitions afforded the chance to see "a sort of resumé of [her] development."[15] After Cassatt's death, her homeland honored her with several such memorial exhibitions.

Proud of Cassatt's connection to Philadelphia—the city where she had studied and lived in the early part of her life, and where many of her family members were among the local elite—the Philadelphia Museum of Art (PMA) organized a major exhibition in 1927.[16] Assembling extensive loans from private collectors and family members, the exhibition featured 155 works (40 paintings and pastels, 15 watercolors and drawings, and 100 prints).[17] Forbes Watson, the editor of *The Arts* and Cassatt's friend, published an article in the magazine, titled "Philadelphia Pays Tribute to Mary Cassatt," in which he stated that her art "places her unquestionably in the front rank of American painters."[18] The museum reprinted Havemeyer's writing on Cassatt (originally printed in 1915, based on her lecture at the opening of the Cassatt, Degas, and old masters show) to accompany the exhibition, and the press quoted it extensively.[19] Two more large memorial exhibitions were held in the United States: in 1926–27 at the Art Institute of Chicago and in 1928 in the city in which she was born, Pittsburgh, at the Carnegie Institute's Department of Fine Arts.[20]

Cassatt was also honored with several smaller exhibitions in New York City that, while not officially memorial exhibitions, were intended as a tribute to her. A few months after her death, the Durand-Ruel gallery in New York held an *Exhibition of Paintings and Pastels by Mary Cassatt*.[21] It included only nineteen canvases and pastels, a small number for a memorial exhibition, but did cover a period of over thirty years, from 1880 to 1911, which made it possible to follow her development. *The Arts* noted that this exhibition "seems to be the nearest approach to a memorial exhibition of the work of this fine artist that New York is likely to see."[22] Around the same time, two exhibitions of her prints were held in the city, reflecting the strong appreciation by

experts for her work in this medium. The first was organized in early 1927 by the Metropolitan Museum of Art's founding print curator, William M. Ivins Jr., and featured her prints and a few pastels from the museum's own collection, displayed in one of its print galleries. Ivins, who greatly valued Cassatt's prints, ranked Cassatt as "after Mr. Whistler, the most distinguished etcher that America has produced."[23] Stressing her great independence of taste, mind, and judgment, he emphasized her originality in printmaking[24] and predicted that although her name was most frequently linked to Degas, "as time goes by, more and more she will be given her own independent position."[25] Cassatt's color prints he described as "the finest and the boldest to be made during the second half of the last century."[26] The second exhibit of prints was mounted shortly before Ivins's exhibition by the Print Department of the New York Public Library and was described as a "memorial exhibition of the prints of Mary Cassatt" (her prints had been gifted by the esteemed connoisseur and dealer S.P. Avery, along with a remarkable collection of nineteenth-century prints).[27] Held from December 1926 to February 1927, the exhibition included drypoints and color prints, and its curator, Frank Weitenkampf, noted that in the field of prints, "not a few believe that she holds first place."[28]

The Met did not hold a retrospective memorial exhibition for Cassatt, as it did for numerous American artists, many of them her contemporaries. Following the preference of the museum's trustees, the main mandate of Bryson Burroughs, the curator of paintings at the Met, was to acquire European paintings by old masters. Yet through the vehicle of memorial exhibitions for recently deceased American artists, he was able to exhibit contemporary American art in the museum. From 1908 through the 1930s, Burroughs organized numerous memorial exhibitions for American artists, all men, including, among many others, James McNeill Whistler (1910) and John Singer Sargent (1926), both of whom, like Cassatt, did not live in the United States.[29] As Amelia Peck and Thayer Tolles argue, each of the memorial exhibitions at the Met "was intended to canonize the featured artist, as well as to enhance the institution's reputation and holdings."[30] Given Cassatt's stature, the all-male nature of the list of artists for whom Burroughs organized memorial exhibitions may suggest that her gender was a factor in her absence from this list.[31] Yet the fact that the Met acquired in 1909 a painting by Cassatt—*Mother and Child* (*Baby Getting Up from His Nap*), ca. 1899, purchased with the George A. Hearn Fund—for its collection despite generally refraining at the time from collecting women artists' work attests to her high artistic status and to the museum's recognition of it.[32]

During the second half of the twentieth century and the first two decades of the twenty-first, Cassatt's art was the subject of several major exhibitions and was also widely exhibited in the permanent collections of American museums, further consolidating her legacy in the United States. By contrast, in French museums, both temporary exhibitions of her art and its representation in permanent collections have been meager. As we will see, looking closely at the framing of Cassatt as an American artist

in American museums and at her limited representation among the Impressionists in Paris museums reveals how national investments can shape an artist's afterlife.

CASSATT'S ART IN AMERICAN MUSEUMS: EXHIBITIONS AND PERMANENT COLLECTIONS, 1926–2022

Gender bias presented limitations and challenges for Cassatt throughout her lifetime and also thereafter, but from the 1970s onward, Cassatt's gender played in her favor, as the interest in women artists grew and a new generation of art historians and curators, many of them women as well as feminists, turned to her art. Major American museums organized retrospectives of Cassatt's art, including museums in Philadelphia, Baltimore, Chicago, Boston, and Washington, DC. Initially, Cassatt exhibitions were featured in the Baltimore Museum of Art (1936, 1941–42), whose longtime curator and later also director, Adelyn Dohme Breeskin, would go on to become a preeminent Cassatt scholar.[33] The Philadelphia Museum of Art organized Cassatt exhibitions in 1960 and in 1985, and will hold one in 2024.[34] In 1970 the National Gallery of Art (NGA), in Washington, DC, featured a retrospective of Cassatt, also curated by Breeskin. Nearly three decades later, in 1998, Judith A. Barter curated a landmark exhibition, *Mary Cassatt: Modern Woman,* at the Art Institute of Chicago (AIC), which traveled to the NGA and to the Museum of Fine Arts, Boston.[35] In 2014 curator Kimberly A. Jones curated the *Degas Cassatt* exhibition at the NGA, which included a significant number of artworks by both artists and was the first time a major museum teamed up the two artists, lending them equal status.[36] All of these exhibitions assembled numerous loans of Cassatt artworks from museums and private collections, and were accompanied by catalogues that made important contributions to Cassatt scholarship.

The Met, to date, has not curated or hosted a retrospective exhibition of Mary Cassatt's art. In 1922 it displayed for one month the nine paintings it accepted as an anonymous gift from Stillman's collection, along with several etchings.[37] It also organized four displays, featuring works by Cassatt from its permanent collection, in 1927, 1943, 1973–74, and 1998–99.[38] None of these was accompanied by catalogues. Such modest displays differ significantly from curated exhibitions, which assemble a substantial number of works by an artist from other collections, receive special attention in the museum's exhibition lineup, are widely attended, and are accompanied by a scholarly catalogue. A lingering gender bias likely explains the contrast between this modest representation and the Met's rich record of exhibitions of Cassatt's contemporaries. Sargent and Whistler, for example, have each had five exhibitions at the Met (of these, two of Sargent's and one of Whistler's were limited to the museum's collection).[39] Although not a Cassatt solo show, there was one occasion on which Cassatt's artworks presented at the Met were not limited to the museum's own holdings. In 1954 the *Sargent, Whistler, and Mary Cassatt* exhibition, organized by Frederick A. Sweet, curator of American painting and sculpture at the AIC, traveled to the Met after its debut in

Chicago.[40] As seen in the installation photograph of the exhibition in Chicago, Cassatt was represented with some of her major works (fig. 7.1). Thirty years later, New Yorkers could see a significant assembly of loans of Cassatt's artworks in an exhibition held in 1984 at a private commercial gallery in New York, the Coe-Kerr Gallery, for the benefit of the American Wing of the Met.[41]

Whereas special exhibitions generate a lot of interest temporarily and allow visitors to see numerous works by an artist, reflecting their development over time, an artist's legacy is to a great extent shaped by museums' displays of their permanent collections. In these displays, the issue of nationality plays a major role, and this presents a problem for exhibiting an artist like Cassatt, who was born in the United States but lived most of her life in France and was associated artistically with the Paris-based Impressionist circle. American museums' curatorial departments and their galleries are usually divided between American art / art of the Americas and European art. Most American museums today exhibit Cassatt's art in the context of nineteenth-century American art, in galleries that typically feature a mix of paintings, sculpture, furniture, and decorative objects, with which her art has little in common. Cassatt's art is exhibited in the American Wing, or department, at the Met, in New York; the MFA Boston;

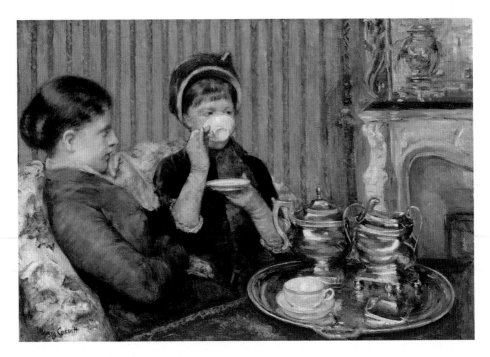

FIGURE 7.2

Mary Cassatt, *The Tea*, ca. 1880. Oil on canvas, 25.5 × 36.2 in. (64.7 × 92 cm). Museum of Fine Arts, Boston. Theresa B. Hopkins Fund, 42.178. Photograph © 2024 Museum of Fine Arts, Boston.

and the Art Institute of Chicago. In most cases, the presence of her paintings in the context of nineteenth-century American art in American museums is not explained, and thus is made to appear as if it requires no explanation. At the AIC, for example, Cassatt's paintings *On a Balcony*, 1878–79, and *The Child's Bath*, 1893 (fig. 5.17), are displayed alongside works by several other artists who are considered American yet lived in Europe for most of their lives, including Sargent, Whistler, and Henry Ossawa Tanner, as well as artists who lived and worked in Europe for various durations but returned to settle in the United States.[42] The MFA Boston displays five paintings by Cassatt in the Art of the Americas Wing alongside works by the realist and Ashcan School painter William James Glackens and the American Impressionists Childe Hassam, William Merritt Chase, and John Henry Twachtman.[43] The MFA highlights Cassatt and uses an interesting exhibition device by including in the exhibition objects that are specifically related to two of her paintings in the gallery—the actual silver teapot and covered sugar bowl by the Philadelphia silversmith Phillip Garrett (1813) that are depicted in her painting *The Tea*, ca. 1880 (fig. 7.2), and objects related to *In the Loge*, 1878 (fig. 7.3)—a fan and a pair of binoculars from the second half of the nineteenth century, typical period accessories of women at the opera or theater in Paris.[44]

This inclusion of Cassatt in American wings occurred in recent years, when many of the major American museums rehung their nineteenth-century American

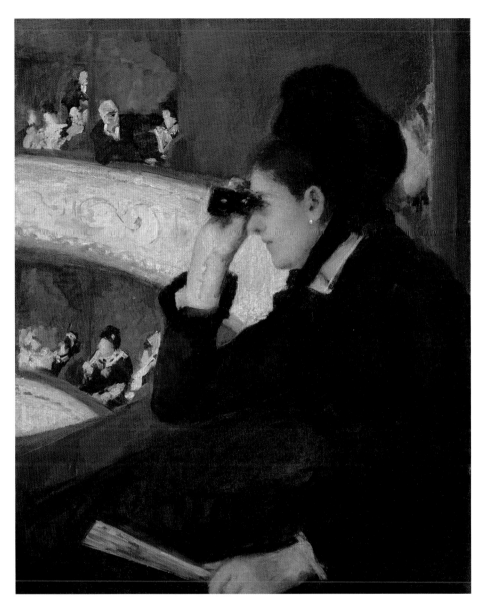

collections in light of new scholarship in the field of American art. Michael Leja's observation about the shifting boundaries of the American art field, once perceived as hermetic but now more difficult to pinpoint, is relevant to the display of American art in museums. Leja suggests: "In the decades to come, greater complexities will surely emerge," and he asks: "How viable is the national art of the United States as a field of

study when the art is thoroughly permeated by significant ties to the arts of other nations in Europe, the Americas and throughout the world?"[45]

The new scholarship on American art broke with the older agenda of some half a century ago that focused on identifying what was American about American art—and at that time, Cassatt was not included in this American context. The rehanging of American collections presents a story of American art that has been expanded to include Cassatt and other transatlantic artists, among them Whistler, Sargent, Chase, and others. Cassatt's current display in most American museums in the context of nineteenth-century American art is part of this new agenda that strives for more inclusivity in museums as well as a broader view that extends beyond the borders of the American nation. Nonetheless, in the case of Cassatt, this welcome change also creates certain problems insofar as it exhibits her art in the context of American Impressionism, which is a movement to which she did not belong, and removes her from the original French Impressionist movement, which Cassatt was the only American to join. American Impressionists, who first banded together to exhibit their art in New York in 1898, were inspired by the French Impressionists and in particular by Monet. Some of the American Impressionists lived in artists' colonies near Monet in Giverny, and some who had studied in Europe returned to the United States and became "repatriated Impressionists," most of them settling in the Northeast,[46] where they founded picturesque colonies.[47] Cassatt had no connection with the American Impressionists in artists' colonies in France or Europe, did not depict their kind of local scenes and American countryside, and did not participate in their group exhibitions.

Yet in what other ways might American museums display Cassatt's art, given their typical separation between American and European art? The Met, which, as I said, also displays Cassatt in its American Wing, offers one strategy, by including some of her paintings in a small gallery dedicated to "Images of Women, 1880–1910."[48] The focus of this gallery is on a particular subject matter, defined on the gallery wall label as "genteel women of leisure," a theme said to reflect a "notion that a woman's proper sphere was within a harmonious interior, absorbed in cultivating pastimes, or in a sheltered outdoor setting, engaged in leisure activities."[49] Yet this approach introduces a different problem, for by associating Cassatt exclusively with depictions of domesticity, the display strengthens a stereotype that has plagued her art for many decades and excludes a broader view of her work that includes the depiction of contemporary life and modernity in Paris. Other Cassatt works in the extensive collection owned by the Met, including oil paintings such as *The Oval Mirror*, ca. 1899 (fig. 7.4), are under glass in the visible storage setting of the Henry R. Luce Center for the Study of American Art. Recently, the Met added Cassatt's painting *The Cup of Tea*, 1880–81 (fig. 7.5), to a gallery devoted to "Renoir and His Contemporaries." This rubric acknowledges Cassatt's affiliation with the Paris Impressionists but does not fully acknowledge her true standing and role among the French Impressionists. The fact

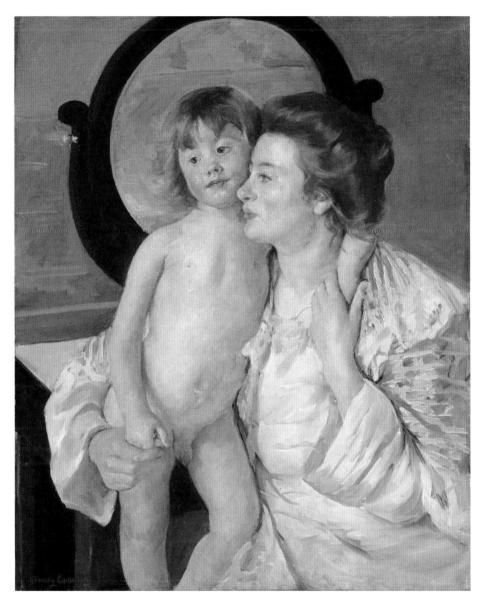

FIGURE 7.4

Mary Cassatt, *The Oval Mirror* (*Mother and Child*), ca. 1899. Oil on canvas, 32.1 × 25.9 in. (81.6 × 65.7 cm). The Metropolitan Museum of Art, New York. H.O. Havemeyer Collection. Bequest of Mrs. H.O. Havemeyer, 1929, 29.100.47. Image © The Metropolitan Museum of Art.

that her name is absent from the gallery label, which mentions Degas, Henri-Fantin-Latour, Morisot, and Alfred Sisley, is symptomatic of this problem.[50]

One occasion on which the Met did display several Cassatt artworks alongside her French avant-garde colleagues was the temporary exhibition of the Havemeyer collection in 1930, held soon after the bequest was made in 1929 and before it was dispersed

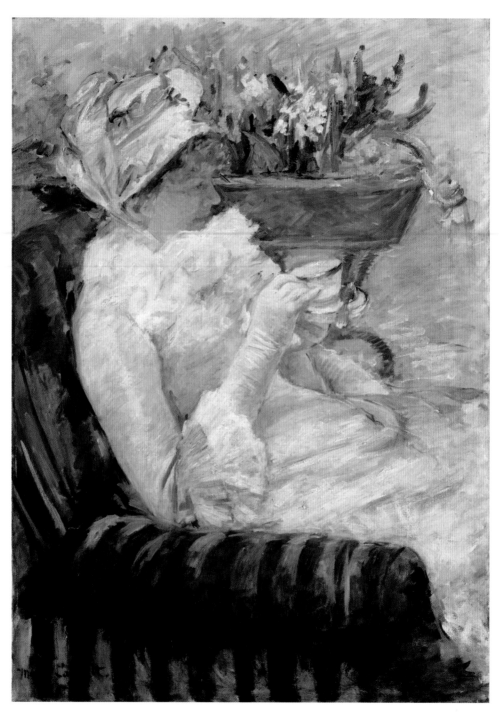

FIGURE 7.5

Mary Cassatt, *The Cup of Tea*, 1880–81. Oil on canvas, 36.37 × 25.74 in. (92.4 × 65.4 cm). The Metropolitan Museum of Art, New York. From the Collection of James Stillman. Gift of Dr. Ernest G. Stillman, 1922. 22.16.17. Image © The Metropolitan Museum of Art.

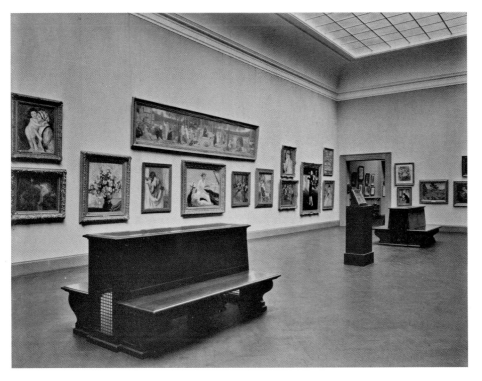

FIGURE 7.6

Installation photograph of the painting gallery, Metropolitan Museum of Art, Wing A, Gallery 20: "The H.O. Havemeyer Collection," March 11–November 2, 1930, image copyright © The Metropolitan Museum of Art. Image source: Art Resource, NY. (Cassatt's *Mother and Child* pastel of 1914 is visible at the top left, and Cassatt's painting *The Oval Mirror,* ca. 1899, is second from the right in the top row, alongside works by Degas, Manet, Renoir, and Puvis de Chavannes).

among the museum's diverse departments.[51] In an installation photograph of that exhibition (fig. 7.6), Cassatt's pastel *Mother and Child,* 1914 (fig. 7.7), is visible on the left (first painting in the upper row), and Cassatt's painting *The Oval Mirror,* ca. 1899 (fig. 7.4), is second from the right in the top row, alongside works by Degas, Manet, Renoir, and Puvis de Chavannes.

Cassatt had definite and strong views about the context in which she wanted her art to be displayed in American museums. When the Met wrote her that her painting *Lady at the Tea Table,* 1883–85 (fig. 5.10), was installed in the same gallery as Sargent, implying that this was a compliment to her, she wrote Havemeyer: "Did I write to you that the Metropolitan told me my portrait of Mrs. R[idle] was in the room with Sargent! They thought I ought to be very proud."[52] Cassatt did not think much of Sargent, as comments in her letters reveal.[53] She wanted her art to be shown with the French avant-garde artists she admired, convinced that to be exhibited next to them in the Havemeyer collection would assure the "survival" of her art. Even the implicit promise that her art would be in the collection of the Musée du Luxembourg in Paris and would

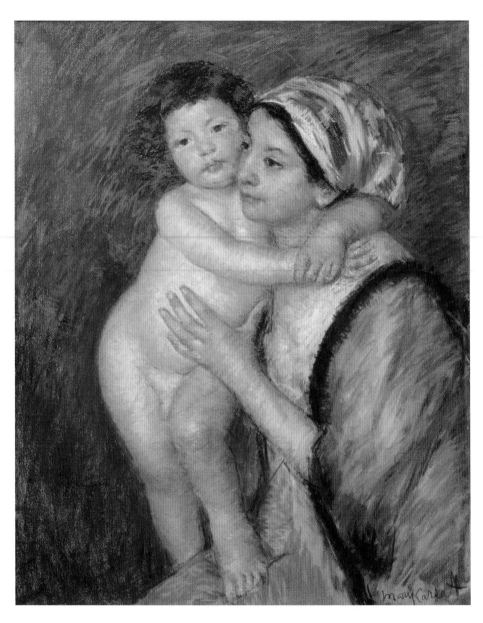

FIGURE 7.7

Mary Cassatt, *Mother and Child*, 1914. Pastel on wove paper mounted on canvas, 32 × 25.5 in. (81.3 × 65.1 cm). The Metropolitan Museum of Art, the H.O. Havemeyer Collection. Bequest of Mrs. H.O. Havemeyer, 1929 (29.100.49). Image copyright © The Metropolitan Museum of Art. Image source: Art Resource, NY.

enter the Louvre after her death was less important to her (as she wrote Havemeyer) than the knowledge that she would "survive in your gallery, *there* I would be surrounded with pictures that are sure to survive."[54]

The National Gallery of Art, in Washington, DC, and the Philadelphia Museum of Art, both of which have extensive collections of Cassatt's work, are two important

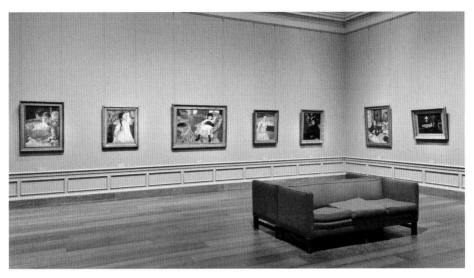

Installation photograph of Mary Cassatt's art in the National Gallery of Art, Washington, DC, showing *Little Girl in a Blue Armchair*, 1878, and to the left of it several more artworks by Cassatt; on the far right is a work by Edgar Degas. Photograph: Rob Shelley, 2015. Courtesy National Gallery of Art, Washington, DC.

exceptions to the preference of American museums to display Cassatt's work exclusively in the context of American art. The NGA is the only museum to house Cassatt's paintings exclusively in its European Art Department (on view on the main floor of the West Building), exhibiting them in the context of French Impressionism (fig. 7.8). It also displays most of the Cassatt oil paintings in its collection (nine out of twelve). Its collection includes Cassatt paintings from her Impressionist period (and three later works), and most of them do not depict the subject of mother and child. Thus, by the nature of its Cassatt collection, the NGA shapes Cassatt's legacy as a painter of contemporary life who is not limited by gender stereotypes to the rubric of a painter of mothers and children. (Many of the Cassatts in the NGA were in the bequest of Chester Dale, who acquired some of them from the 1930 Havemeyer sale.)

Finally, the Philadelphia Museum of Art's pioneering solution to the conundrum of how to exhibit Cassatt presents an innovative approach: the museum displays her in both the American and the French contexts. Two paintings from Cassatt's Impressionist period are shown alongside works by her French Impressionist colleagues, including Cézanne, Degas, Manet, Monet, Pissarro, and Renoir: *Woman in a Loge,* 1879 (fig. 2.10), is displayed next to a Degas painting, and her portrait of her brother Alexander and his son (fig. 5.21, discussed in chapter 5) is on view with paintings by Renoir (fig. 7.9). In another PMA gallery, an early Cassatt painting, *On the Balcony,* 1873, is displayed next to Manet's *Le Bon Bock,* 1873.[55]

In the PMA's American department, a single Cassatt painting is exhibited in each of two nineteenth-century American art galleries, one of which is dedicated to "American

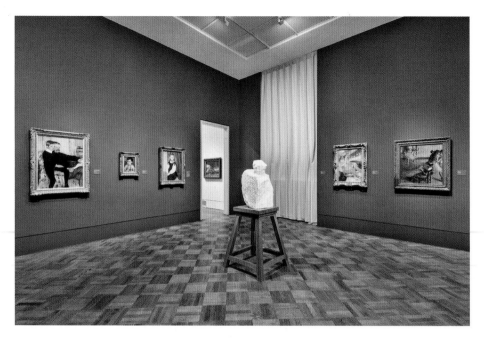

FIGURE 7.9

European Art Galleries installation photograph of Mary Cassatt, *Woman in a Loge,* 1879, and *Alexander J. Cassatt and His Son Robert Kelso Cassatt,* 1884. The Philadelphia Museum of Art, Philadelphia, PA. Photographer: Joseph Hu, 2020. Courtesy of the Philadelphia Museum of Art.

Artists on the World's Stage." Here, Cassatt's *Maternal Caress,* ca. 1896, is displayed amid numerous glass vases by Tiffany and others, a wooden desk, and paintings by Chase and by Frank Duveneck (who spent lengthy periods in Italy and Germany). In another nineteenth-century American art gallery, the PMA displays Cassatt's painting from her Impressionist period *Woman and a Girl Driving,* 1881 (fig. 7.10), in the midst of numerous paintings, several sculptures, and decorative objects by Americans.[56] The PMA's solution to Cassatt's transatlantic status is an interesting one, given the separation of European and American art in American museums. It avoids choosing between Cassatt's identities as French or American, and succeeds in reflecting her historical affiliation with the French Impressionists while still claiming her as an American artist.

For the most part, however, the priority that American museums give to the goal of establishing American art leads them to display Cassatt in American wings or departments. Even though historically Cassatt did not create her art in the American art context, from an American museum's point of view she fits into the category of American art created during the second half of the nineteenth century, a time when most American artists traveled to Europe, and especially Paris, to study and exhibit their work. These artists stayed in Europe for varying lengths of time, and a small number never returned to their homeland. Thus, American art curators see Cassatt as part of this "pattern of travel and exchange" that was crucial to the formation of American art

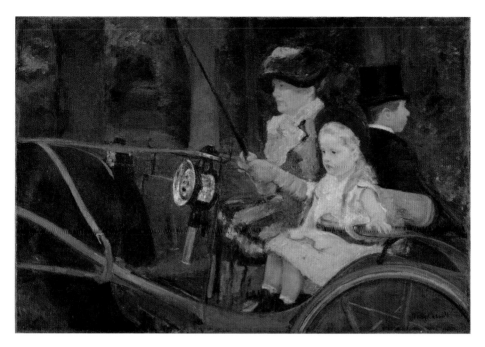

FIGURE 7.10

Mary Cassatt, *Woman and a Girl Driving*, 1881. Oil on canvas, 35.3 × 51.4 in. (89.7 × 130.5 cm). Philadelphia Museum of Art, Philadelphia, PA, purchased with the W.P. Wilstach Fund, 1921, W1921-1-1.

during the nineteenth century, and they include her in the "cosmopolitan spirit and ambition of American artists between 1865 and about 1900."[57] This downplays or even ignores a major part of Cassatt's legacy—namely, her active participation in the original Paris Impressionist exhibitions and milieu. Unlike the "expatriates," Sargent and Whistler, recognized for a cosmopolitan spirit, Cassatt made a full commitment to a French art group, kept loyal to its principles of independence, was committed to showing her art in the context of this group throughout her life, and indeed explicitly expressed the hope that her art would continue to be exhibited with this group of artists after her death.[58]

CASSATT'S ART IN FRENCH MUSEUMS: EXHIBITIONS AND PERMANENT COLLECTIONS, 1926–2022

After Cassatt's death, her paintings and pastels were only rarely seen in exhibitions in Paris, while her prints received a bit more attention. Unlike many of her French Impressionist colleagues, Cassatt did not receive a retrospective memorial exhibition in Paris. Such exhibitions were typically organized by friends and members of the artist's family; but Cassatt's family lived in the United States and was not involved in the Paris art world, and by the time of her death her closest friends among the French Impressionists, Degas and Pissarro, were also dead. Her longtime dealer,

the Durand-Ruel gallery, did not organize a Cassatt show in Paris, though as I mentioned earlier, it did mount one in New York, reflecting the fact that at the time, Cassatt collectors were mostly American. Before any museum in Paris celebrated Cassatt's work after her death, she was commemorated at an exhibition held in 1935 in the Bernheim-Jeune gallery, organized by the Société des femmes artistes modernes (FAM). This Paris-based group founded in 1930 organized annual exhibitions of the work of contemporary female artists in Paris representing different countries and artistic movements, and on several occasions paid special tribute to their predecessors.[59] Marie-Anne Camax-Zoegger, the founder of the organization, included three of Cassatt's works in the 1935 exhibition and lauded her as "one of our great predecessors, one of the women who paved the way for us."[60] It took nearly half a century after Cassatt's death for the artist to receive French institutional recognition. In 1973–74, the Louvre's Department of Graphic Arts mounted an exhibition titled *Hommage à Mary Cassatt*,[61] and in 1988 the Musée d'Orsay collaborated with the Prints Department of the Bibliothèque nationale de France in organizing a Cassatt exhibition at the Orsay that featured fifty-one prints and three pastels.[62] Cassatt also received a more local homage in 1965, after her niece, Ellen Mary Cassatt-Hare, donated Cassatt's Château de Beaufresne, which Ellen Mary had inherited, to the Moulin Vert Association for the purpose of housing homeless children. The exhibition *Hommage à Mary Cassatt* was held at the château and at the nearby Musée Departmental de l'Oise in Beauvais.[63]

Most of the few posthumous Cassatt exhibitions in France were initiated with American support. In 1959–60, the American Cultural Center in Paris held the exhibition *Mary Cassatt, peintre et graveur: 1844–1926*, which featured mostly prints and was accompanied by a catalogue.[64] In 1996 and 2005, the Terra Foundation of American Art organized two Cassatt exhibitions, at its Musée d'Art Américain Giverny.[65] The most extensive posthumous exhibition of Cassatt's work in Paris, *Mary Cassatt, Une Impressionniste Américaine à Paris* (Mary Cassatt: An American Impressionist in Paris), was held at the Musée Jacquemart-André in 2018, and included many paintings, pastels, and prints.[66] Initiated by the American Cassatt scholar Nancy Mowll Mathews, who served as co-curator with the museum's curator, Pierre Curie, it was the kind of retrospective exhibition that Cassatt never had in Paris, featuring numerous loans. It took nearly a century after Cassatt's death and the initiative of an American feminist art historian for this scale of a show of her work to be realized.

The Cassatt exhibition at the Musée Jacquemart-André was a truly rare opportunity to see many of her paintings and pastels along with her prints in Paris. Nonetheless, this type of exhibition, as I noted earlier, is necessarily ephemeral, whereas artists' legacies are to a large extent shaped by the presence of their work in the permanent displays of museums' collections. It is thus significant that only a single painting by Cassatt is regularly on view in the Orsay's legendary Impressionist galleries: her *Young Woman Sewing in the Garden*, 1886, is displayed in the gallery that features the Antonin Personnaz collection,[67] alongside almost forty Impressionist artworks, including

FIGURE 7.11

A temporary installation of Cassatt's pastels next to Degas's sculptures, Gallery 7, August 2019, in the Impression-ist Art galleries at the Musée d'Orsay, Paris. Photograph by Sophie Crépy © Musée d'Orsay. Dist. RMN-Grand Palais-© Sophie Crépy. Image source: Art Resource, NY.

fourteen by Pissarro, nine by Monet, eight by Renoir, and two each by Manet, Sisley, and Morisot.[68] This gallery is part of a series of galleries on the upper floor of the Orsay that house the most extensive Impressionist collection in France. Cassatt's inclusion is crucial in establishing her as part of the French Impressionists, but the fact that she is represented by only one painting positions her as somewhat marginal to the move-ment. Nevertheless, her status as the only American represented in this French con-text acknowledges her place in the French Impressionist movement.

On one exceptional occasion, in 2019, the Orsay temporarily displayed some of its Cassatt pastels (which cannot be shown permanently because of the fragility of this medium) next to Degas's sculptures in one of its Impressionist galleries that normally features only Degas's sculptures (fig. 7.11).[69] This display, curated by Leila Jarbouai, curator of pastels and works on paper, coincided with the Orsay's retrospective exhibi-tion of Berthe Morisot, when the museum highlighted works by women artists from its permanent collection (much of which is usually in storage) throughout the museum. This display strengthened the French recognition of Cassatt's participation in the avant-garde, and in particular her affiliation with Degas.

Like the Orsay, the Petit Palais, Musée des Beaux-Arts de la ville de Paris (the Museum of Fine Arts of the City of Paris) shows Cassatt in its display of the perma-nent collection, alongside her Impressionist colleagues, including Cézanne, Monet, Marie Bracquemond, Sisley, and Pissarro. It displays Cassatt's large oil painting *Le*

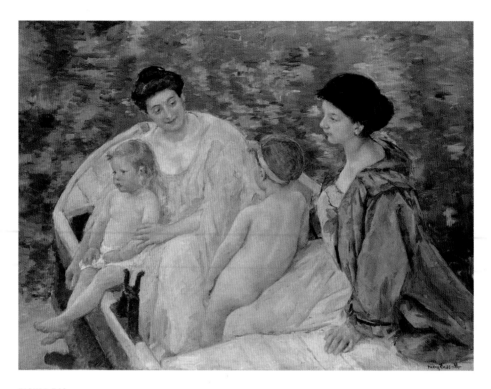

FIGURE 7.12

Mary Cassatt, *Le Bain* (*Two Mothers and Their Nude Children in a Boat*), 1910. Oil on canvas, 38.9 × 50.8 in. (98.8 × 129 cm). The Petit Palais, Musée des Beaux-arts de la Ville de Paris, PPP742.

Bain (*Two Mothers and Their Nude Children in a Boat*), 1910 (fig. 7.12), which represents a typical Impressionist theme of figures on a boat, but Cassatt created it long after her Impressionist period (it was gifted by the son of the American collector and Cassatt's friend James Stillman, in 1923). Cassatt's recognition in France is reflected by the fact that (with the exception of Stillman's gift and her own gifts mentioned earlier) the rest of the Petit Palais's extensive collection of her paintings, pastels, prints, and a decorated vase were gifted by French collectors (the vase was in Vollard's bequest). Cassatt is the only American and one of the very few women to be represented in the Impressionist galleries, attesting to the French recognition that she was part of the Impressionists. As in the Orsay, here, too, only one Cassatt artwork is represented, again positioning her as somewhat marginal in the group. Yet considering that she was a woman, and to the French also a foreigner, Cassatt's representation in the French Impressionist context, however minimal, attests to her artistic status and confirms her place as a member of the French avant-garde.

The differing narratives of most American and French museums reflect these museums' vested interests in their respective national affiliations. Yet these narratives are also enabled by the complexities of Cassatt's own multiple identifications, nationally

and artistically, which were entangled with the transatlantic world in which she lived and, these days, with our globalizing world. Cassatt's representation in museums, both in special exhibitions and in permanent collections, on both sides of the Atlantic, has contributed greatly to her legacy. But this legacy has been impacted throughout the years by the museums' classification systems, which are still based largely on national affiliation and therefore pose a problem for careers that span more than one nation, such as Cassatt's. The lingering gender bias also impacted negatively on Cassatt's legacy, even though she has received far greater museum and scholarly attention than many women artists around the world. As we will see in the following section, Cassatt's own understanding of museums and the deliberate actions she took to assure the afterlife of her art contributed significantly to her legacy.

CASSATT'S EFFORTS TO SHAPE HER LEGACY IN MUSEUMS

Cassatt well understood that it was important for her artworks to enter the collections of major museums in both France and the United States, and she did what she could to achieve this. In 1893, already widely recognized in Paris but not yet in the United States, Cassatt wrote: "I can hardly imagine, though, that the Metropolitan Museum will propose to buy one of the pictures as the Musée du Luxembourg has just made me the compliment of doing."[70] Cassatt aspired for her work to enter the Musée du Luxembourg, which acquired artworks for the French state's collection, with the intention that the best artworks would eventually enter the Louvre. And having her art in the Louvre, she felt in 1894, would bestow "immortality."[71] Yet years later, in 1910, she was more skeptical about the Luxembourg when the museum wanted to buy one of her works at a very low price, "promising it a prominent place, & the Louvre after my death! How do they know? Do they think all the pictures in the Luxembourg will go to the Louvre, everyone now promises me that I will survive."[72]

Initially, in 1892, Cassatt refused to gift one of her works to the Musée du Luxembourg,[73] but she changed her mind a few years later. In 1897 she gave the museum a pastel of a mother and child (later it was transferred to the Louvre, and today, along with other Impressionist works, it is in the Musée d'Orsay). This was likely prompted by her wish that her work be represented alongside her French colleagues, whose work entered the Luxembourg in 1896 when the museum accepted a good portion of Gustave Caillebotte's bequest of Impressionist paintings.[74] During the last years of her life, Cassatt was thinking more about her legacy, and by then favored giving some of her artworks to other major museums. In the early 1920s, just a few years before her death, she gave a painting (*Autumn, Portrait of Lydia Cassatt*, 1880) as well as nineteen prints to the Petit Palais, which now houses the collection of the City of Paris.[75] And in 1923, at Havemeyer's urging, Cassatt gifted her major painting *Lady at the Tea Table*, 1883–85, to the Metropolitan Museum of Art (fig. 5.10).

Cassatt's position as an advisor to important American collectors, many of whom also collected her art, was an important factor in her legacy. Modest about her own

work, Cassatt never pushed collectors to acquire it, in contrast to her persistent promotion of Degas. Scholars have established that Cassatt's principal motivation in advising American collectors was a patriotic conviction of the young nation's need for good art collections.[76] Ample evidence of this motivation is found in her letters, including her correspondence with Havemeyer. But in less direct ways, Cassatt's advising contributed to her legacy. Her close connections with leading American collectors presented many opportunities for them to see her work, when they visited her in France, and to acquire it from Durand-Ruel. Her intellect, passion for art, and great knowledge impressed them and likely affected their appreciation of her art, encouraging them to collect it. Cassatt's close friend Stillman, whom she also advised on collecting and who admired her intellect greatly, acquired twenty-four of her works, the largest Cassatt collection by a private collector. Stillman's son, Ernest, offered nineteen of them to the Met in 1922, out of which the museum selected nine for its collection, and displayed them for one month. Bryson Burroughs described the nine works as a "remarkable varied group" that allows visitors "to have a more or less comprehensive view of the talents of this gifted artist who has been up to now more adequately appreciated in France than in her native country."[77] (The Met later deaccessioned two of the nine works.)[78] It distributed the remaining ten Cassatt artworks among American museums that did not own works by her, among them museums in Cleveland, Detroit, Minneapolis, St. Louis, and Worcester.)[79] As Cassatt foresaw, many acquisitions by the collectors she advised were later gifted to American museums.

Toward the end of her life, Cassatt became particularly concerned about the fate of her artworks, since she did not believe that anyone in her family would take it upon themselves to handle them. She reasoned that to assure their preservation, her works should be in the hands of collectors, and thus sold them to her dealers. In 1906 she reported to Havemeyer: "Vollard looked over all my ancient things . . . I burnt all that was left to save my heirs the trouble."[80] In 1920, six years before her death, Cassatt sold her remaining works to Durand-Ruel, including "all my drypoints & a lot of pastel drawings . . . in all there were about 95 or 100 things."[81] She did this "because I know that at least they will be preserved."[82] Quite pessimistic about her family's interest in her art, she repeatedly expressed her belief that no one in her family valued her art, understood it, or cared about it, nor would they know what to do with it.[83] At some point, she even believed that some of her nieces and nephews "secretly resent my reputation for which I care so little."[84] She was struck, therefore, when two of the children of her brother Alexander and his wife, Lois, visited her and "to my surprise I found that they were very much interested in the pictures they inherited, especially mine." But she was probably right in thinking that the children of both of her brothers cared only about her portraits of the family, and not necessarily about her other works.[85]

The fact that no close family member took charge of Cassatt's estate after her death, to look after the artist's best interests, had an unfavorable consequence that Cassatt did not foresee. Although Cassatt's 1911 will did not leave her remaining art

works to Mathilde Valet, her trusted housekeeper who nursed Cassatt until the end of her life (the will gave Valet a monthly sum for life),[86] after Cassatt's death Valet prioritized her own financial gain over Cassatt's legacy. She organized two anonymous sales of Cassatt's works (1927 and 1931), in which the works appeared under the name of "Mademoiselle X."[87] Mathews rightly observes that these sales exposed "a large number of minor and unfinished works to the public."[88] It seems that at least some of the pastels, oil sketches, and prints in these sales were ones that Cassatt intended to discard.[89] Although the works in the sales were uneven, the Durand-Ruel gallery acquired some of them over the next decades, and some of them eventually entered museum collections through collectors' gifts.[90]

As we have seen, then, Cassatt was active in various ways to ensure that her work would be represented in major museums on both sides of the Atlantic. Highly conscious of the importance of museums in shaping an artist's legacy, she gifted some of her works to the major museums in Paris, the Luxembourg (today in the Orsay) and the Petit Palais, and in New York to the Met. And she correctly anticipated that some of the American collectors she advised would gift her work to American museums. As we will see in the next section, Cassatt's immense work in advising American collectors had another far-reaching impact that informs her legacy.

CASSATT'S LEGACY IN COLLECTING FOR AMERICAN MUSEUMS

Cassatt's extensive work as an advisor, mentor, and collaborator of American collectors had an important impact on the formation of the collections of several major American museums. Even though her extensive work with American collectors has been well established by scholars, the historically significant outcome of this work for American museums has yet to be fully recognized. Acknowledging this impact in no way diminishes Cassatt's stature as an artist but rather contributes to a fuller understanding of another important aspect of her legacy. In recent years, the art collecting of various artists has drawn the interest of scholars, curators, and museums. Degas's collecting, for example, was the subject of a major exhibition at the Met, and the accompanying scholarly catalogue emphasized the importance of his private art collection, even though it was dispersed after his death.[91] The cases of Degas's collecting and Cassatt's collecting-related activities are, of course, different.[92] Yet Cassatt's activities in this area have had a long-lasting impact that continues to enrich the collections of American museums and may thus be a worthy topic for a major exhibition.

Cassatt's choice to work with American collectors to bring art across the Atlantic was part of a lifelong and deliberate dedication to her vision of the development of American art and museums. Initially, this dedication grew out of her own personal experience as an art student in Philadelphia in the early 1860s, which made her keenly aware of the lack of American museums of art. This lack obliged her and other American artists to go to Europe to continue their studies. It was only in the 1870s, after

Cassatt left the United States, that major American museums were founded, including the Metropolitan Museum of Art in New York, the Boston Museum of Fine Arts, and the Art Institute of Chicago. In the following decades, American museums began to form their collections, primarily relying on gifts, and this process coincided with Cassatt's efforts to enrich their collections.

Cassatt recognized that "[a]ll the great public collections were founded by private individuals."[93] Her exposure to the riches of museums in France, Italy, Spain, and Holland fueled her determination to cultivate American collectors. Her immediate goal was to bring innovative contemporary French art, as well as some European old master paintings, to her homeland. But her ultimate goal was that the art she helped private collectors acquire would reach American museums. In keeping with this goal, she had no interest in advising collectors who were not going to ship their art to the United States, regarding it as a waste of her time. In one instance, she wrote to Havemeyer about their mutual friend Stillman: "[I]f his pictures go to America then I am doing the right thing but if he keeps them over here [in Paris] I don't see why I am bothering[,] better leave the Titian to Mr. Frick."[94] As this example shows, in matters of collecting art, Cassatt's national loyalty took precedence over personal friendship (her close friendship with Stillman is discussed in chapter 1). As I discussed earlier, much of Stillman's collection did eventually reach American museums.

Most telling was Cassatt's choice when her two major lifelong loyalties collided: her artistic identity as an Impressionist versus her identity as an American patriot dedicated to building the collections of American museums. When Claude Monet organized a subscription in order to keep Manet's *Olympia*, 1863, in France with the idea that it would enter the Louvre, Cassatt refused to close ranks with her Impressionist colleagues, writing to Camille Pissarro the she "declined to contribute" to the subscription.[95] The reason was that "an American had wished to buy the picture & it was to prevent its leaving France that the subscription was opened. I wish it had gone to America."[96] In matters of collecting, then, her ultimate loyalty was clearly to her homeland. Cassatt had no interest in securing Manet's glory in France but wanted such masterpieces to go to the United States.[97] In sharp contrast, the American expatriate painter Sargent contributed a large sum to this campaign, and was indeed the one who initially proposed it.[98] On another occasion, it was Cassatt's intervention that brought Manet's painting *The Execution of Maximillian*, 1867, to the MFA Boston. In 1909 Cassatt took the Bostonian Frank Gair Macomber to the gallery of her friend Dikran Kelekian, where Macomber saw Manet's monumental painting.[99] Cassatt praised the work before Macomber, and he acquired it with the idea of exhibiting it at the MFA; he later bequeathed it to the museum.[100] With her characteristic modesty, Cassatt wrote to Macomber: "It has been one of the chief pleasures of my life to help fine things across the Atlantic."[101]

For Cassatt, not only collecting and shipping European art to the United States but even lending it to a show there was a patriotic duty. In 1915 she wrote to the collector

Colonel Oliver Payne in New York (a close friend of the Havemeyers): "I come to appeal to you as a patriotic American to lend your Degas to the exhibition Mrs[.] Havemeyer is arranging. The sight of the picture may be a turning point in the life of some young American painter"—as it had been for herself.[102] Referring to the fact that the exhibition was dedicated to the cause of suffrage, to which Payne objected, she urged: "Never mind the object of the exhibition. Think only of the young painters. As to the suffrage for women it must come as a result of this awful war."[103]

Cassatt usually preferred to see any masterpiece available on the market go to an American museum rather than a private collection. She bluntly expressed her impatience to see art that was held in American private collections reach museums, writing in 1909, for example: "Fine pictures are going over fast and little will be left in private collections on this side, I wish more of the pictures were for the Public."[104] In addition to working with American collectors, Cassatt also attempted to influence American museum curators, directors, and trustees to acquire masterpieces when they became available. A prominent example was the case of El Greco's *The Assumption*. Cassatt attempted to interest the Met in it, and when this failed, she corresponded about the work with the director of the Art Institute of Chicago. He responded that he would be coming to Paris, and presumably they met during his visit to discuss it.[105] The Art Institute eventually acquired the painting, making it the second El Greco to enter an American art museum.[106] Yet despite her persistent efforts, it is uncommon to find a full acknowledgment of Cassatt's decisive role in this acquisition. A rare example is this comment by Sweet, Cassatt's biographer: "Mary Cassatt deserves full credit for this since it was she who discovered the painting in Spain in 1901 and she who wrote to museum directors until she was able to arouse the favorable reaction which occurred in Chicago."[107] Cassatt herself did not particularly seek public recognition for her work in collecting, although she was offended when the role she and the Havemeyers played in bringing El Greco's masterpiece to the United States was credited solely to Durand-Ruel.[108] Thinking strategically about building her influence with American museums, Cassatt, who typically refused prizes—due to her objection to the government prize system and her commitment to artistic freedom—agreed to receive the title of Chevalier de la Légion d'Honneur (Knight of the Legion of Honor), France's highest civilian award, because, as she wrote, "Perhaps it will help me to a little influence with Museum Directors at home, to get them to acquire genuine old Masters and *educational* ones."[109]

Thanks to Cassatt's interventions and ongoing work with leading American museums, numerous important works of modern art and some paintings by old masters entered major American museums, beyond the many artworks from the Havemeyer collection that were given to the Met.[110] It would not be an overstatement to say that the location of many important masterpieces in American museums, including a superb representation of French Impressionist artists, is due significantly to Cassatt's dedicated work with American collectors over several decades. Laura D. Corey

estimates that Cassatt "had a hand in exporting thousands of old master and French impressionist works to the United States."[111]

Cassatt's consistent efforts to transfer French art to the United States were diametrically opposed to the typical deep concern of French intellectuals, artists, critics, and other players in the French art world to keep French art in France. Edmond de Goncourt, for example, dreaded that Americans "will buy up everything."[112] Although Cassatt lived most of her adult life in France, she never identified with the French pride in their patrimony. On the contrary, acting on her deep sense of belonging to the American nation, she was committed to transferring important artworks to the United States. Yet she kept another deep identification—namely, that as an artist, she was one of the French Independents (the name that she and the other artists known as the Impressionists preferred). She was inspired by their freedom of style and refusal to succumb to academic constraints, shared their commitment to artistic independence, and once she joined their exhibitions, was loyal to the group by refusing to exhibit in the Salon. This was at the heart of the complexity of Cassatt's transatlantic condition, in which artistic belonging to France and national belonging to the United States coexisted.

Cassatt's work with collectors was part of her comprehensive vision for American art and culture. She believed, as did Havemeyer, that art was important to "a nation's life,"[113] that for "a nation to progress [it] *must* have an art."[114] But possessing great art in its museums and exposing the public to it were not sufficient in Cassatt's vision for the United States; these were part of a broader goal—namely, that American artists would study art in their homeland and produce an original art that would become a national American school. Although close to the end of her life, in the early 1920s, Cassatt continued to believe that an original American school of art did not yet exist, she predicted that, in the future, "the next great art would come from America."[115]

In 1878, when Paris was still the undisputed global art center, Cassatt thought of it as a model for what she aspired for New York to become. Just four years after she settled in Paris, Cassatt wrote to the American artist J. Alden Weir (who later became an American Impressionist): "I always have a hope that at some future time I shall see New York [as] the artist's ground. I think you will create an American School."[116] Her interest in the development of an original American school of painting was shared by many American artists, including those affiliated with the American Art Association of Paris, which "encouraged a separation from the Parisian milieu in favor of the nativist project."[117] One of the members of the association stated in 1892, "We are endeavoring to found a national school of art," explaining that the association wanted young Americans to develop their art in keeping with American ideas.[118] Cassatt, who during those years kept her distance from the American colony in Paris, differed from these American artists in believing that a national American school could be developed only by artists who were working in their homeland but who were familiar with modern art in Paris, available for them to see in museums in their own nation.

Living in Paris, Cassatt never saw herself as an artist who would contribute to this effort of creating a national American school through her own art. Rather, she chose another path to contribute to the development of an American art. As Segard noted, she believed it was necessary for American museums to have good art collections "for the formation of a progressive American painting."[119] In retrospect, Cassatt's vision for American museums and American art was realized, and she made her contribution to its fulfillment.

As Forbes Watson, who understood Cassatt so well, stated:

> Probably no other American painter has been the guide and arbiter of so many collections. As I have often said before, if Miss Cassatt had never painted she would nevertheless have won a permanent place in the history of art through the number of masterpieces that she was directly instrumental in bringing to American collections.[120]

Watson's full recognition of Cassatt's legacy in collecting was quite rare. Certainly, other close friends or associates also credited her for her work with Americans on collecting. Havemeyer repeatedly credited Cassatt for this in her memoir.[121] Vollard, the dealer, and her French biographer, Segard, acknowledged her contribution to the formation of private American collections during her lifetime. Erica E. Hirshler pioneered the study of Cassatt's extensive work with American collectors, and Corey's more recent research further explores it in depth.[122]

The acknowledgment of Cassatt's legacy in building collections for American museums is mostly limited to the realm of Cassatt scholarship. With rare exceptions, in the rest of art history and in the realm of museum exhibitions and catalogues, her role in advising American collectors and specifically her contribution to Durand-Ruel's success is conspicuously missing.[123] A 2014–15 Durand-Ruel exhibition (and catalogue) held in major museums in Philadelphia, Paris, and London is a recent example.[124] In Philadelphia, the show was titled *Discovering the Impressionists: Paul Durand-Ruel and the New Painting,* while in London, the National Gallery's title credited Durand-Ruel with "inventing" Impressionism.[125] Griselda Pollock's vigorous critique of the London exhibition asserted that it aggrandized Durand-Ruel as the "founding father" of Impressionism while Cassatt and the other women who participated in the Impressionist exhibitions were made to disappear.[126] The exhibition, which included only a single painting by Cassatt, did not acknowledge her considerable role in Durand-Ruel's success in bringing Impressionism to the United States. In 1886, when Durand-Ruel organized his first exhibition of the French Impressionists in New York, Cassatt introduced the dealer to key American collectors, among them her brother Alexander, who was extremely well-connected to elite Americans.[127] Most importantly, Cassatt was the one who brought Louisine and Henry Havemeyer to Durand-Ruel's gallery, and it was on her advice that they acquired more paintings from Durand-Ruel than any other client.[128] This was crucial to the survival of Durand-Ruel's business, and to his

eventual thriving. Cassatt's contemporaries knew this, yet it is rarely acknowledged in art history outside of scholarship on Cassatt.[129]

––––––

Cassatt's wide representation in museums on both sides of the Atlantic is crucial to her legacy as one of the most significant women artists of the nineteenth century. Analyzing how her art is exhibited in American and French museums has revealed two different narratives of Cassatt's legacy based on the respective national identifications of France and the United States, as well as on Cassatt's own transatlantic status and multiple identifications. Exhibiting Cassatt's art in their American wings or departments, American museums have given Cassatt a prominent place in American art of the nineteenth century in their broadening narrative on American art. But in the process, most of them have also marginalized her participation in the Impressionist movement in Paris, despite its uniqueness—she was the only American to have done so. In some cases, her Americanization has also given the erroneous impression that Cassatt was part of the later American Impressionist movement. French museums, on the other hand, display Cassatt in the company of the French Impressionists, but by limiting her representation to a single artwork, they have marginalized her place among them.

Cassatt's own actions in her lifetime contributed significantly to the shaping of her legacy, especially her efforts to ensure that her artworks were owned by major museums in both Paris and New York. Her own astute understanding of the role of the art museum in the modern era of the art market, her gifting of her works to major museums on both sides of the Atlantic, and her cultivation of a wide transatlantic network that included leading American collectors who also collected her art all played a crucial role in the making of her transatlantic legacy. Nonetheless, tracing Cassatt's representation in permanent museum collections, the memorial exhibitions held soon after her death, and the major museum exhibitions of her art thereafter has shown that even in the case of an extremely successful woman artist, museums' androcentric tradition and lingering gender bias have also impacted the limits of her legacy. As Cassatt's friend the American critic Forbes Watson recognized back in 1932, Cassatt's art would "not be fully appreciated until all our prejudices against the woman artist have finally vanished."[130]

Cassatt's extensive work in advising American collectors and its extraordinary outcome in the exemplary Havemeyer collection at the Met forms another key aspect of her legacy—which has yet to be acknowledged in a major museum exhibition. The upcoming centennial of Cassatt's death, in 2026, spurs the imagination to consider what it would be like if a museum took that opportunity to reconfigure her legacy so as to include both her artistic achievement and her unique accomplishment as an advisor who collaborated on the Havemeyer collection, of which the Met has been the primary beneficiary. The Met's 1997 exhibition *The Private Collection of Edgar Degas* is

an important precedent for curating an exhibition centered around an artist's collecting activity.[131] At the time of writing, the Met is planning an exhibition, curated by Laura D. Corey, that will take place after the centennial and focus on Cassatt's role as an advisor to American collectors; and the Musée d'Orsay is planning a retrospective of Cassatt's art that will travel to the MFA Boston and to London's National Portrait Gallery. In addition, the NGA, in Washington, DC, is planning an exhibition featuring the numerous Cassatt artworks in their collection. Thus, Cassatt will be featured in major exhibitions on both sides of the Atlantic.

Despite Cassatt's strong artistic identification with the French Impressionists, she consistently identified herself as American. The first identity was about her art making, the second about her art collecting, which ultimately aimed to allow American artists to stay in the United States and develop a national art school. In 1926 a French obituary of Cassatt stated: "We lost a great artist . . . Mary Cassatt belonged to America by her birth, but she belonged to France by her talent and the formation of her esprit."[132] A century later, Cassatt has been reconfigured by both French and American museums. Her display in French museums does not quite live up to Clemenceau's pronouncement of her in the early twentieth century as one of France's glories, while most American museums treat Cassatt as one of America's glories. In the ongoing process of posterity, perhaps museums on both sides of the Atlantic may yet find new ways to exhibit Cassatt and her multiple legacies so as to better reflect the complexities of her identity in the transatlantic world: on the one hand, her strong sense of belonging to the American nation and her dedication, stemming from her cultural nationalism, to advising American collectors; and on the other hand, her identity as an artist who made her art in the French Impressionist context and insisted on her artistic belonging to this movement.

ABBREVIATIONS

LIBRARIES, MUSEUMS, AND ARCHIVES

AAA Archives of American Art
AIC Art Institute of Chicago
GRI Getty Research Institute
HSMA Hill-Stead Museum Archives
HV LOC ProQuest History Vault, National Woman's Party Records;
 originals in the Manuscript Division of the Library of
 Congress
INHA Institut national d'histoire de l'art
LOC Library of Congress
MET Metropolitan Museum of Art
MFA The Boston Museum of Fine Arts
MMAA Metropolitan Museum of Art Archives
NAWSA National American Woman Suffrage Association
NGA National Gallery of Art
NWP National Woman's Party
PMA Philadelphia Museum of Art
SMA Shelburne Museum Archives
WSPU Women's Social and Political Union

CORRESPONDENTS

BP	Bertha Palmer
CST	Carroll S. Tyson
HOH	Henry O. Havemeyer
HW	Harris Whittemore
JD-R	Joseph Durand-Ruel
JS	James Stillman
LH	Louisine Havemeyer
MC	Mary Cassatt
PD-R	Paul Durand-Ruel
STH	Sara T. Hallowell
TP	Theodate Pope

NOTES

INTRODUCTION

Epigraph: Mary Cassatt [hereafter MC] to Emily Sartain, June 7, [1871], in *Mary Cassatt and Her Circle: Selected Letters,* ed. Nancy Mowll Mathews (New York: Abbeville Press, 1984), 72–74.

1. See Burns's insightful article on the role that American Impressionism played in the process of the United States' search for its national school: "'Nothing but Daubs': The Translation of Impressionism in the United States," in *Globalizing Impressionism: Reception, Translation, and Transnationalism,* ed. Alexis Clark and Frances Fowle (New Haven, CT: Yale University Press, 2020).

2. She was one of fifteen artists in the fourth Impressionist exhibition, in 1879. On the Impressionist exhibitions, see Charles S. Moffett, ed., *The New Painting: Impressionism 1874–1886* (San Francisco: Fine Arts Museums of San Francisco, 1986).

3. Robert Cassatt to Alexander Cassatt (his son), May 21, 1879, in Mathews, *Mary Cassatt and Her Circle,* 144.

4. Emily Sartain to John Sartain, June 17, 1874, in Mathews, *Mary Cassatt and Her Circle,* 124–26.

5. Mathews, "The Color Prints in the Context of Mary Cassatt's Art," in *Mary Cassatt: The Color Prints,* ed. Nancy Mowll Mathews and Barbara Stern Shapiro (New York: Abrams, with Williams College Museum of Art, 1989), 19–55, at 43.

6. See the description of the fourth state of the print, *The Letter,* 1890–91, in Mathews and Shapiro, *Mary Cassatt: The Color Prints,* 124. Cassatt also hints at the Japanese iconography in prints that show a woman holding a letter, piece of cloth, or hanging scroll in her mouth—for example, Kitagawa Utamaro, *Portrait of the Oiran Hinzauru,* ca. 1796, Art Institute of Chicago; and Chōbunsai Eishi, *Courtesan with a Letter in Her Mouth,* 1756–1815, Metropolitan Museum of Art.

7. Cassatt's letters to Louisine Havemeyer (and a few letters addressed to Harry O. Havemeyer and other Havemeyer family members) are housed at the Metropolitan Museum of Art Archives (hereafter MMAA). They include over 250 letters, 19 of which are published in Mathews, *Mary Cassatt and Her Circle.*

8. Louisine W. Havemeyer, *Sixteen to Sixty: Memoirs of a Collector,* ed. Susan Alison Stein (New York: Ursus Press, 1993). An earlier version published in 1961 did not include the chapter on Cassatt.

9. Hollis Clayson includes Cassatt in an essay with a broader focus, "Voluntary Exile and Cosmopolitanism in the Transatlantic Art Community, 1870–1914," in *American Artists in Munich: Artistic Migration and Cultural Exchange Processes,* ed. Christian Fuhrmeister, Hubertus Kohle, and Veerle Thielemans (Munich: Deutscher Kunstverlag, 2009), 15–26, at 20. Kevin Sharp addresses the turn in Cassatt's career from her success in France to recognition in the United States: "How Mary Cassatt Became an American Artist," in *Mary Cassatt: Modern Woman,* ed. Judith A. Barter (Chicago: Art Institute of Chicago; New York: Abrams, 1998), 145–75. See also Clayson's linking of Cassatt's identity as an outsider in France to French xenophobia, to her gender, and to printmaking: Clayson, "Cassatt's Alterity," in *Companion to Impressionism,* ed. André Dombrowski (New York: Wiley, 2021), 253–70; and Michel Melot, "Mary Cassatt, An Artist between Two Worlds," in *Mary Cassatt, Impressions,* trans. M. Taylor (Giverny: Terra Foundation of American Art; Paris: Le Passage, 2005), 84–93.

10. Sharp, "How Mary Cassatt Became an American Artist."

11. On the tensions between Cassatt and Durand-Ruel, see Sharp, "How Mary Cassatt Became an American Artist"; on Durand-Ruel and his practices, see Sylvie Patry, "Are Museum Curators 'Very Special Clients'? Impressionism, the Art Market, and Museums (Paul Durand-Ruel and the Musée du Luxembourg at the Turn of the Twentieth Century)," in Dombrowski, *Companion to Impressionism,* 566–82; Sylvie Patry, ed., *Discovering the Impressionists: Paul Durand-Ruel and the New Painting* (London: National Gallery of Art, 2015); and Paul Durand-Ruel, *Memoirs of the First Impressionist Art Dealer (1831–1922)* (Paris: Flammarion, 2014).

12. Patricia Mainardi, *The End of the Salon: Art and the State in the Early Third Republic* (Cambridge: Cambridge University Press, 1993).

13. Harrison C. White and Cynthia A. White, *Canvases and Careers: Institutional Change in the French Painting World* (New York: Wiley, 1965); and Robert Jensen, *Marketing Modernism in Fin-de-Siècle Europe* (Princeton, NJ: Princeton University Press, 1997). On the New York art market, see Leanne M. Zalewski, *The New York Market for French Art in the Gilded Age, 1867–1893* (New York: Bloomsbury, 2022).

14. For a discussion of this caricature, see John Ott, "Patrons, Collectors, and Markets," in *A Companion to American Art,* ed. John Davis, Jennifer A. Greenhill, and Jason D. LaFountain (New York: Wiley, 2015), 525–43.

15. On Keppler's collection, see Elizabeth Hutchinson, *The Indian Craze: Primitivism, Modernism, and Transculturation in American Art, 1890–1915* (Durham, NC: Duke University Press, 2009), 11–14, 20–22, 27–28. The collection became part of the Heye Foundation's Museum of the American Indian, Smithsonian Institution, Washington, DC.

16. On American artists in Paris, see Kathleen Adler, Erica E. Hirshler, and H. Barbara Weinberg, *Americans in Paris, 1860–1900* (London: National Gallery, 2006).

17. Kirsten Swinth, *Painting Professionals: Women Artists and the Development of Modern American Art* (Chapel Hill: University of North Carolina Press, 2001), 37; and Laurence Madeline, *Women*

Artists in Paris, 1850–1900 (New York: American Federation of the Arts; New Haven, CT: Yale University Press, 2017).

18. Cassatt's expat identity is typically referred to in passing—for example, in Frederick A. Sweet, *Miss Mary Cassatt, Impressionist from Pennsylvania* (Norman: University of Oklahoma Press, 1966), xv; and Suzanne G. Lindsay, *Mary Cassatt and Philadelphia* (Philadelphia: Philadelphia Museum of Art, 1985), 9, 18, 22.

19. *Merriam-Webster,* s.v. "expatriate," https://www.merriam-webster.com/dictionary/expatriate.

20. As late as 1911, when she wrote up her will, she listed Philadelphia as her legal residence. Lindsay, *Mary Cassatt and Philadelphia,* 9.

21. Achille Segard, *Mary Cassatt: Un peintre des enfants et des mères* (Paris: P. Ollendorff, 1913), 2.

22. *Oxford Reference,* s.v. "Overview, Cosmopolitanism," https://www.oxfordreference.com/view/10.1093/oi/authority.20110803095641459. For an up-to-date analysis of the reemergence of cosmopolitanism, see Steven Vertovec and Robin Cohen, "Introduction: Conceiving Cosmopolitanism," in *Conceiving Cosmopolitanism: Context and Practice,* ed. Vertovec and Cohen (Oxford: Oxford University Press, 2022), 1–22.

23. Clayson, "Voluntary Exile and Cosmopolitanism," 24.

24. Kwame Anthony Appiah, "Cosmopolitan Patriots," *Critical Inquiry* 23, no. 3 (Spring 1997): 617–39.

25. Gertrude Stein, "An American and France" (1936), cited in Appiah, "Cosmopolitan Patriots," 618.

26. Gordon S. Wood, *Empire of Liberty: A History of the Early Republic, 1789–1815* (Oxford: Oxford University Press, 2009), 543ff, cited in Jaap Verheul, "'A Peculiar National Character': Transatlantic Realignment and the Birth of American Cultural Nationalism after 1815," *European Journal of American Studies* 7, no. 2 (2012): 1–14, at 2.

27. For the history of American cultural nationalism, see Verheul, "'Peculiar National Character.'"

28. Verheul, "'Peculiar National Character,'" 9.

29. Wanda M. Corn, *The Great American Thing: Modern Art and National Identity, 1915–1935* (Berkeley: University of California Press, 2001).

30. Cynthia Salzman, *Old Masters, New World: America's Raid on Europe's Great Pictures* (New York: Penguin Books, 2008).

31. On Cassatt's collection, see Erica E. Hirshler, "Helping 'Fine Things Across the Atlantic': Mary Cassatt and Art Collecting in the United States," in Barter, *Mary Cassatt: Modern Woman,* 177–211, at 179–80.

32. MC to Carroll S. Tyson (hereafter CST), January 23, 1905, in Sweet, *Miss Mary Cassatt,* 163.

33. "I never miss an opportunity to tell people that the country owes him [Mr. Havemeyer] & you a debt." MC to Louisine Havemeyer (hereafter LH), November 13, [1910]. B 97. MMAA.

34. On the development of American art and its relationship to Europe, see Annie Cohen-Solal, *Painting American: The Rise of American Artists, Paris 1867–New York 1948,* trans. Laurie Hurwitz-Attias (New York: Alfred A. Knopf, 2001).

35. Hutchinson, *Indian Craze,* 1.

36. This is Hutchinson's paraphrasing of points made by the Native American artist Angel DeCora in 1911 (Hutchinson, 1). During the 1920s, John Sloan proclaimed Native American art to be "the only 100% American art produced in this country." Cited in Janet Catherine Berlo, "The Art of Indigenous Americans and American Art History: A Century of Exhibitions," *Perspective* 2 (2015): 1–10, at 2.

37. My emphasis. MC to Theodate Pope (hereafter TP), [1903], #58, Hill-Stead Museum Archives (hereafter HSMA).

38. MC to Harrison Morris (the managing director of the Pennsylvania Academy of the Fine Arts), March 15, 1904, in Mathews, *Mary Cassatt and Her Circle,* 291.

39. MC to Morris, March 15, 1904, in Mathews, *Mary Cassatt and Her Circle,* 291.

40. Clark and Fowle, "Introduction: What Is Impressionism?," in *Globalizing Impressionism*; Emily C. Burns and Alice M. Rudy Price, *Mapping Impressionist Painting in Transnational Contexts* (New York: Routledge, 2021); and Dombrowski, *Companion to Impressionism*, section VI. The pioneering scholarship on this topic is Norma Broude's *World Impressionism: The International Movement, 1860–1920* (New York: Abrams, 1990).

41. See Mathews, Griselda Pollock, Linda Nochlin, Norma Broude, and Sally Webster, among others.

42. Anne Higonnet, "Critical Impressionism: A Painting by Mary Cassatt and Its Challenge to the Social Rules of Art," in Dombrowski, *Companion to Impressionism*, 219–33, at 220.

43. Higonnet, "Critical Impressionism," 220.

44. See Griselda Pollock, "Modernity and the Spaces of Femininity," in *Vision and Difference: Femininity, Feminism and Histories of Art* (London: Routledge, 1988), 50–90. Pollock's later book on Cassatt broadens her interpretation; see *Mary Cassatt, Painter of Modern Women* (New York: Thames and Hudson, 1998).

45. On Cassatt as a New Woman, see Pollock, *Mary Cassatt: Painter of Modern Women*; Ruth E. Iskin, "Was There a New Woman in Impressionist Painting?," in *Women in Impressionism: From Mythical Feminine to Modern Woman*, ed. Sidsel Maria Søndergaard (Milan: Skira, 2007), 189–223.

46. On visual culture and history, see Vanessa R. Schwartz and Jeannene M. Przyblyski, eds., *The Nineteenth-Century Visual Culture Reader* (New York: Routledge, 2004).

47. Alice Cooney Frelinghuysen et al., *Splendid Legacy: The Havemeyer Collection* (New York: Metropolitan Museum of Art, 1993).

48. Sweet, *Miss Mary Cassatt*, 31.

49. For an analysis of the two-way relationship between Degas's and Cassatt's art, see Kimberly A. Jones, ed., *Degas Cassatt* (Washington, DC: National Gallery of Art, 2014). For insightful analyses of the Degas-Cassatt relationship that nonetheless assume and describe a hierarchy in which the influence flows mainly from Degas to Cassatt, see Barbara Ehrlich White, *Impressionists Side by Side: Their Friendships, Rivalries, and Artistic Exchanges* (New York: Knopf, 1996); and George T.M. Shackelford, "Pas de Deux: Mary Cassatt and Edgar Degas," in Barter, *Mary Cassatt: Modern Woman*, 109–43.

1. CASSATT'S TRANSATLANTIC NETWORK

1. MC to LH, July 19, [1906?]. B 163. MMAA.

2. MC to LH, December 17, [1919?]. A 21. MMAA.

3. MC to LH, December 17, [1919?]. A 21. MMAA. My emphasis.

4. Howard S. Becker, *Art Worlds* (Berkeley: University of California Press, 1982), xi.

5. Charles Kadushin, *Understanding Social Networks: Theories, Concepts, and Findings* (Oxford: Oxford University Press, 2012), 14. Bruno Latour expanded the definition to include nonhuman objects and systems as actors in networks. Latour, *Reassembling the Social* (Oxford: Oxford University Press, 2005).

6. Mark Granovetter, "Economic Action and Social Structure: The Problem of Embeddedness," *American Journal of Sociology* 91, no. 3 (1985): 481–510; Latour, *Reassembling the Social*, 129.

7. Frederick A. Sweet pioneered the analysis of Cassatt's relationship with family members in *Miss Mary Cassatt*. Nancy Mowll Mathews analyzes Cassatt's friendships with young American art students and artists during her years of studying art in Europe; see Mathews, *Mary Cassatt: A Life* (New York: Villard Books, 1994). Kevin Sharp includes brief discussions of Cassatt's relationships with the Durand-Ruels, Ambroise Vollard, James Stillman, and Louisine Havemeyer in "How Mary Cassatt Became an American Artist," in Barter, *Mary Cassatt: Modern Woman*, 162–69. For an analysis of misrepresentations of Cassatt as a follower of Degas, see chapter 3.

8. Networking was also essential to less privileged women in the art world and to female workers in other fields. See Leslie Page Moch and Rachel G. Fuchs, "Getting Along: Poor Women's Networks in Nineteenth-Century Paris," *French Historical Studies* 18, no. 1 (Spring 1993): 34–49.

9. On Cassatt's young American friends Eliza Haldeman, Miss Gordon, and Emily Sartain, see Mathews, *Mary Cassatt: A Life,* 29–92.

10. Caroline Ticknor, *May Alcott: A Memoir* (Boston: Little, Brown, 1928), 151.

11. Ticknor, *May Alcott,* 151; Mathews, *Mary Cassatt: A Life,* 102, 124.

12. Ticknor, *May Alcott,* 233, 237–38; Havemeyer, *Sixteen to Sixty,* 269–70.

13. Ticknor, *May Alcott,* 194.

14. Cassatt met Stillman probably through her brother Alexander, or else through a mutual acquaintance. Anna Robeson Burr, *The Portrait of a Banker: James Stillman, 1850–1918* (New York: Duffield, 1927), 295–96. Stillman, who sailed to the United States in August 1917, reported seeing Cassatt in April. James Stillman (hereafter JS) to his sister Clara, April 4, 1917, in Burr, 350.

15. John K. Winkler, *The First Billion: The Stillmans and the First National Bank* (New York: Vanguard Press, 1934), 256.

16. Winkler, *First Billion,* 212. The other two were the elder J.P. Morgan and George F. Baker, cofounder of the First National Bank of the City of New York, the forerunner of today's Citibank.

17. Susie Pal, *Gentlemen Bankers: The World of J.P. Morgan* (Cambridge, MA: Harvard University Press, 2013), 233; Winkler, *First Billion,* 73, 261. On Stillman's role in recasting his institution as an imperial bank, see Peter James Hudson, *Bankers and Empire: How Wall Street Colonized the Caribbean* (Chicago: University of Chicago Press, 2017).

18. MC to LH, February 4, 1912. C 25. MMAA. Burr, *Portrait of a Banker,* 280; Winkler, *First Billion,* 161, 179, 188–89, 221.

19. Winkler, *First Billion,* 254.

20. MC to LH, July 6, [1913]. B 96. MMAA.

21. Among Stillman's business associates were E.H. Harriman (financier and railroad executive), William Rockefeller (cofounder of Standard Oil, with his brother, John D. Rockefeller), Henry Huttleston Rogers (leader at Standard Oil), and Jacob H. Schiff (head of a New York–based company that financed eastern railroads, among other enterprises). Stillman also did business with the American financier and banker J.P. Morgan.

22. After living in the mansion for several seasons, Stillman bought it in 1911. Burr, *Portrait of a Banker,* 279.

23. MC to LH, October 20, [1910]. B 121. MMAA.

24. MC to LH, April 20, [1909]. C 64. MMAA.

25. Donna Greene, "Biographical Sketch of Narcissa Cox Vanderlip," in "Part III: Mainstream Suffragists—National American Woman Suffrage Association," https://documents.alexanderstreet.com/d/1009656478.

26. Mildred Whitney Stillman, in Burr, *Portrait of a Banker,* 295.

27. Sweet, *Miss Mary Cassatt,* 185.

28. MC to LH, November 29–30, 1906. B 158. MMAA.

29. Mildred Whitney Stillman, in Burr, *Portrait of a Banker,* 288–89; Winkler, *First Billion,* 190–92. On Stillman's old masters collection, see Hirshler, "Helping 'Fine Things Across the Atlantic,'" 177–211, 202–3.

30. MC to LH, October 31, 1912. B 169. MMAA.

31. MC to LH, [December 1, 1911]. C 28. MMAA. MC to LH, September 7, 1910. B 127. MMAA.

32. MC to LH, September 6, [1912]. C 14. MMAA.

33. Hirshler, "Helping 'Fine Things Across the Atlantic,'" 202.

34. Hirshler, "Helping 'Fine Things Across the Atlantic,'" 190.

35. JS to his sister Clara, May 18, 1913, in Burr, *Portrait of a Banker,* 307.

36. JS to his sister Clara, May 18, 1913, in Burr, *Portrait of a Banker,* 307–8.

37. Segard, *Mary Cassatt*; Sharp, "How Mary Cassatt Became an American Artist," 166.

38. MC to LH, January 17, [1911]. B 143. MMAA.

39. MC to JS, [December 1910], in Burr, *Portrait of a Banker,* 303.

40. MC to JS, n.d., in Burr, *Portrait of a Banker,* 304.

41. JS to his sister Clara, May 18, 1913, in Burr, *Portrait of a Banker,* 306.

42. MC to JS, December 22, [1910], in Burr, *Portrait of a Banker,* 302.

43. MC to LH, [1913]. B 100. MMAA.

44. MC to LH, [1913]. B 100. MMAA.

45. MC to LH, September 28, [1910]. B 129. MMAA.

46. MC to LH, March 12, 1912. C 22. MMAA.

47. Nancy Hale, *Mary Cassatt* (New York: Doubleday, 1975), 243–44.

48. MC to LH, February 18, 1912. C 24. MMAA.

49. MC to LH, March 12, 1912. C 22. MMAA.

50. MC to LH, February 18, 1912. C 24. MMAA.

51. MC to LH, December 29, [1911]. C 31. MMAA.

52. This was Sharp's reading of Cassatt's statement. Sharp, "How Mary Cassatt Became an American Artist," 164.

53. JS to his sister Clara, May 18, 1913, in Burr, *Portrait of a Banker,* 308.

54. MC to JS, n.d., in Burr, *Portrait of a Banker,* 300.

55. MC to JS, September 12, 1909, in Burr, *Portrait of a Banker,* 301.

56. MC to LH, April 4, [1913]. B 98. MMAA.

57. Eugenia Cassatt (later Mrs. Percy Madeira), Cassatt's niece, who knew her aunt as a child and teenager, believed that Stillman wanted to marry Cassatt, while Stillman's descendants thought that this idea was ludicrous. Interview with Madeira and correspondence with Chauncey Stillman, in Nancy Hale Papers, Archives of American Art (hereafter AAA). Sweet speculates that Stillman wanted to marry Cassatt but she felt it was inappropriate due to their age difference. Sweet, *Miss Mary Cassatt,* 183.

58. Mathews, *Mary Cassatt: A Life,* 295.

59. Winkler, *First Billion,* 70.

60. Winkler, *First Billion,* 8.

61. Winkler, *First Billion,* 84–87.

62. Winkler, *First Billion,* 8, 86–87.

63. Winkler, *First Billion,* 255.

64. Winkler, *First Billion,* 9.

65. MC to LH, January 17, [1911]. B 143. MMAA.

66. MC to JS, December 22, [1910], in Burr, *Portrait of a Banker,* 302. These photographs have yet to come to light.

67. In addition to portraying her brother and father, Cassatt portrayed the artist Marcellin Desboutin, ca. 1879; the collector of her work, Moïse Dreyfus, in 1879; and her neighbor, Octave de Sailley, ca. 1909.

68. MC to LH, March 8, [1911]. B 124. MMAA.

69. Mildred Whitney Stillman, in Burr, *Portrait of a Banker,* 295.

70. Mildred Whitney Stillman, in Burr, *Portrait of a Banker,* 296.

71. Mildred Whitney Stillman, in Burr, *Portrait of a Banker,* 296.

72. MC to LH, October 11, [1910]. B 122. MMAA.

73. Winkler, *First Billion,* 29.

74. MC to LH, September 7, [1910]. B 127. MMAA.

75. MC to LH, November 7, [1910]. B 116. MMAA.

76. MC to LH, January 11, [1915?]. C 112. MMAA.

77. JS to his sister Clara, May 18, 1913, in Burr, *Portrait of a Banker,* 306.

78. MC to LH, [December 1911]. C 32. MMAA.

79. MC to LH, June 1910. C 145. MMAA.

80. MC to LH, December 28, [1914?]. C 114. MMAA.

81. MC to LH, August 13, [1914?]. C 91. MMAA.

82. MC to LH, December 28, [1914?]. C 114. MMAA.

83. Greene, "Biographical Sketch."

84. MC to LH, July 5, [1915]. B 86. MMAA.

85. Winkler, *First Billion,* 9.

86. René Gimpel, *Diary of an Art Dealer,* trans. John Rosenberg, intro. Herbert Read (New York: Farrar Straus & Giroux, 1966), 145.

87. Gimpel, *Diary,* 145.

88. Rose Lamb was from a prominent Boston family and active in Boston society. She had a wide social and professional circle that included numerous artists and other cultural figures. On Lamb, see AAA, https://www.aaa.si.edu/collections/rose-lamb-papers-5615.

89. MC to LH, October 19, [1913]. C 55. MMAA. MC to LH, August 28, [1913]. B 93. MMAA.

90. *Boston Daily Globe,* extra five o'clock, June 2, 1905.

91. *Boston Daily Globe,* extra five o'clock, June 2, 1905; Kathleen D. McCarthy, *Women's Culture: American Philanthropy and Art, 1830–1930* (Chicago: University of Chicago Press, 1991), 106.

92. On Sears, see Stephanie Mary Buck, "Sarah Choate Sears: Artist, Photographer, and Art Patron" (MA thesis, Syracuse University, 1985); Hirshler, "The Fine Art of Sarah Choate Sears," *Magazine Antiques* 160, no. 3 (September 2001): 321–29; Hirshler, *A Studio of Her Own: Women Artists in Boston, 1870–1940* (Boston: MFA Publications, 2001), 55–62.

93. Hirshler, "Fine Art of Sarah Choate Sears," 322.

94. Sears joined the New York Watercolor Club and served as a member of the jury of admissions for three years. Kathleen A. Foster, *American Watercolor in the Age of Homer and Sargent* (New Haven, CT: Yale University Press, 2017), 11.

95. Hirshler, *Studio of Her Own,* 57. On Sears's photography, see Katherine Hoffman, "Sarah Choate Sears and the Road to Modernism," *Photoresearcher,* no. 10 (2007): 23–31.

96. Hirshler, "Fine Art of Sarah Choate Sears," 323.

97. Hoffman, "Sarah Choate Sears," 31.

98. Hoffman, "Sarah Choate Sears," 25, 31.

99. Buck, appendix E, "Exhibitions," in "Sarah Choate Sears," 112–13.

100. Alfred Stieglitz, "Our Illustrations," *Camera Notes* 3, no. 1 (July 1899): 24.

101. Hirshler, "Fine Art of Sarah Choate Sears," 327.

102. MC to Electra, Mrs. J. Watson Webb (daughter of the Havemeyers), May 27, 1909, in Sweet, *Miss Mary Cassatt,* 181.

103. Hirshler, "Helping 'Fine Things Across the Atlantic,'" 195. On Sears's art collection, see Buck, chap. 3 and appendix F in "Sarah Choate Sears," 114–18; Hirshler, "Helping 'Fine Things Across the Atlantic,'" 194–95; Hirshler, "Fine Art of Sarah Choate Sears," 326–28.

104. Buck's partial list of Sears's art collection lists eight works by Cassatt. Buck, "Sarah Choate Sears," 114.

105. Buck, "Sarah Choate Sears," 83.

106. MC to LH, November 15, [1912]. C 40. MMAA.

107. MC to LH, October 2, [1912?]. C 15. MMAA.

108. MC to her niece Ellen Mary Cassatt, March 26, [1913?], in Mathews, *Mary Cassatt and Her Circle*, 310.

109. Sweet, *Miss Mary Cassatt*, 196.

110. On Cassatt's dismissal of Laurencin, among others, see Mathews, *Mary Cassatt: A Life*, 308. On her objection to Matisse, see MC to Ellen Mary Cassatt, March 26, [1913?], in Mathews, *Mary Cassatt and Her Circle*, 310.

111. Buck, "Sarah Choate Sears," 84.

112. McCarthy, *Women's Culture*, 185.

113. Buck, "Sarah Choate Sears," 83. Sears's collection featured works by several other Americans as well, including James McNeill Whistler, George de Forest, John La Farge, Dodge McKnight, and Abbot Thayer.

114. Buck, "Sarah Choate Sears," 92.

115. MC to LH, October 18, [1910]. C 70. MMAA.

116. Grant Richards published Tyler's book *Spain: A Study of Her Life and Arts*. "Royall Tyler, 1884–1953," Dumbarton Oaks Research Library and Collection, https://www.doaks.org/resources/bliss-tyler-correspondence/annotations/royall-tyler; "Elisina Tyler, 1878–1959," Dumbarton Oaks, https://www.doaks.org/resources/bliss-tyler-correspondence/annotations/elisina-tyler.

117. MC to LH, November 4, [1910]. B 115. MMAA.

118. MC to LH, January 23, 1914. C 78. MMAA.

119. MC to LH, October 18, 1908. C 70. MMAA. Emphasis in the original.

120. MC to LH, November 29–30, 1906. B 158. MMAA.

121. MC to LH, January 23, 1914. C 78. MMAA.

122. MC to LH, October 1, 1914. C 54. MMAA.

123. MC to LH, May 18, 1920. A 6. MMAA.

124. Colonel Oliver H. Payne, Harry Havemeyer's friend, and Ada Pope, the wife of Arthur Pope and mother of Theodate Pope, refused to lend works to the exhibition.

125. Molly K. Eckel, "'A Touch of Art': Sarah Wyman Whitman and the Art of the Book in Boston" (BA thesis, Wellesley College, 2012), 31.

126. Buck, "Sarah Choate Sears," 52.

127. On Howe, see Valarie H. Ziegler, *Diva Julia: The Public Romance and Private Agony of Julia Ward Howe* (Harrisburg, PA: Trinity Press International, 2003), 148–49.

128. *Boston Daily Globe*, extra five o'clock, June 2, 1905.

129. Sears to the art critic Royal Cortissoz, August 4, 1926, Beinecke Rare Book and Manuscript Library, Yale University, in Hirshler, "Helping 'Fine Things Across the Atlantic,'" 195.

130. Hirshler, "Helping 'Fine Things Across the Atlantic,'" 195–96.

131. The date of Cassatt's first face-to-face meeting with Theodate Pope is not entirely clear. She definitely met Theodate and her parents in 1898 during her several-months-long visit to the United States (Frances Weitzenhoffer, *The Havemeyers: Impressionism Comes to America* [New York: Abrams, 1986], 130), but she may have met them a few years earlier in Paris, while they were on a European tour. Hirshler, "Helping 'Fine Things Across the Atlantic,'" 195. Alfred Pope was aware of Cassatt earlier. In a letter of August 1894, while visiting Europe and acquiring artworks along with Theodate and others, he mentioned Cassatt in several letters, including one to Durand-Ruel (August 11, [1894], #3267, HSMA), in which Alfred suggested that Cassatt might come to the gallery to look at some Utamaro prints. In a letter to Harris Whittemore (a major collector of Impressionist painting, including works by Cassatt, and a very close friend and associate of Alfred Pope), he thanks him for forwarding

a letter by Cassatt, presumably with an invitation, and stated: "I don't think I can make up my mind to trouble her" (August 26, [1894], #W779, HSMA). My thanks to Melanie Bourbeau, curator at the Hill-Stead Museum Archives, for providing the letters and help in clarifying the issue.

132. Weitzenhoffer, *Havemeyers,* 146–47; Mathews, *Mary Cassatt: A Life,* 250, 272–73; Hirshler, "Helping 'Fine Things Across the Atlantic,'" 196–97.

133. Cited by Sara T. Hallowell in her letter to Bertha Palmer, February 6, [1894], in Mathews, *Mary Cassatt and Her Circle,* 254. Italics in the original.

134. MC to TP, May 1, [1916]. #75, HSMA.

135. TP, diary, June 2, 1889. HSMA.

136. The monument was a reconstruction of Theodore Roosevelt's birthplace in New York City (1919–22).

137. The definitive biography of TP is Sandra L. Katz's *Dearest of Geniuses: A Life of Theodate Pope Riddle* (Windsor, CT: Tide-Mark, 2003)

138. TP, diary, February 5, 1886. HSMA.

139. Havemeyer, *Sixteen to Sixty,* 273.

140. Katz, *Dearest of Geniuses,* 279–80.

141. MC to Ada Pope, June 30, [1903], in Mathews, *Mary Cassatt and Her Circle,* 284.

142. MC to Ada Pope, February 18, [1903]. #55, HSMA.

143. MC to TP, April 21, 1903. #60, HSMA.

144. MC to TP, November 30, [1903], in Mathews, *Mary Cassatt and Her Circle,* 289.

145. MC to TP, October 12, [1912], in Mathews, *Mary Cassatt and Her Circle,* 300; MC to TP, December 23, [1910], in Mathews, *Mary Cassatt and Her Circle,* 303.

146. Katz, *Dearest of Geniuses,* 91–93.

147. MC to TP, December 23, [1910], in Mathews, *Mary Cassatt and Her Circle,* 303.

148. Cited in Katz, *Dearest of Geniuses,* 93.

149. MC to TP, August 14, [1910?]. #65, HSMA.

150. MC to TP, August 14, [1910?]. #65, HSMA.

151. MC to TP, December 23, [1910], in Mathews, *Mary Cassatt and Her Circle,* 303.

152. MC to TP, February 19, [1911], in Mathews, *Mary Cassatt and Her Circle,* 305.

153. MC to TP, December 23, [1910], in Mathews, *Mary Cassatt and Her Circle,* 303.

154. Elizabeth von Arnim, *The Benefactress* (New York: Macmillan, 1901).

155. MC to TP, December 23, [1911], in Mathews, *Mary Cassatt and Her Circle,* 304.

156. After the Westover School, Theodate designed the public elementary school Hop Brook School in Naugatuck, Connecticut, and the Avon Old Farms School in Avon, Connecticut. Katz, *Dearest of Geniuses,* 122, 241–73.

157. Cited in Katz, *Dearest of Geniuses,* 245.

158. Cited in Katz, *Dearest of Geniuses,* 224.

159. Katz, *Dearest of Geniuses,* 224.

160. MC to TP, October 12, [1910], in Mathews, *Mary Cassatt and Her Circle,* 300.

161. MC to TP, December 23, [1910], in Mathews, *Mary Cassatt and Her Circle,* 304.

162. Katz, *Dearest of Geniuses,* 108.

163. Katz, *Dearest of Geniuses,* 108.

164. Katz, *Dearest of Geniuses,* 153.

165. MC to TP, August 22, [no year]. #66, HSMA.

166. TP to LH, August 30, 1915. MMAA. Katz, *Dearest of Geniuses,* 153.

167. Katz, *Dearest of Geniuses,* 188.

168. Cited in Katz, *Dearest of Geniuses*, 208.

169. *Hartford Courant*, April 2, 1920, cited in Katz, *Dearest of Geniuses*, 207.

170. TP to LH, August 30, 1915. MMAA.

171. TP to LH, August 30, 1915. MMAA.

172. TP to LH, August 30, 1915. MMAA.

173. TP to LH, August 30, 1915. MMAA.

174. MC to TP, December 23, [1910], in Mathews, *Mary Cassatt and Her Circle*, 303.

175. MC to TP, November 30, [1903], in Mathews, *Mary Cassatt and Her Circle*, 289.

176. MC to TP, November 30, [1903], in Mathews, *Mary Cassatt and Her Circle*, 290.

177. MC to TP, October 12, [1910], in Mathews, *Mary Cassatt and Her Circle*, 300.

178. MC to TP, [n.d.]. #64, HSMA.

179. MC to TP, [n.d.]. #64, HSMA.

180. MC to TP, [n.d.]. #64, HSMA.

181. Katz, *Dearest of Geniuses*, 127–31.

182. MC to TP, November 30, [1903], in Mathews, *Mary Cassatt and Her Circle*, 289.

183. MC to TP, [n.d.]. #64, HSMA.

184. TP, diary, July 19, 1901, HSMA.

185. MC to TP, June 8, [1915], in Mathews, *Mary Cassatt and Her Circle*, 323.

186. MC to Mrs. Whittemore, July 22, 1903. HSMA.

187. MC to TP, [September 1903], in Mathews, *Mary Cassatt and Her Circle*, 285–86.

188. MC to TP, [September 1903], in Mathews, *Mary Cassatt and Her Circle*, 285–86.

189. MC to Ada Pope, July 30, [1903], in Mathews, *Mary Cassatt and Her Circle*, 284.

190. MC to Ada Pope, July 30, [1903], in Mathews, *Mary Cassatt and Her Circle*, 284.

191. TP, diary, May 9, 1889. HSMA.

192. On the Whittemores' collection, see Ann Y. Smith, *Hidden in Plain Sight: The Whittemore Collection and the French Impressionists* (Roxbury, CT: Garnet Hill Publishing Co. and Mattatuck Historical Society, 2009).

193. TP, diary, Paris, August 19, 1889. HSMA.

194. TP, diary, September 14, 1900. HSMA.

195. TP, diary, September 14, 1900. HSMA.

196. MC to Ada Pope, [n.d.]. #67, HSMA.

197. MC to TP, August 14, [1910?]. #65, HSMA. MC to Ada Pope, [n.d.]. #67, HSMA.

198. MC to TP, August 14, [1910?]. #65, HSMA.

199. John D. Kysela, "Sara Hallowell Brings 'Modern Art' to the Midwest," *Art Quarterly* 29, no. 2 (1964): 150–68, at 154.

200. Sara T. Hallowell (hereafter STH) to Mrs. Palmer, February 1894, in Sweet, *Miss Mary Cassatt*, 136.

201. STH to Paul Durand-Ruel (hereafter PD-R), August 14, 1894, in Weitzenhoffer, *Havemeyers*, 124–25.

202. MC to LH, [December 1911]. C 32. MMAA.

203. Ishbel Ross, *Silhouette in Diamonds: The Life of Mrs. Potter Palmer* (New York: Harper & Brothers, 1960), 150, 151.

204. On Hallowell's work for the Palmers and their art collection, see Ross, *Silhouette in Diamonds*, 151–57; Carolyn Kinder Carr, *Sara Tyson Hallowell: Pioneer Curator and Art Advisor in the Gilded Age* (Washington, DC: Smithsonian Institution Scholarly Press, 2019); Hirshler, "Helping 'Fine Things Across the Atlantic,'" 199–201.

205. Weitzenhoffer, *Havemeyers*, 125.

206. Pissarro to his son Lucien, November 4, 1894, in *Camille Pissarro, Letters to His Son Lucien*, ed. John Rewald (Santa Barbara, CA: Peregrine Smith, 1981), 317.

207. MC to Heller, February 1, [1896], in Mathews, *Mary Cassatt and Her Circle*, 263.

208. Sweet, *Miss Mary Cassatt*, 171–72.

209. "'Miss Sara Hallowell Unique in the Art World'—What She Has Done for American Artists Abroad in Her Singular Capacity as a Jury of One," *New York Times*, December 31, 1905.

210. *New York Times*, "Miss Sara Hallowell."

211. *New York Times*, "Miss Sara Hallowell."

212. *New York Times*, "Miss Sara Hallowell."

213. *New York Times*, "Miss Sara Hallowell."

214. *New York Times*, October 1890, in Jeanne Madeline Weimann, *The Fair Women* (Chicago: Academy, 1981), 183.

215. Resolution, November 1890, in Weimann, *Fair Women*, 183.

216. Carr, *Sara Tyson Hallowell*, 132.

217. Kysela, "Sara Hallowell," 162; Carr, *Sara Tyson Hallowell*, 163–64.

218. STH to Mrs. Palmer, in Weimann, *Fair Women*, 187.

219. Carr, *Sara Tyson Hallowell*, 138.

220. Carr, *Sara Tyson Hallowell*, 311.

221. PD-R to STH, August 20, 1894, in Weitzenhoffer, *Havemeyers*, 125.

222. MC to LH, March 22, 1920. C 1. MMAA.

223. *New York Times*, "Miss Sara Hallowell."

224. Sharp, "How Mary Cassatt Became an American Artist," 163.

225. MC to LH, December 14, [1911]. C 30. MMAA.

226. *New York Times*, "Miss Sara Hallowell."

227. George Biddle, "Some Memories of Mary Cassatt," *The Arts* 10 (August 1926): 107–11. Borie and his wife lived in Paris in the years 1921–24. Biddle, *Adolphe Borie* (Washington, DC: American Federation of Arts, 1937); Sweet, *Miss Mary Cassatt*, 206; Mathews, *Mary Cassatt: A Life*, 320.

228. Lenore Clark, *Forbes Watson: Independent Revolutionary* (Kent, OH: Kent State University Press, 2001), 4. This is the principal source for information on Watson's life and career.

229. Forbes Watson, *Mary Cassatt* (New York: Whitney Museum of American Art, 1932), 11.

230. Clark, *Forbes Watson*, 68.

231. Clark, *Forbes Watson*, 15.

232. Clark, *Forbes Watson*, 69.

233. Clark, *Forbes Watson*, 15.

234. Watson, "Art Notes," *New York Evening Post*, March 15, 1915, in Clark, *Forbes Watson*, 28.

235. Watson, *Mary Cassatt*, 12.

236. Watson, *Mary Cassatt*, 13.

237. Watson, *Mary Cassatt*, 12.

238. MC to LH, May 18, 1920. A 6. MMAA.

239. MC to LH, September 8, 1920. C 74. MMAA.

240. MC to LH, March 22, 1920. C 1. MMAA.

241. MC to LH, September 8, 1920. C 74. MMAA.

242. On Watson's progressive ideas about independent exhibitions in America, see Clark, *Forbes Watson*, 37.

243. On Watson's commitment to encourage American collectors of modern art and of American art, see Clark, chap. 4 in *Forbes Watson*.

244. Clark, *Forbes Watson*, 81.

245. On Watson's nationalism, see Clark, *Forbes Watson*, 49–50. On *The Arts'* emphasis on American art, see Clark, *Forbes Watson*, 54–57.

246. Clark, *Forbes Watson*, 30.

247. Clark, *Forbes Watson*, 2. On Watson's editing of *The Arts* and the significance of the publication, see Clark, chap. 3 in *Forbes Watson*.

248. Clark, *Forbes Watson,* 2. On Gertrude Vanderbilt Whitney, Juliana Force, and the founding of the Whitney Museum of American Art, as well as on Watson's role as their advisor, see Avis Berman, *Rebels on Eighth Street: Juliana Force and the Whitney Museum of American Art* (New York: Atheneum, 1990).

249. Clark, *Forbes Watson*, 2.

250. Havemeyer, *Sixteen to Sixty*, 244.

251. For Watson's comments on American art, see Clark, *Forbes Watson*, 33–36, 86.

252. Wanda Corn, "Coming of Age: Historical Scholarship in American Art," *Art Bulletin* 70, no. 2 (June 1988): 188–207, at 192.

253. Clark, *Forbes Watson*, 35.

254. Clark, *Forbes Watson*, 35.

255. Watson, *Mary Cassatt,* 13.

256. Watson, *Mary Cassatt,* 13.

257. Watson, *Mary Cassatt,* 12.

258. MC to LH, January 9, [1912]. C 26. MMAA.

259. Watson, *Mary Cassatt*, 7–8.

260. Clark, *Forbes Watson*, 98.

261. Clark, *Forbes Watson*, 41–44.

262. Clark, *Forbes Watson*, 42.

263. Biddle, "Some Memories," 107–11; Biddle, *Adolphe Borie*; Sweet, *Miss Mary Cassatt,* 206; Mathews, *Mary Cassatt: A Life,* 320.

264. MC to CST, January 23, 1905, in Sweet, *Miss Mary Cassatt,* 163.

265. MC to CST, November 11, 1909, in Sweet, *Miss Mary Cassatt,* 178.

266. Rewald, "The Collection of Carroll S. Tyson, Jr. Philadelphia, USA," *Philadelphia Museum of Art Bulletin* 59, no. 280 (Winter 1964): 59–80, at 60.

267. MC to LH, April 25, [1910]. C 68. MMAA.

268. MC to LH, May 13, 1910. C 67. MMAA.

269. MC to LH, January 20, [1911]. B 144. MMAA.

270. MC to LH, November 13, [1910]. B 97. MMAA.

271. MC to LH, January 20, [1911]. B 144. MMAA.

2. CASSATT AND LOUISINE HAVEMEYER

Epigraph: MC to LH, October 17, 1906. B 149. MMAA.

1. Nancy Hale, *Mary Cassatt* (New York: Doubleday, 1975); Weitzenhoffer, *Havemeyers*; Mathews, *Mary Cassatt: A Life*; Susan Alyson Stein, "Chronology," in *Splendid Legacy: The Havemeyer Collection,* ed. Alice Cooney Frelinghuysen et al. (New York: Metropolitan Museum of Art, 1993). Alicia Faxon's article does not make use of these letters but features several previously unpublished letters by Cassatt and Havemeyer, respectively, to the critic and art agent Théodore Duret, which focus on acquisitions of artworks. See Faxon, "Painter and Patron: Collaboration of Mary Cassatt and Louisine Havemeyer," *Woman's Art Journal* 3, no. 2 (Autumn 1982–Winter 1983): 15–20.

2. Rebecca A. Rabinow, "Louisine Havemeyer and Edgar Degas," in *Degas and America: The Early Collectors,* ed. Ann Dumas and David A. Brenneman (Atlanta: High Museum of Art and Minneapolis Institute of Arts, 2001), 35–45.

3. See, for example, *The Politics of Female Alliance in Early Modern England,* ed. Christina Luckyj and Niamh J. O'Leary (Lincoln: University of Nebraska, 2017).

4. Weitzenhoffer, *Havemeyers,* 19–20. The Elders arrived in February 1874 and sailed back in October.

5. Cassatt met Louisine through Emily Sartain, her friend from the Pennsylvania Academy of the Fine Arts. Havemeyer, *Sixteen to Sixty,* 269; Weitzenhoffer, *Havemeyers,* 20; Mathews, *Mary Cassatt: A Life,* 73, 100.

6. Cassatt exhibited in the Salon in 1868, 1872, 1873, 1874, 1875, and 1876.

7. Havemeyer, *Sixteen to Sixty,* 270.

8. Havemeyer, *Sixteen to Sixty,* 271.

9. Havemeyer, *Sixteen to Sixty,* 269–70.

10. Havemeyer, *Sixteen to Sixty,* 269.

11. Havemeyer, *Sixteen to Sixty,* 269, 286.

12. Weitzenhoffer, *Havemeyers,* 28.

13. Havemeyer, *Sixteen to Sixty,* 249–50.

14. Havemeyer, *Sixteen to Sixty,* 250.

15. Gary Tinterow, "The Havemeyer Pictures," in Frelinghuysen et al., *Splendid Legacy,* 42.

16. Robert Cassatt (Cassatt's father) to Alexander Cassatt (Cassatt's brother), May 21, 1879, in Mathews, *Mary Cassatt and Her Circle,* 144.

17. Nicole M. Georgopulos notes that Cassatt's association with hats went beyond bourgeois accessories and marked her personality and taste. See "Rethinking Mary Cassatt's *Reflection* as a Self-Portrait," *Print Quarterly* 36, no. 4 (December 2019): 425–38, at 430.

18. Weitzenhoffer, *Havemeyers,* 22–23; Mathews, *Mary Cassatt: A Life,* 167; Stein, "Chronology," 203.

19. Electra H. Webb, "Statement about H.O. Havemeyer," 1927, Shelburne Museum Archives (hereafter SMA).

20. See, for example, MC to Henry O. Havemeyer (hereafter HOH), February 3, 1903. B 178. MMAA. Cassatt always referred to him as "Mr. Havemeyer," even in her letters to Louisine.

21. Weitzenhoffer, *Havemeyers,* 32–33; Tinterow, "Havemeyer Pictures," 6–7; Stein, "Chronology," 202.

22. Weitzenhoffer, *Havemeyers,* 33.

23. Weitzenhoffer, *Havemeyers,* 47, 53–54.

24. Havemeyer, *Sixteen to Sixty,* 190.

25. Havemeyer, *Sixteen to Sixty,* 203.

26. Havemeyer, *Sixteen to Sixty,* 191; Weitzenhoffer, *Havemeyers,* 58.

27. Havemeyer, *Sixteen to Sixty,* 191–92.

28. For a thorough account of Harry Havemeyer's collecting, see Weitzenhoffer, *Havemeyers.*

29. Havemeyer, *Sixteen to Sixty,* 269.

30. Havemeyer, *Sixteen to Sixty,* 278.

31. MC to LH, 1890, in Havemeyer, *Sixteen to Sixty,* 287.

32. MC to LH, 1890, in Havemeyer, *Sixteen to Sixty,* 287.

33. Weitzenhoffer, *Havemeyers,* 91.

34. Weitzenhoffer, *Havemeyers,* 99.

35. MC to LH, February 15, [1910]. B 131. MMAA.

36. MC to LH, February 15, [1910]. B 131. MMAA.

37. MC to LH, February 15, [1910]. B 131. MMAA.

38. MC to LH, October 11, [1910]. B 122. MMAA.

39. Weitzenhoffer, *Havemeyers,* 178; Stein, "Chronology," 246.

40. MC to HOH, February 3, 1903. B 178. MMAA.

41. MC to HOH, July 19, 1906. B 162. MMAA.

42. Cassatt referred to this in several letters, reporting on her payments on behalf of the Havemeyers—for example, MC to LH, [1902?]. B 151. MMAA. MC to HOH, February 3, 1903. B 178. MMAA. MC to LH, June 2, [1907?]. B 148.5. MMAA.

43. MC to LH, August 9, 1901. B 146. MMAA.

44. MC to LH, November 23, 1906. B 167. MMAA.

45. MC to LH, November 30, [1906?]. B 168. MMAA. The underlining of "I" is in the letter.

46. MC to LH, December 27, [1906?]. B 172. MMAA.

47. MC to LH, January 5, [1907]. B 175. MMAA.

48. MC to LH, November 23, [1906]. B 167. MMAA.

49. Weitzenhoffer, *Havemeyers,* 175; Stein, "Chronology," 243–44.

50. On the Havemeyer mansion, see Havemeyer, *Sixteen to Sixty,* 11–22; Weitzenhoffer, *Havemeyers,* 70–81, 176–77; Frelinghuysen, "The Havemeyer House," in Frelinghuysen et al., *Splendid Legacy,* 173–98.

51. Weitzenhoffer, *Havemeyers,* 197.

52. Sweet, *Miss Mary Cassatt,* 154–55; Weitzenhoffer, *Havemeyers,* 78.

53. Havemeyer described some of the visitors. Havemeyer, *Sixteen to Sixty,* 26–61.

54. MC to Minnie Drexel Fell Cassatt, December 14, 1907, in Weitzenhoffer, *Havemeyers,* 182.

55. On the trial, see Weitzenhoffer, chap. 15 in *Havemeyers.*

56. MC to LH, October 11, [1910]. B 122. MMAA.

57. For detailed accounts of Louisine Havemeyer's collecting, see Weitzenhoffer, *Havemeyers;* Hirshler, "Helping 'Fine Things Across the Atlantic'"; Stein, "Chronology."

58. MC to LH, April 20, [1910]. C 64. MMAA.

59. MC to LH, May 10, 1910. C 66. MMAA.

60. For example, she was going to see the dealer Kelekian to "do a little bargaining about the Saint [sculpture]." MC to LH, October 3, [1910]. B 130. MMAA.

61. MC to LH, December 4, [1919]. A 23. MMAA.

62. Stein, "Chronology," 260.

63. Weitzenhoffer, *Havemeyers,* 218; Stein, "Chronology," 264.

64. Havemeyer, *Sixteen to Sixty,* 278.

65. On Degas's sculpture in the Havemeyers' collection, see Clare Vincent, "The Havemeyers and the Degas Bronzes," in Frelinghuysen et al., *Splendid Legacy,* 77–80.

66. Weitzenhoffer, *Havemeyers,* 241.

67. MC to PD-R, [1903], in Mathews, *Mary Cassatt and Her Circle,* 287.

68. MC to LH, December 8, [1919]. A 19. MMAA.

69. MC to LH, December 8, [1919]. A 19. MMAA.

70. MC to LH, January 16, [1920]. A 7. MMAA.

71. MC to LH, April 18, 1920. A 14. MMAA.

72. MC to LH, February 2, 1903. B 177. MMAA. See discussion in Weitzenhoffer, *Havemeyers,* 145.

73. MC to LH, February 2, 1903. B 177. MMAA.

74. MC to LH, February 2, 1903. B 177. MMAA.

75. Sweet, *Miss Mary Cassatt,* 155; Weitzenhoffer, *Havemeyers,* 145.

76. MC to LH, February 2, 1903. B 177. MMAA.

77. MC to LH, December 11, [1913]. C 47. MMAA. This part of the letter is from December 15.

78. MC to LH, December 11, [1913]. C 47. MMAA. This part of the letter is from December 15. The underlining is in the letter.

79. Cassatt usually acquired clothes at La Ferrière, one of Paris's elite fashion houses, established by Madame La Ferrière in 1869.

80. MC to LH, December 11, [1913]. C 47. MMAA. This part of the letter is from December 15.

81. MC to LH, December 11, [1913]. C 47. MMAA. This part of the letter is from December 15.

82. Weitzenhoffer, *Havemeyers,* 197.

83. *New York Times,* January 23, 1910, pt. 5, p. 2, in Weitzenhoffer, *Havemeyers,* 197–98.

84. *New York Times,* January 23, 1910, pt. 5, p. 2, in Weitzenhoffer, *Havemeyers,* 197–98.

85. MC to LH, March 10, [1908?]. C 58. MMAA.

86. Hale, *Mary Cassatt,* 238; Mathews, *Mary Cassatt: A Life,* 291.

87. MC to LH, July 16, [1913]. B 95. MMAA.

88. MC to LH, July 16, [1913]. B 95. MMAA.

89. MC to LH, November 4, [1913?]. C 71. MMAA.

90. MC to LH, November 8, [1914?]. C 92. MMAA.

91. MC to LH, November 8, [1914?]. C 92. MMAA.

92. MC to LH, July 13, [1915]. B 85. MMAA.

93. MC to LH, July 7, [1916]. C 152. MMAA. MC to LH, [1916]. C 153. MMAA.

94. MC to LH, July 5, [1915]. B 86. MMAA.

95. MC to LH, July 19, [1918]. C 100. MMAA.

96. MC to LH, August 4, 1918. C 103. MMAA.

97. MC to LH, November 29, 1920. C 79. MMAA.

98. MC to LH, November 29, 1920. C 79. MMAA.

99. MC to LH, [1916]. C 153. MMAA.

100. MC to LH, November 8, [1914?]. C 92. MMAA.

101. MC to LH, November 8, [1914?]. C 92. MMAA.

102. MC to LH, [1916]. C 153. August 3, [1916?]. C 151. MMAA.

103. MC to LH, June 25, 1918. C 98. MMAA.

104. MC to LH, May 14, [1915]. C 147. MMAA.

105. MC to LH, June 25, 1918. C 98. MMAA.

106. MC to LH, June 25, 1918. C 98. MMAA.

107. MC to LH, September 10, [1916]. Y 2. MMAA.

108. MC to LH, July 12, [1917?]. C 110. MMAA.

109. MC to LH, July 19, [1918]. C 100. MMAA.

110. Information appearing on a typed sheet attached to the back of photograph 3057, box 7, in the National Woman's Party (hereafter NWP) archives, currently in the Library of Congress (hereafter LOC). Havemeyer's work on food conservation attracted reports in the press—see clippings in the SMA. Cassatt's letter to Havemeyer states: "Thanks a thousand times for the promise of jam, far more helpful for the hospitals here than money." MC to LH, July 19, [1918]. C 100. MMAA.

111. Ambroise Vollard, *Recollections of a Picture Dealer,* trans. Violet M. Macdonald (Boston: Little, Brown, 1936), 142.

112. Havemeyer, *Sixteen to Sixty,* 196.

113. Hirshler, "Helping 'Fine Things Across the Atlantic,'" 192.

114. MC to LH, September 11, [1918]. C 107. MMAA.

115. Laura D. Corey concludes, based on an examination of the archives of Durand-Ruel and Ambroise Vollard, the two main dealers from which the Havemeyers acquired modern art, that Cassatt was not remunerated by them. Corey, "The Many Hats of Mary Cassatt: Artist, Advisor, Broker, Tastemaker," In *Dealing Art on Both Sides of the Atlantic: 1860–1940,* ed. Lynn Catterson (Leiden: Brill, 2017), 39–58, at 51–52.

116. Corey, "Many Hats of Mary Cassatt," 52.

117. MC to LH, November 13, [1910]. B 97. MMAA.

118. MC to LH, December 3, [1914?]. C 86. MMAA.

119. MC to LH, December 11, 1906. C 56. MMAA. MC to LH, December 21, [1906]. B 157. MMAA. MC to LH, December 27 [1906?]. B 172. MMAA. MC to LH, December 26, 1909. B 133. MMAA.

120. MC to LH, July 19, [1906?]. B 163. MMAA. Emphasis in original.

121. MC to LH, November 24, [1914?]. C 113, MMAA. MC to LH, January 11, [1915?]. C 112. MMAA.

122. MC to LH, December 27, [1906?]. B 172. MMAA.

123. MC to LH, April 4, [1908?]. C 63. MMAA.

124. MC to LH, January 11, [1915?]. C 112. MMAA.

125. MC to LH, December 2, [1913]. C 49. MMAA.

126. Frederick A. Sweet, "Mary Cassatt, 1844–1926," *Art Institute of Chicago Quarterly* 48, no. 1 (February 1, 1954): 4–9, at 6.

127. MC to LH, February 4, [1912]. C 25. MMAA.

128. MC to LH, February 25, [1912]. C 23. MMAA.

129. MC to LH, February 4, [1912]. C 25. MMAA.

130. MC to LH, December 11, [1906]. C 56. MMAA.

131. MC to LH, February 7, [1920]. A 27. MMAA.

132. Havemeyer, *Sixteen to Sixty*, 268.

133. Théodore Duret, *Manet and the French Impressionists: Pissarro, Claude Monet, Sisley, Renoir, Berthe Morisot, Cézanne, Guillaumin,* trans. J.E. Crawford Flitch (Philadelphia: J.B. Lippincott; London: Grant Richards, 1910), 285.

134. MC to LH, January 18, [1910]. B 137. MMAA.

135. MC to LH, April 14, [1915?]. C 90. MMAA.

136. MC to LH, n.d., in Havemeyer, *Sixteen to Sixty*, 290.

137. MC to LH, September 28, [1910]. B 129. MMAA.

138. Havemeyer, *Sixteen to Sixty*, 268–97.

139. MC to LH, December 9, [1910]. B 120. MMAA.

140. Weitzenhoffer, *Havemeyers*, 241.

141. MC to LH, May 18, 1920. A 6. MMAA.

142. MC to LH, January 16, [1920]. A 7. MMAA.

143. MC to LH, April 14, [1915?]. C 90. MMAA.

144. MC to LH, December 8, [1909?]. C 60. MMAA.

145. Havemeyer, *Sixteen to Sixty*, 279. Havemeyer also mentioned this in a text announcing her upcoming public talk in Boston, attached to the back of photograph no. 1055, NWP, box 7, NWP archives. Undated (sometime after 1923). Currently in LOC.

146. Havemeyer, "The Suffrage Torch: Memories of a Militant," *Scribner's Magazine,* May 1922, 528–39, at 528.

147. See Weitzenhoffer, chap. 17 in *Havemeyers.*

148. MC to LH, September 15, [1910]. B 126. MMAA.

149. MC to LH, March 10, [1913]. B 109. MMAA.

150. MC to LH, [May 1913]. B 104.5. MMAA.

151. Elizabeth Frost-Knappman and Kathryn Cullen-DuPont, *Women's Suffrage in America: An Eyewitness History* (New York: Facts On File, 2005), 296.

152. MC to LH, May 19, 1913. C 51. MMAA.

153. MC to LH, November 11, [1914]. C 93. MMAA.

154. TP to LH, August 30, 1915. MMAA.

155. MC to LH, November 11, [1914]. C 93. MMAA. MC to LH, March 24, [1917]. B 26. MMAA.

156. MC to LH, May 7, [1913]. B 110. MMAA. Cassatt was reading C.V. Legros's *Fabre: Poet of Science,* trans. Bernard Miall (New York: Century, 1913). Mathews, *Mary Cassatt: A Life*, 299n19, 353.

157. MC to LH, March 24, [1917]. B 26. MMAA.

158. Havemeyer, "Suffrage Torch," 529.

159. One letter of thanks to Havemeyer stated: "You have helped us so often and so generously that one feels one should invent a new language to thank you for the many gifts and the generous spirit in which you have always sent your checks." National Chairman of the NWP to LH, January 19, 1921, HV LOC; Elizabeth S. Rogers to Alice Paul, January 19, 1921, HV LOC.

160. Rebecca Hourwich, "An Appreciation of Mrs. Havemeyer," *Equal Rights* 14, no. 52 (February 2, 1929): 411.

161. National Chairman of NWP to LH, January 18, 1921, HV LOC; National Chairman of NWP to LH, January 18, 1921, HV LOC. On Bartlett, see Smithsonian American Art Museum, https://americanart.si.edu/artist/paul-wayland-bartlett-266.

162. On Cassatt's portrait of Louisine Havemeyer, see Weitzenhoffer, *Havemeyers,* 113; Mathews, *Mary Cassatt: A Life,* 109; and Mathews, "The Havemeyer Portraits," in *Mary Cassatt: Friends and Family* (Shelburne, VT: Shelburne Museum, 2008), 37–42.

163. Linda Nochlin, "Issues of Gender in Cassatt and Eakins," in *Nineteenth Century Art: A Critical History,* ed. Stephen F. Eisenman (London: Thames & Hudson, 1994), 255–73, at 255 and 258.

164. Mathews, "Havemeyer Portraits," 42.

165. Weitzenhoffer, *Havemeyers,* 107.

166. For an account, see Sweet, *Miss Mary Cassatt,* 199–200; Weitzenhoffer, *Havemeyers,* 246–47; Mathews, *Mary Cassatt and Her Circle,* 336; Mathews, *Mary Cassatt: A Life,* 317–19.

167. MC to Harris Whittemore (hereafter HW) (the art collector), May 12, 1924, in Sweet, *Miss Mary Cassatt,* 199–200.

168. MC to HW, May 12, 1924, in Sweet, *Miss Mary Cassatt,* 199–200.

169. MC to HW, May 12, 1924, in Sweet, *Miss Mary Cassatt,* 201; MC to Mary Gardner Smith (her cousin), 1925, in Sweet, *Miss Mary Cassatt,* 207.

170. Sweet, *Miss Mary Cassatt,* 200. Some of the letters are published in Sweet, *Miss Mary Cassatt,* 200–206, and Mathews, *Mary Cassatt and Her Circle,* 340–41.

171. MC to Joseph Durand-Ruel (hereafter JD-R), March 1, 1924, in Weitzenhoffer, *Havemeyers,* 247.

172. MC to HW, May 12, 1924, in Sweet, *Miss Mary Cassatt,* 201.

173. MC to JD-R, January 19, 1924, in Weitzenhoffer, *Havemeyers,* 246–47.

174. Sweet, *Miss Mary Cassatt,* 208.

175. Mathews, *Mary Cassatt and Her Circle,* 272–73.

176. MC to JD-R, January 13, 1924, in Mathews, *Mary Cassatt and Her Circle,* 337.

177. MC to Jane Miller, 1919, in Sweet, *Miss Mary Cassatt,* 193–94.

178. On the history of the NWP, see Doris Stevens, *Jailed for Freedom* (New York: Boni and Liveright, 1920); and Inez Haynes Irwin, *The Story of the Woman's Party* (New York: Harcourt, Brace, 1921).

179. MC to JD-R, January 13, 1924, in Mathews, *Mary Cassatt and Her Circle,* 337.

180. Havemeyer, "Suffrage Torch"; Havemeyer, "The Prison Special: Memories of a Militant," *Scribner's Magazine,* June 1922, 661–76.

181. "Notes on Scribner Authors June Number," *Scribner's Magazine,* June 1922, 17.

182. MC to LH, May 24, 1919. C 5. MMAA.

183. Frost-Knappman and Cullen-DuPont, *Women's Suffrage in America,* 7–8.

184. Frost-Knappman and Cullen-DuPont, *Women's Suffrage in America,* 8.

185. "Miss Alice Paul on Hunger Strike," *New York Times,* November 7, 1917.

186. Havemeyer, "Prison Special," 664.

187. Cited in Irwin, *Story of the Woman's Party,* 408.

188. Havemeyer, "Prison Special," 672.

189. Havemeyer, "Prison Special," 672–73.

190. MC to HW, May 12, 1924, in Sweet, *Miss Mary Cassatt,* 202.

191. MC to LH, September 8, [1920]. C 74. MMAA.

192. On the activities of the NWP after suffrage was achieved, see "Historical Overview of the National Woman's Party," Library of Congress, https://www.loc.gov/static/collections/women-of-protest/images/history.pdf.

193. Hourwich, "An Appreciation," 411.

194. Valet and MC to LH, December 25, 1925, in Weitzenhoffer, *Havemeyers,* 249–50.

195. Valet and MC to LH, April 30, 1926, in Weitzenhoffer, *Havemeyers,* 250.

196. LH to JD-R, June 16, 1926, in Mathews, *Mary Cassatt and Her Circle,* 342.

197. Weitzenhoffer, *Havemeyers,* 251.

198. Weitzenhoffer, *Havemeyers,* 251.

199. Weitzenhoffer, *Havemeyers,* 251.

200. Handwritten copy of Louisine Havemeyer's speech, April 20, 1920, cited in Weitzenhoffer, *Havemeyers,* 240.

201. Clippings, in bound volume (see initials of Electra and Louisine Havemeyer), SMA.

3. CASSATT AND DEGAS

Epigraphs: Edgar Degas to Ludovic Lepic, [fall 1879], in *The Letters of Edgar Degas,* ed. Theodore Reff (New York: The Wildenstein Plattner Institute, 2020), 3:54; MC to George Biddle, September 29, [1917], in Mathews, *Mary Cassatt and Her Circle,* 328.

1. Jean Sutherland Boggs, *Degas* (New York: Metropolitan Museum of Art, 1988), 320.

2. Denys Sutton, *Degas: Life and Work* (1986; New York: Artabras, 1991), 281, 293.

3. Jeffrey Meyers, *Impressionist Quartet: The Intimate Genius of Manet and Morisot, Degas and Cassatt* (New York: Harcourt and Brace, 2005), 267–87.

4. Hale, *Mary Cassatt,* 57–135.

5. Sweet, *Miss Mary Cassatt,* 18.

6. The practice of erroneously referring to Cassatt as Degas's "pupil" had begun already in her lifetime and continued in twentieth- and some twenty-first-century scholarship. For analysis of this issue, see Kimberly A. Jones, introduction, and Amanda T. Zehnder, "Forty Years of Artistic Exchange," in Jones, *Degas Cassatt,* xiii-xiv, 2–19, at 3–4; Ruth E. Iskin, "The Collecting Practices of Degas and Cassatt: Gender and the Construction of Value in Art History," in *Perspectives on Degas,* ed. Kathryn Brown (London: Routledge, 2017), 205–30.

7. White, *Impressionists Side by Side,* 183–210; Shackelford, "Pas de Deux," 109–43.

8. White, *Impressionists Side by Side,* 183–84.

9. Shackelford, "Pas de Deux," 117.

10. Laura D. Corey ascertained that the dealers Paul Durand-Ruel and Ambroise Vollard did not pay Cassatt for her role in advising the Havemeyers or other collectors. Corey, "Many Hats of Mary Cassatt," 39–58, at 51–52.

11. Shackelford, "Pas de Deux," 110.

12. Mathews, *Mary Cassatt and Edgar Degas* (San José, CA: San José Museum of Art, 1981), 3.

13. Jones, *Degas Cassatt,* xv. On the Degas-Cassatt artistic dialogue, see Zehnder, "Forty Years of Artistic Exchange," in Jones, *Degas Cassatt,* 2–19.

14. Segard, *Mary Cassatt,* 35.

15. A brief version of this is discussed in Iskin, "Cassatt's Singular Women: Reading *Le Figaro* and the Older New Woman," in *A Companion to Nineteenth-Century Art,* ed. Michelle Facos (Oxford: Wiley Blackwell, 2018), 467–84.

16. Joseph Gabriel Tourny (1817–1880) was sometimes misidentified as Léon Tourny (Mathews, *Mary Cassatt: A Life,* 115; White, *Impressionists Side by Side*). He is identified as Joseph Gabriel

Tourny in Sweet, *Miss Mary Cassatt,* 31–32; Shackelford, "Pas de Deux," 109n4; Theodore Reff, ed., *The Letters of Edgar Degas* (New York: Wildenstein Plattner Institute, 2020), 1:119n17.

17. Reff, *Letters of Edgar Degas,* 1:119n17.
18. Segard, *Mary Cassatt,* 35.
19. MC to Emily Sartain, June 25, [1873], in Mathews, *Mary Cassatt and Her Circle,* 121.
20. Reff, *Letters of Edgar Degas,* 1:119n17.
21. Reff, *Letters of Edgar Degas,* 1:119n17.
22. Degas to Gustave Moreau, [September 1858] (no. 5), in Reff, *Letters of Edgar Degas,* 3:10.
23. Degas to Moreau, September 1858, in Reff, *Letters of Edgar Degas,* 3:10.
24. Reff, *Letters of Edgar Degas,* 1:119n17.
25. Reff, *Letters of Edgar Degas,* 1:119n17.
26. Degas to Charles Deschamps, [October 1874] (no. 46), in Reff, *Letters of Edgar Degas,* 1:35.
27. Degas to Charles Deschamps, [October 1874] (no. 46), in Reff, *Letters of Edgar Degas,* 1:195.
28. Color illustration in Jones, *Degas Cassatt,* 3, fig. 1.
29. Segard, *Mary Cassatt,* 35.
30. *Journal amusant,* June 27, 1874, caricature no. 326, in Mathews, *Mary Cassatt: A Life,* 91.
31. Sweet, *Miss Mary Cassatt,* 31.
32. Degas's visit to Cassatt's studio is dated to 1877 in Segard, *Mary Cassatt,* 35.
33. Segard, *Mary Cassatt,* 22.
34. Havemeyer, *Sixteen to Sixty,* 275.
35. Havemeyer, *Sixteen to Sixty,* 8.
36. Havemeyer, *Sixteen to Sixty,* 275.
37. Including, among others, Charles Chaplin, Jean-Léon Gérôme, and Thomas Couture.
38. Reported by Cassatt's friend Eliza Haldeman, an art student with whom she was studying in Ecouen, France, to her mother, Mrs. Samuel Haldeman, May 15, 1867, in Sweet, *Miss Mary Cassatt,* 46.
39. Lionello Venturi, *Les archives de l'Impressionnisme* (Paris: Durand-Ruel, 1939), 1:115.
40. Dorothy Weir Young, *The Life and Letters of J. Alden Weir,* ed. with an introduction by Lawrence W. Chisholm (New Haven, CT: Yale University Press, 1960), 123.
41. Robert Cassatt to Alexander Cassatt, May 21, 1879, in Mathews, *Mary Cassatt and Her Circle,* 144.
42. Havemeyer, *Sixteen to Sixty,* 244–45.
43. Barbara Stern Shapiro, "A Printmaking Encounter," in *The Private Collection of Edgar Degas,* ed. Ann Dumas et al. (New York: Metropolitan Museum of Art, 1997), 235–46, at 235; White, *Impressionists Side by Side,* 197; Zehnder, "Forty Years of Artistic Exchange," in Jones, *Degas Cassatt,* 6–7; Sarah Lees, "Innovative Impressions: Cassatt, Degas and Pissarro as Painter Printmakers," in *Innovative Impressions, Prints by Cassatt, Degas, and Pissarro,* ed. Sarah Lees and Richard R. Brettel (Munich: Hirmer, 2018), 11–103, at 12.
44. Mathews, *Mary Cassatt: A Life,* 142. Cassatt later installed her own printing press on her property in the countryside.
45. Degas to Pissarro, [1879–80] (no. 117), in Reff, *Letters of Edgar Degas,* 3:55.
46. Degas to Félix Bracquemond, [January 1880] (no. 120), in Reff, *Letters of Edgar Degas,* 3:56.
47. Katherine Kelso Cassatt to Alexander Cassatt, April 9, 1880, in Mathews, *Mary Cassatt and Her Circle,* 151.
48. For example, Degas letters no. 202 & no. 244, in Reff, *Letters of Edgar Degas,* 3:75, 88.
49. Degas to Bartholomé, April 28, 1885 (no. 244), in Reff, *Letters of Edgar Degas,* 3:88.
50. Degas to Mallarmé, August 30, [1888] (no. 329), in Reff, *Letters of Edgar Degas,* 3:110.
51. MC to Alexander Cassatt, May 17, 1866, in Sweet, *Miss Mary Cassatt,* 104.
52. Degas to Bartholomé, April 29, [1890] (no. 386), in Reff, *Letters of Edgar Degas,* 3:129.

53. Degas to his sister, Thérèse Degas (Mrs. Morbilli), March 11, [1892] (no. 487), in Reff, *Letters of Edgar Degas,* 3:158–59.

54. Matthews, *Mary Cassatt: A Life,* 374.

55. Paul-André Lemoisne identified eight artworks for which Cassatt modeled. Lemoisne, *Degas et son oeuvre,* 4 vols. (Paris: Brame et Hauke, 1946). See also Jones, "'A Finer Curve': Identity and Representation in Degas' Depictions of Cassatt," in Jones, *Degas Cassatt,* 86–97.

56. Jones, *Degas Cassatt,* 67, illustration no. 53, and see discussion of the painting, 95–96.

57. MC to PD-R, late 1912, in Venturi, *Les archives de l'Impressionnisme,* 2:129.

58. MC to PD-R, late 1912, in Venturi, *Les archives de l'Impressionnisme,* 2:129.

59. Jones, *Degas Cassatt,* 97.

60. Havemeyer, *Sixteen to Sixty,* 267.

61. Segard, *Mary Cassatt,* 168n1.

62. Illustration in Dumas, *Private Collection of Edgar Degas,* 239, fig. 318.

63. For example, White, *Impressionists Side by Side,* 184; Shackelford, "Pas de Deux," 110.

64. Havemeyer, *Sixteen to Sixty,* 275.

65. Havemeyer, *Sixteen to Sixty,* 278. Durand-Ruel acquired only three out of several hundred Degas nudes throughout the 1880s. Gary Tinterow, "The 1880s: Synthesis and Change," in Boggs, *Degas,* 363–74, at 370.

66. Emily Sartain to her father, John Sartain, March 7, 1872, in Mathews, *Mary Cassatt and Her Circle,* 95.

67. Sartain to her father, May 8, 1873, in Mathews, *Mary Cassatt and Her Circle,* 117–18.

68. Forbes Watson, *Mary Cassatt* (New York: Whitney Museum of American Art, 1932), 8, 12.

69. Watson, *Mary Cassatt,* 12.

70. Jacques-Émile Blanche, "Bartholomé et Degas," *L'art vivant,* no. 124 (February 15, 1930): 154–56, as recounted in Sutton, *Degas,* 281.

71. Blanche, "Bartholomé et Degas," 154–56.

72. MC to LH, October 12, 1906, B 154. MMAA.

73. MC to Vollard, 1878, in Sweet, *Miss Mary Cassatt,* 39.

74. Berthe Morisot to her sister, Edma Pontillon, in *Berthe Morisot: The Correspondence with Her Family and Friends,* ed. Denis Rouart, trans. Betty W. Hubbard (New York: E. Wyethe, 1959), 41.

75. Rouart, *Berthe Morisot,* 41.

76. George Moore, *Reminiscences of the Impressionist Painters* (Dublin: Maunsel, 1906).

77. Ambroise Vollard, *Degas: An Intimate Portrait,* trans. Randolph T. Weaver (1927; New York: Dover, 1986), 48.

78. Degas to Pissarro, [January 1880] (no. 121), in Reff, *Letters of Edgar Degas,* 3:57.

79. Dumas, *Private Collection of Edgar Degas,* 240.

80. Cassatt made some anti-Semitic comments, most prominently in discussing the Jewish art collectors Gertrude, Leo, and Michael Stein. See MC to Ellen Mary Cassatt, March 26, [1913?], in Mathews, *Mary Cassatt and Her Circle,* 310; Sweet, *Miss Mary Cassatt,* 196; Mathews, *Mary Cassatt: A Life,* 283.

81. Degas to Mme. de Fleury, [spring 1887] (no. 304), in Reff, *Letters of Edgar Degas,* 1:415. Norma Broude suggested that Degas may have been exposed to Italian feminism through his friend the Italian critic Diego Martelli, who was a feminist. Broude, "Edgar Degas and French Feminism c. 1880: 'The Young Spartans,' the Brothel Monotypes and the Bathers Revisited," *Art Bulletin* 70, no. 4 (December 1988): 640–59, at 647–48.

82. For example, with Morisot. Broude, "Degas' 'Misogyny,'" *Art Bulletin* 59 (March 1977): 95–107, at 103.

83. Cassatt, who was probably introduced to Mme. de Fleury by Degas, did a portrait of her looking pensive as she leans on her elbow resting on a small table with a vase of flowers, *Madame H. de Fleury and Her Child,* 1890 (private collection). Adelyn Dhome Breeskin, *Mary Cassatt: A Cata-*

logue Raisonné of the Oils, Pastels, Watercolors and Drawings (Washington, DC: Smithsonian Institution Press, 1970), Br no. 175.

84. On Degas's artistic interest in Valadon, see Sutton, *Degas*, 294; Henri Loyrette, *Degas* (Paris: Fayard, 1991), 636. Heather Dawkins, *The Nude in French Art and Culture, 1870–1910* (Cambridge: Cambridge University Press, 2002), 86–90.

85. Marx collected Cassatt's artworks, including 130 of her prints. Dumas, *Private Collection of Edgar Degas*, 240.

86. MC to Marx, 1907 (no. 70), in Donations Claude Roger-Marx, 1980, INHA library; this sentence of the letter is in Reff, *Letters of Edgar Degas*, 1:416n4.

87. The issue of misogyny is discussed at length in Broude, "Degas' 'Misogyny'"; and Broude, "Degas' Alleged Misogyny: The Resilience of a Cultural Myth," in *Dance, Politics and Society*, ed. Adriano Pedrosa and Fernando Oliva (São Paulo: Museu de Arte de São Paulo, 2021), 28–40. See also Charles Bernheimer, *Figures of Ill Repute: Representing Prostitution in Nineteenth-Century France* (Cambridge, MA: Harvard University Press, 1989), Carol Armstrong, *Odd Man Out: Readings of the Work and Reputation of Edgar Degas* (Chicago: University of Chicago Press, 1991), 190–99, 222–23.

88. MC to Homer St. Gaudens, December 28, 1922, in Mathews, *Mary Cassatt and Her Circle*, 335.

89. Segard, *Mary Cassatt*, 58n1.

90. Havemeyer, *Sixteen to Sixty*, 244.

91. Havemeyer, *Sixteen to Sixty*, 244.

92. Segard, *Mary Cassatt*, 184.

93. Segard, *Mary Cassatt*, 185.

94. Robert Cassatt to Alexander Cassatt, April 14, 1886, in Sweet, *Miss Mary Cassatt*, 102.

95. See the photograph by Degas, ca. 1895, of Mme. Ludovic Halévy and Elie Halévy, seated in his living room, in which Cassatt's *Girl Arranging Her Hair*, 1886, is visible. Barter, *Mary Cassatt*, 129, fig. 26. Havemeyer (through Durand-Ruel) acquired the painting at the Degas sale.

96. MC to LH, undated fragment of a letter, in Havemeyer, *Sixteen to Sixty*, 288.

97. MC to Pissarro, June 17, [1892], in Mathews, *Mary Cassatt and Her Circle*, 229.

98. Pissarro to his son Lucien, October 2, 1892, in *Camille Pissarro, Letters to His Son Lucien*, ed. John Rewald (Santa Barbara, CA: Peregrine Smith, 1981), 258.

99. MC to Bertha Palmer, December 1, [1892], in Mathews, *Mary Cassatt and Her Circle*, 241.

100. Havemeyer, *Sixteen to Sixty*, 243.

101. Degas to Évariste de Valernes, October 20, 1890 (no. 432), in Reff, *Letters of Edgar Degas*, 3:145.

102. Havemeyer, *Sixteen to Sixty*, 275.

103. Havemeyer, *Sixteen to Sixty*, 275.

104. Sweet, *Miss Mary Cassatt*, 3.

105. Havemeyer, *Sixteen to Sixty*, 244.

106. Havemeyer, *Sixteen to Sixty*, 276.

107. Degas to Lepic, [fall 1879] (no. 112), in Reff, *Letters of Edgar Degas*, 3:54 (emphasis in the original). Broude, "Degas' 'Misogyny,'" 104, cites this letter as evidence of Degas's respect for Cassatt; White, *Impressionists Side by Side*, 186, mentions the letter as one of a few rare examples of instances in which Degas "acted kindly to Cassatt."

108. Degas to Bartholomé, September 9, 1888 (no. 336), in Reff, *Letters of Edgar Degas*, 3:114.

109. Degas to Rouart, [June 14, 1889] (no. 356), in Reff, *Letters of Edgar Degas*, 3:119.

110. For example, Degas to Lucie Degas (his niece), March 16, [1882] (no. 169), in Reff, *Letters of Edgar Degas*, 3:67; Degas to Rouart, October 16, [1883] (no. 202), in Reff, *Letters of Edgar Degas*, 3:75; Degas to Bartholomé, September 15, 1884 (no. 226) in Reff, *Letters of Edgar Degas*, 3:83; Degas to Bartholomé, January 13, 1885 (no. 241), in Reff, *Letters of Edgar Degas*, 3:87.

111.　MC to LH, April 28, 1920. A 18 ABCDE. MMAA.

112.　MC to LH, December 8, [1919]. A 19. MMAA. (The quote appears in the later part of the letter, dated December 10.)

113.　Havemeyer, *Sixteen to Sixty,* 276.

114.　Degas to his sister, Thérèse Morbilli, in Boggs, *Degas,* 495.

115.　MC to LH, [March 1912]. C 20. MMAA.

116.　MC to LH, December 1, [1911]. C 29. MMAA.

117.　MC to LH, September 11, [1913]. B 92. MMAA.

118.　MC to LH, February 15, [1914]. C 96. MMAA.

119.　MC to LH, October 2, [1917]. A 10. MMAA.

120.　MC to LH, October 2, [1917]. A 10. MMAA.

121.　MC to LH, October 2, [1917]. A 10 AB. MMAA.

122.　MC to LH, October 2, [1917]. A 10 AB. MMAA.

123.　For a critical view of the conjectures about a romantic relationship, see Jones, *Degas Cassatt,* xiii–xiv.

124.　Sweet, *Miss Mary Cassatt,* 182.

125.　Hale, *Mary Cassatt,* 85–86.

126.　Roy McMullen, *Degas: His Life, Times, and Work* (Boston: Houghton Mifflin, 1984), 298.

127.　Havemeyer, *Sixteen to Sixty,* 256.

128.　On Cézanne's views, see Alex Danchev, *Cézanne: A Life* (New York: Pantheon Books, 2012), 148.

129.　Watson, *Mary Cassatt,* 14.

130.　Havemeyer, *Sixteen to Sixty,* 261, 278.

131.　Ruth Berson, ed., *The New Painting: Impressionism 1874–1886* (San Francisco: Fine Arts Museums of San Francisco, 1996), 2:240.

132.　MC to LH, December 12, [1917]. A 12. MMAA.

133.　MC to LH, December 28, [1917]. A 9 AB. MMAA.

134.　Erica E. Hirshler and Elliot Bostwick Davis, "A Place in the World of Art: Cassatt, Degas, and American Collectors," in Jones, *Degas Cassatt,* 128–37, at 134.

135.　Hirshler and Davis, "Place in the World," 133; Shackelford, epilogue to *Degas and the Nude,* ed. George T. M. Shackelford, Xavier Rey, et al. (Boston: Museum of Fine Arts, 2011), 213–19, at 213.

136.　MC to LH, January 30, [1913]. B 106. MMAA.

137.　Vollard, *Degas,* 71.

138.　Martha Ward, "The Eighth Exhibition 1886: The Rhetoric of Independence and Innovation," in Moffett, *New Painting,* 421–42, at 433.

139.　Gustave Geffroy, cited in Ward, "Eighth Exhibition," 432.

140.　Ward, "Eighth Exhibition," 431. On the reception of Degas's nudes, see also Armstrong, *Odd Man Out,* 157–210.

141.　MC to LH, April [1913]. B 107. MMAA. (MC's handwriting, presumably to LH. Fragment of a letter; the first page is missing.)

142.　Richard Kendall, *Degas: Beyond Impressionism* (London: National Gallery of Art, 1996), 155.

143.　Dawkins, *Nude in French Art and Culture,* 126. Anthea Callen suggested that a female spectator viewing Degas's nudes in the gallery was "implicated" as "a participant in the voyeuristic adultery of her male peers." Callen, "Degas' Bathers: Hygiene and Dirt—Gaze and Touch," in *Dealing with Degas: Representations of Women and the Politics of Vision,* ed. Richard Kendall and Griselda Pollock (New York: Universe, 1992), 277.

144.　Hirshler, "Helping 'Fine Things Across the Atlantic,'" 177–211, at 185.

145.　On the identities of the nudes, see Eunice Lipton, *Looking into Degas: Uneasy Images of Women and Modern Life* (Berkeley: University of California Press, 1986), 185; Broude, "Edgar Degas and

French Feminism," 653–57; Hollis Clayson's discussion of Degas's monotypes, *Painted Love: Prostitution in French Art of the Impressionist Era* (New Haven, CT: Yale University Press, 1991), 56–112; Shackelford, Rey, et al., *Degas and the Nude,* 97–102.

146. Havemeyer, *Sixteen to Sixty,* 261.

147. Karen Offen, *Debating the Woman Question in the French Third Republic, 1870–1920* (Cambridge: Cambridge University Press, 2018), 120–32.

148. Elizabeth Robins, *My Little Sister* (1912; New York: Dodd, Mead, 1913). The American-born author was a suffragist, actress, playwright, and novelist who lived in England.

149. MC to LH, February 4, [1914?]. C 154. MMAA.

150. The bronze was lost. Once it appeared on the cover of *The Survey,* a liberal magazine, it prompted a controversy over the child's nudity. Susan P. Casteras, "Abastenia St. Leger Eberle's 'White Slave,'" *Woman's Art Journal* 7, no. 1 (Spring–Summer 1986): 32–36.

151. Shackelford, Rey, et al., *Degas and the Nude,* 140.

152. For example, Boggs, *Degas,* 443; Shackelford, Rey, et al., *Degas and the Nude,* 144.

153. Alice Michel, "Degas and His Model," trans. Jeff Nagy (New York: David Zwirner Books, 2017), originally published as "Degas et son Modèle," *Mercure de France,* February 1 and 16, 1919. For analysis of Michel's memoir, see Dawkins, *Nude in French Art and Culture,* 90–112. The French author Rachilde, who had increasing responsibilities at the *Mercure de France* after 1900 and participated in political organizing at the time, was influential in publishing Michel's memoir. Possibly, she and the journalist Séverine encouraged a former model to write, or else wrote the article themselves under the pseudonym "Alice Michel" based on discussions with the model. Dawkins, *Nude in French Art and Culture,* 111–12.

154. Michel, "Degas and His Model," 42.

155. Michel, "Degas and His Model," 48.

156. Broude, "Edgar Degas and French Feminism," 654–55. See also Lipton, *Looking into Degas,* 180–81, who described the bathers as self-absorbed (i.e., depicted as they might experience themselves rather than as a desiring man—or any viewer, for that matter—might look at them).

157. James Huneker, *Promenades of an Impressionist* (New York: Charles Scribner's Sons, 1910), 76.

158. MC to LH, January 11, [1913], in Mathews, *Mary Cassatt and Her Circle,* 308.

159. Degas to Halévy, [August 1880] (no. 132), in Reff, *Letters of Edgar Degas,* 3:59.

160. MC to Morisot, [April 1890], in Mathews, *Mary Cassatt and Her Circle,* 214.

161. Segard, *Mary Cassatt,* 104. Mathews, "Color Prints," 87n63.

162. Dawkins, *Nude in French Art and Culture,* 122.

163. Pollock, *Mary Cassatt: Painter of Modern Women,* 176.

164. Mari Yoshihara, who analyzes white women's participation in the discourse of American Orientalism, interprets Cassatt's prints as breaking with this discourse because Cassatt "used an Asian art *form* for her alternative vision of bourgeois white womanhood." Yoshihara, *Embracing the East: White Women and American Orientalism* (New York: Oxford University Press, 2003), 56.

165. Anne Higonnet, *Berthe Morisot's Images of Women* (Cambridge, MA: Harvard University Press, 1992), 192. Hollis Clayson suggests that Cassatt's use of the Japanese aesthetic was "a gesture in the direction of artistic cosmopolitanism or rather explicitly non-American otherness." Clayson, "Cassatt's Alterity," 259.

166. Lindsay Leard, "The *Société peintres-graveurs Français* in 1889–97," *Print Quarterly* 14, no. 4 (December 1997): 355–63, at 356–60.

167. Leard, "*Société peintres-graveurs Français,*" 360.

168. Pissarro to his son Lucien, January 10, 1891, in Rewald, *Camille Pissarro,* 175.

169. Segard, *Mary Cassatt,* 87; Pissarro to his son Lucien, April 3, 1891, in Rewald, *Camille Pissarro,* 196.

170. Pissarro to his son Lucien, April 3, 1891, in Rewald, *Camille Pissarro*, 196–97.

171. Pissarro to his son Lucien, April 3, 1891, in Rewald, *Camille Pissarro*, 196–97.

172. Segard, *Mary Cassatt*, 87.

173. Havemeyer, *Sixteen to Sixty*, 268.

174. Weitzenhoffer, *Havemeyers*; Hirshler, "Helping 'Fine Things Across the Atlantic,'" 177–211; Hirshler and Davis, "Place in the World"; Ann Dumas and David A. Brenneman, eds., *Degas and America: The Early Collectors* (Atlanta: High Museum of Art; Minneapolis: Minneapolis Institute of Arts, 2001), 13–34; Corey, "Many Hats of Mary Cassatt," 39–57. Corey's "Mary Cassatt (1844–1926), American Tastemaker: Portrait of the Artist as Advisor" (PhD diss., Institute of Fine Arts, 2018), was not available at the time of my writing.

175. For the dating of the purchase to 1877, see Stein, "Chronology," 203.

176. Degas letter (no. 85) to an unnamed recipient, perhaps Henri or Alexis Rouart, in Reff, *Letters of Edgar Degas*, 1:233; letters (nos. 71, 74, 75), written during the spring and summer of 1877 to Mrs. Giuseppe De Nittis, in Reff, *Letters of Edgar Degas*, 1:219–20, 223–26.

177. Degas to Ernest Hoschedé, [1877–78] (no. 86), in Reff, *Letters of Edgar Degas*, 3:47. On the Hoschedé 1874 auction, see *Paul Durand-Ruel: Memoirs*, 127; Merete Bodelsen, "Early Impressionist Sales 1874–94 in the Light of Some Unpublished 'procès-verbaux,'" *Burlington Magazine* 110, no. 783 (June 1968): 330–49, at 332.

178. Degas to Mrs. De Nittis, May 25, 1877 (no. 71), in Reff, *Letters of Edgar Degas*, 1:219–21.

179. Havemeyer, *Sixteen to Sixty*, 250.

180. Pissarro to Lucien, March 4, 1886, in Rewald, *Camille Pissarro*, 74.

181. Degas to Mrs. De Nittis, [September–October 1891] (no. 465), in Reff, *Letters of Edgar Degas*, 3:153.

182. Degas to Félix Bracquemond, [June 1879] (no. 109), in Reff, *Letters of Edgar Degas*, 3:53.

183. Breeskin, *Catalogue Raisonné of Oils, Pastels, Watercolors and Drawings*, Br no. 57.

184. MC to Alexander Cassatt, November 18, [1880], in Mathews, *Mary Cassatt and Her Circle*, 152.

185. Katherine Cassatt to Alexander Cassatt, June 30, 1880, in Lindsay, *Mary Cassatt and Philadelphia*, 14.

186. Hirshler, "Helping 'Fine Things Across the Atlantic,'" 190.

187. Havemeyer, *Sixteen to Sixty*, 255–56.

188. Havemeyer, *Sixteen to Sixty*, 252.

189. Mainardi, *End of the Salon*.

190. White and White, *Canvases and Careers*; Jensen, *Marketing Modernism*.

191. On Rouart and Degas, see Michelle Foa, "The Making of Degas: Duranty, Technology, and the Meaning of Materials in Later Nineteenth-Century Paris," *NONsite*, no. 27 (2019), https://nonsite.org/author/mfoa/.

192. Weitzenhoffer, *Havemeyers*, 208.

193. Weitzenhoffer, *Havemeyers*, 208.

194. Cassatt also worked with other dealers, among them Bernheim, Gimpel, Kelekian, and Trotti.

195. On Cassatt's own modest art collection, see Hirshler, "Helping 'Fine Things Across the Atlantic,'" 179–80.

196. Lindsay, *Mary Cassatt and Philadelphia*, 13–16; Hirshler, "Helping 'Fine Things Across the Atlantic,'" 187; Dumas and Brenneman, *Degas and America*, 19.

197. Dumas and Brenneman, *Degas and America*, 19.

198. Dumas and Brenneman, *Degas and America*, 19.

199. Havemeyer, *Sixteen to Sixty*, 33.

200. Havemeyer, *Sixteen to Sixty*, 33.

201. Havemeyer, *Sixteen to Sixty*, 33.

202. Havemeyer, *Sixteen to Sixty,* 263–64.

203. Havemeyer, *Sixteen to Sixty,* 289.

204. Havemeyer, *Sixteen to Sixty,* 289.

205. Lindsay, *Mary Cassatt and Philadelphia,* 13. Among the works Alexander lent were two Cassatts that were added to the exhibition when it moved to a second venue.

206. Phaedra Siebert, "Appendix: Selected Degas Exhibitions in America, 1878–1936," in Dumas and Brenneman, *Degas and America,* 248–50, at 248.

207. "American Water-Color Society; Eleventh Annual Exhibition—Reception to Artists and the Press—American and Foreign Exhibitors," *New York Times,* February 2, 1878, quoted by Rebecca A. Rabinow, "Louisine Havemeyer and Edgar Degas," in Dumas and Brenneman, *Degas and America,* 37.

208. MC to LH, 1921, in Havemeyer, *Sixteen to Sixty,* 297.

209. Havemeyer, *Sixteen to Sixty,* 297.

210. The following year, she lent twelve of the bronzes to the Metropolitan Museum of Art, and in 1925, she lent the museum eleven more Degas bronzes. Stein, "Chronology," 279.

211. Clare Vincent, "The Havemeyers and Degas Bronzes," in Frelinghuysen et al., *Splendid Legacy,* 77.

212. Laura D. Corey and Alice Cooney Frelinghuysen, "Visions of Collecting," in *Making the Met, 1870–2020,* ed. Andrea Bayer and Laura D. Corey (New York: Metropolitan Museum of Art; New Haven, CT: Yale University Press, 2020), 130–51, at 135.

213. Corey and Frelinghuysen, "Visions of Collecting," 137.

214. Tinterow, "Havemeyer Pictures," Frelinghuysen et al., *Splendid Legacy,* 3–53, at 42.

215. Andrea Bayer with Laura D. Corey, eds., *Making the Met, 1870–2020* (New York: Metropolitan Museum of Art; New Haven, CT: Yale University Press, 2020), 55.

216. Tinterow, "Havemeyer Pictures," 3.

217. Tinterow, "Havemeyer Pictures," 3.

218. MC to LH, December 8, 1919. A 19. MMAA. (In the later part of the letter, dated December 10.)

219. MC to LH, February 1, 1915. C 94. MMAA.

220. Stein, "The Metropolitan Museum's Purchases from the Degas Sales: New Acquisition and Lost Opportunities," in Dumas, *Private Collection of Edgar Degas,* 271–91, at 276–82.

221. Stein, "Chronology," 276–77.

222. E. Waldman, "Modern French Pictures: Some American Collections," *Burlington Magazine* 17, no. 85 (April 1910): 62–63, 65–66, at 62.

223. Hirshler, "Helping 'Fine Things Across the Atlantic.'"

224. Dumas and Brenneman, *Degas and America,* 13–34, at 15.

4. CASSATT'S TRANSATLANTIC FEMINISM

Epigraph: MC to LH, October 6, 1920. C 76. MMAA.

1. Mathews, *Mary Cassatt: A Life*; Griselda Pollock, *Mary Cassatt: Painter of Modern Women,* 2nd ed., with a new preface (1998; New York: Thames and Hudson, 2022); Judith A. Barter, "Mary Cassatt: Themes, Sources, and the Modern Woman," in *Mary Cassatt: Modern Woman,* 45–107; Norma Broude, "Mary Cassatt: Modern Woman or the Cult of Womanhood?," *Women's Art Journal* 21, no. 2 (Autumn 2000–Winter 2001): 36–43; Sally Webster, *Eve's Daughter/Modern Woman: A Mural by Mary Cassatt* (Urbana: University of Illinois Press, 2004); Ruth E. Iskin, "Was There a New Woman in Impressionist Painting?," 189–223; Wanda M. Corn, *Women Building History: Public Art at the 1893 Columbian Exposition* (Berkeley: University of California Press, 2011).

2. Webster, *Eve's Daughter/Modern Woman,* 13–14; Carol Faulkner, *Lucretia Mott's Heresy: Abolition and Women's Rights in Nineteenth-Century America* (Philadelphia: University of Pennsylvania Press, 2011).

3. On international feminist congresses, see Offen, *Debating the Woman Question.*

4. The illustration was published as a centerfold in *Puck* 77, no. 1981 (February 20, 1915): 14–15.

5. MC to LH (from Cairo), January 4, 1911. B 142. MMAA.

6. MC to LH, October 6, 1920. C 76. MMAA.

7. MC to LH, May 17, [1915?]. C 146. MMAA.

8. MC to LH, March 24, [1917]. B 26. MMAA.

9. Steven C. Hause, *Hubertine Auclert: The French Suffragette* (New Haven, CT: Yale University Press, 1987).

10. Hause, *Hubertine Auclert*, 75.

11. Doug Linder, "The Trial of Susan B. Anthony for Illegal Voting," 2001, http://law2.umkc.edu/faculty/projects/ftrials/anthony/sbaaccount.html; Jenna L. Kubly, "Women's Suffrage," in *Ideas and Movements That Shaped America: From the Bill of Rights to "Occupy Wall Street,"* ed. Michael S. Green and Scott L. Stabler (Santa Barbara, CA: ABC-Clio, 2015), 3:1118; Ellen Carol DuBois and Lynn Dumenil, *Through Women's Eyes: An American History with Documents*, 4th ed. (Boston: Bedford/St. Martin's, 2015), 285–88.

12. Hause, *Hubertine Auclert*, 76.

13. Wynona H. Wilkins, "The Paris International Feminist Congress of 1896 and Its French Antecedents," *North Dakota Quarterly* 43, no. 4 (Autumn 1975): 5–28, especially 18–27; Offen, *Debating the Woman Question*, 169.

14. MC to LH, August 2, 1914, in Havemeyer, *Sixteen to Sixty*, 279.

15. MC to LH, July 5, [1915]. B 86. MMAA.

16. MC to LH, July 5, [1915]. B 86. MMAA.

17. Mathews, *Mary Cassatt: A Life*, 307.

18. MC to LH, January 30, [1913]. B 106. MMAA.

19. MC to LH, September 15, [1912]. C 9. MMAA.

20. Wisconsin Historical Society Archives, Madison, WI, https://www.wisconsinhistory.org/Records/Image/IM1932.

21. Carrie Chapman Catt, T.A. Larson, and Nettie Rogers Shuler, *Woman Suffrage and Politics: The Inner Story of the Suffrage Movement* (Seattle: University of Washington Press, 1969), 276, 186.

22. MC to LH, August 28, [1913]. B 93. MMAA.

23. MC to LH, August 28, [1913]. B 93. MMAA.

24. Catt, Larson, and Shuler, *Woman Suffrage and Politics*, 271. On the anti-suffragists, see Rebecca Rix, "Anti-Suffragism in the United States," in *Women Making History: The 19th Amendment*, ed. Tamara Gaskell (National Park Service, Department of the Interior, n.d.), 52–62.

25. Catt, Larson, and Shuler, *Woman Suffrage and Politics*, 271.

26. Catt, Larson, and Shuler, *Woman Suffrage and Politics*, 271.

27. MC to LH, May 18, 1920. A 6. MMAA.

28. MC to LH, [March 7, 1913]. B 100. MMAA.

29. MC to LH, March 10, [1913]. B 109. MMAA. Underlining in the original.

30. MC to LH, December 3, [1912]. C 34. MMAA.

31. *Herald*, December 2, 1912.

32. May 19, [1913]. C 51. MMAA.

33. MC to LH, November 15, [1914?]. C 87. MMAA. Six years later, Cassatt wrote again, "We have now so very little in common." MC to LH, April 28, 1920. A 18. MMAA.

34. MC to LH, 10 March, [1908 or 1910?]. C 58. MMAA.

35. Catt, Larson, and Shuler, *Woman Suffrage and Politics*, 491–92.

36. Catherine H. Palczewski, "The Male Madonna and the Feminine Uncle Sam: Visual Argument, Icons, and Ideographs in 1909 Anti-Woman Suffrage Postcards," *Quarterly Journal of Speech* 91, no. 4 (November 2005): 365–94, at 382.

37. Faye E. Dudden, *Fighting Chance: The Struggle over Woman Suffrage and Black Suffrage in Reconstruction America* (New York: Oxford University Press, 2011), 88.

38. MC to LH, September 15, [1912]. C 9. MMAA.

39. Catt discusses the liquor industry's cooperation with the anti-suffragists. See Catt, Larson, and Shuler, *Woman Suffrage and Politics*, 181, 186–87, 192, 270–71, 273, 303.

40. Dudden, chaps. 2 and 3, *Fighting Chance.*

41. Dudden, chaps. 6 and 7, *Fighting Chance.*

42. Dudden, chaps. 6 and 7, *Fighting Chance*; DuBois and Dumenil, *Through Women's Eyes,* 284–86. For an analysis of racist rhetoric in Stanton's writing against the amendment, see Lori D. Ginsberg, chap. 3 in *Elizabeth Cady Stanton: An American Life* (New York: Hill and Wang, 2009); Dudden, chap. 6 in *Fighting Chance.*

43. MC to LH, February 4, [1914]. C 154. MMAA.

44. Robins, *My Little Sister* (also known as *Where Are You Going To . . .?*).

45. Offen, *Debating the Woman Question, 533–39, 547–613.*

46. MC to LH, February 4, [1914]. C 154. MMAA.

47. MC to LH, January 11, [1915?]. C 112. MMAA.

48. MC to LH, August 13, [1914?]. C 91. MMAA.

49. MC to LH, 1914, in Havemeyer, *Sixteen to Sixty,* 296.

50. MC to LH, July 5, [1915]. B 86. MMAA.

51. MC to LH, May 9, 1918. A 53. MMAA.

52. Alice Paul learned Pankhurst's militant strategies while living in England for a few years after completing her MA at the University of Pennsylvania. Katherine H. Adams and Michael L. Keene, Alice Paul and the American Suffrage Campaign (Urbana: University of Illinois Press, 2008); Mary Walton, A Woman's Crusade: Alice Paul and the Battle for the Ballot (New York: Palgrave Macmillan, 2010).

53. MC to LH, December 2, [1913]. C 49. MMAA.

54. MC to LH, November 23, [1913]. C 46. MMAA. Like Pankhurst, Emily Davidson used militant tactics, was imprisoned, went on hunger strikes, and was force-fed. Vera Di Campli San Vito, "Davison, Emily Wilding (1872–1913)," *Oxford Dictionary of National Biography* (Oxford: Oxford University Press, 2004); online edition, September 2017, https://doi.org/10.1093/ref:odnb/37346.

55. San Vito, "Davison, Emily Wilding."

56. MC to LH, November 23, [1913]. C 46. MMAA.

57. MC to LH, November 23, [1913]. C 46. MMAA.

58. MC to LH, August 3, [1916?]. C 151. MMAA.

59. MC to LH, December 3, [1914?]. C 86. MMAA.

60. MC to LH, April 4, [1913]. B 98. MMAA.

61. Twenty-six nations granted the vote to women before the United States.

62. MC to LH, October 6, 1920. C 76. MMAA.

63. Ida Husted Harper, *The Life and Work of Susan B. Anthony: Including Her Addresses, Her Own Letters and Many from Her Contemporaries during Fifty Years,* vol. 2 (Indianapolis: Hollenbeck Press, 1898), 859.

64. *The Revolution* (a weekly newspaper founded by Stanton and Anthony), May 19, 1870, in Françoise Basch, "Women's Rights and Wrongs of Marriage in Mid-Nineteenth-Century America," *History Workshop* 22, no. 1 (Autumn 1986): 18–40, at 21.

65. H.G. Wells, *Marriage* (New York: Duffield, 1912); MC to LH, January 30, [1913]. B 106. MMAA.

66. MC to LH, December 18, [1906]. B 173. MMAA.

67. MC to LH, December 8, [1909?]. C 60. MMAA.

68. Stanton, in Dudden, *Fighting Chance,* 82n137.

69. Maud Howe Elliott, "The Building and Its Decoration," in *Art and Handicraft in the Woman's Building of the World's Columbian Exposition, Chicago, 1893*, ed. Elliott (Paris: Boussod, Valadon, 1893), 23.

70. Offen, *Debating the Woman Question*, 100.

71. Offen, *Debating the Woman Question*, 100.

72. Offen, *Debating the Woman Question*, 102–3.

73. Mary Roth Walsh, *"Doctors Wanted: No Women Need Apply": Sexual Barriers in the Medical Profession, 1835–1975* (New Haven, CT: Yale University Press, 1977).

74. Offen, *Debating the Woman Question*, 327–30, 432–84; Charlotte Alter, "Here's the History of the Battle for Equal Pay for American Women," April 14, 2015, Time.com, "History, Feminism," https://time.com/3774661/equal-pay-history/.

75. On the women Impressionists, see Tamar Garb, *Women Impressionists* (New York: Rizzoli, 1986); Ingrid Pfeiffer and Max Hollein, eds., *Women Impressionists,* trans. Bronwen Saunders and John Tittensor ([Frankfurt am Main]: Schirn Kunsthalle Frankfurt; Ostfildern: Hatje Cantz, 2008). On women and the art system in France, see Garb, *Sisters of the Brush: Women's Artistic Culture in Late Nineteenth-Century Paris* (New Haven, CT: Yale University Press, 1994).

76. Sweet, *Miss Mary Cassatt,* 14.

77. Sweet, *Miss Mary Cassatt,* 15.

78. MC to Eliza Haldeman, 18 March, [1864], in Mathews, *Mary Cassatt: A Life,* 23.

79. Havemeyer, *Sixteen to Sixty,* 282.

80. Havemeyer, *Sixteen to Sixty,* 283.

81. Havemeyer, *Sixteen to Sixty,* 273, 283.

82. MC to LH, January 11, [1915?]. C 112. MMAA.

83. MC to LH, December 26, 1909. B 133. MMAA.

84. MC to LH, December 4, [1913]. C 48. MMAA.

85. MC to LH, May 17, [1910]. B 113. MMAA.

86. Interview with Marcelle Tinayre, *Femina,* April 1906, in Offen, *Debating the Woman Question,* 465.

87. MC to LH, December 2, [1913]. C 49. MMAA.

88. Offen, *Debating the Woman Question,* 461–68.

89. MC to LH, December 4, [1913]. C 48. MMAA.

90. Anna Lea Merritt, "A Letter to Artists: Especially Women Artists," *Lippincott's Magazine,* March 1900, 463–69, reprinted in Nancy Mowll Mathews, ed., *Cassatt: A Retrospective* (New York: Hugh Lauter, 1996), 239–40, at 240.

91. Offen, *Debating the Woman Question,* 102–3.

92. Offen, *Debating the Woman Question.*

93. Sweet, *Miss Mary Cassatt,* 143; Wendy Bellion, "Chronology," in Barter, *Mary Cassatt: Modern Woman,* 345.

94. Mathews, *Mary Cassatt: A Life,* 241. Valet was listed as *"demoiselle de compagnie"* in the census report of the Département de Mesnil-Théribus, 1901, in Bellion, "Chronology," 345.

95. MC to Mary Gardner Smith (her cousin), 1925, in Sweet, *Miss Mary Cassatt,* 207.

96. Havemeyer, *Sixteen to Sixty,* 284.

97. Havemeyer, *Sixteen to Sixty,* 284.

98. MC to LH, February 11, [1911]. B 140. MMAA.

99. MC to LH, December 13, [1910]. B 123. MMAA.

100. MC to LH, January 20, [1911]. B 144. MMAA.

101. MC to LH, May 19, [1913]. C 51. MMAA.

102. MC to LH, August 21, [1913]. C 53. MMAA.

103. Breeskin, *Catalogue Raisonné of Oils, Pastels, Watercolors and Drawings*.

104. Havemeyer, *Sixteen to Sixty*, 283.

105. Catt, Larson, and Shuler, *Woman Suffrage and Politics*, 6–7.

106. Louise Debor, "Féminists et Féminines," *La Fronde,* no. 427 (February 8, 1899): 1, in Offen, *Debating the Woman Question*, 176.

107. Offen, *Debating the Woman Question*, 162.

108. Offen, *Debating the Woman Question*, 162.

109. Robert Cassatt to Alexander Cassatt, December 13, 1878, in Sweet, *Miss Mary Cassatt*, 36–37; Mathews, *Mary Cassatt and Her Circle*, 143.

110. Mathews, *Mary Cassatt and Her Circle*, 142.

111. Katherine Cassatt to Alexander Cassatt, July 23, 1891, in Mathews, *Mary Cassatt: A Life*, 200.

112. Mathews, *Mary Cassatt: A Life*, 231.

113. Mathews, *Mary Cassatt: A Life*, 278.

114. Patricia Talbot Davis, *End of the Line: Alexander J. Cassatt and the Pennsylvania Railroad* (New York: Neale Watson Academic Publications, 1978).

115. Lindsay, *Mary Cassatt and Philadelphia*; Mathews, *Mary Cassatt: A Life*, 278–79.

116. Anon., *North American,* March 1, 1907, in Lindsay, *Mary Cassatt and Philadelphia*, 25.

117. MC to LH, April 9, 1920. A 22. MMAA. Some newspapers estimated Alexander's fortune after his death at $50 million. Mathews, *Mary Cassatt: A Life*, 278.

118. MC to LH, April 28, 1920. A 18. MMAA.

119. Robert Cassatt to Alexander Cassatt, April 18, 1881, in Mathews, *Mary Cassatt and Her Circle*, 160–61. On Alexander Cassatt's collection and Cassatt's involvement in it, see Sweet, *Miss Mary Cassatt*, 56–57, 62, 64, 84; Lindsay, *Mary Cassatt and Philadelphia*, 13–15; Hirshler, "Helping 'Fine Things Across the Atlantic,'" 187–89.

120. Lindsay, *Mary Cassatt and Philadelphia*, 15.

121. Joan W. Scott, "The Woman Worker," in *A History of Women in the West,* ed. Geneviève Fraisse and Michelle Perrot, vol. 4. of *Emerging Feminism from Revolution to World War* (Cambridge, MA: Belknap Press of Harvard University, 1993), 399–448, at 411.

122. Mathews, *Mary Cassatt: A Life*, 278.

123. Mathews, *Mary Cassatt: A Life*, 278.

124. Sweet, *Miss Mary Cassatt*, 65; Mathews, *Mary Cassatt: A Life*, 129.

125. Mathews, *Mary Cassatt: A Life*, 278. Cassatt's father died in 1891, her mother in 1895.

126. On the financial strain of this period, Cassatt wrote: "I will have to sell with all that is before us." MC to LH, September 18, [1913]. B 94. MMAA.

127. Nancy F. Cott, "Marriage and Women's Citizenship in the United States, 1830–1934," *American Historical Review* 103, no. 5 (December 1998): 1440–74, at 1462.

128. This was the case, with the exception of certain racial limitations. See Cott, "Marriage and Women's Citizenship," 1462.

129. Cott, "Marriage and Women's Citizenship," 1463.

130. MC to L H, December 5, [1910]. B 118. MMAA. The director of the United States Information Service, Evan Fotos, explained the context for Cassatt's strong objection: "In those days there was, we understand, a provision of the citizenship law that put a woman's American citizenship in jeopardy if she married a foreigner abroad." Letter by Fotos to Nancy Hale, December 11, 1972, in "Nancy Hale research material on Mary Cassatt, 1970–75," AAA.

131. Harold Melvin Hyman, "Loyalty Defined: The Ironclad Test Oath," in *Era of the Oath: Northern Loyalty Test during the Civil War and Reconstruction* (Philadelphia: University of Pennsylvania Press, 1954), 21–32.

132. Cott, "Marriage and Women's Citizenship," 1464.

133. Cott, "Marriage and Women's Citizenship," 1464.
134. On the suffrage discourse on taxation and examples of feminist tax resistance, see Juliana Tutt, "'No Taxation without Representation' in the American Suffrage Movement," *Stanford Law Review* 62, no. 5 (May 2010): 1473–1512.
135. This postcard was part of a set of thirty, each featuring a pro-suffrage message. Published by the commercial company the Cargill Publishing Company, which was endorsed and approved by the National American Woman Suffrage Association.
136. MC to LH, September 15, [1910]. B 126. MMAA.
137. Tutt, "'No Taxation without Representation,'" 1492.
138. Tutt, "'No Taxation without Representation'"; Elizabeth Cady Stanton, Susan B. Anthony, Matilda Joslyn Gage, and Ida Husted Harper, eds., *History of Woman Suffrage,* New York National American Woman Suffrage Association (New York: Fowler & Wells, 1922), 6:654.
139. Stillman's daughter-in-law, Mildred Whitney, who was married to his youngest son, Ernest Stillman, recounted that Cassatt had dismissively commented that Vigée Le Brun "painted herself." Sweet, *Miss Mary Cassatt,* 185.
140. Mathews, *Mary Cassatt: A Life,* 308, 167; Mathews, *Mary Cassatt and Her Circle,* 316.
141. Cassatt to Marx, [ca. 1896]. INHA Library (Donations Claude Roger-Marx, 1980, no. 70). Cassatt's three unpublished letters to Marx discussed here were transcribed and annotated by Catherine Meneux. My thanks to Meneux for alerting me to them and for making them available to me. The letters are in French; the translations are my own.
142. Cassatt to Marx, undated (written after Morisot's death in March 1895). INHA Library (Donations Claude Roger-Marx, 1980).
143. Roger Marx, "Berthe Morisot, sa vie, son œuvre, d'après l'exposition posthume ouverte chez Durand-Ruel du 5 au 23 mars 1896," *Revue encyclopédique,* t. VI, n° 136, April 11, 1896. The article appeared in slightly modified form in the *Gazette des Beaux-Arts,* December 1, 1907, 491–508.
144. Cassatt to Marx, [ca. 1896]. INHA Library (Donation Claude Roger-Marx, 1980, no. 70).
145. Cassatt to Marx, [ca. 1896]. INHA Library (Donation Claude Roger-Marx, 1980, no. 70).
146. Reported by Cassatt's friend Eliza Haldeman, an art student with whom she was studying in Ecouen, France, in a letter to her mother, Mrs. Samuel Haldeman, May 15, 1867, in Sweet, *Miss Mary Cassatt,* 46.
147. On the Union of Women Painters and Sculptors, see Garb, *Sisters of the Brush*; on Morisot and feminism, see Sylvie Patry, *Berthe Morisot* (Paris: Musée d'Orsay/Flammarion, 2019), 24–27.
148. Sharp, "How Mary Cassatt Became an American Artist," 163.
149. Cassatt to Marx, undated (written after Morisot's death in March 1895). INHA Library (Donations Claude Roger-Marx, 1980).
150. Cassatt to Marx, undated. INHA Library (Donations Claude Roger-Marx, 1980).
151. Cassatt to Marx, undated. INHA Library (Donations Claude Roger-Marx, 1980).
152. Cassatt to Marx, undated. INHA Library (Donations Claude Roger-Marx, 1980).
153. Merritt, "Letter to Artists," in Mathews, *Cassatt: A Retrospective,* 241.
154. Giles Edgerton, "Is There a Sex Distinction in Art? The Attitude of the Critic toward Women's Exhibits," *Craftsman* 14, no. 3 (June 1908): 239–51.
155. Edgerton, "Is There a Sex Distinction in Art?," 240, 251.
156. Cassatt to Marx, November 4, [1896?]. INHA Library (Donations Claude Roger-Marx, 1980).
157. Cassatt to Marx, [ca. 1896]. INHA Library (Donations Claude Roger-Marx, 1980, no. 70).
158. Lindsay, *Mary Cassatt and Philadelphia,* 15.
159. Cassatt to Marx, [ca. 1896]. INHA Library (Donations Claude Roger-Max, 1980, no. 70).
160. Cassatt to Marx, [ca. 1896]. INHA Library (Donations Claude Roger-Max, 1980, no. 70).
161. Palmer to MC, December 15, 1892, in Mathews, *Mary Cassatt and Her Circle,* 242.

162. Palmer to MC, January 31, 1893, in Mathews, *Mary Cassatt and Her Circle,* 246.

163. Pollock, "Modernity and the Spaces of Femininity."

164. DuBois, "The Radicalism of the Woman Suffrage Movement: Notes toward the Reconstruction of Nineteenth-Century Feminism" (originally published in *Feminist Studies* 3, 1975), in *Woman Suffrage and Women's Rights* (New York: New York University Press, 1998) 30–42, at 34.

165. DuBois, "Radicalism of the Woman Suffrage Movement," 46.

166. DuBois, "Radicalism of the Woman Suffrage Movement," 46.

167. Stanton et al., *History of Woman Suffrage,* 1:855.

168. Stanton et al., *History of Woman Suffrage,* 1:856.

169. Stanton et al., *History of Woman Suffrage,* 2:779.

170. Stanton et al., *History of Woman Suffrage,* 2:779.

171. Offen, *Debating the Woman Question,* 487.

172. The journal addressed the "suffrage worker" in New York. Henrietta W. Livermore, "Woman's Sphere in New York," *Woman Voter* 6, no. 4 (April 1915): 14.

173. Coralie Franklin Cook, "Votes for Women," *The Crisis* 10 (August 1915).

174. Jane Addams, "Utilization of Women in City Government," chap. 7 in *Newer Ideals for Peace* (London: Macmillan, 1907), 180–208, at 183.

175. MC to LH, October 6, 1920. C 76. MMAA.

176. MC to LH, January 11, [1915?]. C 112. MMAA.

177. MC to LH, January 11, [1915?]. C 112. MMAA.

178. Iskin, *Modern Women and Parisian Consumer Culture in Impressionist Painting* (Cambridge: Cambridge University Press, 2007), 102–5.

5. CASSATT'S ART AND THE SUFFRAGE DEBATES OF HER TIME

1. Among these are Susan Fillin-Yeh, "Cassatt's Images of Women," *Art Journal* 35, no. 4 (Summer 1976): 359–63; Nancy Mowll Mathews, "Mary Cassatt and the 'Modern Madonna' of the Nineteenth Century" (PhD diss., New York University, 1980); Griselda Pollock, *Mary Cassatt* (New York: Harper & Row, 1980); Linda Nochlin, "Mary Cassatt's Modernity," in *Representing Women* (New York: Thames & Hudson, 1999), 181–215; Mathews, *Mary Cassatt* (New York: Harry N. Abrams with the National Museum of American Art, Smithsonian Institution, 1987); Judith A. Barter, ed., *Mary Cassatt: Modern Woman* (Chicago: Art Institute of Chicago, 1998); Pollock, *Mary Cassatt: Painter of Modern Women*; Norma Broude, "Mary Cassatt: Modern Woman"; Iskin, "Collecting Practices of Degas and Cassatt."

2. The exceptions are interpretations of Cassatt's *Modern Woman* mural at the Woman's Building, the Chicago World's Fair, 1893: Judy Sund, "Columbus and Columbia in Chicago 1893: Man of Genius Meets Generic Woman," *Art Bulletin* 75, no. 3 (September 1993): 443–66; Webster, *Eve's Daughter/Modern* Woman; Corn, *Women Building History*. The context of suffrage politics is also considered in a study of a painting by Cassatt in Nicole Georgopulos's article "'The Sunflower's Bloom of Women's Equality': New Contexts for Mary Cassatt's *La Femme au tournesol,*" *Panorama* 8, no. 1 (Spring 2022): 1–18, https://journalpanorama.org/article/the-sunflowers-bloom/.

3. Lisa Tickner, *The Spectacle of Women: Imagery of the Suffrage Campaign, 1907–14* (Chicago: University of Chicago Press, 1988); Allison K. Lange, *Picturing Political Power: Images in the Women's Suffrage Movement* (Chicago: University of Chicago Press, 2020).

4. The exception is Shira Gottlieb, "Class and Gender in Representations of Old Age in the Paintings of Manet and the Impressionists" (master's thesis, Ben-Gurion University of the Negev, 2017 [Hebrew]), for which I served as advisor. My thanks to Gottlieb for bringing the topic of aging in Impressionist painting to my attention. Two of Gottlieb's revised chapters have been published in English: "Aging and Urban Refuse in Edouard Manet's *The Ragpicker,*" *Nineteenth-*

Century Art Worldwide 18, no. 2 (2019), and "Mary Cassatt's *La lecture, The New Grandmother,*" *Woman's Art Journal* 42, no. 1 (Spring/Summer 2021): 3–10.

5. Susan Sontag, "The Double Standard of Aging," *Saturday Review,* September 23, 1972, 29–38, at 32.

6. Alison M. Downham Moore, *The French Invention of Menopause and the Medicalisation of Women's Ageing: A History* (Oxford: Oxford University Press, 2022), 340.

7. Downham Moore, *French Invention of Menopause,* 7.

8. Downham Moore, *French Invention of Menopause,* 5

9. Downham Moore, *French Invention of Menopause,* 338.

10. Downham Moore, *French Invention of Menopause,* 338.

11. For women's responses to aging and the medical discourses about it, see Downham Moore, chap. 9 in *French Invention of Menopause.*

12. Downham Moore, *French Invention of Menopause,* 343.

13. Downham Moore, *French Invention of Menopause,* 344, 345.

14. Yvette Guilbert, *Les Demis-Vielles* (Paris: Félix Juven, 1902), 286–87, cited in Downham Moore, *French Invention of Menopause,* 337, and discussed 341–48.

15. "Le vieillesse est plus heureuse. On est plus en possession de soi-même." In Patry, *Berthe Morisot,* 277. Translations are my own unless otherwise noted.

16. MC to LH, July 13, [1915]. B 85. MMAA.

17. Elizabeth Cady Stanton, "The Pleasures of Old Age," address, March 12, 1885, 1–8, at 7. Elizabeth Cady Stanton Papers: Speeches and Writings, 1848–1902. LOC, https://www.loc.gov/item/mss412100094/.

18. Corrine T. Field, "Grand Old Women and Modern Girls: Generational and Racial Conflict in the US Women's Rights Movement, 1870–1920" (lecture delivered at Radcliffe, during Field's fellowship there, 2018–19), https://www.youtube.com/watch?v=3Upz0FXBozk.

19. Field, "Grand Old Women."

20. Field, "Grand Old Women."

21. Field, "Grand Old Women."

22. Iskin, "Cassatt's Singular Women," 467–83. For discussions of this painting, see Nochlin, "Mary Cassatt's Modernity," 191–95; Pollock, *Mary Cassatt: Painter of Modern Women,* 133–36; Tamar Garb, chap. 3 in *The Painted Face: Portraits of Women in France, 1814–1914* (New Haven, CT: Yale University Press, 2007). On women reading, see Kathryn Brown, *Women Readers in French Painting 1870–1890* (Burlington, VT: Ashgate, 2012).

23. Havemeyer, *Sixteen to Sixty,* 272.

24. Pollock, *Mary Cassatt: Painter of Modern Women,* 133–40; Nochlin, "Mary Cassatt's Modernity," 191–95.

25. N.S. Carter, "Exhibition of the Society of American Artists," *Art Journal* 5 (1879): 157, reprinted in Mathews, *Cassatt: A Retrospective,* 103.

26. *Le Radical,* April 3, 1877, in Hause, *Hubertine Auclert,* 237.

27. Iskin, "Cassatt's Singular Women," 477–78. On Daumier's antifeminist caricatures, see Janis Bergman-Carton, *The Woman of Ideas in French Art, 1830–1848* (New Haven, CT: Yale University Press, 1995).

28. Pollock has interpreted Mrs. Cassatt's thinker's posture as linked to melancholia and death (Pollock, *Mary Cassatt: Painter of Modern Women,* 137), and Tamar Garb interpreted the portrait as related to Mrs. Cassatt's loss, separation, melancholia, and mourning over the death of her daughter Lydia (Garb, chap. 3 in *Painted Face*).

29. Sweet, *Miss Mary Cassatt,* 151.

30. On Cassatt and the Whittemore collection, see Weitzenhoffer, *Havemeyers*, 198, 92–93, 130; Hirshler, "Helping 'Fine Things Across the Atlantic,'" 197–98; Smith, *Hidden in Plain Sight*.

31. MC to Mrs. Whittemore, July 19, 1898. HSMA.

32. MC to Mrs. Whittemore, July 19, 1898. HSMA.

33. Nochlin, "Mary Cassatt's Modernity," 181, 185.

34. Mathews, *Mary Cassatt: A Life*, 165–67; Higonnet, "Critical Impressionism."

35. Higonnet, "Critical Impressionism," 226.

36. Katherine Cassatt to Alexander Cassatt, November 30, [1883], in Matthews, *Mary Cassatt and Her Circle*, 174. On the Chinese tea set and Cassatt's depiction of it, see Higonnet, "Critical Impressionism," 226–28.

37. Mathews, *Mary Cassatt: A Life*, 166. See Higonnet, "Critical Impressionism," for a different interpretation.

38. MC to LH, undated, [1899], in Weitzenhoffer, *Havemeyers*, 216–17.

39. MC to LH, undated, [1899], in Weitzenhoffer, *Havemeyers*, 216–17.

40. Cassatt painted a peasant mother and child once, early on: *Little Savoyard Child in the Arms of Her Mother*, ca. 1869. Br no. 4, Breeskin, *Catalogue Raisonné of Oils, Pastels, Watercolors and Drawings*.

41. Mathews, "Mary Cassatt and the 'Modern Madonna,'" discusses Cassatt's secularizing of the Madonna and Child tradition; Pollock, *Mary Cassatt: Painter of Modern Women*, 188–207, introduces a psychoanalytical feminist theory to the topic; Pamela A. Ivinski focuses on the critical reception in "Mary Cassatt, the Maternal Body, and Modern Connoisseurship" (chap. 6 in PhD diss., City University of New York, 2003); Broude views Cassatt's mother and child topic as "a conservative view of woman's nature and position" that simultaneously incorporates social resistance and complicity (Broude, "Mary Cassatt: Modern Woman," 37). See also Steward Buettner's argument that Cassatt, Morisot, and Käthe Kollwitz brought "greater insight and invention" to the topic than had been given to it since the Renaissance. Buettner, "Images of Modern Motherhood in the Art of Morisot, Cassatt, Modersohn-Becker, Kollwitz," *Woman's Art Journal* 7, no. 2 (Autumn 1986–Winter 1987): 14–21.

42. Rebecca A. Rix, "Anti-Suffragism in the United States," National Park Service, https://www.nps.gov/articles/anti-suffragism-in-the-united-states.htm; Manuela Thurner, "'Better Citizens without the Ballot': American Anti-Suffrage Women and Their Rationale during the Progressive Era," *Journal of Women's History* 5, no. 1 (Spring 1993): 33–60.

43. Advertisement by Oklahoma Association Opposed to Woman Suffrage, *Tulsa Daily World*, November 3, 1918.

44. British images used a similar formula. For example, John Hassall's *A Suffragette's Home*, 1912, published by the National League for Opposing Woman Suffrage, shows a working-class man returning "After a Hard Day's Work" to a home in distress, with crying children, supposedly caused by the absence of the wife/mother. The poster was part of an anti-suffrage propaganda campaign directed at working-class men. Tickner, *Spectacle of Women*, 209.

45. On the milk bottle and breast feeding, see Gal Ventura, *Maternal Breast-Feeding and Its Substitutes in Nineteenth-Century French Art* (Leiden: Brill, 2018), 341–413 (on Cassatt's representations of breastfeeding, 367–72; on a rare Impressionist painting, by Pissarro, showing a mother feeding a baby with a bottle, fig. 126, 399–401).

46. O'Neill was the first woman cartoonist hired by *Puck*, and her cartoons appeared in leading magazines including *Life*, *Harper's Bazaar*, and *Cosmopolitan*. See Miriam Forman-Brunell, ed., *The Story of Rose O'Neill: An Autobiography* (Columbia, MO: University of Missouri Press, 1997); Shelley Armitage, *The Kewpies and Beyond: The World of Rose O'Neill* (Jackson: University Press of Mississippi, 1994).

47. Carlynn Trout, "Rose Cecile O'Neill (1874–1944)," State Historical Society of Missouri, https://historicmissourians.shsmo.org/historicmissourians/name/o/oneill/index.html.

48. Nochlin, "Mary Cassatt's Modernity," 191.

49. On the change in conceptions of motherhood during the course of the nineteenth century, see Nancy M. Theriot, *Mothers and Daughters in Nineteenth-Century America: The Biosocial Construction of Femininity*, rev. ed. (Lexington: University Press of Kentucky, 1996).

50. Ellen M. Plante, *Women at Home in Victorian America: A Social History* (New York: Facts On File, 1997), 94.

51. David M. Lubin, "Lilly Martin Spencer's Domestic Genre Painting in Antebellum America," chap. 4 in *Picturing a Nation: Art and Social Change in Nineteenth-Century America* (New Haven, CT: Yale University Press, 1994), 164.

52. André Mellerio, *Exposition Mary Cassatt,* November–December 1893, reprinted in Mathews, *Cassatt: A Retrospective,* 202.

53. "Mary Cassatt's Achievement: Its Value to the World of Art," *The Craftsman* 19, no. 6 (March 1911): 540–46, at 540.

54. Frank Weitenkampf, "Some Women Etchers," *Scribner's Magazine,* December 1909, 731–39, at 736.

55. Weitenkampf, "Some Women Etchers," 736.

56. R.R., "Miss Mary Cassatt," *Art Amateur* 38, no. 6 (May 1898): 130.

57. Mellerio, *Exposition Mary Cassatt.*

58. "Mary Cassatt's Achievement," *The Craftsman,* 540.

59. "Mary Cassatt's Achievement," *The Craftsman,* 540.

60. "Pictures by Mary Cassatt," *New York Times,* April 18, 1895, reprinted in Mathews, *Cassatt: A Retrospective,* 215.

61. "Exhibition for Suffrage Cause," *New York Times,* April 4, 1915.

62. Arthur Hoeber, "*The Century*'s American Artists Series: Mary Cassatt," *Century Magazine* 5, no. 5 (March 1899): 740–42, at 741.

63. Forbes Watson, "Philadelphia Pays Tribute to Mary Cassatt," *The Arts* 11, no. 6 (June 1927): 289–97, at 297.

64. "Mary Cassatt's Achievement," *The Craftsman,* 540.

65. William Walton, "Miss Mary Cassatt," *Scribner's Magazine,* March 1896, 353–61, at 354.

66. Walton, "Miss Mary Cassatt," 361.

67. "Mary Cassatt's Achievement," *The Craftsman,* 545.

68. The Shelburne Museum. On Electra's collecting, see Aline B. Saarinen, *The Proud Possessors: The Lives, Times and Tastes of Some Adventurous American Art Collectors* (New York: Random House, 1958), 287–396.

69. MC to LH, November 29, [1907?]. B 171. MMAA.

70. Colin B. Bailey, ed., *Renoir's Portraits: Impressions of an Age* (Ottawa: National Gallery of Canada; New Haven, CT: Yale University Press, 1997), 162.

71. Lindsay, *Mary Cassatt and Philadelphia,* 60; Mathews, *Mary Cassatt* (1987), 62; Barter, "Mary Cassatt: Themes, Sources," 76.

72. Pollock, *Mary Cassatt: Painter of Modern Women,* 164.

73. On Degas's fathers and daughters, see Broude, *Degas* (New York: Rizzoli, 1993), [6]. For an analysis of Morisot's paintings of her husband, Eugène Manet, and their daughter, Julie, see Higonnet, *Berthe Morisot's Images of Women,* 228–29; Iskin, "Was There a New Woman in Impressionist Painting?," 210–11; Patry, *Berthe Morisot,* 24, 42.

74. Elizabeth H. Pleck and Joseph H. Pleck, "Fatherhood Ideals in the United States: Historical Dimensions," in *The Role of the Father in Child Development,* ed. Michael E. Lamb (New York: Wiley, 1997), 33–48, at 35.

75. Nancy E. Dowd, *Redefining Fatherhood* (New York: New York University Press, 2000), 157.

76. Dowd, *Redefining Fatherhood*, 5.

77. E.D.B., "Alexander J. Cassatt," *New York Times,* June 18, 1899.

78. Bob Goshorn, "A.J. Cassatt's Chesterbrook Farm," Tredyffrin Easttown Historical Society *History Quarterly* 19, no. 4 (October 1981): 121–28.

79. After 1899, the farm was maintained by the eldest son, Edward Cassatt, a West Point graduate and cavalry officer. Audrey Baur, *History Quarterly* 40, no. 1 (2003): 27–32.

80. Robert Kelso, Alexander's younger son, graduated from Harvard University in 1895 and subsequently became a manager in the coal business in Philadelphia and a member of the banking house of Cassatt & Company. https://www.wikitree.com/wiki/Cassatt-52.

81. Publishers' preface to Elliott, *Art and Handicraft in the Woman's Building,* n.p.

82. These measurements appear in Bertha Palmer, *Addresses and Reports of Mrs. Potter Palmer: President of the Board of Lady Managers* (Chicago: Rand McNally, 1894), 102. Another source suggests that the measurements were 64.5 feet wide and 15 feet high at the center. This is mentioned in a letter by Mr. William M.R. French, the first director of the Art Institute of Chicago, to John Worden, art instructor at Notre Dame University, discussing the MacMonnies' mural, whose measurements were identical to Cassatt's mural. The letter is quoted in Carolyn Kinder Carr and Sally Webster, "Mary Cassatt and Mary Fairchild MacMonnies: The Search for Their 1893 Murals," *American Art* 8, no. 1 (Winter 1994): 52–69, at 66. Carr and Webster traced the whereabouts of Cassatt's and MacMonnies's murals after the fair closed. Cassatt's mural was stored from 1895 in the Chicago home of Mrs. Palmer, who died in 1918, and there is no record of the mural's whereabouts thereafter; Carr and Webster, "Mary Cassatt and Mary Fairchild MacMonnies," 66. See also Charlene G. Garfinkle, "Women at Work: The Design and Decoration of the Woman's Building at the 1893 World's Columbian Exposition: Architecture, Exterior Sculpture, Stained Glass, and Interior Murals" (PhD diss., University of California, Santa Barbara, 1996).

83. Corn, *Women Building History,* 96n51.

84. On the fate of the mural, see Carr and Webster, "Mary Cassatt and Mary Fairchild MacMonnies." On its critical reception, see Weimann, *Fair Women,* 313–23; Webster, chap. 4 in *Eve's Daughter/ Modern Woman*; Corn, chap. 3 in *Women Building History*; Ivinski, chap. 5 in "Mary Cassatt, the Maternal Body."

85. MC to Bertha Palmer (hereafter BP), October 11, [1892], in Mathews, *Mary Cassatt and Her Circle,* 238.

86. Iskin, "Cassatt's Mural of Modern Woman" (paper presented at the College Art Association annual meeting, Washington, DC, January 1975). My discussion here draws in part on this paper and on Iskin, "Was There a New Woman in Impressionist Painting?" On the mural, see John D. Kysela, "Mary Cassatt's Mystery Mural and the World's Fair of 1893," *Art Quarterly* 29, no. 2 (1966): 128–45; Mathews, *Mary Cassatt* (1987), 82–89; Pollock, *Mary Cassatt: Painter of Modern Women,* 35–67; Barter, *Mary Cassatt: Modern Woman,* 88–97; Nochlin, "Mary Cassatt's Modernity," 208–15; Webster, chap. 3 in *Eve's Daughter/Modern Woman*; Iskin, "Was There a New Woman in Impressionist Painting?," 211–17; Corn, chap. 3 in *Women Building History*.

87. Stanton et al., *History of Woman Suffrage,* 1:265.

88. MC to TP, December 23 [1910], in Sweet, *Miss Mary Cassatt,* 187.

89. Elizabeth von Arnim, *The Benefactress* (New York: Macmillan, 1901).

90. MC to LH, December 8, [1909?]. C 60. MMAA. Thomas Buckle, *The Miscellaneous and Posthumous Works of Henry Thomas Buckle* (London: Longmans Green, 1885).

91. Corn, *Women Building History,* 170.

92. MC to BP, October 11, [1892], in Mathews, *Mary Cassatt and Her Circle,* 238.

93. Sund, "Columbus and Columbia," 462.

94. Proverbs 31:31. https://www.burchfieldpenney.org/artists/artist:evelyn-rumsey/.

95. Iskin, "Art Nouveau and the New Woman: Style, Ambiguity and Politics," in *Art Nouveau Goddesses* (Amsterdam: Allard Pierson Gallery, University of Amsterdam, and WBooks, 2020), 28–45. For a discussion of the traditionally feminine women often featured in pre–World War I suffrage posters, see Paula Hays Harper, "Votes for Women? A Graphic Episode in the Battle of the Sexes," in *Art and Architecture in the Service of Politics,* ed. Henry A. Millon and Linda Nochlin (Cambridge, MA: MIT Press, 1978), 150–61.

96. MC to BP, October 11, [1892], in Mathews, *Mary Cassatt and Her Circle,* 238. Broude, "Mary Cassatt: Modern Woman," 36, notes that Cassatt inverted the theme of girls running after Cupid (i.e., after love, as depicted in the Pompeii frescoes) by replacing it with girls pursuing fame.

97. For analysis of the two side scenes, see Corn, *Women Building History,* 134–43, and Webster, chap. 3 in *Eve's Daughter/Modern Woman.*

98. MC to BP, October 11, [1892], in Mathews, *Mary Cassatt and Her Circle,* 238.

99. Ann Massa, "Black Women in the 'White City,'" *Journal of American Studies* 8, no. 3 (December 1974): 319–37; Frances K. Pohl, "Historical Reality or Utopian Ideal? The Woman's Building at the World's Columbian Exposition, Chicago 1893," *International Journal of Women's Studies* 5 (September/October 1982): 289–311.

100. Approved official minutes of the Board of Lady Managers of the World's Columbian Commission, November 19–26 (Chicago, 1891), 79, in Massa, "Black Women in the 'White City,'" 320.

101. Massa, "Black Women in the 'White City,'" 323–37.

102. Cassatt included the large sunflower pinned to a mother's dress also in *Denise and Her Child Holding a Hand Mirror,* ca. 1905. Br no. 474, Breeskin, *Catalogue Raisonné of Oils, Pastels, Watercolors and Drawings.*

103. Georgopulos, "'Sunflower's Bloom of Women's Equality,'" 2. See this article also for a summary of some earlier interpretations of the painting.

104. R.R. Wark, "A Note on Van Dyck's 'Self-Portrait with a Sunflower,'" *Burlington Magazine* 98, no. 635 (February 1956): 53–54.

105. Georgopulos, "'Sunflower's Bloom of Women's Equality.'"

106. Georgopulos, "'Sunflower's Bloom of Women's Equality,'" 3. Ivinski, "Mary Cassatt, the Maternal Body," 467n297, raised the possibility that Cassatt knew that the sunflower was a symbol of suffrage used by NAWSA, but Ivinski did not further develop this idea.

107. Georgopulos, "'Sunflower's Bloom of Women's Equality,'" 3–4.

108. Georgopulos, "'Sunflower's Bloom of Women's Equality,'" 3–4.

109. Georgopulos, "'Sunflower's Bloom of Women's Equality,'" 4.

110. "Symbols of the Woman's Suffrage Movement," National Park Service, https://www.nps.gov/articles/symbols-of-the-women-s-suffrage-movement.htm.

111. Smithsonian, National Museum of American History, https://americanhistory.si.edu/collections/search/object/nmah_507974.

112. *The Suffragist,* December 6, 1913. Stanton's pen name was "Sunflower" in her writings for *The Lily,* the first American newspaper edited by and for women.

113. Smithsonian, National Museum of American History, https://americanhistory.si.edu/treasures/womens-suffrage.

114. MC to TP, [September 1903], in Mathews, *Mary Cassatt and Her Circle,* 286.

115. Havemeyer, "Suffrage Torch," 531.

116. Havemeyer's name appeared among the eighty-two founders of the National Woman's Party. The NWP headquarters were located in a mansion known as "Old Capitol," which was "immediately opposite the capitol . . . offering a visible reminder to Congress that women have at last

'arrived,' politically speaking." "The Woman's Party Will Occupy the 'Old Capitol,'" *Washington D.C. Post,* January 22, 1922. HV LOC.

117. "Make Old Capitol Shrine for Women, Imposing Ceremonies Mark the Dedication of National Woman's Party Headquarters," *Washington, D.C. [The Washington] Star,* May 22, 1922. HV LOC.

118. Emma H. Dunclaf, "The Children's Building," in Elliott, *Art and Handicraft in the Woman's Building,* 164.

119. The slim file on this exhibition documents only the early planning stages. See draft of program for the exhibition, December 6, 1900. File, Cote: VR240, "Exposition de l'Enfance," 1900, Archives de Paris. The organizers planned to give free invitations to children at schools and to include attractions for children in one of the galleries. The other galleries displayed paintings and sculptures to show the role of the child through the ages; the material culture associated with children at home, including toys, costumes, and furniture, both ancient and modern; and material related to children's education, protection, and assistance.

120. Havemeyer, *Sixteen to Sixty,* 279.

6. THE 1915 CASSATT AND DEGAS EXHIBITION IN NEW YORK

1. Sweet mentioned the 1915 exhibition only in a footnote in his *Miss Mary Cassatt,* 194. The exhibition was missing from the chronology in Breeskin's *Mary Cassatt: A Catalogue Raisonné of the Oils, Pastels, Watercolors, and Drawings,* 23–24. Weitzenhoffer first discussed it briefly in *The Havemeyers,* 222–26; Rebecca A. Rabinow dedicated an article to it, "The Suffrage Exhibition of 1915," in Frelinghuysen et al., *Splendid Legacy,* 89–95. See also Mathews, *Mary Cassatt: A Life,* 104–7; Pollock, *Mary Cassatt: Painter of Modern Women,* 207–13; Sharp, "How Mary Cassatt Became an American Artist," 169; Shackelford, "Pas de Deux," 138; Ruth E. Iskin, "The Degas and Cassatt 1915 Exhibition in Support of Women's Suffrage," in *Monographic Exhibitions and the History of Art,* ed. Maia Gahtan and Donatella Pegazzano (London: Routledge, 2018), 26–37 (part of this chapter draws on my article).

2. Corn, *Great American Thing.*

3. Numerous other American women established collections of modern art. See Wanda M. Corn, "Art Matronage in Post-Victorian America," *Cultural Leadership in America: Art Matronage and Patronage,* Fenway Court, vol. 27 (Boston: Isabella Stewart Gardner Museum, 1997); Dianne MacLeod, *Enchanted Lives, Enchanted Objects: American Women Collectors and the Making of Culture, 1800–1940* (Berkeley: University of California Press, 2008); Inga Jackson Reist and Rosella Mamoli Zorzi, eds., *Power Underestimated: American Women Art Collectors* (proceedings of a symposium jointly organized by the Center for the History of Collecting in America at the Frick Collection and the Doctoral Studies School in Languages, Culture and Societies of the University of Venice, Ca' Foscari, held at University of Venice, Ca' Foscari, April 2008).

4. Louisine W. Havemeyer, *Mrs. H.O. Havemeyer's Remarks on Edgar Degas and Mary Cassatt* (New York: M. Knoedler, 1915), [2].

5. See list of the lenders in Rabinow, "Suffrage Exhibition of 1915," 95.

6. "Our States to Vote on Woman Suffrage This Fall," *Eye of the World,* 1915, in Weitzenhoffer, *Havemeyers,* 227.

7. Originating in 1907, suffrage maps were produced in various designs and media, such as posters, illustrations in newspapers and magazines, murals, parade floats, paper fans, glasses, and more. Christina E. Dando, "'The Map Proves It': Map Use by the American Woman Suffrage Movement," *Geography and Geology Faculty Publications* 45, no. 4 (2010): 221–49.

8. Weitzenhoffer, *Havemeyers,* 219.

9. MC to LH, February 15, 1914. C 96. MMAA.

10. MC to LH, December 4, [1913]. C 48. MMAA.

11. René Degas to Paul Lafond, November 17, 1915, in Boggs, *Degas*, 497.

12. Loyrette, *Degas*, 666–69.

13. Weitzenhoffer, *Havemeyers*, 219.

14. MC to LH, May 30, [1914], in Rabinow, "Suffrage Exhibition of 1915," 89.

15. Listed in Rabinow, "Suffrage Exhibition of 1915," n. 27.

16. Rabinow, "Suffrage Exhibition of 1915," 95, accounted for a total of sixty-six works in the show, including eighteen by old masters, twenty-seven by Degas, and twenty-one by Cassatt (plus the Guys portrait of Degas and a photographic portrait of Cassatt).

17. The two unpublished photographs are in the Knoedler Gallery archive, which is now housed in the Getty Research Institute (hereafter GRI), box 3629, M. Knoedler & Co. records (acc. no. 2012.M.54). My thanks to Lois White at the GRI for help with accessing them. The photographs were first published in Iskin, "Degas and Cassatt 1915 Exhibition," figs. 2.2 and 2.4.

18. Segard, *Mary Cassatt*. I identified the small photograph based on an installation photograph—fig. 13 in Rabinow, "Suffrage Exhibition of 1915," 93.

19. Rabinow, "Suffrage Exhibition of 1915," 95.

20. Mathews, *Mary Cassatt: A Life*, 306–7.

21. Seven out of the additional eight Cassatt works displayed in the exhibition appear in Breeskin, *Catalogue Raisonné of Oils, Pastels, Watercolors and Drawings*, Br nos. 157, 205, 240, 255, 275, 463, 502.

22. Br no. 157.

23. Br no. 205.

24. Br no. 240.

25. Br no. 275.

26. Br no. 255.

27. Br no. 463.

28. Br no. 502.

29. Rabinow, "Suffrage Exhibition of 1915," 91.

30. MC to LH, March 12, [1915?]. C 88. MMAA.

31. MC to LH, April 29, [1915]. B 85. MMAA.

32. Breeskin, *Catalogue Raisonné of Oils, Pastels, Watercolors and Drawings*, Br no. 502.

33. This revises earlier statements that all of Cassatt's works in the exhibition were from after 1900. Mathews, *Mary Cassatt: A Life*, 306.

34. Pollock, *Mary Cassatt: Painter of Modern Women*, 211.

35. The Knoedler catalogue includes a full list of the works by old masters with a description of each artwork. M. Knoedler & Co., *Loan Exhibition of Masterpieces by Old and Modern Painters*, catalogue (New York, 1915), 1–19.

36. Havemeyer, *Sixteen to Sixty*, 178.

37. Eliza Haldeman to Mrs. Samuel Haldeman, May 15, 1867, in Mathews, *Mary Cassatt and Her Circle*, 46.

38. MC to LH, January 20, [1915]. C 89. MMAA.

39. Havemeyer, *Mrs. H. O. Havemeyer's Remarks*, n.p. [2].

40. MC to LH, April 29, [1915]. B 185. MMAA.

41. MC to LH, April 29, [1915]. B 185. MMAA.

42. "Loan Exhibition in Aid of Suffrage," *The Sun*, April 6, 1915.

43. James Britton, "Old Masters for 'Suffrage,'" *American Art* 13, no. 27 (April 10, 1915): n.p.

44. "Exhibition for Suffrage Cause," *New York Times*, April 4, 1915.

45. Gustav Kobbe, "Painted by Rembrandt in 1634, First Exhibited in New York 1915," *New York Herald*, April 4, 1915, in Rabinow, "Suffrage Exhibition of 1915," 92. On feminism during Rem-

brandt's time, see Mary Garrard, *Artemisia Gentileschi and Feminism in Early Modern Europe* (London: Reaktion Books, 2020).

46. MC to LH, November 24, [1914?]. C 113. MMAA.

47. MC to LH, July 13, [1915]. B 85. MMAA. Cassatt's nieces (Jennie's daughters) were also anti-suffragists. Mathews, *Mary Cassatt: A Life*, 309.

48. For example, Colonel Oliver Payne and Ada Brooks Pope, Theodate Pope's mother.

49. MC to LH, July 5, [1915], in Mathews, *Mary Cassatt and Her Circle*, 324.

50. On women's art exhibitions, see Charles Musser, "1913: A Feminist Moment in the Arts," in *The Armory Show at 100: Modernism and Revolution*, ed. Marilyn Kushner and Kimberly Orcutt (New York: New-York Historical Society in association with D. Giles [London], 2013), 169–79.

51. Knoedler Galleries, April 20–May 2, 1908. There were numerous associations of American women artists that organized exhibitions. Julie Graham, "American Women Artists' Groups: 1867–1930," *Woman's Art Journal* 1, no. 1 (Spring–Summer 1980): 7–12.

52. Mariea Caudill Dennison, "Babies for Suffrage: 'The Exhibition of Painting and Sculpture by Women Artists for the Benefit of the Woman Suffrage Campaign,'" *Woman's Art Journal* 24, no. 2 (Autumn 2003–Winter 2004): 24–30, at 24.

53. *Twenty-Third Annual Exhibition of the Association of Women Painters and Sculptors*, Knoedler Galleries, April 6–18, 1914.

54. Weitzenhoffer, *Havemeyers*, 206–7, 268 nn. 13, 15.

55. Havemeyer used white, green, and purple, the colors of the Women's Social and Political Union in the United Kingdom. In 1917 US suffragists adopted purple, white, and yellow or gold for flags and banners. "Tactics and Techniques of the National Woman's Party Suffrage Campaign," LOC, "American Memory," https://www.loc.gov/static/collections/women-of-protest/images/tactics.pdf.

56. Havemeyer, "Suffrage Torch," 529.

57. Havemeyer "Suffrage Torch," 529.

58. "Art Show Offends 'Antis,'" *New York Tribune*, April 3, 1912, in Charles Musser, "1913: A Feminist Moment," 171–72.

59. Musser, "1913: A Feminist Moment," 172.

60. Musser, "1913: A Feminist Moment," 172.

61. The organizers were the artists Anne Goldwaite, Abastenia St. Leger Eberle, Alice Morgan Wright, Adele Herter, and Elizabeth Alexander; at the lead was Ida Proper, chair of the art committee of the woman suffrage campaign. Dennison, "Babies for Suffrage," 24, 25. Seven of the artists in the exhibition had exhibited in the Armory Show. Jennifer Pfeifer Shircliff, "Women of the 1913 Armory Show: Their Contributions to the Development of American Art" (PhD diss., University of Louisville, 2014), 149.

62. Quoted in Dennison, "Babies for Suffrage," 25.

63. "Suffragists at Art Show," September 28, no. 43, Macbeth Gallery Records, 1838–1962, Bulk, 1892–1953, series 5: Scrapbooks Papers, box 123, folder 1, AAA.

64. Macbeth AAA, no. 35.

65. Dennison, "Babies for Suffrage," 26.

66. Macbeth AAA, no. 42.

67. Fig. 7 in Dennison, "Babies for Suffrage," 27.

68. Macbeth ΛΛΛ, no. 44.

69. *The Sun*, October 24, 1915, clipping, O'Neill archive at the Norman Rockwell Museum. My thanks to Jesse Kowalski, curator of the Norman Rockwell Museum and of the special permanent collection installation at the museum, *Rose O'Neill: Artist & Suffragette*, for providing the clipping.

70. Tickner, *Spectacle of Women*, 70–71, 80.

71. Tickner, *Spectacle of Women*, 324n16.

72. O'Neill adapted the slogan from the one carried at the head of the 1911 parade in New York (the first suffrage parade held in the United States). On the banners in that parade, see Tickner, *Spectacle of Women*, 324n8.

73. Musser, "1913: A Feminist Moment"; Shircliff, chap. 4 in "Women of the 1913 Armory Show."

74. Shircliff, chaps. 2 and 3 in "Women of the 1913 Armory Show," 15, 46.

75. Cassatt's painting was listed as *Mère et enfant* (Mother and child), oil, 1903, no. 493. Kushner and Orcutt, *Armory Show at 100*, 467, 437.

76. Listed as *Mère et enfant* in Breeskin, *Catalogue Raisonné of Oils, Pastels, Watercolors and Drawings*, Br no. 584, Br no. 623, present location unknown.

77. Kushner and Orcutt, *Armory Show at 100*, 437.

78. Harold Rosenberg, "The Armory Show Revolution Reenacted," in *The Anxious Object* (Chicago: University of Chicago Press, 1964), 189, cited in Casey Nelson Blake, "Greenwich Village Modernism: 'The Essence of It All Was Communication,'" in Kushner and Orcutt, *Armory Show at 100*, 83–94, at 92.

79. MC to LH, [March 1913]. B 100. MMAA.

80. MC to LH, [March 1913]. B 100. MMAA.

81. Quoted in Meyer Schapiro, "Introduction to Modern Art in America: The Armory Show," in *Modern Art: Nineteenth and Twentieth Centuries* (New York: Braziller, 1978), 135–78, at 146.

82. MC to LH, [March 1913]. B 100. MMAA.

83. Weitzenhoffer, *Havemeyers*, 210.

84. Alfred H. Barr Jr., "The Lillie P. Bliss Collection," in MoMA, *The Lillie P. Bliss Collection, 1934* (New York: MoMA, 1934), 7.

85. Berman, *Rebels on Eighth Street*, 260–65.

86. Royal Cortissoz, "M. Degas and Miss Cassatt: Types Once Revolutionary Which Now Seem Almost Classical," *New York Herald Tribune*, April 4, 1915.

7. CASSATT'S LEGACY

1. "The Painter of Children," *Literary Digest* 13, no. 2 (July 10, 1926): 26–27.

2. Lula Merrick, "The Art of Mary Cassatt," *The Delineator* 74, no. 2 (August 1909): 121.

3. Forbes Watson to Frederick A. Sweet, August 28, 1954, Sweet Papers, AAA.

4. Sweet, who was the curator of American Painting and Sculpture at the Art Institute of Chicago (AIC), assembled much of Cassatt's correspondence and wrote the first English-language biography, *Miss Mary Cassatt: Impressionist from Pennsylvania* (1966); he also curated the first major museum exhibition that featured Cassatt with Whistler and Sargent: *Sargent, Whistler, and Mary Cassatt*, shown in Chicago and in New York at the Metropolitan Museum of Art (the Met) in 1954.

5. A partial list of this new scholarship includes Breeskin, *A Catalogue Raisonné of the Oils, Pastels, Watercolors and Drawings* (1970); Hale, *Mary Cassatt* (1975); Breeskin, *Mary Cassatt: A Catalogue Raisonné of the Graphic Work* (1979); Mathews, *Mary Cassatt and Her Circle: Selected Letters* (1984); Mathews, *Mary Cassatt: A Life* (1994). Other prominent second-wave Cassatt art historians and curators include Judith A. Barter, Norma Broude, Tamar Garb, Linda Nochlin, Griselda Pollock, and Sally Webster. On the influence of second-wave feminism, see Mathews, *Mary Cassatt: A Life*, 330–33.

6. For example, *Les Femmes Impressionnistes: Mary Cassatt, Eva Gonzalès, Berthe Morisot*, at the Musée Marmottan, Paris, 1993; *Women Impressionists: Berthe Morisot, Mary Cassatt, Eva Gonzalès, Marie Bracquemond*, at the de Young / Legion of Honor Fine Arts Museums of San Francisco, 2008; *Her Paris: Women Artists in the Age of Impressionism*, 2018, at the Denver Museum, the Speed Museum (Louisville, KY), and the Clark Institute (Williamstown, MA).

7. Segard, *Mary Cassatt*.

8. Discussed in chaps. 6 and 5.

9. Mathews, *Mary Cassatt: A Life*, 321–33.

10. Kevin Sharp, "How Mary Cassatt Became an American Artist," 145–75. See also Hadrien Viraben, "Constructing a Reputation: Achille Segard's 1913 Biography of Mary Cassatt," *Art in America* 31, no. 1 (Spring 2017): 98–113. For a brief discussion of Cassatt in museums, focusing mostly on French museums, see Laurent Manoeuvre, *Mary Cassatt, au Coeur de L'Impressionnisme* (Paris: Éditions À Propos, 2018), 175–79.

11. In this respect, my use of the notion of artistic legacy differs from the meaning of "legacy" as a bequest, such as money or property left by someone through a will.

12. Jessica Goodman, "Introduction: What, Where, Who Is Posterity?," *Early Modern French Studies* 40, no. 1 (July 2018): 2–10, at 6.

13. Rachel Middleman and Anne Monohan, "Introduction: The Politics of Legacy," *Art Journal* (July 2017): 70–74.

14. On the role of museums, MC to TP, September 1903, cited in Mathews, *Mary Cassatt and Her Circle*, 285–86. On the role of private dealers, MC to CST, July 11, 1904, cited in Sweet, *Miss Mary Cassatt*, 162.

15. "Cassatt Show for Chicago," *Art News*. 25, no. 11 (December 1926): 2.

16. At the time, it was named the Pennsylvania Museum.

17. *The Cassatt Exhibition* (April 30–May 29, 1927) at the Pennsylvania Museum, in Philadelphia. Lindsay, *Mary Cassatt and Philadelphia*, 27. For a list of Cassatt exhibitions, see Russell T. Clement, Annick Houzé, and Christiane Erbolato-Ramsey, *The Women Impressionists: A Sourcebook* (Westport, CT: Greenwood Press, 2000).

18. Watson, "Philadelphia Pays Tribute," 297.

19. Louisine W. Havemeyer, "The Cassatt Exhibition," *Pennsylvania Museum Bulletin* 22, no. 113 (May 1927): 173–82; Dorothy Grafly, "In Retrospect—Mary Cassatt," *American Magazine of Art* 18, no. 6 (June 1927): 305–12.

20. Art Institute of Chicago, *Catalogue of a Memorial Collection of the Works of Mary Cassatt*, 1926–27. The exhibition included 108 works, of which 37 were paintings and pastels and the rest were drypoints, aquatints, and color aquatints. Carnegie Institute, Department of Fine Arts, Pittsburgh, *A Memorial Exhibition of the Works of Mary Cassatt*, March 15–April 15, 1928.

21. "Mary Cassatt, Durand-Ruel Galleries," October 23–November 12, 1926, *Art News* 25, no. 4 (October 30, 1926): 9.

22. *The Arts* 10, no. 6 (December 1926): 348.

23. William M. Ivins Jr., "New Exhibition in the Print Galleries," *Bulletin of the Metropolitan Museum of Art* 22, no. 1 (January 1927): 8–10, at 9.

24. Ivins, "New Exhibition," 9, 10.

25. Ivins, "New Exhibition," 9.

26. Ivins, "New Exhibition," 10.

27. "Prints at the Public Library, *Art News* 25, no. 11 (December 18, 1926): 9.

28. F[rank] W[eitenkampf], "Mary Cassatt, Print-Maker," *Bulletin of the New York Public Library* 30 (1926): 858–59.

29. Among the many artists who were given memorial exhibitions at the Met prior to Cassatt's death, in addition to Whistler and Sargent, were Augustus Saint Gaudens (1908), Winslow Homer (1911), Thomas Eakins (1917), William Merritt Chase (1917), Albert P. Ryder (1918), Abbott H. Thayer (1922), J. Alden Weir (1924), and George W. Bellows (1925). "The Metropolitan Museum of Art Special Exhibitions, 1870–2021," compiled by the Metropolitan Museum of Art Archives.

30. Amelia Peck and Thayer Tolles, "Creating a National Narrative," in *Making the Met, 1870–2020*, ed. Andrea Bayer with Laura D. Corey (New York: Metropolitan Museum of Art, 2020), 116–27, at 116–17.

31. Joseph Breck, the curator of decorative arts, organized one memorial exhibition for a woman ceramicist, Adelaide Alsop Robineau, in 1929–30.

32. "Few works by American women were acquired beyond those by revival miniature painters and Mary Cassatt, leaving subsequent generations of curators to address this lacuna." Peck and Tolles, "Creating a National Narrative," 118.

33. Breeskin curated a total of eight Cassatt exhibitions and authored the catalogues raisonnés of her prints and of her paintings, pastels, and drawings. Mathews, *Mary Cassatt: A Life*, 326.

34. The PMA's exhibition *Mary Cassatt and Philadelphia*, February 17–April 14, 1985, coincided with the museum's two exhibitions of Degas, one organized by the museum (*Edgar Degas in Philadelphia Collections*), the other originating at the MFA Boston (*Edgar Degas: The Painter as Printmaker*).

35. Barter, *Mary Cassatt: Modern Woman.*

36. Jones, *Degas Cassatt.*

37. The paintings were displayed in gallery 25 and some in gallery 12. J.B. [Joseph Beck] and B.B. [Bryson Burroughs], "An Anonymous Gift," *Bulletin of the Metropolitan Museum of Art* 17, no. 3 (March 1922): 51–58, at 58.

38. The 1922 display of the Cassatt paintings bequeathed by Stillman and Ivins's 1927 exhibition of prints, discussed earlier, is not mentioned in the Met's document that lists its special exhibitions from 1870 to 2021; Cassatt solo exhibitions mentioned in it are *Etchings and Color Prints by Mary Cassatt* (January 1, 1943); *Works by Mary Cassatt from the Metropolitan Collection* (September 10, 1973–February 1, 1974); and *Mary Cassatt Drawings and Prints in the Metropolitan Museum of Art* (October 20, 1998–January 24, 1999), displayed in the Luce Center. The Met document also lists the exhibition *Sargent, Whistler and Mary Cassatt* (March 26, 1954–May 23, 1954). This exhibition was accompanied by a catalogue.

39. Met exhibitions of Whistler were held in 1910, 1935, 1941, 1972, and 1984; of Sargent, in 1926, 1972, 1992, 2000, and 2015. The 1972 and 2000 exhibitions were of works from the Met collection. The 1972 exhibition *John Singer Sargent: A Selection of Drawings and Watercolors from the Metropolitan* was an extensive show commemorating the seventy-fifth anniversary of Sargent's death; it featured one hundred works and was accompanied by a catalogue.

40. *Sargent, Whistler, and Mary Cassatt*, at the AIC, January 14–February 25, 1954; at the Met, March 26–May 23, 1954.

41. *Mary Cassatt: An American Observer, A Loan Exhibition for the Benefit of the American Wing of the Metropolitan Museum of Art*, October 3–27, 1984 (New York: Coe Kerr Gallery, 1984). A retrospective exhibition of paintings, pastels, watercolors, drawings, and graphic works was also held at International Galleries (a private gallery in Chicago) in 1965, and another major exhibition of Cassatt was held in 1966 at the Knoedler Gallery in New York as a benefit for the development of the National Collection of Fine Arts, Smithsonian Institution, Washington, DC.

42. Gallery 273. All the information on the permanent displays in museums is based on observation or research conducted between 2018 and 2022.

43. Gallery 226 shows Cassatt's *The Tea*, ca. 1880; *Mrs. Duffee Seated on a Striped Sofa, Reading*, 1876; *In the Loge*, 1878; *Caresse Maternelle*, ca. 1902; and *Ellen Mary in a White Coat*, 1896.

44. For discussion of the woman's active gaze in this painting, see Pollock, *Mary Cassatt: Painter of Modern Women*, 141, 144–45; Nochlin, "Mary Cassatt's Modernity," 194. On the depiction of women as spectators, see Ruth E. Iskin, "Selling, Seduction, and Soliciting the Eye: Manet's Bar at the Folies-Bergère," *Art Bulletin* 77, no. 1 (March 1995): 25–44, at 32–43.

45. Michael Leja, "American Art's Shifting Boundaries," *American Art* 11, no. 2 (Summer 1997): 48–49, at 49. See John Davis for a discussion of diverse voices in the field, "The End of the American Century: Current Scholarship on the Art of the United States," *Art Bulletin* 85, no. 3 (September 2003): 544–80.

46. H. Barbara Weinberg, "American Impressionism," Heilbrunn Timeline of Art History, essays, Metropolitan Museum of Art, 2004, https://www.metmuseum.org/toah/hd/aimp/hd_aimp.htm.

47. Weinberg, "American Impressionism."

48. Gallery 768.

49. Text of the gallery label in 2018.

50. Gallery 824.

51. On the full Havemeyer bequest, see Frelinghuysen et al., *Splendid Legacy*.

52. MC to LH, August 24, 1918. C 106. MMAA.

53. MC to LH, March 24, [1911]. B 125. MMAA.

54. MC to LH, February 15, [1910]. B 131. MMAA.

55. Gallery 255.

56. Gallery 211. Among the painters in this gallery are Thomas Eakins, Henry Ossawa Tanner, George Inness, Cecilia Beaux, and Sarah Paxton Ball Dodson, as well as the Mexican painter José Maria Velasco. The gallery also displays marble sculptures and a variety of functional decorative objects.

57. PMA's wall label for gallery 210, "On the World's Stage," in which a painting by Cassatt is exhibited primarily among American art, design, and craft.

58. MC to LH, February 15, [1910]. B 131. MMAA.

59. Paula J. Birnbaum, *Women Artists in Interwar France: Framing Femininities* (Burlington, VT: Ashgate, 2011), 1, 13.

60. Marie-Anne Camax-Zoegger, "Les Femmes Artistes Modernes," *Art et Artisanal* (June 15, 1935): 11–12, cited in Birnbaum, *Women Artists in Interwar France*, 48.

61. Musée du Louvre, France, October 24, 1973–January 7, 1974 (no accompanying catalogue). Les collections du département des arts graphiques, http://arts-graphiques.louvre.fr/resultats/expositions.

62. Martine Mauvieux, *Mary Cassatt* (Paris, Musée d'Orsay, March 7–June 5, 1988), organized by the Musée d'Orsay and the Bibliothèque nationale (Paris: Éditions de la Réunion des Musées Nationaux, 1988).

63. *Hommage à Mary Cassatt*, Château de Beaufresne, Le Mesnil-Théribus, Catalogue du Musée départemental de l'Oise (Beauvais, 1965), June–July 1965. Catalogue by Simone Cammas et Monique Quesnot.

64. November 25, 1959–January 10, 1960.

65. *Regard sur Mary Cassatt* (Mary Cassatt at a glance), April 1–October 31, 1996; *Mary Cassatt: Impressions* (Mary Cassatt: Impressionist printmaker), April 1–July 3, 2005.

66. Mathews, Flavie Durand-Ruel Mouraux, and Pierre Currie, *Mary Cassatt: Une Impressionniste Américaine à Paris* (Paris: Musée Jacquemart-André, Institut de France, March 9–July 23, 2018).

67. Personnaz met Camille Pissarro in 1875 and became one of the earliest collectors of Impressionism. In 1947, several years after his death, his wife gave part of his collection to the Louvre (letters from Mme. Personnaz's lawyers to the director of the Louvre Museum, in the Orsay Museum's documentation). Initially shown in the Jeu de Paume Museum (which from 1947 to 1986 was an offshoot of the Louvre), the Personnaz collection was moved to the Orsay Museum when it opened in 1986.

68. On the history of the state's exhibition of the Impressionists prior to the Orsay, see Martha Ward, "The Museum of Impressionism, 1947," in Dombrowski, *Companion to Impressionism*, 583–600.

69. *Berthe Morisot (1841–1895)*, Musée d'Orsay, June 18–September 22, 2019. Sylvie Patry, the French curator of the exhibition, initiated it while she was curator at the Barnes Foundation in the United States, where the exhibition had its debut (October 21, 2018–January 14, 2019). The Musée d'Orsay arranged for the exhibition to travel to Paris (and Patry returned to the Orsay).

70. MC to Harris Whittemore, December 22, [1893], in Mathews, *Mary Cassatt and Her Circle*, 250.

71. MC to John H. Whittemore, February 15, [1894], in Mathews, *Mary Cassatt and Her Circle*, 259.

72. MC to LH, February 15, [1910]. B 131. MMAA.

73. At the time, she believed that if the state did not pay for her artwork, "the proposed honor . . . would be discounted." Montague Marks, "My Notebook," *Art Amateur* 27, no. 3 (August 1892): 51, cited in Sharp, "How Mary Cassatt Became an American Artist," 173n34.

74. Sharp, "How Mary Cassatt Became an American Artist," 155–56. Cassatt's work (along with that of Caillebotte himself and Morisot) was not represented in Caillebotte's collection.

75. On Cassatt's relationship with the Petit Palais, see Manoeuvre, *Mary Cassatt, au Coeur de L'Impressionnisme*, 177, 179.

76. Hirshler, "Helping 'Fine Things Across the Atlantic.'" An exception is Hirshler and Davis, who claim that Cassatt's motivation in promoting Degas's art to American collectors was her own self-interest—her career and her artistic legacy. Hirshler and Davis, "A Place in the World of Art."

77. J.B. [Joseph Beck] and B.B. [Bryson Burroughs], "Anonymous Gift," 55, 58.

78. Corey and Frelinghuysen, "Visions of Collecting," 265n46.

79. It is not clear whether the Met was not keen on adding so many Cassatt artworks to its own collection, or followed a possible wish by Stillman to spread Cassatt's artworks outside of New York. Sharp, "How Mary Cassatt Became an American Artist," 167; Corey and Frelinghuysen, "Visions of Collecting," 138–39. At that time, the Met owned a single Cassatt painting, *Mother and Child (Baby Getting Up from His Nap)*, ca. 1899, purchased in 1909 with the George A. Hearn Fund. Cassatt's painting *Lady at the Tea Table*, 1883–85, was on loan from the artist, who gifted it to the Met the following year. Stillman's bequest to the Met also included works by other artists

80. MC to LH, July 27, [1906]. B 161. MMAA.

81. MC to LH, March 1920, cited in Mathews, *Mary Cassatt and Her Circle*, 332.

82. MC to LH, March 1920, cited in Mathews, *Mary Cassatt and Her Circle*, 332.

83. For example, MC to LH, April 30, 1920. A 6. MMAA.

84. MC to LH, May 18, 1920. A 6. MMAA.

85. MC to LH, April 4, 1920. A 16. MMAA.

86. When the will was written in 1911, the monthly allotment to Valet was $50 (equivalent to about $1,560 in 2022). It also gave Valet a choice of a picture or a piece of jewelry. Sweet, *Miss Mary Cassatt*, 212.

87. Mathews, *Mary Cassatt: A Life*, 324.

88. Mathews, *Mary Cassatt: A Life*, 324.

89. Ellen Mary Cassatt Hare to Sweet, ca. 1952, Sweet Papers, AAA; mentioned in Sweet, *Miss Mary Cassatt*, 212.

90. Some of the works in the Valet sales remained unsold, and the Durand-Ruel gallery bought some of them as late as 1966. This is evident from information on various entries in Breeskin, *Catalogue Raisonné of Oils, Pastels, Watercolors and Drawings*.

91. Dumas et al., *Private Collection of Edgar Degas*.

92. On the differences between Cassatt's and Degas's collecting, see Iskin, "Collecting Practices of Degas and Cassatt."

93. MC to TP [September 1903], cited in Mathews, *Mary Cassatt and Her Circle*, 286.

94. MC to LH, November 8, [1906]. B 160. MMAA.

95. MC to Pissarro, November 27, [1889], cited in Mathews, *Mary Cassatt and Her Circle*, 213; Hirshler, "Helping 'Fine Things Across the Atlantic,'" 180.

96. MC to Pissarro, November 27, [1889], cited in Mathews, *Mary Cassatt and Her Circle*, 213; Hirshler, "Helping 'Fine Things Across the Atlantic,'" 180.

97. MC to Camille Pissarro, November 27, [1889], cited in Mathews, *Mary Cassatt and Her Circle*, 213.

98. According to Théodore Duret, art critic and friend of Manet. See Anne Higonnet, "Introduction: The Gift of Olympia," in Denise Murrell, *Posing Modernity: The Black Model from Manet to Matisse and Today* (New Haven, CT: Yale University Press, 2018), xiv–xvii, at xiv, xv.

99. Vollard was seeking a buyer for Manet's painting, which was on display at Kelekian's.

100. Macomber's letter to the MFA's director, Arthur Fairbanks, July 28, 1909 (Archives of the MFA). My thanks to Erica E. Hirshler for providing access to this letter. Macomber's collection included old masters and only a few other modern artworks. Hirshler, "Helping 'Fine Things Across the Atlantic,'" 206n1.

101. Hirshler, "Helping 'Fine Things Across the Atlantic,'" 177. Originally cited in *Mary Cassatt at Home* (Boston: Museum of Fine Arts, 1978), 9–10.

102. MC to Colonel Oliver Payne, February 28, [1915], in Mathews, *Mary Cassatt and Her Circle*, 321.

103. MC to Payne, February 28, [1915], in Mathews, *Mary Cassatt and Her Circle*, 321.

104. MC to CST, November 11, 1909, cited in Sweet, *Miss Mary Cassatt*, 178.

105. MC to CST, January 22, 1905, cited in Sweet, *Miss Mary Cassatt*, 171.

106. Sweet, *Miss Mary Cassatt*, 171.

107. Sweet, *Miss Mary Cassatt*, 172.

108. MC to LH, January 18, [1910]. B 137. MMAA.

109. MC to CST, January 22, 1905, cited in Sweet, *Miss Mary Cassatt*, 170–71. Italics in the original.

110. On the Havemeyer bequest to the Met, see Frelinghuysen et al., *Splendid Legacy*. On the Havemeyers' collecting with Cassatt's active advice, see Weitzenhoffer, *Havemeyers*; Hirshler, "Helping 'Fine Things Across the Atlantic'"; Corey and Frelinghuysen, "Visions of Collecting," 130–49.

111. Corey, "Going Public: Mary Cassatt and the 1886 First Impressionist Exhibition in America," in Clark and Fowle, *Globalizing Impressionism*.

112. George J. Becker and Edith Philips, eds., *Paris and the Arts, 1851–1896: From the Goncourt Journal* (Ithaca, NY: Cornell University Press, 1971), 300.

113. MC to CST, January 23, 1905, cited in Sweet, *Miss Mary Cassatt*, 163.

114. Havemeyer, "The Freer Museum of Oriental Art," *Scribner's Magazine*, May 1923, 529–40, at 540.

115. Biddle, "Some Memories of Mary Cassatt."

116. MC to J. Alden Weir, March 10, [1878], cited in Sweet, *Miss Mary Cassatt*, 48.

117. Emily C. Burns, "Revising Bohemia: The American Artist Colony in Paris, 1890–1914," in *Foreign Artists and Communities in Modern Paris, 1870–1914: Strangers in Paradise*, ed. Karen L. Carter and Susan Waller (Farnham, England: Ashgate, 2015), 97–110, at 101.

118. "Art Students in Paris: Sculptor Partridge Describes the Work of the American Association," *New York Times*, July 18, 1892, cited in Burns, "Revising Bohemia," 101.

119. Segard, *Mary Cassatt*, 192.

120. Watson, *Mary Cassatt*, 9.

121. Havemeyer, *Sixteen to Sixty*.

122. Weitzenhoffer, *Havemeyers*; Hirshler, "Helping 'Fine Things Across the Atlantic'"; Corey, "Many Hats of Mary Cassatt."

123. An exception is the catalogue for the exhibition *Mary Cassatt: Modern Woman*, which originated at the Art Institute of Chicago and included a pathbreaking article by Hirshler, "Helping 'Fine Things Across the Atlantic': Mary Cassatt and Art Collecting in the United States."

124. Jennifer A. Thompson's chapter in the catalogue, "Durand-Ruel and America," fails to discuss Cassatt's role. See Corey, "Going Public."

125. The exhibition was shown at the Musée du Luxembourg, October 9, 2014–February 8, 2015; the National Gallery, London, March 4–May 31, 2015; and the Philadelphia Museum, June 24–September 13, 2015.

126. Griselda Pollock, "The National Gallery Is Erasing Women from the History of Art," *The Conversation*, June 3, 2015, https://theconversation.com/the-national-gallery-is-erasing-women-from-the-history-of-art-42505.

127. In her study of Cassatt's role in the 1886 New York Impressionist exhibition, Corey notes that Cassatt's "lasting impression on her contemporaries has since been largely overlooked." Corey, "Going Public."

128. Durand-Ruel, *Memoirs of the First Impressionist Art Dealer,* 158. Cassatt even gave Durand-Ruel some financial support during one of his particularly difficult times.

129. For example, Renoir acknowledged that Cassatt saved the Durand-Ruel gallery by sending the Havemeyers and numerous other American collectors to it. MC to LH, March 22, 1920. C 1. MMAA.

130. Watson, *Mary Cassatt,* 15.

131. Dumas et al., *Private Collection of Edgar Degas.*

132. Unidentified French paper, cited in Sweet, *Miss Mary Cassatt,* 211–12.

SELECTED BIBLIOGRAPHY

ARCHIVES

Archives of American Art, Smithsonian Institution, Washington, DC

Archives de Paris, Paris

Getty Research Institute, Los Angeles

Hill-Stead Museum Archives, Farmington, CT

INHA Library, Institut national d'histoire de l'art, Paris

Library of Congress, Manuscript Division, Washington, DC

Metropolitan Museum of Art Archives, New York

Metropolitan Museum of Art, Curatorial Files, New York

Musée d'Orsay Service de Documentation, Paris

National Gallery of Art, Washington, DC

National Gallery of Art, Curatorial Files, Washington, DC

National Woman's Party Archive, Belmont House, Washington, DC; collection now
at the Library of Congress

ProQuest History Vault, National Woman's Party Records; originals in the Manu-
script Division of the Library of Congress

Shelburne Museum Archives, Shelburne, VT

BOOKS, EXHIBITION CATALOGUES, AND OTHER SOURCES

Adams, Katherine H., and Michael L. Keene. *Alice Paul and the American Suffrage
Campaign*. Urbana: University of Illinois Press, 2008.

Adler, Kathleen, Erica E. Hirshler, and H. Barbara Weinberg. *Americans in Paris,
1860–1900*. London: National Gallery, 2006.

"American Water-Color Society; Eleventh Annual Exhibition—Reception to Artists and the Press—American and Foreign Exhibitors." *New York Times,* February 2, 1878, 5.

Appiah, Kwame Anthony. "Cosmopolitan Patriots." *Critical Inquiry* 23, no. 3 (Spring 1997): 617–39.

Armitage, Shelley. *The Kewpies and Beyond: The World of Rose O'Neill.* Jackson: University Press of Mississippi, 1994.

Armstrong, Carol M. *Odd Man Out: Readings of the Work and Reputation of Edgar Degas.* Chicago: University of Chicago Press, 1991.

Arnim, Elizabeth von. *The Benefactress.* New York: Macmillan, 1901.

Assouline, Pierre. *Discovering Impressionism: The Life and Times of Paul Durand-Ruel.* New York: Vendome Books, 2004.

Bailey, Colin B., ed. *Renoir's Portraits: Impressions of an Age.* Ottawa: National Gallery of Canada; New Haven, CT: Yale University Press, 1997.

Barr, Alfred H., Jr. "The Lillie P. Bliss Collection." In MoMA, *The Lillie P. Bliss Collection,* 1934, 5–7. New York: Museum of Modern Art, 1934.

Barter, Judith A., ed. *Mary Cassatt: Modern Woman.* Chicago: Art Institute of Chicago, 1998.

———. "Mary Cassatt: Themes, Sources, and the Modern Woman." In *Mary Cassatt: Modern Woman,* edited by Judith A. Barter, 45–107. Chicago: Art Institute of Chicago; New York: Abrams, 1998.

Basch, Françoise. "Women's Rights and Wrongs of Marriage in Mid-Nineteenth-Century America." *History Workshop* 22, no. 1 (Autumn 1986): 18–40.

Beck, Joseph J.B. [Joseph Beck], and B.B. [Bryson Burroughs]. "An Anonymous Gift." *Bulletin of the Metropolitan Museum of Art* 17, no. 3 (March 1922): 51–58.

Becker, Howard S. *Art Worlds.* Berkeley: University of California Press, 1982.

Bellion, Wendy. "Chronology." In *Mary Cassatt: Modern Woman,* edited by Judith A. Barter, 328–52. Chicago: Art Institute of Chicago; New York: Abrams, 1998.

Bergman-Carton, Janis. *The Woman of Ideas in French Art, 1830–1848.* New Haven, CT: Yale University Press, 1995.

Berlo, Janet Catherine. "The Art of Indigenous Americans and American Art History: A Century of Exhibitions." *Perspective* 2 (2015): 1–10.

Berman, Avis. *Rebels on Eighth Street: Juliana Force and the Whitney Museum of American Art.* New York: Atheneum, 1990.

Bernheimer, Charles. *Figures of Ill Repute: Representing Prostitution in Nineteenth-Century France.* Cambridge, MA: Harvard University Press, 1989.

Berson, Ruth, ed. *The New Painting: Impressionism 1874–1886,* vol. 2. San Francisco: Fine Arts Museums of San Francisco, 1996.

Biddle, George. "Some Memories of Mary Cassatt." *The Arts* 10 (August 1926): 107–11.

Birnbaum, Paula J. *Women Artists in Interwar France: Framing Femininities.* Burlington, VT: Ashgate, 2011.

Blake, Casey Nelson. "Greenwich Village Modernism: 'The Essence of It All Was Communication.'" In *The Armory Show at 100: Modernism and Revolution,* edited by Marilyn S. Kushner and Kimberly Orcutt, 83–94. New York: New-York Historical Society Library & Museum in association with D. Giles (London), 2013.

Blanche, Jacques-Émile. "Bartholomé et Degas." *L'art vivant,* no. 124 (February 15, 1930): 154–56.

Bodelsen, Merete. "Early Impressionist Sales 1874–94 in the Light of Some Unpublished 'procès-verbaux.'" *Burlington Magazine* 110, no. 783 (June 1968): 330–49.

Boggs, Jean Sutherland. *Degas.* New York: Metropolitan Museum of Art, 1988.

Bradbury, Malcolm. "Second Countries: The Expatriate Tradition in American Writing." *Yearbook of English Studies* 8 (1978): 15–39.

Breeskin, Adelyn Dhome. *Mary Cassatt: A Catalogue Raisonné of the Graphic Work.* Washington, DC: Smithsonian Institution Press, 1979.

———. *Mary Cassatt: A Catalogue Raisonné of the Oils, Pastels, Watercolors and Drawings.* Washington, DC: Smithsonian Institution Press, 1970.

Britton, James. "Old Masters for 'Suffrage.'" *American Art* 13, no. 27 (April 10, 1915): n.p.

Broude, Norma. "Degas' Alleged Misogyny: The Resilience of a Cultural Myth." In *Dance, Politics and Society*, edited by Adriano Pedrosa and Fernando Oliva, 28–40. São Paulo: Museu de Arte de São Paulo, 2021.

———. "Degas' 'Misogyny.'" *Art Bulletin* 59, no. 1 (March 1977): 95–107.

———. "Edgar Degas and French Feminism c. 1880: 'The Young Spartans,' the Brothel Monotypes and the Bathers Revisited." *Art Bulletin* 70, no. 4 (December 1988): 640–59.

———. "Mary Cassatt: Modern Woman or the Cult of Womanhood?" *Woman's Art Journal* 21, no. 2 (Autumn 2000–Winter 2001): 36–43.

———. *World Impressionism: The International Movement, 1860–1920.* New York: Abrams, 1990.

Brown, Kathryn. *Women Readers in French Painting 1870–1890.* Burlington, VT: Ashgate, 2012.

Buck, Stephanie Mary. "Sarah Choate Sears: Artist, Photographer, and Art Patron." MA thesis, Syracuse University, 1985.

Buettner, Steward. "Images of Modern Motherhood in the Art of Morisot, Cassatt, Modersohn-Becker, Kollwitz." *Woman's Art Journal* 7, no. 2 (Autumn 1986–Winter 1987): 14–21.

Burns, Emily C. "'Nothing but Daubs': The Translation of Impressionism in the United States." In *Globalizing Impressionism: Reception, Translation, and Transnationalism,* edited by Alexis Clark and Frances Fowle. New Haven, CT: Yale University Press, 2020. https://aaeportal.com/?id=-20008.

———. "Revising Bohemia: The American Artist Colony in Paris, 1890–1914." In *Foreign Artists and Communities in Modern Paris, 1870–1914: Strangers in Paradise,* edited by Karen L. Carter and Susan Waller, 97–110. Farnham, UK: Ashgate, 2015.

———, and Alice M. Rudy Price. *Mapping Impressionist Painting in Transnational Contexts.* New York: Routledge, 2021.

Burr, Anna Robeson. *The Portrait of a Banker: James Stillman, 1850–1918.* New York: Duffield, 1927.

Callen, Anthea. "Degas' *Bathers*: Hygiene and Dirt—Gaze and Touch." In *Dealing with Degas: Representations of Women and the Politics of Vision*, edited by Richard Kendall and Griselda Pollock, 159–85. New York: Universe, 1992.

Cammas, Simone, and Monique Quesnot. *Hommage à Mary Cassatt: Château de Beaufresne, Le Mesnil-Théribus.* Catalogue du Musée départemental de l'Oise. Beauvais, 1965.

Carr, Carolyn Kinder. *Sara Tyson Hallowell: Pioneer Curator and Art Advisor in the Gilded Age.* Washington, DC: Smithsonian Institution Scholarly Press, 2019.

———, and Sally Webster. "Mary Cassatt and Mary Fairchild MacMonnies: The Search for Their 1893 Murals." *American Art* 8, no. 1 (Winter 1994): 52–69.

Carter, N.S. "Exhibition of the Society of American Artists." *Art Journal* 5 (1879): 156–58.

"Cassatt Show for Chicago." *Art News* 25, no. 11 (December 1926): 2.

Casteras, Susan P. "Abastenia St. Leger Eberle's 'White Slave.'" *Woman's Art Journal* 7, no. 1 (Spring–Summer 1986): 32–36.

Catt, Carrie Chapman, T.A. Larson, and Nettie Rogers Shuler. *Woman Suffrage and Politics: The Inner Story of the Suffrage Movement.* Seattle: University of Washington Press, 1969.

Clark, Alexis, and Frances Fowle, eds. *Globalizing Impressionism: Reception, Translation, and Transnationalism.* New Haven, CT: Yale University Press, 2020. https://aaeportal.com/?id=-19996.

Clark, Lenore. *Forbes Watson: Independent Revolutionary.* Kent, OH: Kent State University Press, 2001.

Clayson, Hollis. "Cassatt's Alterity." In *Companion to Impressionism,* edited by André Dombrowski, 253–70. New York: Wiley, 2021.

———. *Painted Love: Prostitution in French Art of the Impressionist Era.* New Haven, CT: Yale University Press, 1991.

———. "Voluntary Exile and Cosmopolitanism in the Transatlantic Art Community, 1870–1914." In *American Artists in Munich: Artistic Migration and Cultural Exchange Processes,* edited by Christian Fuhrmeister, Hubertus Kohle, and Veerle Thielemans, 15–26. Berlin: Deutscher Kunstverlag, 2009.

Clement, Russell T., Annick Houzé, and Christiane Erbolato-Ramsey. *The Women Impressionists: A Sourcebook.* Westport, CT: Greenwood Press, 2000.

Cohen-Solal, Annie. *Painting American: The Rise of American Artists, Paris 1867–New York 1948.* Translated by Laurie Hurwitz-Attias. New York: Alfred A. Knopf, 2001.

Corey, Laura D. "Going Public: Mary Cassatt and the 1886 First Impressionist Exhibition in America." In *Globalizing Impressionism: Reception, Translation, and Transnationalism,* edited by Alexis Clark and Frances Fowle. New Haven, CT: Yale University Press, 2020. https://aaeportal.com/?id=-20012.

———. "The Many Hats of Mary Cassatt: Artist, Advisor, Broker, Tastemaker." In *Dealing Art on Both Sides of the Atlantic: 1860–1940,* edited by Lynn Catterson, 39–58. Leiden: Brill, 2017.

———, and Alice Cooney Frelinghuysen. "Visions of Collecting." In *Making the Met, 1870–2020,* edited by Andrea Bayer with Laura D. Corey, 130–49. New York: Metropolitan Museum of Art; New Haven, CT: Yale University Press, 2020.

Corn, Wanda M. "Art Matronage in Post-Victorian America." In *Cultural Leadership in America: Art Matronage and Patronage,* 3–12. Fenway Court, vol. 27. Boston: Isabella Stewart Gardner Museum, 1997.

———. "Coming of Age: Historical Scholarship in American Art." *Art Bulletin* 70, no. 2 (June 1988): 188–207.

———. *The Great American Thing: Modern Art and National Identity, 1915–1935.* Berkeley: University of California Press, 2001.

———, with contributions by Charlene G. Garfinkle and Annelise K. Madsen. *Women Building History: Public Art at the 1893 Columbian Exposition.* Berkeley: University of California Press, 2011.

Cortissoz, Royal. "M. Degas and Miss Cassatt: Types Once Revolutionary Which Now Seem Almost Classical." *New York Herald Tribune,* April 4, 1915.

Cott, Nancy F. "Marriage and Women's Citizenship in the United States, 1830–1934." *American Historical Review* 103, no. 5 (December 1993): 1440–74.

Danchev, Alex. *Cézanne: A Life.* New York: Pantheon Books, 2012.

Dando, Christina E. "'The Map Proves It': Map Use by the American Woman Suffrage Movement." *Geography and Geology Faculty Publications* 45, no. 4 (2010): 221–49.

Davis, John. "The End of the American Century: Current Scholarship on the Art of the United States." *Art Bulletin* 85, no. 3 (September 2003): 544–80.

Davis, Patricia Talbot. *End of the Line: Alexander J. Cassatt and the Pennsylvania Railroad.* New York: Neale Watson Academic Publications, 1978.

Dawkins, Heather. *The Nude in French Art and Culture, 1870–1910.* Cambridge: Cambridge University Press, 2002.

Dennison, Mariea Caudill. "Babies for Suffrage: 'The Exhibition of Painting and Sculpture by Women Artists for the Benefit of the Woman Suffrage Campaign.'" *Woman's Art Journal* 24, no. 2 (Autumn 2003–Winter 2004): 24–30.

Dombrowski, André, ed. *Companion to Impressionism.* New York: Wiley, 2021.

Donation Claude Roger-Marx. Paris: Musée du Louvre, Cabinet des Dessins, 1980.

Dowd, Nancy E. *Redefining Fatherhood.* New York: New York University Press, 2000.

Downham Moore, Alison M. *The French Invention of Menopause and the Medicalisation of Women's Ageing: A History.* Oxford: Oxford University Press, 2022.

DuBois, Ellen Carol. "The Radicalism of the Woman Suffrage Movement: Notes toward the Reconstruction of Nineteenth-Century Feminism" [1975]. In *Woman Suffrage and Women's Rights,* 30–42. New York: New York University Press, 1998.

———, and Lynn Dumenil. *Through Women's Eyes: An American History with Documents.* 4th ed. Boston: Bedford/St. Martin's, 2015.

Dudden, Faye E. *Fighting Chance: The Struggle over Woman Suffrage and Black Suffrage in Reconstruction America.* New York: Oxford University Press, 2011.

Dumas, Ann, Colta Ives, Susan Alyson Stein, and Gary Tinterow. *The Private Collection of Edgar Degas.* New York: Metropolitan Museum of Art, 1997.

Dunclaf, Emma H. "The Children's Building." In *Art and Handicraft in the Woman's Building of the World's Columbian Exposition, Chicago, 1893*, edited by Maud Howe Elliott, 159–69. Paris: Boussod, Valadon, 1893.

Durand-Ruel, Paul. *Paul Durand-Ruel: Memoirs of the First Impressionist Art Dealer (1831–1922)*. Revised, corrected, and annotated by Paul Louis Durand-Ruel and Flavie Durand-Ruel. Paris: Flammarion, 2014.

Duret, Théodore. *Manet and the French Impressionists: Pissarro, Claude Monet, Sisley, Renoir, Berthe Morisot, Cézanne, Guillaumin*. Translated by J.E. Crawford Flitch. Philadelphia: J.B. Lippincott; London: Grant Richards, 1910.

Eckel, Molly K. "'A Touch of Art': Sarah Wyman Whitman and the Art of the Book in Boston." BA thesis, Wellesley College, 2012.

Edgerton, Giles. "Is There a Sex Distinction in Art? The Attitude of the Critic toward Women's Exhibits." *Craftsman* 14, no. 3 (June 1908): 239–51.

Elliott, Maud Howe, ed. *Art and Handicraft in the Woman's Building of the World's Columbian Exposition*. Paris: Boussod, Valadon, 1893.

———. "The Building and Its Decoration." In *Art and Handicraft in the Woman's Building of the World's Columbian Exposition, Chicago, 1893*, edited by Elliott, 23–49. Paris: Boussod, Valadon, 1893.

"Exhibition for Suffrage Cause." *New York Times*, April 4, 1915.

Faulkner, Carol. *Lucretia Mott's Heresy: Abolition and Women's Rights in Nineteenth-Century America*. Philadelphia: University of Pennsylvania Press, 2011.

Faxon, Alicia. "Painter and Patron: Collaboration of Mary Cassatt and Louisine Havemeyer." *Woman's Art Journal* 3, no. 2 (Autumn 1982–Winter 1983): 15–20.

Field, Corrine T. "Are Women . . . All Minors? Woman's Rights and the Politics of Aging in the Antebellum United States." *Journal of Women's History* 12, no. 4 (2001): 113–37. doi:10.1353/jowh.2001.0007.

———. "Grand Old Women and Modern Girls: Generational and Racial Conflict in the US Women's Rights Movement, 1870–1920." A lecture delivered at Radcliffe as part of Field's project as a Mellon Schlesinger Fellow, 2018–19. https://www.radcliffe.harvard.edu/video/grand-old-women-and-modern-girls-corinnet-field.

Fillin-Yeh, Susan. "Cassatt's Images of Women." *Art Journal* 35, no. 4 (Summer 1976): 359–63.

Finnegan, Margaret. *Selling Suffrage: Consumer Culture & Votes for Women*. New York: Columbia University Press, 1999.

Florey, Kenneth. *Women's Suffrage Memorabilia: An Illustrated Historical Study*. Jefferson, NC: McFarland, 2013.

Foa, Michelle. "The Making of Degas: Duranty, Technology, and the Meaning of Materials in Later Nineteenth-Century Paris." *NONsite*, no. 27 (2019). https://nonsite.org/the-making-of-degas/.

Forman-Brunell, Miriam, ed. *The Story of Rose O'Neill: An Autobiography*. Columbia: University of Missouri Press, 1997.

Frelinghuysen, Alice Cooney. "The Havemeyer House." In *Splendid Legacy: The Havemeyer Collection*, edited by Alice Cooney Frelinghuysen, Gary Tinterow, Susan Alyson Stein, Gretchen Wold, and Julia Meech, 173–98. New York: Metropolitan Museum of Art, 1993.

———, Gary Tinterow, Susan Alyson Stein, Gretchen Wold, and Julia Meech. *Splendid Legacy: The Havemeyer Collection*. New York: Metropolitan Museum of Art, 1993.

Frost-Knappman, Elizabeth, and Kathryn Cullen-DuPont. *Women's Suffrage in America: An Eyewitness History*. New York: Facts On File, 2005.

Garb, Tamar. *The Painted Face: Portraits of Women in France, 1814–1914*. New Haven, CT: Yale University Press, 2007.

———. *Sisters of the Brush: Women's Artistic Culture in Late Nineteenth-Century Paris*. New Haven, CT: Yale University Press, 1994.

———. *Women Impressionists*. New York: Rizzoli, 1986.

Garfinkle, Charlene G. "Women at Work: The Design and Decoration of the Woman's Building at the 1893 World's Columbian Exposition—Architecture, Exterior Sculpture, Stained Glass, and Interior Murals." PhD diss., University of California, Santa Barbara, 1996.

Georgopulos, Nicole. "Rethinking Mary Cassatt's *Reflection* as a Self-Portrait." *Print Quarterly* 36, no. 4 (December 2019): 425–38.

———. "'The Sunflower's Bloom of Women's Equality': New Contexts for Mary Cassatt's *La Femme au tournesol*." *Panorama* 8, no. 1 (Spring 2022). https://journalpanorama.org/article/the-sunflowers-bloom/.

Gimpel, René. *Diary of an Art Dealer*. Translated by John Rosenberg. With an introduction by Herbert Read. New York: Farrar Straus & Giroux, 1966.

Ginsberg, Lori D. *Elizabeth Cady Stanton: An American Life*. New York: Hill and Wang, 2009.

Goodman, Jessica. "Introduction: What, Where, Who Is Posterity?" *Early Modern French Studies* 40, no. 1 (July 2018): 2–10.

Gordon, Laura de Force. "Woman's Sphere from a Woman's Standpoint." In *The Congress of Women Held in the Woman's Building, World's Columbian Exposition, Chicago USA 1893*, edited by Mary Kavanaugh Oldham Eagle, 74–76. Chicago: International Pub., 1894.

Gottlieb, Shira. "Aging and Urban Refuse in Edouard Manet's *The Ragpicker*." *Nineteenth-Century Art Worldwide* 18, no. 2 (2019). https://www.19thc-artworldwide.org/autumn19/gottlieb-on-aging-and-urban-refuse-in-edouard-manets-the-ragpicker.

———. "Mary Cassatt's *La lecture, The New Grandmother*." *Woman's Art Journal* 42, no. 1 (Spring/Summer 2021): 3–10.

Grafly, Dorothy. "In Retrospect—Mary Cassatt." *American Magazine of Art* 18, no. 6 (June 1927): 305–12.

Graham, Julie. "American Women Artists' Groups: 1867–1930." *Woman's Art Journal* 1, no. 1 (Spring–Summer 1980): 7–12.

Granovetter, Mark. "Economic Action and Social Structure: The Problem of Embeddedness." *American Journal of Sociology* 91, no. 3 (1985): 481–510.

Greene, Donna. "Biographical Sketch of Narcissa Cox Vanderlip." In "Part III: Mainstream Suffragists—National American Woman Suffrage Association." https://documents.alexanderstreet.com/d/1009656478.

Groseclose, Barbara, and Jochen Wierich, eds. *Internationalizing the History of American Art*. University Park: Pennsylvania State University Press, 2009.

Guilbert, Yvette. *Les Demis-Vielles*. Paris: Félix Juven, 1902.

Hale, Nancy. *Mary Cassatt*. New York: Doubleday, 1975.

Harper, Ida Husted. *The Life and Work of Susan B. Anthony: Including Her Addresses, Her Own Letters and Many from Her Contemporaries during Fifty Years*. Vol. 2. Indianapolis: Hollenbeck Press, 1898.

Harper, Paula Hays. "Votes for Women? A Graphic Episode in the Battle of the Sexes." In *Art and Architecture in the Service of Politics*, edited by Henry A. Millon and Linda Nochlin, 150–61. Cambridge, MA: MIT Press, 1978.

Hause, Steven C. *Hubertine Auclert: The French Suffragette*. New Haven, CT: Yale University Press, 1987.

Havemeyer, Louisine W. "The Cassatt Exhibition." *Pennsylvania Museum Bulletin* 22, no. 113 (May 1927): 173–82.

———. "The Freer Museum of Oriental Art." *Scribner's Magazine*, May 1923, 529–40.

———. *Mrs. H. O. Havemeyer's Remarks on Edgar Degas and Mary Cassatt*. New York: M. Knoedler, 1915.

———. "The Prison Special: Memories of a Militant." *Scribner's Magazine*, June 1922, 661–76.

———. *Sixteen to Sixty: Memoirs of a Collector*. Edited by Susan Alison Stein. New York: Ursus Press, 1993.

———. "The Suffrage Torch: Memories of a Militant." *Scribner's Magazine*, May 1922, 528–39.

Higonnet, Anne. *Berthe Morisot's Images of Women*. Cambridge, MA: Harvard University Press, 1992.

———. "Critical Impressionism: A Painting by Mary Cassatt and Its Challenge to the Social Rules of Art." In *Companion to Impressionism*, edited by André Dombrowski, 219–33. New York: Wiley, 2021.

———. "Introduction: The Gift of Olympia." In Denise Murrell, *Posing Modernity: The Black Model from Manet to Matisse and Today*, xiv–xvii. New Haven, CT: Yale University Press, 2018.

Hirshler, Erica E. "The Fine Art of Sarah Choate Sears." *Magazine Antiques* 160, no. 3 (September 2001): 321–29.

———. "Helping 'Fine Things Across the Atlantic': Mary Cassatt and Art Collecting in the United States." In *Mary Cassatt: Modern Woman*, edited by Judith A. Barter, 177–211. Chicago: Art Institute of Chicago; New York: Abrams, 1998.

———. *A Studio of Her Own: Women Artists in Boston, 1870–1940*. Boston: MFA Publications, 2001.

———, and Elliot Bostwick Davis. "A Place in the World of Art: Cassatt, Degas, and American Collectors." In *Degas Cassatt*, edited by Kimberly A. Jones, 128–37. Washington, DC: National Gallery of Art, 2014.

Hoeber, Arthur. "*The Century*'s American Artists Series: Mary Cassatt." *Century Magazine* 5, no. 5 (March 1899): 740–42.

Hoffman, Katherine. "Sarah Choate Sears and the Road to Modernism." *Photoresearcher*, no. 10 (2007): 23–31.

Hourwich, Rebecca. "An Appreciation of Mrs. Havemeyer." *Equal Rights* 14, no. 52 (February 2, 1929): 411.

Hudson, Peter James. *Bankers and Empire: How Wall Street Colonized the Caribbean*. Chicago: University of Chicago Press, 2017.

Huneker, James. *Promenades of an Impressionist*. New York: Charles Scribner's Sons, 1910.

Hutchinson, Elizabeth. *The Indian Craze: Primitivism, Modernism, and Transculturation in American Art, 1890–1915*. Durham, NC: Duke University Press, 2009.

Hyman, Harold Melvin. "Loyalty Defined: The Ironclad Test Oath." In *Era of the Oath: Northern Loyalty Test during the Civil War and Reconstruction*, 21–32. Philadelphia: University of Pennsylvania Press, 1954.

Irwin, Inez Haynes. *The Story of the Woman's Party*. New York: Harcourt, Brace, 1921.

Iskin, Ruth E. "Art Nouveau and the New Woman: Style, Ambiguity and Politics." In *Art Nouveau Goddesses*, exh. cat., Allard Pierson Gallery, University of Amsterdam, Badisches Landesmuseum Karlsruhe, Braunschweigisches Landesmuseum Braunschweig, 28–45. Amsterdam: WBooks, 2020.

———. "Cassatt's Mural of Modern Woman." Paper presented at the College Art Association annual meeting, Washington, DC, January 1975.

———. "Cassatt's Singular Women: Reading *Le Figaro* and the Older New Woman." In *A Companion to Nineteenth-Century Art*, edited by Michelle Facos, 467–83. Oxford: Wiley Blackwell, 2018.

———. "The Collecting Practices of Degas and Cassatt: Gender and the Construction of Value in Art History." In *Perspectives on Degas*, edited by Kathryn Brown, 205–30. London: Routledge, 2017.

———. "The Degas and Cassatt 1915 Exhibition in Support of Women's Suffrage." In *Monographic Exhibitions and the History of Art*, edited by Maia Wellington Gahtan and Donatella Pegazzano, 26–37. London: Routledge, 2018.

———. *Modern Women and Parisian Consumer Culture in Impressionist Painting*. Cambridge: Cambridge University Press, 2007.

———. "Selling, Seduction, and Soliciting the Eye: Manet's Bar at the Folies-Bergère." *Art Bulletin* 77, no. 1 (March 1995): 25–44.

———. "Was There a New Woman in Impressionist Painting?" In *Women in Impressionism: From Mythical Feminine to Modern Woman*, exh. cat., edited by Sidsel Maria Søndergaard, the Ny Carlsberg Glyptotek Museum, Copenhagen, 189–223. Milan: Skira, 2006.

Ivins, William M., Jr. "New Exhibition in the Print Galleries." *Bulletin of the Metropolitan Museum of Art* 22, no. 1 (January 1927): 8–10.

Ivinski, Pamela A. "Mary Cassatt, the Maternal Body, and Modern Connoisseurship." PhD diss., City University of New York, 2003.

Jensen, Robert. *Marketing Modernism in Fin-de-Siècle Europe*. Princeton, NJ: Princeton University Press, 1997.

Jones, Kimberly A., ed. *Degas Cassatt*. Washington, DC: National Gallery of Art, 2014.

Kadushin, Charles. *Understanding Social Networks: Theories, Concepts, and Findings*. Oxford: Oxford University Press, 2012.

Katz, Sandra L. *Dearest of Geniuses: A Life of Theodate Pope Riddle.* Windsor, CT: Tide-Mark, 2003.

Kendall, Richard. *Degas: Beyond Impressionism.* London: National Gallery of Art, 1996.

Knoedler, M. & Co. *Loan Exhibition of Masterpieces by Old and Modern Painters.* New York, 1915.

Kobbe, Gustav. "Painted by Rembrandt in 1634, First Exhibited in New York 1915." *New York Herald,* April 4, 1915, section 3, 1.

Kushner, Marilyn S., and Kimberly Orcutt, eds. *The Armory Show at 100: Modernism and Revolution.* New York: New-York Historical Society Library & Museum in association with D. Giles (London), 2013.

Kysela, John D. "Mary Cassatt's Mystery Mural and the World's Fair of 1893." *Art Quarterly* 29, no. 2 (1966): 128–45.

———. "Sara Hallowell Brings Modern Art to the Midwest." *Art Quarterly* 27, no. 2 (1964): 150–67.

Lange, Allison K. *Picturing Political Power: Images in the Women's Suffrage Movement.* Chicago: University of Chicago Press, 2020.

Latour, Bruno. *Reassembling the Social.* Oxford: Oxford University Press, 2005.

Leard, Lindsay. "The *Société peintres-graveurs Français* in 1889–97." *Print Quarterly* 14, no. 4 (December 1997): 355–63.

Lees, Sarah. "Innovative Impressions: Cassatt, Degas, and Pissarro as Painter Printmakers." In *Innovative Impressions: Prints by Cassatt, Degas, and Pissarro,* exh. cat., edited by Sarah Lees and Richard R. Brettel, Philbrook Museum of Art, 11–103. Munich: Hirmer, 2018.

Leja, Michael. "American Art's Shifting Boundaries." *American Art* 11, no. 2 (Summer 1997): 48–49.

Lemoisne, Paul-André. *Degas et son oeuvre.* 4 vols. Paris: Brame et Hauke, 1946.

Lindsay, Suzanne G. *Mary Cassatt and Philadelphia.* Philadelphia: Philadelphia Museum of Art, 1985.

Lipton, Eunice. *Looking into Degas: Uneasy Images of Women and Modern Life.* Berkeley: University of California Press, 1986.

Livermore, Henrietta W. "Woman's Sphere in New York." *Woman Voter* 6, no. 4 (April 1915): 14.

"Loan Exhibition in Aid of Suffrage." *The Sun,* April 6, 1915.

Loyrette, Henri. *Degas.* Paris: Fayard, 1991.

Lubin, David M. "Lilly Martin Spencer's Domestic Genre Painting in Antebellum America." Chap. 4 in *Picturing a Nation: Art and Social Change in Nineteenth-Century America.* New Haven, CT: Yale University Press, 1994.

Luckyj, Christina, and Niamh J. O'Leary, eds. *The Politics of Female Alliance in Early Modern England.* Lincoln: University of Nebraska, 2017.

MacLeod, Dianne. *Enchanted Lives, Enchanted Objects: American Women Collectors and the Making of Culture, 1800–1940.* Berkeley: University of California Press, 2008.

Madeline, Laurence. *Women Artists in Paris, 1850–1900.* New York: American Federation of the Arts; New Haven, CT: Yale University Press, 2017.

Mainardi, Patricia. *The End of the Salon: Art and the State in the Early Third Republic.* Cambridge: Cambridge University Press, 1993.

Manoeuvre, Laurent. *Mary Cassatt, au Coeur de l'Impressionnisme.* Paris: Éditions À Propos, 2018.

Marks, Montague. "My Notebook." *Art Amateur* 27, no. 3 (August 1892): 51.

"Mary Cassatt, Durand-Ruel Galleries." *Art News* 25, no. 4 (October 30, 1926): 9.

"Mary Cassatt's Achievement: Its Value to the World of Art." *The Craftsman* 19, no. 6 (March 1911): 540–46.

Massa, Ann. "Black Women in the 'White City.'" *Journal of American Studies* 8, no. 3 (December 1974): 319–37.

Mathews, Nancy Mowll, ed. *Cassatt: A Retrospective.* New York: Hugh Lauter, 1996.

———. "The Color Prints in the Context of Mary Cassatt's Art." In *Mary Cassatt: The Color Prints,* edited by Nancy Mowll Mathews and Barbara Stern Shapiro, 19–55. New York: Abrams, with Williams College Museum of Art, 1989.

———. "The Havemeyer Portraits." In *Mary Cassatt: Friends and Family,* exh. cat., 37–42. Shelburne, VT: Shelburne Museum, 2008.

————. *Mary Cassatt.* New York: Harry N. Abrams with the National Museum of American Art, Smithsonian Institution, 1987.

————. *Mary Cassatt: A Life.* New York: Villard Books, 1994.

————. *Mary Cassatt and Edgar Degas.* Exh. cat. San José, CA: San José Museum of Art, 1981.

————, ed. *Mary Cassatt and Her Circle: Selected Letters.* New York: Abbeville Press, 1984.

————. "Mary Cassatt and the 'Modern Madonna' of the Nineteenth Century." PhD diss., New York University, 1980.

————, with Flavie Durand-Ruel Mouraux and Pierre Currie. *Mary Cassatt: Une Impressionniste Américaine à Paris.* Paris: Musée Jacquemart-André, Institut de France, March 9–July 23, 2018.

Mauvieux, Martine. *Mary Cassatt.* Paris, Musée d'Orsay, March 7–June 5, 1988. Organized by the Musée d'Orsay and the Bibliothèque nationale. Paris: Éditions de la Réunion des Musées Nationaux, 1988.

McCarthy, Kathleen D. *Women's Culture: American Philanthropy and Art, 1830–1930.* Chicago: University of Chicago Press, 1991.

McMullen, Roy. *Degas: His Life, Times, and Work.* Boston: Houghton Mifflin, 1984.

Mellerio, André. *Exposition Mary Cassatt,* November–December 1893. Reprinted in *Cassatt: A Retrospective,* edited by Nancy Mowll Mathews, 202. New York: Hugh Lauter, 1996.

————. "Mary Cassatt." In *L'art et les artistes* 12 (October 1910–March 1911): 69–75.

Melot, Michel. "Mary Cassatt, an Artist between Two Worlds." In *Mary Cassatt, Impressions,* translated by M. Taylor, 84–93. Giverny: Terra Foundation of American Art; Paris: Le Passage, 2005.

Merrick, Lula. "The Art of Mary Cassatt." *The Delineator* 74, no. 2 (August 1909): 121–32.

Merritt, Anna Lea. "A Letter to Artists: Especially Women Artists." *Lippincott's Magazine,* March 1900, 463–69. Reprinted in *Cassatt: A Retrospective,* edited by Nancy Mowll Mathews, 239–40. New York: Hugh Lauter, 1996.

"The Metropolitan Museum of Art Special Exhibitions, 1870–2021." Compiled by the Metropolitan Museum of Art Archives.

Meyers, Jeffrey. *Impressionist Quartet: The Intimate Genius of Manet and Morisot, Degas and Cassatt.* New York: Harcourt and Brace, 2005.

Michel, Alice. "Degas and His Model." Translated by Jeff Nagy. New York: David Zwirner Books, 2017. Originally published as "Degas et son Modèle." *Mercure de France,* February 1 and 16, 1919.

Middleman, Rachel, and Anne Monahan. "Introduction: The Politics of Legacy." *Art Journal* 76, no. 1 (July 2017): 70–74.

Miller, Angela L., Janet Catherine Berlo, Brian J. Wolf, and Jennifer L. Roberts. *American Encounters: Art, History, and Cultural Identity.* New York: Pearson Education, 2018.

Moch, Leslie Page, and Rachel G. Fuchs. "Getting Along: Poor Women's Networks in Nineteenth-Century Paris." *French Historical Studies* 18, no. 1 (Spring 1993): 34–49.

Moffett, Charles S., ed. *The New Painting: Impressionism 1874–1886.* San Francisco: Fine Arts Museums of San Francisco, 1986.

Moore, George. *Reminiscences of the Impressionist Painters.* Dublin: Maunsel, 1906.

Musser, Charles. "1913: A Feminist Moment in the Arts." In *The Armory Show at 100: Modernism and Revolution,* edited by Marilyn S. Kushner and Kimberly Orcutt, 169–79. New York: New-York Historical Society Library & Museum in association with D. Giles (London), 2013.

Nochlin, Linda. "Issues of Gender in Cassatt and Eakins." In *Nineteenth Century Art: A Critical History,* edited by Stephen F. Eisenman, 255–73. London: Thames & Hudson, 1994.

————. "Mary Cassatt's Modernity." In Nochlin, *Representing Women,* 181–215. New York: Thames & Hudson, 1999.

————. "Why Have There Been No Great Women Artists?" *Art News,* May 30, 2015 [January 1971]. https://www.artnews.com/art-news/retrospective/why-have-there-been-no-great-women-artists-4201/.

Offen, Karen. *Debating the Woman Question in the French Third Republic, 1870–1920.* Cambridge: Cambridge University Press, 2018.

Ott, John. "Patrons, Collectors, and Markets." In *A Companion to American Art.* Edited by John Davis, Jennifer A. Greenhill, and Jason D. LaFountain, 525–43. New York: Wiley, 2015.

"The Painter of Children." *Literary Digest* 13, no. 2 (July 10, 1926): 26–27.

Pal, Susie. *Gentlemen Bankers: The World of J.P. Morgan.* Cambridge, MA: Harvard University Press, 2013.

Palczewski, Catherine H. "The Male Madonna and the Feminine Uncle Sam: Visual Argument, Icons, and Ideographs in 1909 Anti-Woman Suffrage Postcards." *Quarterly Journal of Speech* 91, no. 4 (November 2005): 365–94.

Palmer, Bertha. *Addresses and Reports of Mrs. Potter Palmer: President of the Board of Lady Managers.* Chicago: Rand McNally, 1894.

Patry, Sylvie. "Are Museum Curators 'Very Special Clients'? Impressionism, the Art Market, and Museums (Paul Durand-Ruel and the Musée du Luxembourg at the Turn of the Twentieth Century)." In *Companion to Impressionism,* edited by André Dombrowski, 566–82. New York: Wiley, 2021.

———. *Berthe Morisot.* Paris: Musée d'Orsay/Flammarion, 2019.

———, ed., with Anne Robbins et al. *Discovering the Impressionists: Paul Durand-Ruel and the New Painting.* Philadelphia: Philadelphia Museum, 2015.

Peck, Amelia, and Thayer Tolles. "Creating a National Narrative." In *Making the Met, 1870–2020,* edited by Andrea Bayer with Laura D. Corey, 116–27. New York: Metropolitan Museum of Art, 2020.

Pfeiffer, Ingrid, and Max Hollein, eds. *Women Impressionists.* Translated by Bronwen Saunders and John Tittensor. [Frankfurt am Main]: Schirn Kunsthalle Frankfurt; Ostfildern: Hatje Cantz, 2008.

"Pictures by Mary Cassatt." *New York Times,* April 18, 1895. Reprinted in *Cassatt: A Retrospective,* edited by Nancy Mowll Mathews, 215. New York: Hugh Lauter, 1996.

Plante, Ellen M. *Women at Home in Victorian America: A Social History.* New York: Facts On File, 1997.

Pleck, Elizabeth, and Joseph H. Pleck. "Fatherhood Ideals in the United States: Historical Dimensions." In *The Role of the Father in Child Development,* edited by Michael E. Lamb, 33–48. New York: Wiley, 1997.

Pohl, Frances K. "Historical Reality or Utopian Ideal? The Woman's Building at the World's Columbian Exposition, Chicago 1893." *International Journal of Women's Studies* 5 (September/October 1982): 289–311.

Pollock, Griselda. *Mary Cassatt.* New York: Harper & Row, 1980.

———. *Mary Cassatt: Painter of Modern Women.* New York: Thames & Hudson, 1998. 2nd ed., with a new preface, 2022.

———. "Modernity and the Spaces of Femininity." In *Vision and Difference: Femininity, Feminism and Histories of Art,* 50–90. London: Routledge, 1988.

———. "The National Gallery Is Erasing Women from the History of Art." *The Conversation,* June 3, 2015. https://theconversation.com/the-national-gallery-is-erasing-women-from-the-history-of-art-42505.

Pope, Theodate. Diary, 1886–1902, unpublished. Hill-Stead Museum Archives, Farmington, CT.

"Prints at the Public Library." *Art News* 25, no. 11 (December 18, 1926): 9.

Rabinow, Rebecca A. "Louisine Havemeyer and Edgar Degas." In *Degas and America: The Early Collectors,* edited by Ann Dumas and David A. Brenneman, 35–45. Atlanta: High Museum of Art; Minneapolis: Minneapolis Institute of Arts, 2001.

———. "The Suffrage Exhibition of 1915." In *Splendid Legacy: The Havemeyer Collection,* edited by Alice Cooney Frelinghuysen et al., 89–95. New York: Metropolitan Museum of Art, 1993.

Reff, Theodore, ed. *The Letters of Edgar Degas.* 3 vols. New York: Wildenstein Plattner Institute, 2020.

Reist, Inge Jackson, and Rosella Mamoli Zorzi, eds. *Power Underestimated: American Women Art Collectors.* Proceedings of a symposium jointly organized by the Center for the History of Collecting in America at the Frick Collection and the Doctoral Studies School in Languages, Culture and Societies of the University of Venice, Ca' Foscari. Held at the University of Venice, Ca' Foscari, April 2008.

Rewald, John, ed. *Camille Pissarro, Letters to His Son Lucien.* Santa Barbara, CA: Peregrine Smith, 1981.

———. "The Collection of Carroll S. Tyson, Jr. Philadelphia, USA." *Philadelphia Museum of Art Bulletin* 59, no. 280 (Winter 1964): 59–80.

Robins, Elizabeth. *My Little Sister.* New York: Dodd, Mead, 1913 [1912]. Also known as *Where Are You Going To . . .?*

Ross, Ishbel. *Silhouette in Diamonds: The Life of Mrs. Potter Palmer.* New York: Harper & Brothers, 1960.

Rouart, Denis, ed. *Berthe Morisot: The Correspondence with Her Family and Friends.* Translated by Betty W. Hubbard. New York: E. Wyethe, 1959.

R.R. "Miss Mary Cassatt." *Art Amateur* 38, no. 6 (May 1898): 130.

Saarinen, Aline B. *The Proud Possessors: The Lives, Times and Tastes of Some Adventurous American Art Collectors.* New York: Random House, 1958.

Salzman, Cynthia. *Old Masters, New World: America's Raid on Europe's Great Pictures.* New York: Penguin Books, 2008.

Schapiro, Meyer. "Introduction to Modern Art in America: The Armory Show." In *Modern Art: Nineteenth and Twentieth Centuries,* 135–37. New York: Braziller, 1978.

Scott, Joan W. "The Woman Worker." In *A History of Women in the West,* edited by Geneviève Fraisse and Michelle Perrot, 399–448. Vol. 4 of *Emerging Feminism from Revolution to World War.* Cambridge, MA: Belknap Press of Harvard University, 1993.

Schwartz, Vanessa R., and Jeannene M. Przyblyski, eds. *The Nineteenth-Century Visual Culture Reader.* New York: Routledge, 2004.

Segard, Achille. *Mary Cassatt: Un peintre des enfants et des mères.* Paris: P. Ollendorff, 1913.

Shackelford, George T.M. "Pas de Deux: Mary Cassatt and Edgar Degas." In *Mary Cassatt: Modern Woman,* edited by Judith A. Barter, 109–43. Chicago: Art Institute of Chicago; New York: Abrams, 1998.

———, Xavier Rey, et al. *Degas and the Nude.* Boston: Museum of Fine Arts, 2011.

Shapiro, Barbara Stern. *Mary Cassatt at Home.* Boston: Museum of Fine Arts, 1978.

———. "A Printmaking Encounter." In *The Private Collection of Edgar Degas,* edited by Ann Dumas et al., 235–46. New York: Metropolitan Museum of Art, 1997.

Sharp, Kevin. "How Mary Cassatt Became an American Artist." In *Mary Cassatt: Modern Woman,* edited by Judith A. Barter, 162–69. Chicago: Art Institute of Chicago; New York: Abrams, 1998.

Shircliff, Jennifer Pfeifer. "Women of the 1913 Armory Show: Their Contributions to the Development of American Art." PhD diss., University of Louisville, 2014.

Siebert, Phaedra. "Appendix: Selected Degas Exhibitions in America, 1878–1936." In *Degas and America: The Early Collectors,* edited by Ann Dumas and David A. Brenneman, 248–50. Atlanta: High Museum of Art; Minneapolis: Minneapolis Institute of Arts, 2001.

Smith, Ann Y. *Hidden in Plain Sight: The Whittemore Collection and the French Impressionists.* Roxbury, CT: Garnet Hill Publishing Co. and Mattatuck Historical Society, 2009.

Sontag, Susan. "The Double Standard of Aging." *Saturday Review,* September 23, 1972, 29–38.

Stanton, Elizabeth Cady. "The Pleasures of Old Age." Address, March 12, 1885, 1–8. Elizabeth Cady Stanton Papers: Speeches and Writings, 1848–1902. Library of Congress. https://www.loc.gov/item/mss412100094/.

———, Susan B. Anthony, Matilda Joslyn Gage, and Ida Husted Harper, eds. *History of Woman Suffrage.* New York National American Suffrage Association. 6 vols. New York: Fowler & Wells, 1922.

Stein, Susan Alyson. "Chronology." In *Splendid Legacy: The Havemeyer Collection,* edited by Alice Cooney Frelinghuysen et al., 201–87. New York: Metropolitan Museum of Art, 1993.

———. "The Metropolitan Museum's Purchases from the Degas Sales: New Acquisition and Lost Opportunities." In *The Private Collection of Edgar Degas,* edited by Ann Dumas et al., 271–91. New York: Metropolitan Museum of Art, 1997.

Stevens, Doris. *Jailed for Freedom.* New York: Boni and Liveright, 1920.

The Sun, October 24, 1915, clipping. O'Neill Archive, Norman Rockwell Museum, Stockbridge, MA.

Sund, Judy. "Columbus and Columbia in Chicago 1893: Man of Genius Meets Generic Woman." *Art Bulletin* 75, no. 3 (September 1993): 443–66.

Sutton, Denys. *Degas: Life and Work.* New York: Artabras, 1991 [1986].

Sweet, Frederick A. "Mary Cassatt, 1844–1926." *Art Institute of Chicago Quarterly* 48, no. 1 (February 1, 1954): 4–9.

———. *Miss Mary Cassatt, Impressionist from Pennsylvania*. Norman: University of Oklahoma Press, 1966.

Swinth, Kirsten. *Painting Professionals: Women Artists and the Development of Modern American Art*. Chapel Hill: University of North Carolina Press, 2001.

Theriot, Nancy M. *Mothers and Daughters in Nineteenth-Century America: The Biosocial Construction of Femininity*. Rev. ed. Lexington: University Press of Kentucky, 1996.

Thurner, Manuela. "'Better Citizens without the Ballot': American Anti-Suffrage Women and Their Rationale during the Progressive Era." *Journal of Women's History* 5, no. 1 (Spring 1993): 33–60.

Tickner, Lisa. *The Spectacle of Women: Imagery of the Suffrage Campaign, 1907–14*. Chicago: University of Chicago Press, 1988.

Ticknor, Caroline. *May Alcott: A Memoir*. Boston: Little, Brown, 1928.

Tinterow, Gary. "The 1880s: Synthesis and Change." In Jean Sutherland Boggs, *Degas*, 363–74. New York: Metropolitan Museum of Art, 1988.

———. "The Havemeyer Pictures." In *Splendid Legacy: The Havemeyer Collection*, edited by Alice Cooney Frelinghuysen et al., 3–53. New York: Metropolitan Museum of Art, 1993.

Trout, Carlynn. "Rose O'Neill." State Historical Society of Missouri. https://historicmissourians.shsmo.org/rose-oneill.

Tutt, Juliana. "'No Taxation without Representation' in the American Suffrage Movement." *Stanford Law Review* 62, no. 5 (May 2010): 1473–512.

Ventura, Gal. *Maternal Breast-Feeding and Its Substitutes in Nineteenth-Century French Art*. Leiden: Brill, 2018.

Venturi, Lionello. *Les archives de l'Impressionnisme*. 2 vols. Paris: Durand-Ruel, 1939.

Verheul, Jaap. "'A Peculiar National Character': Transatlantic Realignment and the Birth of American Cultural Nationalism after 1815." *European Journal of American Studies* 7, no. 2 (2012): 1–14.

Vertovec, Steven, and Robin Cohen. "Introduction: Conceiving Cosmopolitanism." In *Conceiving Cosmopolitanism: Context and Practice*, edited by Steven Vertovec and Robin Cohen, 1–22. Oxford: Oxford University Press, 2022.

Vincent, Clare. "The Havemeyers and the Degas Bronzes." In *Splendid Legacy: The Havemeyer Collection*, edited by Alice Cooney Frelinghuysen et al., 77–80. New York: Metropolitan Museum of Art, 1993.

Viraben, Hadrien. "Constructing a Reputation: Achille Segard's 1913 Biography of Mary Cassatt." *Art in America* 31, no. 1 (Spring 2017): 98–113.

Vollard, Ambroise. *Degas: An Intimate Portrait*. Translated by Randolph T. Weaver. New York: Dover, 1986 [1927].

———. *Recollections of a Picture Dealer*. Translated by Violet M. Macdonald. Boston: Little, Brown, 1936.

Waldman, E. "Modern French Pictures: Some American Collections." *Burlington Magazine* 17, no. 85 (April 1910): 62–63, 65–66.

Walton, Mary. *A Woman's Crusade: Alice Paul and the Battle for the Ballot*. New York: Palgrave Macmillan, 2010.

Walton, William. "Miss Mary Cassatt." *Scribner's Magazine*, March 1896, 353–61.

Ward, Martha. "The Eighth Exhibition 1886: The Rhetoric of Independence and Innovation." In *The New Painting: Impressionism 1874–1886*, edited by Charles S. Moffett, 421–42. San Francisco: Fine Arts Museums of San Francisco, 1986.

———. "The Museum of Impressionism, 1947." In *Companion to Impressionism*, edited by André Dombrowski, 583–600. New York: Wiley, 2021.

Wark, R. R. "A Note on Van Dyck's 'Self-Portrait with a Sunflower.'" *Burlington Magazine* 98, no. 635 (February 1956): 53–54.

Watson, Forbes. *Mary Cassatt*. New York: Whitney Museum of American Art, 1932.

———. "Philadelphia Pays Tribute to Mary Cassatt." *The Arts* 11, no. 6 (June 1927): 288–97.

Webster, Sally. *Eve's Daughter/Modern Woman: A Mural by Mary Cassatt*. Urbana: University of Illinois Press, 2004.

Weimann, Jeanne Madeline. *The Fair Women: The Story of the Woman's Building at the World's Columbian Exposition, Chicago 1893*. Chicago: Academy, 1981.

Weir Young, Dorothy. *The Life and Letters of J. Alden Weir*. Edited with an introduction by Lawrence W. Chisholm. New Haven, CT: Yale University Press, 1960.

W[eitenkampf], F[rank]. "Mary Cassatt, Print-Maker." *Bulletin of the New York Public Library* 30 (1926): 858–59.

Weitenkampf, Frank. "Some Women Etchers." *Scribner's Magazine*, December 1909, 731–39.

Weitzenhoffer, Frances. *The Havemeyers: Impressionism Comes to America*. New York: Abrams, 1986.

Wells, H. G. *Marriage*. New York: Duffield, 1912.

White, Barbara Ehrlich. *Impressionists Side by Side: Their Friendships, Rivalries, and Artistic Exchanges*. New York: Knopf, 1996.

White, Harrison C., and Cynthia A. White. *Canvases and Careers: Institutional Change in the French Painting World*. New York: Wiley, 1965.

Wilkins, Wynona H. "The Paris International Feminist Congress of 1896 and Its French Antecedents." *North Dakota Quarterly* 43, no. 4 (Autumn 1975): 5–28.

Wilson, Ellen Janet. *American Painter in Paris: A Life of Mary Cassatt*. New York: Farrar, Straus & Giroux, [1971].

Winkler, John K. *The First Billion: The Stillmans and the First National Bank*. New York: Vanguard Press, 1934.

Yoshihara, Mari. *Embracing the East: White Women and American Orientalism*. New York: Oxford University Press, 2003.

Zalewski, Leanne M. *The New York Market for French Art in the Gilded Age, 1867–1893*. New York: Bloomsbury, 2022.

Zehnder, Amanda T. "Forty Years of Artistic Exchange." In *Degas Cassatt*, edited by Kimberly A. Jones, 2–19. Washington, DC: National Gallery of Art, 2014.

ILLUSTRATIONS

INDEX

Page numbers with *fig* refer to a figure or a caption; *n* refers to a note. Titles to artwork without an identifying artist's name are work by Cassatt.

World War I: Cassatt during, 136; community service/donations during, 73; impact on Cassatt, 51, 72, 73, 144; influence on Cassatt's thinking about women and politics, 140, 154; *"She prepares the Child for the World. Help her to help prepare the World for the Child"* (O'Neill), 216, 217*fig*

WSPU (Women's Social and Political Union), 140

Young Woman Sewing in the Garden, 238
Young Women Picking Fruit, 108
Young Women Plucking the Fruit of Knowledge and Science, 191*fig*

Zhender, Amanda, T., on Degas-Cassatt artistic dialogue, 270n6, 270n13
Zorn, Anders Leonard: Cassatt's view of, 71; *Mrs. Bertha Honoré Palmer,* 85–86, 85*fig*

Founded in 1893,
UNIVERSITY OF CALIFORNIA PRESS
publishes bold, progressive books and journals
on topics in the arts, humanities, social sciences,
and natural sciences—with a focus on social
justice issues—that inspire thought and action
among readers worldwide.

The UC PRESS FOUNDATION
raises funds to uphold the press's vital role
as an independent, nonprofit publisher, and
receives philanthropic support from a wide
range of individuals and institutions—and from
committed readers like you. To learn more, visit
ucpress.edu/supportus.